SEX AND THE FLOATING WORLD

Sex and the Floating World

Erotic Images in Japan, 1700–1820

Timon Screech

UNIVERSITY OF HAWAI'I PRESS

HONOLULU

Published in North America by
University of Hawai'i Press
2840 Kolowalu Street
Honolulu, Hawai'i 96822

First published in Great Britain by
Reaktion Books Ltd
79 Farringdon Road
London EC1M 3JU
UK

Printed in Great Britain

Library of Congress Cataloging-in-Publication Data

Screech, Timon.
 Sex and the floating world : erotic images in Japan, 1700–1820 /
Timon Screech.
 p. cm.
 Includes bibliographical references and index.
 ISBN 0-8248-2203-x (alk. paper). — ISBN 0-8248-2204-8 (pbk.: alk. paper)
 1. Erotic art—Japan. 2. Ukiyoe. 3. Art, Japanese—Edo period,
1600–1868. I. Title.
N7353.5.S39 1999
760′.04428′095209033—dc21
 99-12423
 CIP

Contents

Introduction 7

1 Erotic Images, Pornography, *Shunga* and Their Use 13

2 Time and Place in Edo Erotic Images 39

3 Bodies, Boundaries, Pictures 88

4 Symbols in *Shunga* 129

5 The Scopic Regimes of *Shunga* 193

6 Sex and the Outside World 237

References 289

Bibliography 305

List of Illustrations 313

Introduction

This book aspires to offer a new interpretation of Japanese erotic images from the eighteenth century to the middle of the nineteenth century, that is, the mid-Edo period. During that period of 120 years there were great social changes, with a general movement of power and wealth to the shogunal capital of Edo. There were also specifically pictorial changes in invention of the technology of the multi-coloured woodblock print.

It is my hope to set erotic images properly into their social context. To do this I have found it necessary to go beyond the domain of what are known as *shunga*, that is, overtly sexual pictures, and to push farther. All works of painting and print that participated in the libidinous economy and which kindled or satisfied cravings for sexual activity are treated. It is a premise that, like any erotica, the Japanese images of this period have much to do with private fantasy and would most often have been used in conditions of solitary pleasure. The reader will have to tolerate discussion of masturbation, for it is the central practice that accounts for the genres here discussed. It is necessary to stress this point, for recent interpretations in Japan and elsewhere have been amazingly resistant to analyses of just what erotica was *for*; use remains the big encompassing silence.

The field is, I hope, reasonably covered here, but it has not been possible to address everything by any means. The periodization, at least, is justifiable for two reasons. Erotic images begin to appear in appreciable numbers from about the 1680s, but it was only in the first decades of the eighteenth century that production in quantity seems to have begun. What does exist from the earlier period fits best under a different rubric from that which I propose as defining my area, and typically they have to do with humour and parody, and seldom show couples copulating. This tradition of bawdiness gave way in the early eighteenth century to a kind of picture that was self-consciously refined in appearance and produced to illustrate primarily or solely an act of sex. Phallic competitions, farting,

or women inserting mushrooms disappeared as renditions of elegant bedrooms and fine-clad lovers emerged. Heartiness is alien to the urbane world of mid-Edo-period erotica, as I understand it. We see something equivalent to what Peter Wagner has proposed as occurring at roughly the same time in Europe with the invention of a pure pornography, which is 'an aim in itself'.[1] This is not to say that sexual practice itself necessarily changed, although whether it did or not is part of this book's project, for the uneven nature of the links between pornographic images and human behaviour is part of the necessary field for those who wish to study either.

Erotic images of the mid-Edo period can reasonably be called pornographic, and I intend to use that term. I shall also use the term common in Japanese (and cognate with Chinese and Korean words), *shunga*, 'spring pictures'. In Japan, these formed part of the culture of the 'Floating World' (*ukiyo*), a cognitive condition of being apart from the 'fixed' world of daily life and duty. The Floating World was a state of mind, but it had a concrete arm in the licensed brothel areas and extra-legal 'other places' of entertainment; these locales were then brought back into the domestic world of duty via the medium of pictures. The culture of the brothel areas has been noticed in the West ever since admiration of woodblock prints began in the nineteenth century. They were not pleasurable places for those indentured to work in them, but they nevertheless sent mesmerizing clouds billowing into the cities on whose peripheries they were built, and their wilful self-representations as loci of all libidinous delights were widely consumed and certainly coloured real sexual aspirations. Central to the mythology was the greatest pleasure quarter, set to the north-east of Edo (modern Tokyo), the Yoshiwara. Erotica were intended for those who as a result of constraints of time or finance, or their ethical stance, were unable to go there often. Images were consumed compensatorily and were probably used by those who could not venture into the kinds of places depicted, as of course is the case with pornography today. The Yoshiwara was the apex of the Floating World which formed the core structure of most libidinous pictures.

Around the second decade of the nineteenth century, this began to collapse. The Yoshiwara itself went into decline and with it declined a certain kind of representation of sex. Copious comment exists from this period on the decline of

erotic levels, on the frumpiness of modern prostitutes (so unlike, it was said, the intelligent and beautiful courtesans of previous generations). What was regretted was the absorption of a *culture* of eroticism by *sex*. Such comments do not need to be taken as historical fact, but they do evince a shift in consciousness. Alteration occurred in both male–female encounters and in the male–male sexuality for which Japan has always been famous, called *nanshoku*, literally 'man sex' (I shall leave the term untranslated). Changes in auto-eroticism probably also occurred, although these are difficult to gauge. Yet the changes in erotic images are immediately obvious. Some of the old effete type continue, but a new impetus is seen towards depiction of coercive, violent encounters. Despite the prominence of prostitutes in earlier pictures, with all that this implies of exploitative relations, equality had been honed into the *pictorial* norm.

Chapter One will attempt to set this scene and to assess what *shunga* were for. I have already given my *a priori* assumption but, as this is not at all the received view, I shall attempt to make it impregnable to those who persist in seeing Japanese *shunga* as categorically separate from solitary-use pornography. Chapter Two will investigate social reactions to the erotic images which proliferated during the eighteenth century. Fears were expressed for social health. It is not at all the case that the works so celebrated for their beauty today and displayed in museums and galleries were benignly viewed in their own time, and this goes for non-overtly sexual pictures of the Floating World as well as for pornography. Reactions changed over the course of the 120 years covered by this book, with anxiety peaking in the 1790s.

Chapters Three and Four will offer close readings of some images, both overtly sexual and more subtly libidinous, in order to assess their status as figures of representation within the larger field of painting and printing, and also within the field of sexual practice. It is necessary to assess mimetic constructions and postulates about the body and gender. The sexualized body was accorded a particular discursive space via the pictures, and this must be carefully read. Nothing is irrelevant here, whether posture, manners of interaction or – more widely – the ambience of the rooms and the objects disposed within them. Pictures of the Floating World do not depict actuality: they spin fantasies.

Chapter Five is concerned with the scopic regimes of *shunga*, that is, with the politics and mechanics of the gaze. Both the gaze of the viewer of the picture and the mutuality of the gazes of the depicted persons are crucial. Many new systems of vision were introduced during the eighteenth century, with new methods of seeing which enhanced and altered vision dramatically. The signification of peering, peeping, magnifying and shrinking were all implicated. Lensed equipment was generally imported, and so issues of foreignness and alterity intrude here. Scopic systems were also set up and deconstructed within pictures by internal devices such as 'pictures within pictures', stylistic shocks, or the presence of alter egos that offset the viewer him- or herself.

The final chapter will address the 'end' of the Floating World culture referred to here, with the movement of erotica out of the pleasure quarters and into the open. The tradition did not implode suddenly, but it dwindled and lost the power to engross and convince. Pornography that fails in this fails in its most crucial test, and users began to search for other stimulants. I shall maintain that a new contract between cities (especially Edo) and their rural hinterland underpinned this refashioning of pornography. After this change, I feel it appropriate to abandon the term '*shunga*'. Fears over depopulation of the countryside brought the first decriers of the pleasure districts as places of sexual waste (there had always been those who called them financially ruinous) and, with this, the first condemnations of masturbation. The mythological bastion of *shunga* and the purpose for which one owned it were assaulted at the same time.

I must close with a caveat, as well as with words of thanks. The caveat is that most *shunga* take the form of books, and there are very few single-sheet images. A sense of the full collectivity of a book is impossible to convey in the selective reproductions included here. It might have been desirable to offer one complete book to show how narratives unfolded, and germanely too, given my claim for masturbation, where breaks occur for the reader to put the book down. Yet even when *shunga* are bound together, they are rarely stories, and in most instances a page can reasonably stand alone. Many glossy reproductions of entire books are available for those who wish to use them. More problematic is that many *shunga* have texts. This book is rooted in the assessment of images

and the texts are not translated, nor are stories recapped, except where expressly required. A literary discussion of *shunga* writing (called *shunpon*) is needed, although that surpasses the brief of the current study and no doubt also my own abilities.

I began the research presented here many years ago. Haruko Iwasaki and Howard Hibbett offered initial encouragement. Further assistance was generously given by Sumie Jones, Kobayashi Tadashi, Joshua Mostow, Henry Smith and Tan'o Yasunori. Several scholars have shared thoughts, books and photographs, including Timothy Clark, Drew Gerstle, Fukuda Kazuhiko, Nicolas McConnell, Murayama Kazuhiro, Gregory Pflugfelder, Nicole Rousmaniere, Shirakura Yoshihiko, Ellis Tinios and many private collectors who prefer not to be named. I am profoundly grateful to them all. I am profoundly grateful to them all. I would also like to express thanks to the staff at Reaktion Books, who laboured to make my prose accurate and readable, and the book appealing.

1 Erotic Images, Pornography, *Shunga* and Their Use

The encounter of foreign countries with Japanese erotica began a surprisingly long time ago. In 1615, shock was registered in London when the first import of 'certaine lasciuious bookes and pictures' were briefly seen before being summarily burned.[1] At about the same time, moralists of the Ming dynasty in China were counselling against the 'extremely detestable custom' of importing Japanese 'spring pictures', which led to lewdness.[2] Korean ambassadors were regular visitors to Japan, and thought the deplorable condition of sexual ethics, which they believed they saw, must surely have been the result of unfettered circulation of the wrong sort of picture.[3]

Few works are left from these early periods, and accordingly this book will address primarily those of the eighteenth and early nineteenth centuries. But there are good reasons apart from the fortuity of survival for doing this. The growth of printing vastly expanded the output of all kinds of picture and text from the 1680s, and massive urbanization concentrated and expanded readership for many works. But cities were demographically artificial, and none more so than the shogunal capital of Edo (modern Tokyo), also the centre of printing, which may have been two-thirds male. This had clear implications for auto-eroticism and hence erotica. Many men lived in the large garrisons serving the Edo palaces of the 280 or so regional princes (daimyo) who governed the Japanese states, and their barrack quarters deprived them of access to females. The late seventeenth-century fictionalist Ihara Saikaku referred to Edo as the 'city of bachelors'.[4] Even those of non-military caste were often living without family roots and traditional networks of socialization and fraternization.

With roughly one million inhabitants, few of whom had been born there, Edo became a centre for the generation of disenfranchised urban modes. But it was not a place of laxity and freedom, sexual or other. The city was disciplined and under

tight control. Pictures showed the city as it was not, or rather, they showed its illusory spaces of pleasure and momentary enjoyment, adrift from normalcy, that is, they showed the 'Floating World' (*ukiyo*). The shogun's chief minister at the turn of the eighteenth century expressed horror that future generations might look back at these vain and eroticized images and conclude that such was how Edo had really been. He did not seek to ban all libidinous pictures, but, as we shall see in Chapter Two, he did relegate them back to their proper spheres; some artists were punished. All art contests the real, but, with erotica, we are dealing with a sort that sets out, as its objective, to misrepresent. Unlike all other genres, erotica – *shunga*, pornography or whatever – trigger a viewer into willing deceptions which the body's physiology, aided most often by hands and fingers, takes further in summoning up fantasies of pleasure.

THE LIBIDINOUS IMAGE

Although I wish to erode the too-easy division made between erotica as such and 'normal' pictures of the Floating World, it is nevertheless important to establish some terms. The usual designations for the former were the descriptive 'pillow pictures' (*makura-e*) and the euphemistic 'laughing pictures' (*warai-e*); the second sounds less coy when we realize that 'laughter' meant masturbation. Another term was 'sexual book' (*kōshokubon*), which tends to figure in official pronouncements, and a vernacular term with the same meaning (*ehon*). Also known was the blunt 'dangerous pictures' (*abuna-e*). Here is the crux: these items were for a purpose that people found it hard to talk about, and this naturally clouds the issue. I use these terms where necessary but have preferred to harmonize them under the label '*shunga*'. Although already known in the nineteenth century, *shunga* is the word deployed today to create a distance from the subject. It is neither antiquarian, nor does it condone a readership seeking to rekindle the original purposes of publication in their own bedrooms today. Since I am seeking to delineate a field for erotic images beyond the overtly sexual, I find *shunga* the best term to use. The English 'pornography' will do as well, although it may carry baggage that is not entirely helpful.

Until recently, it was illegal under Japanese law to publish

images of human genitals, pubic hair or anuses (interestingly, though, semen could be shown). The law applied to modern and historic works, which in a way was heartening since it at least showed the authorities were taking the subject-matter at face value and were not ready to consign pictures to the meaningless void of 'art' just because they were old. An absolute continuum was assumed between what a modern reader would end up doing with historical and with modern pornography. It was fraudulent, however, that this policy was pursued while promoting non-overt equivalents as if they had no connection with the libido and with auto-eroticism. The male and female prostitutes and blatant sex symbols that feature in so many 'normal' pictures of the Floating World were deemed to count for nothing. The great divide between the two was thoroughly artificial.

Cut off from their larger sustaining pool, and reproduceable only with such egregious bowdlerizations as to make them worthless for art-historical as well as onanistic purposes, *shunga* retained a wraithlike existence as supports to sexological writings on the Edo period, much of which was fine, but little of which regarded pictures as important in their own right, much less as having any claim to being a discrete semiotic system. On the other hand, the few people outside Japan who investigated the matter beat the censorship laws obtaining there with the stick of overstatements about the acceptability of *shunga* in their original context. We may be sure that Edo parents, spouses and officials *were* worried about the availability of *shunga* and (a crucial point) about the pull of the whole panoply of Floating World culture.

The law has recently changed, provoking a surge of reissuings of and commentaries on *shunga*, some of it undertaken by prominent art historians. Much material has come to light, most of it, notably, by artists already respected for their achievements in 'normal' Floating World imagery. The choicer pieces of *shunga* have acceded to the embrace of 'Japanese art'. This has brought a rather different problem. While we do now have a better idea of how high *shunga* can climb aesthetically, and how oeuvres fit together and developments occur, the art historians have ousted the sexologists, and with a few laudable exceptions the issue of use has fallen further into the abyss. Most art historians are unwilling to make statements about the history of sexuality, and in any

case they seldom concern themselves with *use* at all, and when that use is masturbation, they wish to proffer nothing. *Shunga* have become 'art' and their context has contracted to that which academe allows for artistic genres, namely position in the oeuvre, biography of the maker, developmental position in the type, etc. I have benefited from recent work but insist that *shunga* belong within a configuration of libidinous images that ripple outwards with no clear demarcation line. *Shunga* are bound to a context that subsumes the histories of pictures and of sexual behaviour. Only by treating them in this way can we see them for what they are: *libidinous representation*. It is now commonplace to call the fantasies fostered by erotica 'pornotopia'.[5] No one has so far attempted to identify a 'shungatopia', or the false salaciousness of images that substituted for experience in the Edo world.

SHUNGA AND 'PICTURES OF BEAUTIFUL PEOPLE'

At the forefront of themes depicted by 'normal' artists of the Floating World was a genre with no parallel in Western art: 'pictures of beautiful people' (*bijin-ga*). There were numerous subdivisions. In the Edo language, both genders were covered, although with the characteristic twist of the compulsory heterosexuality that emerged in Japan in the late nineteenth century, the label is now used to refer only to pictures of beautiful *women*. Worse, it seems, than masturbation over pictures of females is that over pictures of males (the gender of the masturbator is a question that will be addressed below). 'Pictures of beautiful people' do not show the sexual act, which has enabled them to be cleansed and displayed unproblematically. But in most cases the sitters were people whose sexual persona defined them, and so sex defines the picture too. Ihara Saikaku included a story in his *Great Mirror of Sexual Matters* (*Shoen ōkagami*) of 1684 of a court minister forced to relocate in the desolate provinces, who took such pictures, referred to as 'likenesses of courtesans' (*taiyū no sugata-e*), to appease himself. As Saikaku's book was illustrated, the reader is given a rendition of the man, pictures hanging up (seven portraits and one piece of calligraphy on a fan), and four admirers who have befriended him and come to view them (illus. 1).

1 (*below*) Anon., *The Minister Relocated to the Northern Provinces*, monochrome woodblock illustration for Ihara Saikaku, *Shoen ōkagami (Kōshoku nidai otoko)* (1684).

2 (*right*) Anon., *Monk Worshipping a Painting*, monochrome woodblock illustration for *Kōshoku tabi nikki* (1687).

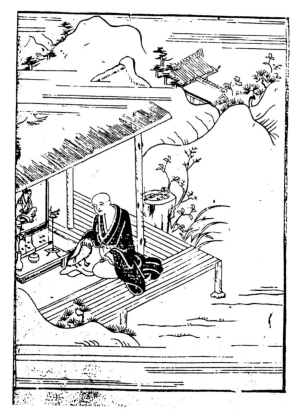

On seeing the set of eight scrolls, their emotions over-
flowed and their words, they found, were unequal. The
minister and his four companions each approached close,
worshipping the images. They could not get enough of
recitations of poetry and extollings of the wondrous delin-
eations of the women's likenesses. The friends begged to be
told, for their delight, how the minister had done the 'fine
thing' with these women long ago, and asked to hear more
and more about what they had been like, since just looking
could never be enough.[6]

The term 'worship' (ogamu) is used to describe their activity
before the paintings. There are other anecdotes of 'worship-
ping' 'beautiful-people' pictures. The anonymous Sexual
Travel Diary (Kōshoku tabi nikki) of 1687, for example, tells of a
sybarite who travelled in search of erotic encounters before
ultimately retiring to a life of solitude as a monk. He left the
company of beautiful men and women (both of which he had
enjoyed) but could not forego sex altogether, and so took a
picture of his favourite partner, treating it as a devotional icon
(honzon) and 'worshipping it, trusting in its efficacy' (illus. 2).[7]
A third, similar story is of a man who commissions
'Hishikawa' (that is, the great commoner artist Moronobu) to
do the image of youths for him to 'worship', and this he is said
to do all through the night.[8] This sounds like a covert refer-
ence to a quite different activity, and since the book is entitled
Male and Female Prostitutes Play the Shamisen Together (Yakei
tomo-jamisen), the shamisen being an instrument associated
with the pleasure quarters, the kind of liaison the man hopes
for with the boys is transparent. In the centre he hangs his
favourite, with the two others flanking, in the manner of a
sacred triad, where lower divinities stand beside a Buddha.
The man had these 'always suspended in the place where he
slept', and he considered the paintings 'as equal to the sacred
icons of perpetual invocation (ikkō sennen) that are wor-
shipped for their efficacy'. Shunga were also 'worshipped',
and the joke is that in Buddhist devotion this was done by
rubbing the palms of the hands together with a rosary in
between; for a male, it looked, and perhaps felt, like mastur-
bation. There is a verse from the 1740s in the senryū mode
which relates to this. (Senryū are a version of the 5:7:5-syllable
poetic genre of haikai [usually referred to as haiku in English]

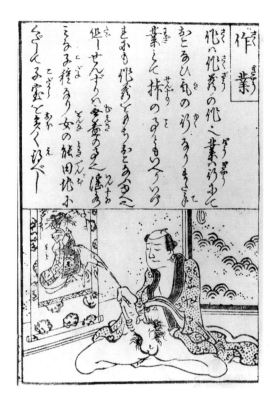

3 Anon., *Produce*, monochrome woodblock illustration for Teikin, *Teikin warai-e shō* (c. 1830).

which treat contemporary fads and neuroses; they are hugely useful for evidence of sexual mores and will be cited repeatedly below.) The anonymous versifier also puns the rod used to jolt the meditating adept with the phallus:

> From the hands in prayer
> The voice of a beating rod –
> The pillow book.[9]

In all three stories (though not the verse), the depicted form is not a generic beauty, but an actual person (within the context of a fictional narrative), and, moreover, they are the previous or future sexual partners of their respective 'worshippers'.

The difference between *shunga* and 'normal' pictures of the Floating World is obvious to the eye, but the difference need not have affected use. There is 'soft' and 'hard' pornography too. While hanging as a picture properly did, in an ornamental alcove, someone might come across them and find themselves provoked. Overtly sexual books encouraged this type of usage of non-overtly sexual pictures. An illustration to a book published by the otherwise unknown Teikin, probably

19

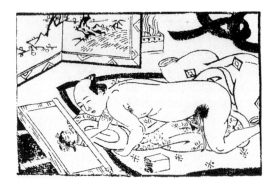

4 Anon., *Man using a Portrait and an 'Edo shape'*, monochrome woodblock illustration separated from an unknown *shunga* book (*c.* 1760).

in the 1830s, shows a painting of what is clearly a prostitute (her clothing is fastened in front, whereas civic women tied theirs behind), seemingly a top-of-the-range worker, being used by a man (illus. 3). The book is called *Teikin's Laughing Pictures* (*Teikin warai-e shō*) and, other than this, all the illustrations are of copulation (one male–male, all the rest male–female) and, as in the previous cases, the context in which the propositions are advanced is itself pornographic. But insofar as Teikin's book is for masturbation ('laughing'), it acts as a recommendation for this way of treating 'beautiful-picture' pictures.

The same picture might have functioned in different ways on different occasions for different viewers. One *shunga* book that has lost the page containing its publication details (many books evince punishing thumbing) illustrates an imaginative man who has rolled up a 'beautiful person' picture until it reveals only the face, and has then fashioned a body out of clothing and tied to it what was called an 'Edo shape' (*azuma-gata*), or artificial vagina (generally made from leather or velvet and stuffed with boiled *konnyaku*), the name of which attests to the frustrated males of that city (illus. 4).[10] It is unsure whether the sitter is supposed to be known to him or not, but in Ihara Saikaku's Floating World novel, *Life of a Sex-mad Man* (*Kōshoku ichidai otoko*), of 1682, the reader hears how the protagonist keeps 44 life-sized 'dressed models' of prostitutes he has slept with, 17 of women from Keishi (modern Kyoto), 8 from Edo and 19 from Osaka. 'Costume, face and loins were individualized for each one', although since this was not an overtly erotic book, Saikaku quickly confirmed, 'there was nothing lewd about them'.[11] Such stories may derive from a *locus classicus* in the first century BC, where the

ruler of the Han had an artist produce a mural of the woman Li so that he could 'rub his body up against the image to find release'. This antique story was retold in c. 1785 in the preface to the *shunga* book *The Scrolling Sleeve* (*Sode no maki*), signed with the pseudonym 'Jikkotsu' ('the one who makes love to himself'); the book was lavishly illustrated by Torii Kiyonaga.[12] It must be conceded that all 'beautiful person' pictures could have been used for auto-erotic purposes.

To return to our third example of the boy to play the *shamisen* with, the picture is said to be a portrait of Arashi Kiyosaburō. This was the name of a real kabuki actor, a female-role specialist, who was famous in Osaka before causing a sensation in Edo in 1707 (the year before the story was written) with his performance of the pyromaniac Yaoya Oshichi – a real person who had accidentally burned the shogun's castle down and most of the city with it in 1682. Kiyosaburō died young in 1713.[13]

The inclusion of a factual beauty within the fictional frame of a story may have been a means of enlisting the attention of a readership who themselves knew such sentiments as were attributed to the man. Terminated sexual encounters might be recalled by a picture, or viewing a likeness might hasten the time until a repeat meeting. Or they compensated for an inability to meet in the first place. Kiyosaburō would have been available for rent as a prostitute, for many kabuki actors were, especially the female-role specialists (real women could not appear on stage). But an encounter with someone of his fame would be expensive, costing less perhaps than a painting by a famous hand, but more than a woodblock print. The eighteenth-century printing boom ensured that portraits of people whose sexual favours were for hire were easily available, indeed, these were some of the prime printed materials. When a painting was commissioned, some close contact would probably already have been formed, but prints circulated easily, including among those who could not afford access to the actual person. They 'worshipped' those they had never directly touched.

The portrait genre is nothing like as central to any of the north-east Asian traditions as it is in the West. Nevertheless, the late eighteenth century saw the rise of a new sort called 'likeness pictures' (*nigao-e*), which startled viewers with their verisimilitude. This type emerged from the Floating World

and stemmed from the need to represent the 'beautiful people' of the quarters to those who could only aspire to see them, and who could never pay for them or hold their attention in conversation. The regenerated portrait came into existence at the same time as the popular print began to be produced in full colour, the technology for which was perfected in 1765. A generation later, Utamaro simulated a letter to a prostitute by someone who owned an Utamaro portrait of her:

> I have gained an understanding of your appearance from the brush of Utamaro – that artist who shuns replicating others' work and style, trusting to his mastery alone. At moments when I want to be with you, I look at it, and feel I am there. [The picture] is so like you that my passions stir.[14]

The man seems to have seen the woman, Hanazuma, but she was of the top grade and, while the owner of a painting (note the word 'brush') might have met her, the consumer of a cheap Utamaro probably had not. The point of the 'letter' is for Utamaro to lay claim to perfection for his works, as even those who have seen his sitters find his portraits accurate. The viewer can 'use' Utamaro's oeuvre without qualm, sure in the knowledge that he was enjoying the real (depiction of) the women. This is rather typical of Utamaro's self-promotion, as recently studied by Julie Nelson Davis.[15] Interesting, then, that there is also the *senryū* verse,

> Using a 'likeness picture'
> She sticks it in.
> The serving woman.[16]

The woman is not often free to leave her mistress's side so, using fingers or a dildo, she views a print, perhaps an Utamaro. No sitter's name is mentioned. A rather later example by Utagawa Kunimaro shows a nun doing just the same in front of a male portrait, lamenting, 'this world of ours being what it is, never gives you what you want, but I'll get by thanks to this clever product and a bit of "finger puppetry"'. Tanobe Tomizō has identified the man as the famous actor Matsumoto Kōshirō (illus. 18).[17] Subsequent to the appearance of the 'likeness picture' came the close-up, or bust, from the 1780s. These had not been seen before but offered a further approximation to the genuine capture of appearance. This is what the nun uses. They were called 'big head pictures'

(*ōkubi-e*), although wags reclassified them as 'big cunt pictures' (*ōtsubi-e*).[18]

'Likeness pictures' brought portraiture to a level where a depicted person was genuinely recognizable if subsequently seen (by no means always the case before this time). Pictures could serve as advertisements for those whose services were to be bought, offering a vision that the client could rely on. Paintings were expensive, but prints allowed multiple procurement by those trying to decide on whom to patronize. In such contexts, overt sexual depiction was counter-productive, since the objective was to titivate only to the level of prompting a separate transaction. When women were shown, it was in their best finery (not worn every day, even by prostitutes), and actors were shown in ravishing costumes. The daimyo of Kōriyama, Yanagisawa Nobutoki (grandson of the important shogunal advisor Yoshiyasu), for example, had a vast collection of actor prints, which many a fan would have bought in all innocence. He did not need to use them as the maidservant or the nun did (thwarted by finances, vocational constrictions and the over-riding disadvantage of their gender, they could not act on their desires): he was rich and powerful enough to be able to flick through the pictures, make his choice and have the boy summoned. Nobutoki's sexual interest in men and his collection of prints – he was famous for both enthusiasms – were two sides of the same erotic coin.

These matters were no more open to public discussion then than now, and the goings-on in a daimyo's bedchamber were not general knowledge. But one other fictional context can be cited to suggest how the common people of the city of Edo, who did consume prints aplenty, liked to envisage the great and powerful using the same imagery. In a long, novel-like work of 1763, *Rootless Grasses* (*Nenashi-gusa*), Hiraga Gennai told the story of the infatuation of no less a panjandarum than Enma, king of Hell, with a print.[19] Gennai was at the forefront of developments in picture-making and two years later was to change the face of printing by assisting his friend and neighbour, Harunobu, to devise technology for multi-colour printing; five years after that, he was to learn something of European and Chinese representational techniques at first hand on a field trip to Nagasaki, where the Dutch East India Company and Chinese traders were stationed. Enma is said to have come across a portrait of a real person, Segawa Kikunojō

(also called Rokō), another kabuki female-role specialist and one of the heart-throbs of the age. The print had been brought to Hell in the baggage of a deceased monk. This would not yet be truly multi-coloured or a 'likeness picture' but was probably printed in just two or three colours, or hand-tinted over a monochrome impression. Gennai relates the name of the artist too, Torii Kiyonobu; presumably this was Kiyonobu II since Kiyonobu I had died in 1729, while Kiyonobu II died about the time Gennai's book came out.[20] No portrait by Kiyonobu II of Segawa Kikunojō is extant, but as the Torii specialized in kabuki work, it would be odd if he had not depicted one of the most famous actors of the period, although Kikunojō was to achieve even greater celebrity after Kiyonobu's death, retiring about 1773. A portrait of the juvenile actor by Torii Kiyomitsu, Kiyonobu's son and successor , will have to serve to indicate the general effect. Kikunojō is dressed in the costume he wore to take the role of Minor Captain Keshōzaka in an as-yet undetermined play (illus. 19).

Enma had not previously ventured into male–male sex, and Gennai says he was repulsed by it. But confronted with the picture, he reconsidered and announced he would surrender royal status to 'swap pillows' with the boy. Since Gennai was himself a known aficionado of *nanshoku* (male–male love), as well as a person with an interest in the status of representation, his claim for the power of such pictures to sway the hearts of even the initially uninterested is significant. Enma is not said to have masturbated over the picture and, in the context of Gennai's non-pornographic book, intended for the general reader, such remarks would have been out of place. Also, as a king, Enma did not need to content himself with autoeroticism. He sent a servant to find Kikunojō and fetch him to Hell. The two finally enjoyed a night of love together.

It might seem preferable to tackle these issues the other way around and work from surviving pictures rather than from literary anecdotes, which are fictional and so open to objections about their validity. It is not often possible to do this, since extant works mostly lack accompanying documents. One case, however, can be cited, since the purpose of its creation is recorded on a second scroll made to hang beside the first as a pendant. Sadly, both are now only known through black-and-white photographs taken in the 1930s

5 Kitao Shigemasa, *Geisha from the Nishigashi* and *Inscription*, 1781, diptych, colour on silk. Original lost.

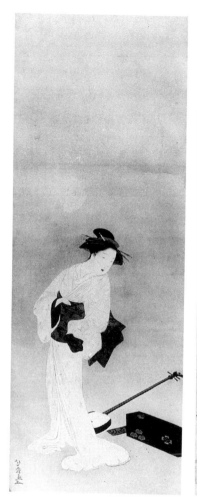

天明元年辛丑秋八月

一寛仙主人

(illus. 5). The owner was a man of substance, the 45-year-old daimyo of Shibata, Mizoguchi Naoyasu, but his advances to a woman were rebuffed, he lost his quarry and commissioned the picture as a substitute in 1781 from Kitao Shigemasa, an established Floating World artist and *shunga*-maker. In this instance, Shigemasa signed his name with the scholarly studio sobriquet 'Karan' – possibly in deference to the daimyo's status, as 'Shigemasa' sounded too much like the Edoite merchant he was. The woman is a geisha, that is, an entertainer who did not sleep with clients. This was the nub of Naoyasu's chagrin. Although the daimyo invited her to his residence up to six times per week, no additional services seemed ever likely to be forthcoming, so after three years he

25

gave up and called in Shigemasa. Naoyasu wrote these facts to hang beside the portrait, using archaic *man'yō-gana* script, which is virtually indecipherable, unburdening himself in cryptic prose.[21] No more information is given, but the picture is blatantly a stand-in for the body of the sitter.

The barrier modern scholarship has so studiously erected between *shunga* and 'normal' pictures of the Floating World crashes down. All Floating World art is libidinous, and once the tension of sexual encounter (thwarted, pending or consummated) is removed, the whole genre grows flaccid. Portraits of known people encouraged attempts to gain access to the person him- or herself, while unnamed beauties inflamed the viewer in a more diffuse way. *Shunga* and non-overt works might be used in an identical fashion. It was for the above reasons that in the 1790s, during a government clamp-down, the representation of all living persons was restricted: they could still be depicted but they could not be named on a print and, portraiture still being only loosely linked to a person's appearance, this was enough to sever the connection between picture and sitter and so curtail the capacity of the image to advertise the person as a sexual commodity.[22] Only generic beauties could be shown. Cunning publishers used rhebuses to get around this, and Hanazuma might be shown beside cherry blossoms (*hana*) and a lightning bolt (*zuma*), or the sublime Hanaōgi (the most expensive prostitute of the period) beside cherry blossoms and a fan (*ōgi*). Generic 'pictures of beautiful people' were unaffected by the ban, as was overt *shunga*, which rarely showed named people anyway.

The movement between *shunga* and 'normal' pictures of the Floating World is not, however, only the result of (mis)use of the latter by owners. Artists themselves encouraged it. One print by Harunobu exists in both forms. Between the invention of the multi-colour print in 1765 and his death in 1770, Harunobu depicted a beautiful man and woman lingering under a snowy willow (illus. 6). The image is referred to as the 'Shared Umbrella', or (from the black and white clothes) 'Crow and Heron in the Snow', both latter-day titles intended to highlight refinement. The long sleeves of the woman and her unplucked eyebrows reveal that she is unmarried, while her sash tied at the back suggests she is bourgeois, not for sale; the man is dressed fashionably, with jet-black overcoat and

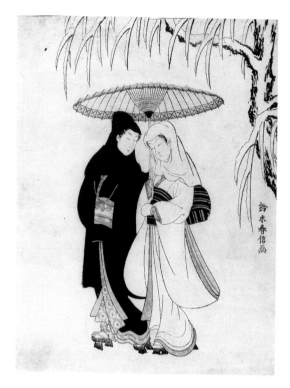

6 Suzuki Harunobu, *Shared Umbrella,* late 1760s, multi-coloured woodblock print.

sumptuous kimono beneath (very few men actually dressed this well). The man is a peg for aspirations to wealth, and the woman his ideal civic partner. Sharing an umbrella was a recognized token of egalitarian love – rather than the woman walking behind the man, as would properly happen. This image is not a representation of real life for a citizen of Edo. Viewers today are not encouraged to speculate on where the couple are bound and how their intimacy could be socially condoned. And yet the image was reissued in a pornographic version (illus.7). Behind the willow is a fence and, leaning on it, the woman hitches up her skirts to allow the man to penetrate her; the umbrella lies jettisoned, and a clog has fallen off in the fumbling. Dialogue has been added, and it is of a none-too-elevated kind: 'Is it all right if I lean on the bend in this tree to do the thing I want?' 'No need to ask'. The reissuing is unsigned and may be by Harunobu himself, but it is also attributed to Isoda Koryūsai. The two artists were associates, even friends (although Koryūsai was of samurai class and Harunobu a townsman), so that this is not persiflage. Koryūsai does not debase or humiliate Harunobu's image but

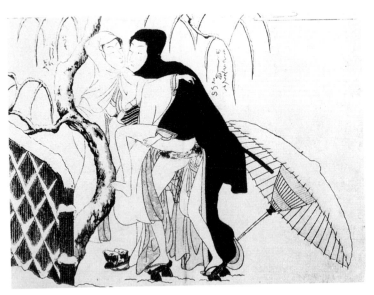

7 Attrib. Isoda
Koryūsai, *Lovers
under a Willow in the
Snow*, late 1760s,
multi-coloured
woodblock print.

offers a logical and satisfactory second leg to the event, entirely
reasonable given the Floating World idiom of the original, and
what any viewer would have been thinking of anyway.[23]

The migration of a single image (even with different
artists), sometimes back and forth multi-directionally, is also
expressed in the pop-up print, a type that seems to have
begun shortly after Harunobu's time, in the 1780s, and was
then revived by Utagawa Toyokuni thirty years later.[24] A
'normal' picture would be gummed over all or part of another,
leaving the viewer to pull up the flap and see the unexpected
development beneath. Although initially used to show the
twist of theatrical plots, and so called 'quick-change pictures'
(*hayagawari-e*) from the swift on-stage costume changes of the
kabuki theatre, they were soon subsumed into pornography.
In kabuki, the technique was used to strip a character of dis-
guise and reveal their true identity, as the denouement of a
play. Here, it is the deceitful cladding of the innocent picture
that is pulled away, revealing the sexual message inherent
from the outset. I have argued elsewhere that these were
probably indebted to the European medical illustrations
called 'fugitive prints', in which pictures of bodily layers were
stuck one on top of the other, to be opened by the armchair
anatomist. But it is interesting that, in Europe too, these were
adapted pornographically.[25] In the Edo case, a 'normal' Floating
World image would be on top, showing some eroticized,

8 Utagawa Kunifusa, *Playing Sugoroku at a Heated Table*, multi-coloured wood-block page with pull-up, from a *shunga* album, *Tsukushi matsufuji no shirakami* (1830).

9 Utagawa Kunifusa's *Playing Sugoroku...* with the pull-up raised.

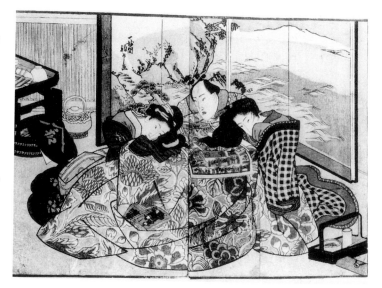

though not overtly sexual scene, with the hidden truth beneath: a night watchman might pass a door which could be opened to reveal a scene of copulation, or a tablecloth might be lifted to show a game of footsie going on beneath (illus. 8, 9). The permeability of the membrane between covertly and overtly sexualized pictures of the Floating World was itself the point of the image, as much as the immediate role of exciting the viewer.

Again, it is necessary to recall that *shunga* as pictures were

part of the larger production of Floating World eroticism that
extended into literature. What has been said for the images
holds good for the narratives too, and many *shunga* are part
of stories. There were also unillustrated books (although the
terminology is unclear, so that when a reference appears in
an Edo-period source it cannot be known whether pictures
shared the space with words or not). One piece of pictorial
evidence for the use of Floating-World literature comes from
Katsukawa Shunshō's illustrations to Jintaku Sanjin's book,
The Needle Hole of the Floating World (*Ukiyo no itoguchi*), which
is a loose parody of the tenth-century classic by the court lady
Sei Shōnagon. Sei's book happened to be known as *The Pillow
Book* (*Makura no sōshi*), but in her time this only meant a diary.
The book was too difficult for the average eighteenth-century
reader, but its title gave rise to jokes at the expense of literary
endeavours and reading.[26] Sei's *Pillow Book* was not illustrated
and had nothing to do with pornography, but the ill-informed
of the Edo period might wonder. The story begins with a man
who falls asleep over a 'pillow book' of the new sort, which is
unillustrated but seems to be a listing of Yoshiwara women
and their specialities. It provokes a night-time emission (illus.
10). The text reads: 'Taking a look at one of these makes you
feel pretty good – these latest edition pillow books that come
out in the early spring. Next thing you know there's a wet
dream.' By the man's mouth is the sound of his groans, 'haha
mumumu fufufufu aaaaa'. The next page shows, in a dream
bubble, the man embracing a prostitute.[27]

10 Katsukawa
Shunshō, *Wet
Dream After Reading
a Pillow Book*,
monochrome
woodblock illustra-
tion for Jintaku
Sanjin, *Ukiyo no
itoguchi* (1780).

The act of masturbation could be discussed, although not in every setting, and was free from any great policing through medical or moral directives. It would be odd indeed, given the social situation of the major cities, and also the profusion of masturbatory equipment that sexologists have brought to notice, if pictures had not played their part in the release of cravings.[28]

The vocabulary of auto-eroticism was vast. We have seen *ateire* ('sticking it in') for women, and *ategaki* ('stroking it') for men was the most common. There was a mock-erudite spoof ideogram conflated from three characters: 'hand' with 'up' and 'down' beside it. There was *senzuri* ('thousand rubs', also pronounced *chizuri*) and *manzuri* ('ten-thousand rubs') for men. We have also encountered the term 'finger puppetry' (*gonin ningyō*), applicable to both genders. The assumption of most writing is that masturbators are apt to be male. Whether this grew from Edo's demography, from higher levels of male rampancy or from other causes is hard to determine. A sexual compendium that came out in 1834 reports that 'masturbation is infallibly performed by males from about the age of fifteen'. It goes on:

> Routinely, there's what's called the 'salt-shaker', 'stroking the cat' and the 'five-man gang', but of course there's more. Old Master Horny once said, 'If you feel like a bit of the "five maidservants", first imagine that lovely woman you're mad about. Then stick the middle finger of your left hand up your bottom while playing with yourself in the right hand; this will feel delicious. All your sensitivity will congregate in your nether parts. If anything oozes out of your arse it will spoil the fun. The real freak wanker can spend half a day working his juices out, and at the end of it he'll be as tired as if he had done two days' hard labour'.[29]

Stimulation of the anus as a masturbatory practice has caused alarm to modern heterosexual commentators.[30] The age of fifteen seems arbitrary and is not corroborated elsewhere. Maruyama Ōkyo, for example, who at the time of his death in 1795 was acclaimed as the best artist in Keishi, made a sketch of a boy masturbating, interesting in itself but useful also for

its inscription: 'male child ejaculating, aged about ten'. What Ōkyo intended to do with this drawing is uncertain, but he added the reminder, 'pigments per usual, do the sperm in powdered or chrysaline white'.[31] Since a child was reckoned as one year old at birth and became two the following New Year (advancing annually on that day, not on the day of their birth), this boy may be substantially under ten by the modern count. Diet and socialization patterns would have brought different classes of child to sexual awareness and maturity at different ages.

Issues of privacy and invasion are also relevant. There is another *senryū*,

> Pillow pictures,
> Read too noisily
> Earn you a scolding.[32]

The user cannot read silently (most eighteenth-century people could not) and, perhaps behind a screen or paper door, is overheard and made to realize he is doing something that should be hidden. Another verse reads,

> Pornographic pictures
> Stowed each day
> In a different place.[33]

Family members did not wish to be haphazardly presented with erotic materials scattered about, and users wished their fetishes to be left unseen. Still, the typical Edo home was small and did not have designated rooms for each family member or for specific functions. Bedrooms did not exist. Toilets were not secluded. In Keishi and Osaka conditions were more generous, and in country places even more so, but sudden intrusion, peeping and the travelling of sound always had to be taken into account and if necessary guarded against. The *shunga* artist Terasawa Masatsugu included a boy taken by surprise by his parents in an anonymous mid-century book, *A Twist of Figured Cloth* (*Aya no odamaki*); four pages parody the 'four accomplishments' or constituents of culture, said to be painting, music, calligraphy and board games. On the music page (inscribed 'song' at top right), a boy called Sukejirō is supposed to be doing singing practice, but is using it to hide quite different sounds as he concentrates on onanism (illus. 11). Parents quietly abed are not impressed:

11 Terasawa Masatsugu, *Song*, monochrome woodblock page from his *Aya no odamaki* (1770s).

[Man:] Not often he gets out his 'devil-eyed horn'.
[Woman:] He's at it again? He never takes his mind off sex.
[Man:] Sukejirō, that wasn't your singing you were doing just now, was it? Finished already, have you?
[Sukejirō:] What are you on about? Stop embarrassing me and let me just go to bed.[34]

Frequently, male masturbation is relegated to a time of infancy, as the discourse-controlling adult expels all thought of substitutional sexual acts into the zone of the weak. *Shunga* themselves may show a masturbating adult male (since that was the state in which images were often viewed), but sober and semi-sober writings confine themselves to talk of boys. By contrast, female masturbation is represented as the lot of adult women. This may have been to allay the fear that a man's own womenfolk took lovers, although the vision of women stimulating themselves alone offers a recurrent thrill, and also one which allows the male the fiction of entering their depicted space and contributing a real thing to replace a dildo.

Adult male masturbation was excused as special, not habitual, and pictures aided this. *Shunga* illustrations of masturbation always form part of larger works in which copulatory sex is paramount. *Shunga* ownership might be excused as only for interim use until the next authentic bout. Images were flatteringly called 'Elder Gold and Monkeys' (*kanoezaru*), referring to the day when ritual abstinence from intercourse was observed, falling every other month; the contraction to *kanoe* was used as a pun on 'his pictures' (*kano-e*).[35] In other words, masturbatory images were tokens of the man's scrupulous ethics, not of his failure to find partners.

In contrast to what Craig Clunas has found to be the case in Ming-period China (1368–1644), pornographic images in Japan were admitted to be intended for auto-eroticism, albeit denials hovered in the air.[36] But outright mythologies concerning *shunga* use also abound, some of them identical to those heard in China, where masturbatory use was never admitted. Some claims are quite improbable, although scholars persist in giving them credence. The first claim (that Clunas calls an 'old canard') is prophylaxis, especially against fire. Anzai Un'en wrote of this in his influential *Famous Modern Painters and Calligraphers (Kinsei meika shōga dan)* of 1830–52, 'There was once a man with an impressive library who always placed *shunga* on top of his book presses. When asked why, he replied it was to ward off fire . . .' Un'en fixed the myth in the specifics of a particular (unnamed) person. He then went further, citing the authority of one of the foremost masters of the Floating World genre, and of *shunga* in particular:

> According to Tsukioka Settei, when the great conflagration hit Keishi in the Meiwa period [1764–72], the storehouse of one shop was preserved because it had some *shunga*, done by him, in it.[37]

Un'en does admit, 'I wonder if this is a true report', and it sounds more like advertising for Settei and ownership-extenuation for his patrons. Probably in 1813, the samurai and doyen of Floating World circles Ōta Nanpo wrote generally, 'if you collect these types of book, you will save yourself from destruction by fire'.[38] These references are duly taken note of by scholars, but they are not convincing evidence, and the last example itself comes from the preface to a *shunga* book. Only a predisposition against accepting the obvious usage will allow this kind of explanation to be considered valid. Of course, some viewers might have heard the myths so often that they came to believe them and did place *shunga* among their valuables, but the notion cannot account for *shunga* as a whole, much less be the inspiration for their production.

A second claim is that *shunga* were used for sex education. The evidence for this is limited. Hachisuka Toshiko, granddaughter of the last shogun, as an old woman told of how she had been given *shunga* at the age of fourteen, before her marriage.[39] Some hand-painted erotica of exceptional quality

exist, and these may well have been produced for wealthy daughters. But no amount of looking at *shunga* will instruct a girl on how sex is pleasurably or safely performed. Such pictures may have helped the over-protected young come to terms with the concept of loss of virginity, but more likely they were for masturbation. It is irrational to expect an elderly lady like Toshiko to be frank to this extent. Manuals relating to contraception and sexual hygiene were written in the Edo period, but they are entirely different from the genre known as *shunga*.

Saikaku created a fetish of the idea of the prim aristocratic girl for the middle-class readers of his *Life of a Sex-Mad Man*. He included the observation,

> It is rare for them to catch a glimpse of a male, and quite impossible for them to get up to anything with them, so right up to the age of twenty-four or five they turn bright red if they catch sight of a rude pillow book or stumble in on someone 'laughing alone'. They stammer out, 'this won't do, I feel faint'.[40]

This is a mythology of the effete virgin. The facts of the matter were totally unknown to a man of Saikaku's ilk, who could have no inkling of the real conditions in a daimyo mansion.

An eighteenth-century source generally mentioned in this context is an extract from the puppet play *A Syllabary of the Treasury of Loyal Retainers* (*Kanadehon chūshingura*), which was first performed in 1748 and became a run-away success. One of the loyal retainers, Amakawa-ya Gihei, is bound for Edo with a trunk of military hardware for use by his fellows in the avenging of their dead master. At the barrier point at Hakone, Gihei is commanded to open his trunk for inspection but refuses with the excuse that it contains 'hand equipment', 'laughing books' and 'laughing tools' destined for a daimyo's wife, and that her name is written on the order form.[41] This is deemed reasonable, and the trunk passes unopened. The note to the standard modern edition glibly states it was the custom to place *shunga* in trunks to ward off fire.[42] Under Edo law, daimyo wives were required to reside permanently in the shogunal capital as surety against rebellion by their husbands. For long periods wives would be alone while these husbands were off governing their home states. Who would need masturbation equipment more than a daimyo's wife,

dynastically married, sequestered in the women's quarters and left behind?

White lies accrue around pornography. If a male buyer excused himself with talk of ritual abstinence, a wife could say she purchased it for fire safety in the home, and both could claim the things were for the instruction of their carefully-raised daughters.

A third myth is also common, namely that soldiers kept *shunga* in their helmets or war chests to prevent injury; this is linked to the fireproof pretence, although here specific to military men. Latter-day samurai of the eighteenth century who never knew danger and seldom drew their swords, pen-pushing by day and retiring to barracks at night (as most did), seem an obvious *shunga* market. They might have wished to claim warrior-like pedigrees for their frustrated lifestyles and for their *shunga*. By virtue of repetition, this myth might have become fact too. Copious *senryū* on the placing of *shunga* among armaments exist, and Henry Smith has calculated from Hanasaki Kazuo and Aoki Meirō's collection of *senryū* that around a quarter of all *shunga*-related verses refer to military trunks. Smith also quotes Hanasaki and Aoki's citation from a more credible work of 1717, *Correcting Opinion about Military Men* (*Buke zokusetsu ben*), which condemns the vanity of contemporary samurai, stating tersely that while moderns may do this with their *shunga*, the mixing of pornography with swords would not have been the wont of heroes in the past.[43] Once again, we have not fact but wishful self-excusing.

One final 'canard' must be dealt with, namely the belief that *shunga* were for collective viewing, as erotic arousal among couples, not as solitary substitution. This myth is also common in China. It is only maintainable by suppression of the historical evidence to the contrary presented above, and it is supported by a woefully naive interpretation of the nature of the pictorial evidence. True, *shunga* showing couples viewing *shunga* together are scattered through the tradition: Kunisada's *Recitations for the Four Seasons* (*Shiki no nagame*) of *c.* 1827 includes such a scene (illus. 12). But these are insufficiently common to take as a primary viewing context, even within the fictional systematics of *shunga* themselves. People might occasionally have used *shunga* together, but once real sex was initiated pictures would seem to become rapidly superfluous, with painted genitals losing appeal when live

12 Utagawa Kunisada, *Lovers Viewing a* Shunga *Scroll*, multi-coloured wood-block page from the anonymous *Shiki no nagame* (*c.* 1827).

ones were at hand. Single users of *shunga*, conversely, may well have wished to see their private actions mirrored and expanded on the page they viewed, as if to support the authenticity of the orgasm they were giving themselves. The myth of shared viewing is exploded by Utamaro where he extends it to a myth of shared production. In his *Picture Book: The Laughing Drinker* (*Ehon warai jōgo*) of *c.* 1803, he claimed that he made the pictures and his wife coloured them in (the claim is made in the form of a mock letter said to be written by her to the publisher); it concludes, 'there is no better con-junction of *yin* and *yang* than for a wife to add the colouring to drawings done by her husband'.[44] Some scholars have taken this as proof that Utamaro was married (something for which there is no other evidence). But this is a pun: 'colour' (*iro*) also meant sex. Sharing sex was the objective, but *shunga* users mostly operated as Jean-Jacques Rousseau said of consumers of European pornography (what he called 'livres dangereux'): they read 'd'une seule main'.[45]

Shunga depict private fantasies. The small amount of evi-dence available suggests that at moments of prearranged sexual encounter, or in professional locations (brothels), *shunga* were kept well out of the way. It would have eroded the myth so carefully fostered in the quarters that they were locales of ethereal elegance. The better class of establishment in fact had very good pictures on display, intended to repli-cate what would be seen in a wealthy withdrawing room, suspended in the formal alcove or painted on screens, and

sometimes by famous artists. Harunobu's student Shiba Kōkan recorded seeing an Ōkyo work hanging in a brothel on the Dōtonbori in Osaka (the subject is not stated) in the autumn of 1788, only months before Ōkyo was commissioned to produce a series of works for the palace of the *shujō* (emperor).[46] There is also a *senryū* telling of a prostitute who satisfied clients' expectations for pictorial elegance in her boudoir with a scroll by Kano Tan'yū, the pillar of academic art, only, unable to get a real one, she hung up a fake.[47] I know of only one instance where pornography is shown as part of the furnishings of a brothel, and that occurs in the unstable position of a picture within a *shunga* picture (illus. 98).

In all situtions it is necessary to view with caution the internal evidence of the mendacious 'shungatopia'. The world was not, and could not, be as represented. This was recognized at the time, and it is necessary to look no further than *senryū* to discover jibes at those too foolish to know the difference. Several point to discrepancies by reference to the *shunga* pose:

> The stupid couple
> Try doing it as in *shunga*
> And sprain their hands

> Going all out
> To copy *shunga*
> They get muscle spasms[48]

Pictures yes, but the recumbent person, and the wider social body, will not bend to answer to every sexual whim.

2 Time and Place in Edo Erotic Images

A great danger in art history is the temptation to believe an appreciation of images is equivalent to historical analysis. Too often, a response to a work on an emotional level is equated with understanding and thus taken as sufficient. The argument would be that since works were originally produced to solicit emotions, if we, in the present, are able to feel something in front of them, then we have transcended the barrier of time. The danger is particularly strong with works where the type of response provoked is, as it were, obvious. Religious art would fit here, as, of course, would erotica. Modern people may be tempted to think that if they can read *shunga* with, as Rousseau put it, 'just one hand', they have also grasped Edo sexuality. But it is not so. Sexual thrill is one of the most basic, animal, of sensations. But it is culturally encoded and not static. Reading Edo erotica in the same way it was read at the time is a problematic undertaking, and we can never be quite sure we feel what earlier viewers would have felt. To be sexually stimulated by *shunga* today is to have one's thrill locked into a vast array of specific external factors and impulses which will have changed since the eighteenth century. It is necessary to stress this point, for while the purpose of this book is to explain *shunga*, not to titivate the reader, I must nevertheless accept that, as I have studied the subject over many years, one of the most constant barriers I have encountered is from those who simply wish to let *shunga* be, that is, allow them to remain tools for their private fantasies of Edo sex.

The prominent historian of European sexuality Robert Darnton wrote of his experience when researching the X-rated section of the Bibliothèque Nationale in Paris. He found traces of sperm on the books and was tempted, he confided, to add his own stains.[1] As Darnton well knew, this was to admit the special ability of erotic pictures and texts to speak across time. But it was also to build a false bridge. Empathy teaches

nothing about the historical moment of making. Distance is important.

In the first chapter we looked at the uses and consumption of *shunga* imagery, including what I have called 'normal' pictures of the Floating World. I sought to overturn the romanticist notion that Edo pictures were somehow different from what we know similar images are produced for today. In this chapter we will look more closely at the specific period of *shunga* production and at how images were thought about by people who did think about them, as distinct from using those content only to use them in a passionate craze. The nineteenth century dominated in the generation of myths of *shunga* use. The eighteenth dominated their production and their early critiques.

Shunga did not exist throughout Japanese history. Erotic pictures may have done, but the particular system of images considered here is specific to one period. Some scholars have wished to treat the erotic work of all epochs as a single block, linking images from even as far back as the eighth century (such as the phallic drawings found in the rafters of the ancient Temple of the Hōryū-ji) with paintings and prints of one thousand years later. Yet even if all such images were intended to provoke the same one-handed response (and we cannot be certain they were), that same response would still be constructed differently in each period. Every thread of the web that ties gender, power, possession, escape and delight would be different. Sexuality, we now know, has a history. If we are to understand, we must keep our time periods as short as reasonably possible.

Shunga were the result of the coming together of a specific set of conditions. Most basically, of the economic and libidinous structures of the cities of Edo and Osaka from the turn of the seventeenth century. The surge of printing, the spread of basic levels of education, and a highly artificial demography were core elements. By the mid-nineteenth century, the situation had evaporated into something else, and although pornography continued to be produced, the conditions had mutated sufficiently to require us to draw a line and to consider a new age to have been entered. It might be nice to take a smaller slice than the 120-odd years that I am taking here, but the amount of data that survives and the stunted state of current scholarship precludes such a reduction at the present time.

We know little about the real extent of *shunga* circulation. Hayashi Yoshikazu has estimated that a total of about 3,000 books would have been produced, each containing some dozen pictures. The work of Asano Shūgō, Shirakura Yoshihiko and others has resulted in listings of some of the more sophisticated *shunga* books.[2] They have come up with 24 books for Hishikawa Moronobu, 5 for Torii Kiyonaga, 17 for Nishikawa Sukenobu, 22 for Okumura Masanobu, 9 for Suzuki Harunobu, 23 for Isoda Koryūsai, 17 for Kitagawa Utamaro, 7 for Utagawa Kunitora, to name only a few, although they do not claim these to be exhaustive. We only have partial evidence, and our estimates of quantity may be too low. Many works survive only partially, or indeed just as titles mentioned in other contexts. Conversely, reissuings and the assigning of new titles to old books may mislead by exaggeration.

To give figures only for the books illustrated by the great masters twists our sense of the state of the market, which was surely saturated by articles of a much cruder kind. Many *shunga* books were unsigned, or signed with pen names that leave the identity of writer and illustrator unclear. Not all buyers even aimed at obtaining works by the celebrated artists of the period. For many, expensive pornography was superfluous.

Lists of titles are not particularly helpful in assessing waves of production. Since much *shunga* material is undated as well as unsigned, this matter is never likely to be entirely sorted out, but no artist would have published at a constant rate. It has been assessed, for example, that most of Utamaro's shunga came from the last ten years of his life, about 1794–1803.[3] Outside the oeuvre of one person, there were shared periods of explosion and repression.

Recent research does enable us to subject the matter to overall analysis. Matthi Forrer has been able to detect a first surge in *shunga* in the third quarter of the seventeenth century.[4] As is often said, this was when the Kamigata remained the cultural centre, that is, the area around Osaka and Keishi, with Edo as something of an outpost. Yoshida Hanbei was working in Osaka, but Moronobu and Sugimura Jihei were already active in Edo, and there is not much to choose between the two locations in terms of refinement. Edo was a male-dominated city from the first, and this was exacerbated

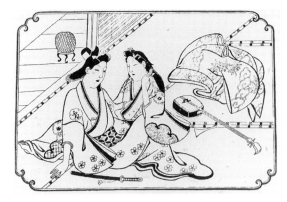

13 Hishikawa Moronobu, *Lovers Indoors*, monochrome woodblock page from *Hana no katari* (modern title) (1679[?]).

by establishment of the system of Alternate Attendance (*sankin kōtai*) in 1635, under which regional rulers were obliged to stand attendance on the shogun intermittently, with retinues of several hundred men. Edo was jokingly called the 'city of bachelors', and it naturally had a vast capacity for sex-related purchases. Most of the men lived in barrack conditions. Some bought sexual partners (the licensed brothel district of the Yoshiwara was established in 1618 and relocated and upgraded in 1657). More would have gone for the cheaper option of sexual fantasy in print. It is not hard to envisage why *shunga* served a necessary role. Paintings had to be treated with care as they were luxury items. Prints were cheap, stainable and disposable.

Moronobu's books are perhaps the best examples of these early *shunga*. They tend to take the form of a series of unrelated pictures, frequently twelve. The first is anodyne, the rest erotic, but otherwise there is little discernible progression (illus. 13). Twelve would allow pictures to fall naturally into a sequence of one per month, with changes of appropriate flowers, clothes or furnishings. The genre of paintings of the cycle of months (*tsukinami-zu*) was established among academic artists, and in general seasonality is a governing factor in many of the Edo arts, so this might account for the twelve of a *shunga* book. But, if so, the potential of the arrangement was not much explored. There is little seasonal progression, nor, with the changing of the cast on each page, is there a story.

The figures that appear in these images mirror the aspirations of their users. If pictures were viewed by single men unable to find a partner, it would not be surprising that they should include depictions of the kind of person those men

would typically hope their partners to be. High-grade prostitutes figure, as do maidservants and female functionaries. The cult of the *yūjo*, or prostitute, as exemplified by the upper echelons of the women indentured in the Yoshiwara, invaded Edo male consciousness and had a notable effect on manipulating desire, which was in turn inevitably reflected in imagery. It was easier to spare time and money to look at a book than to visit a brothel and so, by equipping *shunga* with Yoshiwara-like settings, the concrete fantasies of the constructed reality of the red-light districts could be re-created on the page. This was far from the actual domestic experiences of most Edo men, and far even from the purchased sexual encounters of any but the most spendthrift or wealthy. Pictures offer just enough of the seed of authenticity for excitement to grow.

A second surge occurred in the 1710s with Nishikawa Sukenobu, active in Keishi. He became famous enough to give his name to the pornographic idiom as a whole as '*nishikawa-e*'. Sukenobu produced *shunga* into the early 1720s, but his output diminished. In fact, very few *shunga* books at all were produced in the 1720s. Okumura Masanobu was the only major player, and his pictures often depart from previous norms by being illustrations to a longer accompanying text. In 1722 there was an initial attempt to control *shunga*, and it may have been this that temporarily terminated the genre. The code of control was issued by the Edo magistracy as a *machibure*, not a shogunal law.[5]

The shogun at this point was the eighth in the Tokugawa line, Yoshimune. He had assumed power in 1716 and held it for almost thirty years. Immediately on taking office he embarked on a comprehensive governmental clean-out and issued a raft of legislation known as the Kyōho Reforms. Among the edicts, which this time did carry the weight of the central bureaucracy, was one stating in lumpen official prose,

> Whereas, among material heretofore published by houses of edition there have been books on sexual matters some of which are not conducive to good mores, and all of which are constantly changing, these are no longer to be produced.[6]

This was the first of its kind. It is important to note the precise terms. Outlawed are *kōshokubon* that are not conducive to good *fūzoku*. The first of these terms has been discussed in

43

Chapter One; it implies books of an overt sexual nature and is pretty much the same as the later term *shunga*. *Fūzoku* is a crucial Edo-period concept that will detain us below. It is generally translated as 'manners and customs', that is, social behaviour as regulated by disciplining traditions. Apparently, the shogunate is permitting educational sex manuals, and possibly also books that offer masturbatory releases which sublimate upsetting erogenous drives, but it is ruling out works that aggravate sexual encounters. Is there a difference? Here is one of the chestnuts of pornographic discussion: do pictures dissipate the urge in rapid hand movements, or do they incline to sexual activity involving (sometimes unwilling) third parties and so debase minds?

In sum, the main points to make about erotica in the first half of the eighteenth century relate to its increasing scarcity. Relatively little was produced until the first half of the 1760s. This silence is salient for those who see the Edo period as a time of unmodulated sexual ease. The reasons for so protracted a lull are difficult to determine, since neither the civic code nor the Kyōho law seems to have been reissued, as they would have to have been to remain in force.

This gradual fading was reversed by a boom that began as part of a revival of interest stemming from the invention of a technology of printing in full colour. These so-called 'brocade pictures' (*nishiki-e*) were the collective achievement of a group of thinkers and artists, based in Edo, most of whom were active in the Floating World but who also had interests in the more general world of visual representation. Several were involved with imported styles, such as those coming from Ming China or from Europe, together with their respective systems of viewing. Hiraga Gennai and his neighbour Harunobu were pivotal; Harunobu's pupil, initially called Harushige, was to become one of the foremost producers of Western-style imagery, under the name of Shiba Kōkan. The first multi-coloured prints were a series of calendars for 1765, allowing their dating to be precisely established; the numbers of the long and short months were hidden within the designs (illus. 20).[7]

Early eighteenth-century printing was not markedly different in the Kamigata and Edo, but colour prints were, and closely enough associated with Edo to be called 'eastern brocade pictures' (*azuma-e*), eastern brocade pictures (*azuma-*

nishiki-e), or simply 'Edo pictures' (*Edo-e*). Other cities were not initially able to replicate the manner, and in the early nineteenth century visitors to the Kamigata from Edo were still supercilious about the efforts of publishers there.[8]

There was no reason why colour printing could not have been used to depict the whole range of subjects in the pictorial tradition. A few artists, such as Utagawa Toyoharu, experimented with topographical views or with scenes from history and legend. But it was not until some three-quarters of a century after the invention of the technique that colour-print artists routinely used the medium with anything approaching a full spectrum of themes. The name of Hiroshige is prominent, but he flourished only in the second quarter of the nineteenth century, and his work was instrumental in bringing about change. Initially, colour prints were marked as the medium of the Floating World. Perhaps this was part of what was so 'Edo' about them. The Yoshiwara was celebrated throughout the Japanese states as the *sine qua non* of flamboyant entertainment, the best red-light district by far. Prints were closely linked to its field of entertainment and that meant also to desire; the other arena was kabuki theatre which, again, steamed with the eroticism of its stars. Although the very first colour print batch of calendars for the year 1765 was not related to either prostitution or acting, they were provocative none the less. The arousal of the male viewer was evidently their point, as is clear in Harunobu's calendar showing a woman rushing to gather in her washing during a shower; her skirts pull open to reveal shapely legs, her clog falls off, giving the air of confusion beloved of Edo males, and she is more comely than the average woman employed in such labour. Throughout the remainder of the century, the emphasis continued to be on the litheness and appealing nature of young bodies, whether female or male.

Colour-printed *shunga* appeared immediately. But they were expensive. It was one thing to have a coloured calendar which would function throughout the year; it was another to buy coloured pictures for incidental private pleasure. It might be imagined that those who had experienced colour printing were loath to go back to the more rudimentary forms of semi-colour or hand-tinted pictures (such as *tan-e* or *benizuri-e*), much less black-and-white. But it is incorrect to suppose that Edo suddenly went polychrome across the board. If anything,

as the century drew to a close, the brief flirtation with colour that can be detected immediately after 1765 came to an end as users discovered that the improved results did not justify the greater outlay, or at least not in the case of pornography. Forrer has calculated that of the 31 erotic books (*kōshokubon*) known to have been published between about 1765 and 1771, 23 are in colour, which does indeed suggest an infatuation with the medium. But then from 1772 to 1788 (a span more than twice as long), only 18 colour books were produced out of a total of 86 known.[9]

This trend away from deluxe *shunga* has been obscured by art historians who have been on the ceaseless quest for 'masterpieces', or for innovation and progress, to the occlusion of underlying habits. The return to non-colour may be largely attributable to cost, but it may be that colour prints were too cumbersome or too embarrassingly visible. Older *shunga* were often bound in book format with the design running across the central gutter, so that the whole was fairly small, whereas coloured prints were more commonly sewn together as unfolded sheets. Throughout the Edo period, most illustrated books in all genres were monochrome, and so it is not surprising that *shunga* were too. Is it likely that an average buyer would spend more on erotica than on more erudite titles? Such questions can only be answered on the level of assumption, but what can be said with assurance is that, despite what is often claimed about Edo citizens' spendthrift nature and love of splashy sex, they did not seem to spend a great deal on their pornography, or not on any single item: *collections* might have become costly.

The *shunga* market was not unitary of course, and there are numerous variant cases. Men and women possibly bought different things – not only preferring different images, but also different formats, and in different price brackets. Rich and poor would not consume the same, and it is also possible that older and younger spent differently. But for all, overt pornography came in the form of books, not single-sheet prints. This may have to do with the process of masturbation, wherein the masturbator takes time to pass through a series of images as he or she builds fantasies. Books were also easier to hide and store when not in use and so did not become so dog-eared or torn. They could be placed anonymously in a stack, with the contents unexposed. Most prevalent in shunga books

is the *koban* or 'small block' size, measuring about 23 × 17 cm; this is rarely seen for other sorts of book, which suggests that, although an erotic work might be immediately identified by its shape, even if the cover were closed, it had about it the aura (and also the facts) of secrecy. Ease of hiding does not seem to have been irrelevant to purchasers. There is the *senryū* verse quoted above, 'Pornographic pictures/Stowed each day/In a different place'.[10] This again runs counter to clichés about acceptance of the eroticization of the home environment. Booksellers wrapped works up, exposing a tempting cover to entice, while leaving the contents unknown until the purchase had been made, but also keeping the pictures out of reach of the young and innocent. Wrapping was also a means of segregating politically polemic or satirical stories.

The size of *shunga* books was not static. In fact, it changed remarkably. Forrer has counted at least 50 sizes, far in excess of those used for other types of book, and many indeed peculiar to pornography. There was such constant alteration that it appears deliberate with publishers anxious to give their books a fluid, ever-novel feel, perhaps to compensate for their falling behind technologically in the persistent use of old-fashioned monochrome, and often being very carelessly finished to boot.

Lavish *shunga* made a come-back in the 1780s and 1790s, almost two decades after full-colour printing had begun. Why? Lavishness was seen not only in tonality, but in scale. The 'large block', or *ōban*, was used, which at nearly 40 × 26 cm was virtually twice the dimensions of the *koban*. These are probably the kind of pictures that the modern reader associates with the word *shunga*.

By this time Harunobu was long dead and his pupil Harushige (later Kōkan) was no longer working in the Floating World idiom. But a number of fine artists were producing for an avid market, and this second generation brought colour printing to its highest levels, and perhaps its prices to their (then) all-time low. It is recorded that a coloured work cost about the price of a cheap meal out.[11] Politically this was when Tanuma Okitsugu controlled the shogunal council, under the inept watch of Tokugawa Ieharu. A vast disparity had opened up between rich and poor, with the former enjoying unparalleled affluence and the latter starving in greater numbers than had previously been thought acceptable. This is

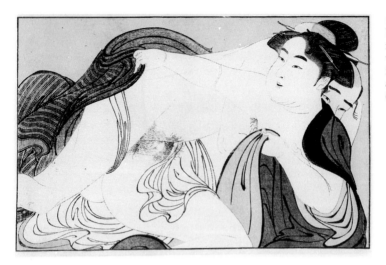

14 Kitagawa Utamaro, *Lovers*, multi-coloured woodblock page from a *shunga* album, *Utamakura* (1788).

not the judgement of the present so much as the constantly-repeated plaint of those alive at the time. This will be more closely considered below, but arrivism was identified as a hallmark of the age. If the newly rich hardly needed prints (they could buy paintings), a host of smaller entrepreneurs might move into the colour-print bracket, and all could upgrade the quality of their ephemera. Floating World painting ('normal' and pornographic) also increased in quantity and quality; the exemplars are Katsukawa Shunshō, his pupil Shunchō, Torii Kiyonaga, Chōbunsai Eishi and of course Kitagawa Utamaro. Still, even in this period, less than half of *shunga* books were coloured. Utamaro's first effort was monochrome and was probably published in 1786, the year of Ieharu's death and the first crumbling of Okitsugu's power, under the title *Erotic Book: Dew on the Chrysanthemum* (*Ehon kiku no tsuyu*). Many erotic books include the term 'erotic book' (*ehon*) in their title, which alerts the buyer and stops mistaken purchases. (We may recall how Samuel Pepys accidentally bought a pornographic work in London in 1668, after being led astray by the title, *Ecole des Filles*; he claimed he had bought the book in all honesty 'for my wife to translate' and was so scandalized that when he had finished reading the work – and, importantly, masturbating while doing so – he burned it.)[12] Inclusion of the term '*ehon*' also removed the useful excuse of mistaken purchase. This was punning though, for *ehon*, if written with the character *e* for 'picture' (not 'sex'), means 'illustrated book'; aurally the two could not

48

be distinguished.[13] Perhaps the finest example of the printed erotica of this period is Utamaro's set of 1788, *The Pillow of Verses* (*Utamakura*), published by Tsuta-ya Jūzaburō as twelve sheets of ōban (illus. 14). Ieharu's successor Ienari was by this time installed as the eleventh shogun. The following year saw the beginning of the Kansei era, with the well-known re-pressions that will be considered below. The appearance of multi-coloured large-block erotica in the Kansei era needs explaining. Utamaro's set is not the only one. For example, Shunchō produced a sensational *Thread of Male and Female Sexual Encounter of the Modern Sort* (*Imayō irokumi no ito*) – also consisting of twelve leaves of ōban in full colour – in 1789. It was perhaps precisely the clamp-down on other forms of pop-ular cultural expression by the post-Okitsugu regime that provoked purchase of surrogate imagery for one-handed reading at home. Semi-secret purchases were the only ones that could still be extravagant, as limits were placed on the number of colours and sizes of book that publishers could issue openly. Frustrations at proscriptions on the brothel world were relieved by a fetishistic attention to sexually-orientated books, and cash that might have keen kept for the classic means of stress relief was available for pornographic purchases instead.

REACTIONS

The above appraisal, I think, goes as far as it is possible to do, given the present state of research. But the baldness of such data cannot furnish a complete picture. To gauge that, we would have to know how many times each book was read, how much it was passed around between readers, what kind of excitement greeted each new publication and each rereading. It is quite possible, for example, that lavishly pro-duced books such as those by Utamaro and Shunchō, which form the basis of the recent boom in *shunga* studies with its agenda to insinuate erotica under the umbrella of 'Japanese art', actually had the least impact, since owners of more expensive works were more likely to keep them carefully for themselves and not show them about too much or risk their getting stained. This would mean that the best *shunga* thus has the least relevance for the study of sexuality.

But even these questions cannot unload the imagery of all

49

its meaning. We need to know not only how *shunga* were enjoyed by those who owned them, but also how those who did not do so kept them at bay. What did the majority think about *shunga*? What would they think if they found some in the possession of a son, daughter, parent, spouse, sibling, colleague or neighbour? So much study nowadays is undertaken by enthusiasts and collectors whose purpose is extenuation and whose judgements laudatory that the situation has become hard to reconstruct. But actually Edo literature is not short on characterizations of the good bourgeois outraged by wastage of time and money in the pleasure quarters. The belief (held by some today) that the Yoshiwara was somehow the natural orbit of Edoite culture would have seemed preposterous to the many sober merchants worried about the impact sex had on their family morals and budgets. Many figures in the shogunal bureaucracy were concerned at the snowball effect that had given prostitution a much greater visibility in Edo than had ever been envisaged when the Yoshiwara had been set up under shogunal licence. Stories that tell of wastrel sons being disinherited by abstemious fathers because of riotous living (which always includes elements of sexual extravagance in the Yoshiwara) are a staple of Edo lore and fiction. Rakes' progresses always end in ruin.

We should not forget either that, if the Yoshiwara had its sophisticating side, it was also a place of crudity and deleteriousness. The youth of Edo are praised today as bastions of refinement and their mutual words of praise, such as *tsū* (fashionable) and *iki* (refined and understated), crop up in most current scholarly writings. But these words arose from the requirement of the few to distance themselves from the many. Brothel areas had an ample numbers of toughs too. The stock character of the boorish yob (*yabo*) up from the country was not the only ugly type on the streets, and in general, the Edoites' love of fighting also had a place in their lore. Fights were not just the outpouring of the energy and ebullience of the townsman class (as one often reads) but could have serious consequences for person and property. Family ties unravelled during the overheating of Okitsugu economics, and controlling youthful behaviour became a matter of concern to the authorities. In 1791 there was the first shogunal attempt to deal with this, in the issuance of a law to combat youth (*wakamono*) delinquency.[14] There is no necessary link between

unmannerliness and the reading of *shunga*, except that critics of the time were sure there was, with the loosening of sexualized culture from its constraints in the designated out-of-town districts and its descent into the cities. It was pictures of the Floating World (cleaned up, cheap and attractive) that brought brothel norms into the streets.

By the end of the eighteenth century, the Tokugawa regime was approaching its third century. There was great unrest. The celebrations for the 150th anniversary of the death of Tokugawa Ieyasu, founder of the regime, were scheduled for 1766, but it was recommended that they be cancelled for fear the citizenry turn them into a mockery through anti-government protests.[15] People drew connections between the various problem areas they detected around them, from bad harvests to government corruption, to youth violence, to family decline. As the eleventh shogun took over, it became clear just how far society had diverged from the founding principles. It would be absurd for the modern historian to isolate a single cause of malaise in a change in the representation of sex. But sex meandered into so many walks of life that there were plenty of Edoites who did see it as a cause, whether or not the critic of today concurs. The dilemma raised by the world of sex, and specifically by the pleasure districts (which formed the pillars of the edifice of sexual myth), was that they encouraged *fashion*. Fashion meant shift and the need to spend to keep abreast with it. The Floating World was the natural enemy of the fixed world. It was by shift that society was taken ever further away from its original structure, as established by the first Tokugawa rulers and their predecessors, and it was by shift that the poor were outpaced and fell into moroseness caused by debt and want, while the rich became extravagant. The pleasure districts had been the places where such flux was tolerated (they were the 'Floating Worlds') as safety valves that enabled greater pressure to be put on normal urban life. Pains had been made to keep the two worlds distinct: the Yoshiwara was a good hour's journey outside Edo. Through pictures, they leaked.

Floating World prints were elaborate in the attention they gave to interior furnishings, personal accessories and dress. They egged on buyers and made the (again cleaned-up) lifestyle of the epicentres of fashion into something visible in any bourgeois context. The pace of change and the dictatorial

force of fashion were not even stable increments, but were said to be increasing. Fashion was growing faster and ever more extreme. Matsudaira Sadanobu was the shogunal counsellor (*rōjū*) from 1787 and became author of the Kansei Reforms; the escalation of fashion was one of his themes. He recorded in his *Words Beneath the Eaves* (*Uge no hitokoto*) the observation that older people dressed more modestly than the young, not because they discarded fashionable clothes with advancing age, but because, in the past, such dress had been the height of fashion:

> If you look at old women in their seventies, you will note how none of them wears silver hairpins or tortoise-shell combs; they only use dark shell or ivory, and their orna-mental pins are just bamboo. But no-one uses such things today and few even restrict themselves to silver [. . .] In clothing and other appurtenances, materials unknown just twenty years ago are now everywhere.[16]

Old fashions had lasted for longer, but when they became passé it was to make way for more expensive fabrics and ornamentation. This is probably what was meant by the *senryū*, 'Utamaro's/Beautiful women stuck on a screen/Grow old'.[17] You could not even display a Floating World print for very long before it had to be replaced with something more up to date.

Ishino Hiromichi, the author of an interesting ramble through matters related to pictures published about 1797, linked change specifically to art. In his *Truth in Pictures* (*Esoragoto*) he wrote that it was the erotica of modern life that promoted shift, for the bald and ribald depictions of sex of the traditional sort (which he called *toba-e*) were remarkably static over centuries. The Yoshiwara made a commodity of sex, turned it into the powerhouse of change, and then used pictures to promote this among the common people.

> There are many pictures of prostitutes, entertainers and actors, and all show them in modern dress; in just five or ten years there has been a monumental shift [. . .] What never change are *toba-e* [. . .] Generation after generation they are passed on identically.[18]

The Kyōho Reforms accepted this division of the field when they banned books that challenged and degraded the stability

of *fūzoku*. The laws made no mention of other sorts of erotic works – *toba-e* for instance – which could still be produced.

SEX AND SOCIETY

The fear that sex might overtake life, and that the erotic behaviour of male and female prostitutes, as depicted in *ukiyo-e*, might infect normal people, had been intermittently expressed throughout the Edo period. The Yoshiwara, initially located near Nihonbashi (the 'Original' or Moto-Yoshiwara), was relocated to beyond Asakusa in 1657, making it considerably further away from Edo proper; the Shimabara in Keishi and the pleasure districts of several other cities were similarly sited. There were various reasons for the (re)locations, such as to safeguard against fire, brothels necessarily needing artificial lighting at night. But the intention was also to keep the women there beyond encounter with the bourgeoisie of the city, to the detriment of the latter's 'manners and customs'. Even when a pleasure district was nearer (and the Shimabara was not far from Keishi, although there was a *cordon sanitaire* of open fields), prostitutes and other workers were not permitted to leave its confines. Nagasaki was the only city where sex-workers were tolerated roaming the city to encounter such ordinary civilians as might be on the streets after dark (which few civil women were). Legitimate intermixing was unique to Nagasaki, and this may be one of the reasons why that place was always said to have evolved the most vulgar and coarsest *fūzoku* – an opinion that was expressed by many, including the topographical researcher Furukawa Koshōken, later employed by Sadanobu for his regional knowledge. (Perhaps unbeknown to Sadanobu, Koshōken was himself a pornographer, working under the pseudonym Kibi Sanjin.) The German physician Engelbert Kaempfer observed at the turn of the seventeenth century that the citizens of Nagasaki were 'the greatest debauchees and the lewdest people in the whole Empire'.[19] Behaviour in Nagasaki was notoriously difficult to control because of the presence there of so many unorthodox entities, not just prostitues but foreigners. It was accepted that spillage across systems of body language would occur.

Non-licensed brothel districts emerged, and women did walk the streets. But in Edo, at least, the extra-legal venues

sensibly stuck to the perimeters of town. These were generically known as the 'other places' (*oka-basho*, originally *hoka-basho*, but Edoites dropped their aitches) and were at Shinagawa, Naitō-Shinjuku and Fukagawa. Later, in 1841, this sequestration of female prostitution was matched with the removal of theatre boys, who were gathered from the homosexual brothels-cum-kabuki fan centres and consolidated in Saruwaka-chō, which was also near Asakusa.

Already during the sixth shogunate, in the early years of the eighteenth century, fears had been expressed by Arai Hakuseki, a close shogunal advisor and Confucian expert. Hakuseki deplored how the manners of Yoshiwara and the theatre and prostitution district of Sakai-chō were permeating the rest of the city, and, although he did not cite pictures (at this time the Floating World medium had not reached its apogee), some kind of reportage must have been responsible, since not everyone went to either locale. Hakuseki's opinion, offered directly to the shogun, Ienobu, was recorded by the scholar Muro Kyūsō:

Arai said: In the time of the Third Shogun [Iemitsu, r. 1623–51] elite customs flourished, and trickled down to those below. But in later ages, the elite's ways deteriorated and the behaviour of the base people gradually worked up. Nowadays, in Edo and elsewhere, you notice that youth hairstyles and clothing patterns are just like those of the lads (*yarō*) in Sakai-chō, while domestic maids look like prostitutes from the Yoshiwara [. . .] Things are improper, vulgar and lewd.[20]

Hakuseki was known to be something of a crier in the wilderness, and his fears do not seem to have reflected the majority thinking. But by the end of the century such claims were routine. Moriyama Takamori was a shogunal retainer much favoured by Sadanobu, and he wrote of the situation in the 1780s,

Combs were painted red with arched tops, and were made very long widthways; little girls were given flower [-shaped] hairpins or ones with flowers fixed onto them. This was done in imitation of trainee prostitutes in the louche quarter called the Yoshiwara.[21]

First the ordinary townspeople succumbed to the vortex of the Floating World, then even the senior ranks fell. Daimyo began to patronize actors and prostitutes, inviting them to their mansions, and mimicked their slick behaviour by learning to play brothel instruments (like the three-stringed *shamisen*) or by singing in the theatrical mode (*kouta*). Takamori told of 'eldest sons of up-standing families' who were now practising such music, and even the shogun's senior retainers (*hatamoto*) were 'following the behaviour of female impersonators or kabuki swells'.[22] Soon, 'that kabuki dregs were so deliriously popular they were copied from house to house, and when night fell, colleagues collected and rushed off'. Class and decency dissolved, 'there was no district from [commoner] Shitamachi to [samurai] Yamanote where any girl with a bit of looks wasn't getting herself up as a geisha and setting about learning the *shamisen*, and scarcely a soul now plays the *biwa*, so as to idle about with cacophonous friends'.[23] Most people only went to the theatre 'in order to have orgies with young men and women'.[24] Then there was Takenouchi Hachirō, son of the governor of Bingo. 'One recoils at the mention of him', thought Takamori, who then cited him at length:

> if he's staying out somewhere and meets a geisha, or if some other dubious little girl flounces past, this Hachirō, who will not, of course, even be wearing his military trousers and other distinctions, sticks his hands in his breast, sidles up in his sleak footwear and greets her as if they were of equal rank and station.

This was not just rumour, for 'when he once saw me while doing this he evinced not one iota of shame, but breezed on, although he ought not to have been able to look me in the face'.[25] Pictures served to keep the mind occupied during moments when duties prevented one meeting Yoshiwara women or Sakai-chō boys in person (although one shogunal officer moved his desk to the Yoshiwara to hold his business meetings there so he need never be without sensualized company).[26]

In 1785, a *hatamoto* demonstrated the extent to which brothel culture had undermined proper norms in the grossest outrage against the order imaginable: he performed double love suicide (*shinjū*) with a prostitute. This convention of mutually assisted suicide was a last resort when social rules

made a satisfactory liaison impossible. It was the stuff of many fine plays and stories and was occasionally undertaken by the desperate throughout the Edo period, although officially banned.[27] It was bad enough when a townsman did it, but the new implication that sex professionals could control the life of a very senior samurai was absolute perversion; by rights, a samurai's life was his lord's, to keep or throw away as only he deemed fit. The event shocked Edo and left a legacy in the writings of Sugita Genpaku, an important physician and compiler of the degradations of the age in a chronicle called *Gleanings in Hindsight* (*Nochimigusa*):

> Goodness knows what overcame him, but he had a love suicide pact with one Ayai, a prostitute from the Obishi-ya brothel in the New Yoshiwara. When the shogunate heard of this, they declared it conduct unbecoming of his rank, and contrary to virtuous behaviour. They had his body exhumed and mutilated. Nothing like it had ever happened before.[28]

Some years later, the then-shogun Ienari himself became infected and, yearning to experience the Yoshiwara, which decorum forbade him to visit, he built the architectural form of a brothel beside the shogunal residence in the Western Enceinte of Edo Castle, complete with the latticed front room in which the women displayed their charms.[29] All thought, 'what a thing for him to augustly delight in, and they raised their eyebrows'.

With such examples being set by the elite, it was small wonder that the lower orders now seemed to be living in a permanent state of sexual excitement, with commensurate obliviousness to higher ideals. Edo was no longer like the Osaka made famous through Ihara Saikaku's stories of the 1680s about the occasional sex-mad man or woman (*kōshoku-otoko/onna*), or even five sex-mad women – as appeared in the titles of his best-selling fiction.[30]

To Genpaku, pictures were indeed the instruments of the spread of evil manners. He went on, 'And we now have things called "laughing pictures" depicting contemporary men and women in the nude and engaged in the most appalling acts, which they display for sale in the public street'.[31]

The shogun Ieharu, who died in 1786, had been a lover of *ukiyo-e* and, although he did not go as far as his successor

Ienari, in retrospect he appeared culpable. He extensively patronized Chōbunsai Eishi, anomalously both a Floating World artist and a samurai of rank (he was the first son of the shogun's minister of finances). Unlike most of the rest, Eishi was able to frequent elite circles and purvey his style in the form of gifts to top people. He had trained in the government academies of the Kano School, of which his teacher had been the most senior master; this was Kano Eisen-in Michinobu, who held a battery of titles and accolades, notably shogunal 'Interior Painter' (the summit of the artistic tree).[32] Eishi ought, many surely felt, to have remained true to Michinobu's uplifting sense of theme. But he went on to produce an unspecified body of work for the shogun, bringing visions of the Yoshiwara, Sakai-chō and other 'floating' locales into the corridors of power. In his persona Eishi blithely fused the academic pedigree onto his new manner, adopting a name that derived from both his Kano and his Floating World teachers, Eisen-in Michinobu and Bunryūsai, combining these into Chōbunsai Eishi.

The lionization of Eishi may be contrasted with the treatment accorded Hanabusa Itchō a century or so earlier. Itchō had trained under the then senior Kano master, Yasunobu, but had suffered expulsion in about 1670 for becoming too involved with trivial styles such as that of the emerging Floating World. In 1698, Itchō was exiled to a distant island for taking two members of the shogunal family (Motoatsu Tadatoshi and Rokkaku Hiroharu, both relations of the fifth shogun Tsunayoshi's powerful mother, Keishō-in) to the Yoshiwara.[33] The charge may have been trumped up, but Itchō was only allowed back in 1709 at the age of nearly sixty. In short, Itchō was expelled from the senior site of official Tokugawa representation (the Kano School) for his engagement with the Floating World, and then from Edo altogether for bringing the shogunate and the Yoshiwara together. Eishi, by contrast, was showered with praise and brought further into the centre of Tokugawa power, being allotted a lodging within Edo Castle itself.

The shogun Ienari went further in even tempting the family of the *shujō* (emperor) to do the same. In 1800 a senior prince-abbot (*monzeki*), Myōhō-in-no-Miya, happened to be in Edo, where he was introduced to a scroll commissioned by the shogun from Eishi.[34] The prince-abbot liked it and was

15 Chōbunsai Eishi, *Life on the River Sumida*, 1828, pair of six-fold screens, ink and colour on paper.

invited to take it back for more leisurely inspection by himself and his seniors in Keishi. He did so, showing it to the retired *shujō*, Toshiko (posthumously, Go-Sakuramachi). The scroll, no longer extant, is described as being 'pictures of the River Sumida'. This seems to be a subject that was popularized by Eishi, and several by him, and by his followers, survive.[35] Not all are identical, but generally they celebrate the journey up the Sumida from the Willow Bridge in Edo to the San'ya Ditch, and then by foot on to the Yoshiwara (such was the usual route of access) (illus. 15). Many end up with the travellers who have been depicted as taking this route relaxing in a brothel (illus. 22). It is less the beauties of the river bank than the rites of movement of the tremulous sybarite as he seeks sexual pleasure that are being shown. Toshiko, famous as a quiet, scholarly type, was also a sober 60 years old at this point and, moreover, was one of the infrequent female *shujō*. Did she really need to see such things? But, far from being shocked, she let it be known she had officially viewed the scroll, thereby permitting Eishi to take the coveted title of *tenran* ('viewed by the court'). This event made its way into the official annals of Edo painting, the *Expanded Record of Old Painting* (*Zōchō koga bikō*), where it is stated in a taut tautology,

> The reason why Eishi used a *tenran* seal was that a prince who was in the East [Edo] saw his picture of the River Sumida, and offered it to the *sentō* [= retired *shujō*], who was impressed by it. On his return to Kyōto the prince made a gift of the River Sumida picture to the *sentō* who thought its beauty without blemish, and who to the last kept it in her storehouse. Thus it was that he used the *tenran* seal.[36]

Encroachment of the Yoshiwara into Edo civic life was a gradual process, but it took a major step in 1771. That year the Yoshiwara burned down, and owners of the devastated houses of entertainment petitioned for temporary accommo-

dation during the rebuilding work. After debate, they were granted a site in Edo, but enclosed by water, the small island of Nakazu, in the Sumida between the bridges of Shin'ohashi and Eitai-bashi.[37] This was the era of Tanuma Okitsugu. Policing was lax and, after reconstruction of the Yoshiwara, the Nakazu district was allowed to remain; it was still there nearly twenty years later.

The profits gleaned from dealing in boys and women outdid earnings from many more regular businesses, a fact that was soon realized by the Edo townspeople presented with such enterprises operating virtually on their doorsteps. There were those who reacted by diverting their acumen towards these industries. In Genpaku's words,

> Recently, the trend has been on the increase, with erection of make-shift brothels called 'hells' on new ground round the back of normal people's houses and sometimes quite near to important residences. Men rent out their own daughters, and on days when customers are many they even rent out their wives.[38]

It was not only depravity: it was apocalypse. The rule of Okitsugu came to a calamitous end in a string of bad harvests with attendant misery for the people, projected onto a cosmic scale by a collapse of the stable order of life in tidal wave, earthquake and volcanic eruption. The 1780s was a time of unparalleled geological instability, which, according to the prevailing thought processes, was attributable to the inadequacy of the rulers' maintenance of the protocols of *fūzoku*. *Shunga* was part of the deluge, as a whole cultural system seemed to be coming to an end.

A vignette of the extent to which social ritual had been suborned by sex was recorded by Matsura Seizan, daimyo of Hirado: instead of people exchanging the established pictorial greetings at New Year, with auspicious imagery of cranes, pines, bamboo etc., they were decorating cards with pornography.[39] Another instance was the daimyo of Matsue who took to holding tea ceremonies in the nude.[40]

REFORM

Okitsugu, lax though he might have been, was more a symptom than a cause of the disasters visited on the period.

Matsudaira Sadanobu, though, personally began a process of villainization of him shortly after himself being selected as head of the shogunal council, and this continues to colour historical writing. Sadanobu's Kansei Reforms were as much aimed at the rectification of *fūzoku* as the economic restructuring for which they are famous, and their objective was the removal of the whole culture of the preceding period. Everyone thought it a good thing that Ieharu died childless, allowing a new start, and if Okitsugu initially thought he could control the incoming Ienari (still a child), he was soon no longer in a position to do so. Even if not an improvement in the long run, there was initial enthusiasm for the new Ienari and Genpaku, for one, was delighted enough to terminate his ledger of acrimony with a paean to the new regime, which had reformed manners in just three months.[41] Sadanobu for his part wrote that,

> Manners and customs are not loud and showy any more and people like what is pure. They have improved to an excellent degree. Women dislike sashes and other items made with flamboyant imported gold thread. They just go about wearing light silk, not showy, but simple [...] Just ten years ago people were paying vast sums for hairpins of the greatest intricacy, and a single one sold for significant sums. They were banned by law, and now are scarcely to be seen.[42]

Takamori of course followed suit:

> Society at large was subject to immediate change and those guilty of vice and error and suspicious behaviour were expelled, while profligate youth, among whom you could scarcely tell a samurai from a townsman, who up to the day before had known only riot and feebleness of mind, realized what they were up against and shortened their clothes and donned more modest attire, changing their style. The sight of them going about with looks of high dudgeon, all those who had never previously given a thought to education or the fine and martial arts, was enough to send me into hysterics.[43]

Expensive fabric smacked of luxury and so of prostitution. In 1788, Sadanobu had outlined in a treatise on government that 'the correction of manners and customs is the first obligation

of rulers' and this depended on 'keeping luxury in check'.[44] The words were intended both as an indictment of the old administration and as a statement of his aims. In the summer of the next year, 1789, Sadanobu sent workers to dig up Nakazu. The entertainers of various ilks moved back to the Yoshiwara. This was no doubt greeted with regret by those who frequented Nakazu and liked its convenience (which was the whole problem), and it had offered a wide range of diversions beyond sexual frissons, such as fireworks, sideshows, food and exhibitions of rarities. But customers were now once again obliged to travel up the Sumida. It was from about this time that Eishi began his paintings of the route.

An anonymous poem in the 'mad-verse' (kyōka) genre captured the purging and dulling down of Nakazu in a clever sequence of words and onomatopoeas that transform themselves from the merry to the glum:

> From covered vessels and floating restaurants
> To government boats.
> No more chink-chink-chink,
> Only chug-chug-chug.[45]

The ostensible reason for abolition was to ease contra-currents in the river, but it was clear what really lay behind the move. Earth from the obliterated island was used for the unexciting purpose of building flood barriers at Honjo and Fukagawa.

Demolition of Edo's city-centre emporium of fun was prefigured the previous year in Keishi, where Sadanobu's policies had also taken their toll on commercialized sex. Sadanobu had made a trip there, and, shocked by conditions, had ordered the clearing away of all prostitutes from the streets and their forcible relocation back into the Shimabara. He was proud of this purifying and noted in his journal that in no more than two days 'one thousand, I don't know how many many hundred persons' had been rounded up.[46] I have discussed Sadanobu's attitudes to Keishi elsewhere, but it is worth repeating his objection: people came to see the historic sights, but within two or three days, all the money they brought with them from the country had fallen into the hands of the managers of brothels.[47]

Sadanobu did not have much need for sex and counselled others against indulgence.[48] He did not want it dominating

61

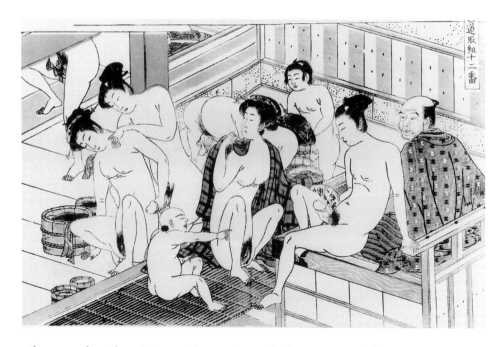

other people either. He went beyond regulating commercial sex and introduced legislation to keep men and women apart in other contexts where the libido might be easily aroused. Public bathing had always been mixed and was something of an urban ritual, but he enforced separation from the first month of 1791.[49] Every person over six years old (by the inclusive Edo count – in other words, over four or five) could thereafter bathe only in the presence of their own sex. If a bathhouse had only one tub, men and women had to enter it on alternate days, or else the owner might petition the shogunate for funds to build a second (women's) tub. The old erotic and often downright sexual culture of the bath was celebrated in stories and verses and was a common setting for *shunga*. One example is a picture of *c*. 1775 by another samurai-turned-Floating World artist, Isoda Koryūsai (illus. 16). The third volume of the famous *senryū* anthology *The Safflower* (*Suetsumuhana*), published in the year of Sadanobu's ban, included an earlier poem wistfully evoking the touchy-feely bath that had become a thing of the past:

> People from the land of the long-arms
> And the long-legs find their way into
> The public bath.[50]

16 Isoda Koryūsai, *Public Bathhouse*, multi-coloured woodblock page from the *shunga* album, *Shikidō torikumi jūni awase* (*c*. 1775).

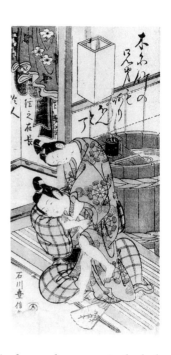

17 Ishikawa Toyonobu, *Wooden Bathtub,*
c. 1760, three-tone woodblock print.

The countries of these two mythical peoples were included
on Edo-period maps. Shikitei Sanba's famous novel, *The Bath-*
house of the Floating World (*Ukiyo-buro*), published in instal-
ments from 1809 to 1813, is divided into two sections, one
taking place in the Men's Bath, and one in the Women's; this is
entirely a product of Sadanobu's division. Sadanobu was so
successful in creating a sense of prudishness that, when Edoites
went to Keishi (where bathing remained unsegregated), they
found it disgusting.[51] The separation of bathing led conversely
to prying, as another *senryū* attests:

> The screens at
> The women's bath
> Riddled with holes.[52]

By virtue of the prohibition, the erotic power of bathing
might actually have increased. An image by Utagawa
Toyokuni shows a situation that Sadanobu would have been
unlikely to find preferable to that depicted by Koryūsai (illus.
23). The homoeroticism of the bath – never absent and often
depicted, as in Ishikawa Toyonobu's early print – was probably
heightened (illus. 17).[53]

Seeing the opposite sex naked was no longer routine,
which made access to it a special and forbidden act, and hence

one striven for and fetishized. Erotic pictures showing intrusive gazes at women bathing alone at home, or at Yoshiwara women taking baths in their own quarters, had existed before. But this multiplies as a Floating World construction after 1791, as women in water became something that few men any longer saw (illus. 21).

Sadanobu's policies for Edo may have been modelled on what was already the situation in other cities. Keishi was under shogunal control, but the daimyo of Kaga had organized his capital of Kanazawa quite differently. This was one of the finest cities, famous for its palaces and gardens. It had no public baths at all (each family heated their water in a tub at home), no official red-light district (although there were illegal *oka-basho*), nor any kabuki theatres supplying boys.[54] Sadanobu would have been aware that the situation he had inherited in Edo and Keishi was not the only possible way to order a polity.

Sadanobu knew the situation much further away than Kanazawa. In 1793 a castaway by the name of Daikoku-ya Kōdayū, together with another survivor, returned from St Petersburg, where they had spent several years, and almost a decade altogether in the Russias, after shipwreck and rescue by one of Catherine the Great's ships. Kōdayū was interrogated by shogunal officers, and the record was written up into a gripping account by a scholar of European matters who was also Ienari's private physician, Katsuragawa Hoshū. The book reported at length on the state of affairs in the Russian empire and dealt, among many other things, with city organization, including prostitution. Kōdayū claimed (wrongly in fact) that while prostitution did exist, it was not allowed to destroy family life because married men could not go.[55] About the same time, the botanist and scholar Satō Narihiro, who spent many years researching in Kyūshū, wrote that he had been informed by the head of the Dutch East India Company legation in Nagasaki that he never went to brothels, but, if he were inclined to, he would first consult his wife about it.[56] Narihiro was impressed by this, not least because the Dutchman was 'a goodlooking fellow and not yet twenty'.

18 Utagawa Kunimaro, *Nun using a Portrait of Matsumoto Kōshirō* (?), multi-coloured woodblock page from a *shunga* album, *Ikurasemu* (*c.* 1830s).

19 Torii Kiyomitsu I, *Segawa Kikunojō II in the Role of Minor Captain Keshōzaka*, 1763, colour woodblock print.

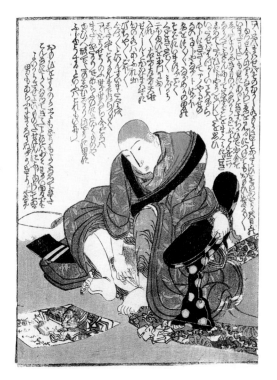

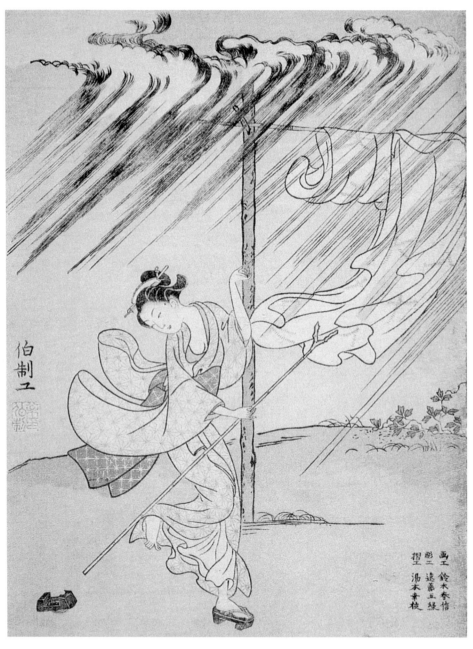

20 Suzuki Harunobu, *Woman Bringing in Washing During a Shower*, 1765,
calendar, multi-coloured woodblock print.

21 Tamagawa Senshū, *Woman Washing*, c. 1795, multi-coloured woodblock print.

22 Chōbunsai Eishi, *Three of the Seven Lucky Gods at a Yoshiwara Brothel*, late 18th century, section of a hand-scroll, *Lucky Gods Travel to the Yoshiwara*, colour on silk.

23 Utagawa Toyokuni I, *At the Women's Bath*, triptych, three-tone woodblock page from Karasutei Enba II, *Ōyo kari no koe* (1822).

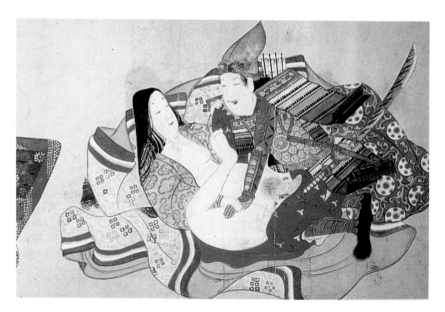

24 Anon., *Mediaeval Lovers*, *c.* 1600, section of an untitled *shunga* handscroll, colour on paper.

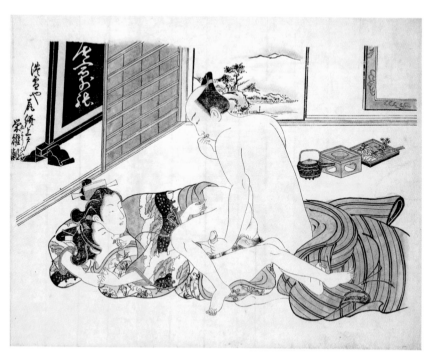

25 Attrib. Okumura Masanobu, *Sexual Threesome*, *c.* 1740s, section of three-tone woodblock printed handscroll, *Neya no hinagata*.

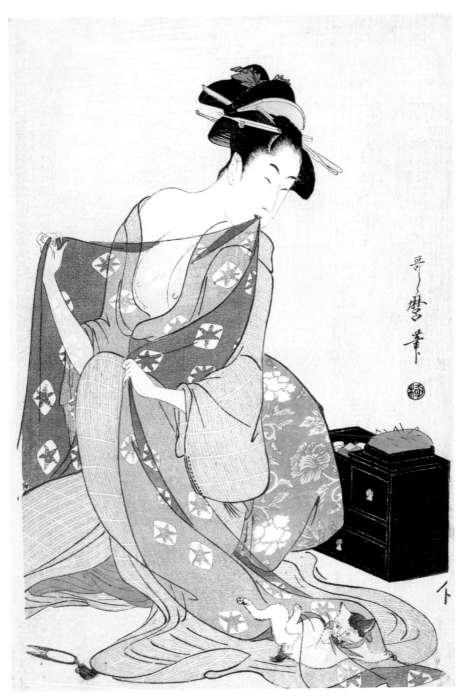

26 Kitagawa Utamaro, *Needlework*, *c.* 1797–8, multi-coloured woodblock.

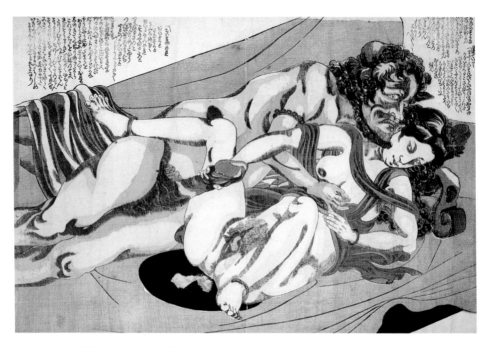

27 Yanagawa Shigenobu, *Foreign Couple, Rendered in Imitation of Copperplate*, multi-coloured woodblock page from a *shunga* album, *Yanagi no arashi* (1822).

28 Sakai Tadanao (Toryō, or Sakai Hōitsu), *Courtesan with Attendants*, late 1780s, colour on silk.

DEALING WITH *SHUNGA*

Matsudaira Sadanobu was a lover of painting. He may have had some tastes in common with the shogun Ienari, but his attitude towards the art of the Floating World was diametrically opposed. The shogun took Eishi out of the Kano School and encouraged him in his study of the eroticized style, whereas Sadanobu set himself to do the reverse and move the better sort of samurai Floating World figure in the other direction, towards official styles. In general, Sadanobu had no truck with public samurai engagement in the popular manners. Sakai Tadanao, for example, was a very senior samurai on account of his brother Tadazane being the daimyo of Himeji. In the 1780s, then in his mid-twenties, he became

a painter of the Floating World, in which context he used the name Toryō, and as part of the package he frequented the pleasure districts. He became highly accomplished at the depiction of Yoshiwara women (illus. 28). Shortly after Sadanobu came to power, Tadanao moved away from the Floating World style and into the classical manner of the Sōtatsu–Kōrin School stemming from the esteemed Tawaraya Sōtatsu in the 1610s, whose special feature was said to be that he never painted degraded modern *fūzoku* themes and restricted himself to depictions of the past.[57] After 1798, Tadanao changed his studio name from Toryō to Hōitsu and shed his old persona; although he still occasionally made a Floating World work for his own amusement, he largely dispensed with the idiom, working in the Sōtatsu–Kōrin mode and devising a hybrid style with which to render Buddhist icons.

The extent of Sadanobu's personal role in Hōitsu's conversion is uncertain, but a clear case of the squeezing of Floating World artists under Sadanobu is to be found in the life of Kitao Masayoshi (illus. 29). Born in Edo in 1764, Masayoshi had trained under the prolific colour-print master Kitao Shigemasa. Shigemasa was also an important illustrator of books, including *shunga* books, and has some twenty titles to his name.[58] Unlike Shigemasa (who was a townsman), Masayoshi was of samurai stock on his mother's side and in 1794 he was suddenly appointed painter-in-attendance on the daimyo of Tsuyama. Three years later he was sent to study with Eisen-in Michinobu's son and successor, now the leading painter of the Kano School, Yōsen-in Korenobu. This odd transformation required a cessation of all work in the Floating World style and a rapid adoption of academy manners. It cannot be coincidental that the daimyo of Tsuyama was a relation of Sadanobu, whose notion it clearly was to reform the able but (to Sadanobu's mind) misemployed artist. Under Korenobu, Masayoshi was given a new name, Kuwagata Keisai, 'Kuwagata' being his lapsed maternal samurai surname. One of his first commissions under this new name was to paint a scroll for Sadanobu himself, about as serious-minded a commission as could be imagined, as it was a representation of the legends associated with the foundation of the shogunal mausoleum in which Ieyasu was enshrined as a god.[59] Later Keisai became famous for his teach-yourself art books, through which anyone could take their first steps in

29 Kitao Masayoshi (Kuwagata Keisai), *Two Women with a Man*, 1780s, multi-coloured woodblock print.

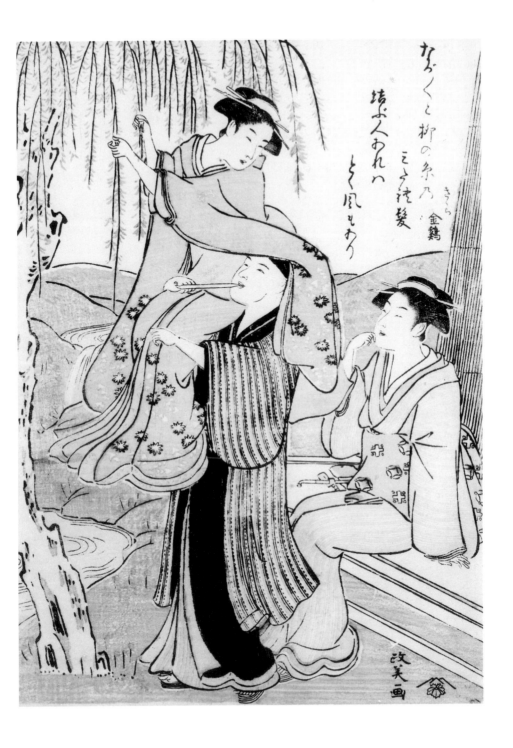

なぎくと柳の糸乃 <ruby>金鶏<rt>きんけい</rt></ruby>

三ヶ津徳髪

琉ぶ人あれハ

とく風もあり

改美画

orthodox painting, and also for his introduction of the panoramic view.[60]

Late in life, after retirement and the collapse of many of his hated policies, Sadanobu gathered in his Edo villa a group of the artists and writers he had in one way or another persecuted for their Floating World involvements and had them produce a collective work for him. Masayoshi, recycled as Keisai, was to make the pictures. Three accompanying portions of text were undertaken. One was by Santō Kyōden, a Yoshiwara addict who had redeemed a prostitute by making her his formal wife and who had also been an erstwhile fellow-pupil of Masayoshi under Shigemasa (and as such had illustrated eleven *shunga* books). Interestingly, Kyōden's brother was also the first biographer of Itchō. The other blocks of text were by Hōseidō Kisanji, who had lampooned the Kansei Reforms in several popular novels and who had written the prefaces to the annual Yoshiwara sex prospectus (*Yoshiwara saiken*) until he was stopped in 1790, and Ōta Nanpo, who had done much to enliven the 'mad-verse' genre and whose most-quoted poem in that genre was a pillory of Sadanobu.[61] The theme of the handscrolls was *Workers at their Trades*: it is a painting about industriousness. The reader winds through three scrolls of decent people at their work and, although there is plenty of humour, with Edo depicted as a lively place, the imagery attests to the fact that it is by productive labour, each in his or her allotted task, that society thrives. In setting these particular men this commission, Sadanobu was clearly bent on making the punishment fit the crime.

The final scenes are set in the Yoshiwara (illus. 30). Sadanobu was no fool, and he understood the need for relaxation and even, when absolutely necessary, for sex (in others if not himself), so long as recreation took its rightful place – last in the sequence of priorities. He was interested in Yoshiwara memorabilia and, having brought the quarter under control, he encouraged the shogunal official Nakamura Butsuan to chronicle its (terminated) glories; Butsuan bought timbers of the old Yoshiwara gate (burned in 1824) and fashioned them into a lantern.[62] The last scenes of the scroll evince an ambivalence, and perhaps Masayoshi/Keisai and Kyōden (who wrote the text for this section) had the last laugh. The penultimate scene is the main street of the Yoshiwara, with women waiting for customers; this moves into the final scene,

30 Kuwagata Keisai
(Kitao Masayoshi),
*A Brothel in the
Yoshiwara*, 1822,
detail from a
collaborative
handscroll *Edo
shokunin-zukushi*,
colour on paper.

where men begin dalliance, but over the distancing technique
of a bridge. The first person seen in the last scene has eyes
covered; the *shamisen* player sits across the doorway, half in
and half out, and indeed, everyone exists in positions athwart
the normal division of space, standing or sitting on the breaks
between the *tatami* mats (which was not the way one properly
sat). The leading guest stares out at the viewer, interroga-
tively, as if daring a challenge to be made. Behind him, a scene
of agricultural work – scarcely an image likely to adorn an
actual brothel – counterposes this painted room with sites of
real production. The picture self-consciously jars, although
Sadanobu would hardly have wished it this way. From the
blindfolded man on the right to this figure on the left, the
viewer traverses a line from non-seeing to seeing. But what do
we see? That this is all folly? Kyōden signed off with the
following ambivalent statement: 'For me to do so is like
adding unnecessary syllables on the end of a line of verse, but
since we have now come to the close of this scroll, let me burst
forth in sounds of joy'.[63] The Yoshiwara was supposedly
superfluous (*jiamari*) to good Edo life.

Again, it was Matsura Seizan who some years later hinted
at the actual purpose of this famous scroll in his journal:

In the extensive painting collection of the Lord of
Shirakawa [Sadanobu] is a picture scroll with text, in three

parts, of workmen at their trades. It is unlike the traditional sort of work in that genre because it shows them all in modern guise.[64]

The mistrust of the arts of the Floating World, and of *shunga*, was based less on the belief that they were bad in themselves than that they had coerced too much into their purview. They had not only corrupted 'manners and customs' but had usurped the panoply of representations of modern life and the means of depicting the present. There was no way to paint contemporary situations other than via the Floating World. Old-style genre painting that showed the yearly round in a non-erotic, placid way had been smothered, and good '*fūzoku* pictures' (from which the Floating World manners are said to have emerged) had succumbed. *Fūzoku* pictures had the important role of preserving the appearance of rituals for the future and, though Sōtatsu might have refused to make any, they were important referents against which change could be rectified and decline reversed. There is an enormous body of such pictures, showing, for instance, what cities looked like, how festivals were conducted, how farms were manned and how leisure was decently enjoyed. Floating World art swamped this under a layer of libido, and to view it was to gain the impression that no one in Edo did more than engage in, or prepare for, sex. Sadanobu was disturbed. If future ages looked back at the time of his rule through the lens of such mis(representations), he would be a laughing stock in history. He called for a revision of *fūzoku* pictures, which he boldly called 'pictures of now' (*imaga*) which would be strong enough to claw back what the Floating World style had arrogated:

> There is a mistaken opinion that the only way to make depictions of contemporary themes (*imaga*) is in the Floating World manner [. . .] When painting things of modern life, such as pleasure boating on the Sumida, or the Plum Mansion in spring, artists do them in the vulgarity of the Floating World way. Even when they mount them as full hanging scrolls, their painting will be slap-dash. And is it right to select these activities as illustrations for future ages of the kind of *fūzoku* we loved?[65]

Sadanobu concluded that 'the true purpose of picture making has dwindled to nothing' and issued the chilling warning,

'pictures of the Floating World may be all we leave to p
ity to inform about how our society was'. The horror c
generations looking at such works – or even *shunga* – and
thinking that was how Edoites really lived! And yet here at
the turn of the twentieth century, that is just what many
people are doing.

Intellectuals were fearful of the consequences of nurturing
a new generation on libidinous imagery and of letting
them grow up to think such behaviour was normal. Far from
erotica having any educational role, it was an obstacle to the
teaching of proper moral messages. Or so thought Moriyama
Takamori, who put succinctly what many people must have
felt:

> Now we have works of eroticized popular fiction (*kusa-
> zōshi*). But in the past, real truths were made into pictures
> and children were taught by them – there were the lives of
> Kusunoki and Yoshitsune, tales like Princess Pot-head, Old
> Man Withered-Branch who Brought Forth Flowers, the
> Battle of the Apes and Crabs, and Kinbei, and so on. None
> lost touch with the primary principle of encouraging virtue
> and chastising vice. Now we have nothing left to offer
> correctives with. Children are given things they can't deal
> with and which should be kept for adult amusement only.[66]

Erotica were prematurely sexualizing children and was bring-
ing the Japanese states, as cultural entities, to the brink.

THE PROBLEM OF MANHOOD

Of considerable importance in the eighteenth-century debate
about sexual behaviour was the issue of changes in masculin-
ity. Femininity had been seen as inherently more fluid (it was
yin, moist, liquid), as was apparently proven by the more
rapid mutability of women's minds and thoughts. The male
was dubbed resolute and firm. It began to be observed that
men were no longer static. This period is regularly celebrated
in history books as the 'rise of the townsman', but in its own
day it was more commonly expressed in reverse: as the time
of sclerosis and enfeeblement of the Tokugawa ruling class.
Samurai were not what they had been. Eishi, Koryūsai,
Nanpo, Kisanji and others were all samurai. A samurai was a
swordsman, and until the end of the Edo period his badge of

office was two swords thrust into the sash. But could such men fight? Many samurai could barely ride a horse. Ieharu's own son and intended successor, Iemoto, died in a trivial fall from a horse which a competent equestrian could have avoided, for the second time in the century terminating direct Tokugawa father-to-son succession (hence Ienari's installation).[67]

Decline in what might be called 'samurai values' was visible everywhere to those who wished to find it. Symptomatic was the shogunal retainer's double love suicide mentioned above: in the old days, it would have been death in battle or at worst codified *seppuku* ('harakiri'), performed to expunge shame. But now a senior samurai could sneak off by night for an ignoble death with a prostitute.

We are talking mythologies. The belief that samurai ever fought to the death does not survive investigation, nor the claim that they made the sacrifice of disembowelment when atonement was required. The motto 'the way of the samurai is death' was invented long after death had ceased to be on most samurai minds or a reality in their lives and, indeed, the phrase appears in the eighteenth century, precisely when the samurai as an effective military caste had ceased to be. They were bureaucrats. Relevant here is the fact that, at this time, dilemmas about masculinity began to be expressed, and these locked into discussions of erotic behaviour and erotica.[68]

Seppuku itself had died out as a means of suicide because it hurt too much: samurai were afraid.[69] Suicide actually took the form of a pretended stab carried out with a wooden sword, or even a paper fan, at which signal an assistant would sever the head from behind, cleanly and painlessly. So much for 'Japanese *bushidō*'. But the romanticized view of the past took hold as a stick with which to beat the present. Many thinkers held that vigour among Japanese men was dying out, and this was seen as part of a sexual and gender transformation for which modern trends (such as the culture of luxury and 'floating') were responsible. The samurai physician Tachibana Nankei wrote in about 1800,

> The Japanese warrior thinks always of the fact that in time of urgency he must go down before his lord's horse and die; his mind is unswayed from the absolute hope of giving his life for his lord. He concentrates on overcoming the

enemy and prays for the endurance of the state, urging his lord along the path of righteousness. He acts from a pure and true love of his master. Just imagine our modern Confucianists and literary types having a good old laugh at that! The Japanese warrior, they would say, is a fool who delights in a dog's death, unaware of the real meaning of loyalty.[70]

Talk of heroism at this late stage provoked ridicule. Men were embarrassed by the virility of previous ages. The urbanization of the samurai (they were required to live at their lord's castle and did not own land) resulted in a sedentary life and – woefully to many – closer contact with women and an equivalently cosseted lifestyle. Feminization of taste was said to have ensued. Some daimyo considered the option of returning samurai to the countryside, and a couple of daimyo enacted laws to this effect in the 1780s.[71] Urbanization was the cause of lethargy in many analyses, and the terms of objection were that men were becoming womanish. The well-named treatise, *Medicine for the Lands* (*Kokui-ron*), of 1793 stated,

> Urban people like only the fulsome and wicked pleasures [associated with] floating and cherry-blossom. This is gradually spreading to country gentlemen. As a consequence, loyalty and righteousness are thinning out of their own accord and literature ousts the martial arts.[72]

And again, 'If a provincial samurai with his fine old ways comes to Edo, within two or three years he will have been totally turned around in all his manners and will have become trivial and lax'.[73]

To Sadanobu it was clear that urban effeteness was the cause of decline. He came across a napkin belonging to Hideyoshi, the great warlord of the immediately pre-Tokugawa period, and he noted how plain it seemed by modern standards:

> It is just a half-sheet of thin paper, folded in four, with a few toothpicks inside. This is how people used to be. Even one who brandished his strength before barbarians, made the country rich, and even acquired a reputation for enjoying the good life was like this then. Nowadays, common people would hardly accept a napkin like that.[74]

Note that this comment appears not in a diary but in Sadanobu's treatise on government. A sense of enfeeblement was not the subjective opinion of a few malcontents, for medical discourse propped it up as fact. Tachibana Nankei, we must remember, was a doctor, and one given to experimentation in the field and to the emerging science of anatomy.[75] Sadanobu believed the medical men and wrote in his journal that pill and cordial consumption was on the rise, because 'modern people are weak and feeble, develop headaches over nothing at all and suffer from nervous sensitivity, sending them racing immediately for medicines'.[76] This was medically proven:

> Many different treatments were established in the past to suit varying constitutions. There were different sorts of cure, some just mild solutions in water [. . .] Doctors who still use the old methods work according to former standards, but the ancients were born with a quite different order of physical strength from us today.

The process of weakening brought the male closer to the female, for enfeeblement meant an ascendance of *yin* over *yang*. Yamamoto Tsunemoto, an early romanticist and issuer of samurai jeremiads, in his massive compilation of 1716, *Hidden by Leaves* (*Hagakure*), cited a physician who said,

> In medicine, cures are dispensed differently for men and women because they have to accord with levels of yin and yang [. . .] But I became aware of something when treating eye complaints, namely men now respond to medicines intended for a women, while those properly prescribed for men have no effect. This indicates the collapse of order as we know it. In my opinion, masculinity is disappearing as men assimilate into women. Although my data was irrefutable, I kept it to myself. But just look at modern men – many quite palpably have female pulses, and few are what I would call a real male.[77]

Even young men were no longer men.

Possibly this changed the way sex was performed. At least, it changed the way *shunga* depicted sexual acts, for gender shift affected what viewers wanted their pornography to look like. Early *shunga* tended to show adult males engaging in

fleeting encounters, during which they would not even remove their armour, so hot was their attention to the clamour of battle (illus. 24). The pictures gave a sense of the continual presence of fighting in the male mind and the priority of the battlefield with its all-male solidarity. Tales of samurai who forsook women altogether and contented themselves with intercourse with other warriors or page boys, so that they did not need to leave the encampment, were also rife. Images made to capture those times continued to be made into the early days of the eighteenth century, but then they disappear. Later depictions of samurai or sword-wearing townsmen show them with military hardware removed and the blade placed beside the bed; often clothes are taken off too, so that comfort during sex is now the main desideratum (see illus. 45). Bodies mingle indistinguishably.

We will consider the imagery of the sword more fully in Chapter Four, but we may note here that swords were banned in the Yoshiwara. Samurai who went there deposited their two blades somewhere along the way, usually at the boat-house of the operator who had poled them up the Sumida. The pleasure quarter was a zone in which, as it were, the samurai as a category was visually annulled or rather, by losing his sword, he was subsumed into the merchant. In the Yoshiwara, everyone looked non-military. In a humorous book of 1771, *Modern Inconsistencies* (*Tōsei anabanashi*), the author, Sharakusai, wrote of how the route up the Sumida to the Yoshiwara was a kind of path of deheroization of the masculine: 'men turn into women and take the label "female impersonators" (*o-yama*), [samurai] consign their swords at a boathouse and become townsmen, monks transform into doctors'.[78] He means youth donned showily exaggerated clothes, older samurai checked in their weapons to mingle unnoticed with townsmen, and clerics who were banned from areas of female prostitution borrowed doctoral robes (both groups shaved their heads) for disguise. Proper men were eclipsed from view. Sharakusai likened these changes to a butterfly emerging from the chrysalis: the result is prettier, but the armoured outer protection has been shed and, once hatched, butterflies have a short time to live. Women were unaffected, but men were slipping into a *yin* mode.

We must treat the statements made by contemporaries with caution, but we must also respect their sense of peril. When-

ever people write about the fields of aspiration and desire, they are apt to fabricate, to twist the facts to suit their purposes. An interesting feature of pre-Tokugawa sexuality, often mentioned in later Edo writings, was the prevalence of homoeroticism, called, as we have seen, *nanshoku*. Personalities such as Oda Nobunaga's boy lover Mori Ranmaru were widely known throughout the Edo period; they appeared in pictures and plays, and stories were told about them.[79] Males having sex only with other males might be a means of retaining *yang*, and that is how it was often proposed, with Tsunemoto arguing for *nanshoku* on these grounds. *Nanshoku* pertained to the battlefield, where women had no place and where boys had to be instructed in survival and killing. The influential Confucian scholar and *nanshoku* enthusiast Ōta Kinjo wrote in 1827 of the strongman days of the sixteenth century, when *nanshoku* was part of a dynastic system:

> In the times of civil war, *nanshoku* was extensively practised and many was the valiant warrior who emerged from the ranks of the pretty boys (*randō*). A good example is Naoe Kanetsugu, who became governor of Yamashiro. When he was still called Kasuga Gengorō, he was lover (*kozō*) of Kagekatsu (later he was adopted by Chōshin Naoe of Yamato). By brilliant strategy he secured victory after taking on generals Date Masamune and Mogami Yoshimitsu as adversaries at the great battle of the entry to Fuku Island. Kagekatsu then withdrew to the mountains to live in peace, handing on his standards to Kanetsugu.[80]

Kinjō then listed those heroic fighters who 'had an attendant noted for his looks', including the second shogun, Hidetsugu, who had Fuwa Mansaku. As warfare came to an end, this tradition also dwindled, and instead of sex with boys being a way of avoiding the debilitation of women and of training future heroes, it began to be presented as a way of males avoiding any masculine role at all. Boy prostitutes of the Edo period commonly dressed as girls, as Ranmaru for all his youthful cuteness certainly had not. Since boy prostitutes were often associated with actors, whose stage lives required cross-dressing (kabuki has no actresses), the charge was easy to lay. Saikaku noted at the close of his *Great Mirror of Nanshoku* (*Nanshoku ōkagami*) of 1687 that whereas his chosen form of sexual activity had once been something for tough

men to do, precisely to keep them tough, it was now the domain of the weak:

> In the past the 'way of boys' meant something strong and rugged. They spoke bluntly and preferred boys who were forcefully built, and acquired wounds in the course of things. This was the way it was done, until even actor-prostitutes slung swords, even if they did not have occasion to use them. Now, you won't even see any blood when they manhandle the portable shrines at the Sannō Festival! This is a time when samurai have no use for armour, and don't expect to find anyone drawing a blade in a brothel – they even have their watermelon sliced for them before being served up on the plate. Boys today are just plain ponces (*yowa-yowa*).[81]

As a Kamigata writer, it is possible that Saikaku composed this book to make inroads into the military world of Edo, where the samurai presence was more visible than in Osaka. It may just have worked in 1687. By a century later, *nanshoku* had been transformed. Kinjō argued that it had literally declined in numerical terms and that it had become quite hard to find a decent rent boy.[82] One source from 1833 calculated that, compared with the 1750s, the number of *nanshoku* prostitutes in Edo was down by 90 per cent.[83] Others saw rather a movement of *nanshoku* out of the orbit of war and into the softer ones of normal mercantile life or the homosocial world of monasteries. Saikaku had carefully structured his *Great Mirror* in two parts, first on warriors, the second on kabuki actors.

It would truly have been hard to argue that the male brothels of Yushima, Fukiya-chō or Yoshichō were the breeding grounds for heroism. Encounters there were based on money, not loyalty. There were atavistic exceptions, such as that described in a *senryū* of 1761 telling of clients who hired boys to dress up as Minamoto no Yoshitsune ('the noble child minister') while they slept together:

> On Yoshichō's paper screens
> Is cast the shape of
> The noble child minister.[84]

This was a clever choice since the twelfth-century Yoshitsune was not only a general and brother of the first shogun,

Yoritomo, but also a beautiful youth. He functioned as a sex symbol, a kind of generic Ranmaru, for much of subsequent Japanese history.[85] At least some clients liked to recapture the idea of the hero-in-waiting type. But by and large, if it is true to say that the Yoshiwara fed on a classical mythology of antique femininity (names and terms from the *Tale of Genji* were much used), the *nanshoku* districts did not feed on an equivalent folklore of medieval masculinity. Indeed, boy prostitutes were said to be best if they came from the Kamigata, since that way they smacked less strongly of the inherent virility of the 'eastern male' (*azuma otoko*), supposedly defining those bred in the Edo region; Saikaku was appalled that boy prostitutes had taken to using girls' names extracted from *Genji*.[86] In *shunga* this femininity of boy partners is exaggerated, with swords stripped off (i.e. these are not samurai youths) and the boy's genitals covered or shown so small as to be unobtrusive; often anal penetration is the only proof (although not conclusive, since male–female anal intercourse was practised) as to whether a male or female body is being shown. Of course, in pornography a viewer is unlikely to want genuine uncertainty about gender, since his or her own imagination will be inclining to one or the other option (or to a two-gender threesome, but there too the roles will be clear). What was wanted was boys who looked like girls. Portraits of boys attribute to them enough of the feminine, without confusion.

The story of the decline of *nanshoku* was part of the story of the rise of the Yoshiwara. I say 'story', for these are the theories of the people of the period and do not fit with our modern interpretations of gender balance. Queer theory would strongly resist interpretations like that of Kinjō, arguing rather that sexual orientation is something in-born and, although subject to discipline via social codes, cannot be eradicated by them. Modern scholars have wished to terminate talk of *nanshoku* prematurely as a way of clearing space for the modern Japanese nation state, with its typically nineteenth-century compulsory regime of heterosexuality.[87] There were also voices stating that the Yoshiwara was no longer what it had once been.[88]

A new image was needed for boys, to encourage forceful and strategic thinking. The practice of celebrating the Boys' Festival (on the fifth day of the fifth month) by hanging up a

31 Katsushika
Hokusai, detail
from *Boys' Festival*,
1810s, multi-
coloured wood-
block print.

red flag emblazoned with an image of Zhong Kui (the eighth-century Chinese general, called in Japanese Shoki) seems to date from this time. I have found no explicit records, and the image itself was an old one, but the large number of pictures of Zhong Kui executed in a vibrant, bloody red seem to date from after the 1790s (illus. 31). For a few days a year, Edo would be covered with symbols of this ancient general and mythical strong-armed queller of demons. This complemented well the standard *yowa-yowa* icon of iris plants also used at the festival, not to mention the limply billowing (perhaps phallic) carp windsock. By the nineteenth century, Red Shoki was part of the iconographic celebration of the Japanese male, just as dolls celebrated the female at the Girls' Festival held two months earlier.

3 Bodies, Boundaries, Pictures

In the first two chapters we have considered the specific historical contexts of Edo pornography, who used it and how, and the ways in which the imagery fitted into the larger rhetoric of sex, gender and social norms. In this chapter and the following one we will look more closely at some of the pictures themselves and assess, via the evidence that the imagistic space alone supplies, what assumptions were being constructed and articulated.

Shunga are always compensatory and fanciful, and we must look at them in full realization of this: they are not an objective representation of Edo erotic behaviour, nor a transparent vista onto the practice of sex. They are impregnated with contentions about the human body, governed by conventions of picture-making and the technologies of paint and print.

SEXUALITY AND DIFFERENCE

It is a general assumption among those who have studied pornography in the West that it has certain abiding and inescapable characteristics. Most prominent is the belief that an aggressive male stance towards women is inalienable, with a corresponding self-flattering of male power. Despite Rousseau's *bon mot* (quoted above, and indeed almost always quoted when discussing this topic), which puts pornography firmly into the zone of female consumption, the more usual stance is to see the preponderance of erotica as pertaining to a male (and heterosexual) gaze. George Steiner several years ago offered it as a law of pornography that however fine artistically individual works might be, they were, because of their genre, 'banal fantasies of phallic prowess and female responsiveness'.[1] Even in cases where violence is not overt and where women enjoy their roles, the argument continues, they are still being possessed, made subservient, bought or controlled, in short, forced into a depictional mode of

'sexploitation'. Women are rarely envisaged as the originator of the sexual act, unless as a dominatrix, nymphomaniac, hussy or whore.

These norms will need some adjusting for the Edo situation, but in many ways they define *shunga* reasonably well. By and large, *shunga* show women as belonging to a lower, controlled grade and suppose a controlling gaze that is male. The greater prevalence of homoerotic imagery does not challenge this view, since power there also belongs to the penetrator, who is in all cases the older partner and senior player in an anal economy that is not reversible. More than is often accepted for Europe, too, Edo pornography seems to have been usable by women, although whether this resulted in the creation of specifically female-oriented imagery, or whether women and girls consumed pictures destined to perpetuate male fantasies, is a moot point. Until the end of the eighteenth century, one of the main publishers of *shunga* was Tsutaya Jūzaburō (publisher of Utamaro, among others), whose shop was situated by the entrance to the Yoshiwara – a place where female buyers simply could not come. How then, in eighteenth-century Edo pornography, are bodies shown and genders differently construed?

To answer this question, we must think more about the meanings of gender as such in the Edo world. This topic was broached in the preceding chapter, where I stressed that, in the Edo period, sexuality was not predicated on the binary division of homosexuality from heterosexuality. That is not to say that no difference was seen between male–male sex (*nanshoku*), male–female sex (*nyoshoku*) or female–female sex (for which there was no word). But the difference was one of degree, not of absolutes. In Ihara Saikaku's famous story of 1682, *Life of a Sex-man Man* (*Kōshoku ichidai otoko*), the hero Yonosuke, whose name literally means 'man of the world', sleeps with 3,752 women and 725 men (not including the uncounted men with whom he had affairs before he reached adulthood).[2] Very many figures in the culture of the Edo period, from the shoguns and their courtiers to the *haikai* master Bashō, Edo rakes such as Hiraga Gennai and Ōta Nanpo, scholars such as Kinjō and, of course, Saikaku himself, routinely slept with other men, as well as (in most cases) with women.

There was the phenomenon of the *onna-girai*, or 'woman-

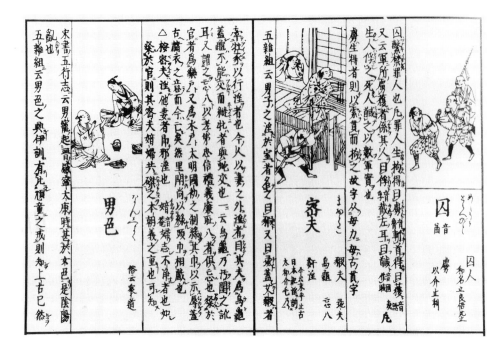

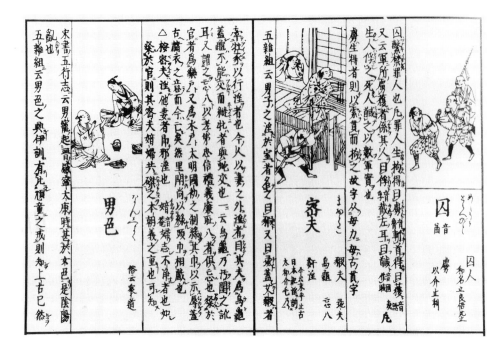

avoiding' males, and Gennai was one such; but there were no 'homosexuals'. There were men who were *nanshoku-girai*, or averse to male–male sex; but there were no heterosexuals. This must have been the case with women too although, frustratingly, no data have so far come to light. 'Heterosexual' and 'homosexual' were not fixed, distinct human types, they might have been understood as activities. Similar findings have been reported for early modern European history. There are no personal nouns that could designate the person who does *nyoshoku* or *nanshoku* although, interestingly, the word *nanshoku-ka* ('*nanshoku*-ist') has been neologized in recent Japanese by gay men engaged in a project of implanting their identity back in history.

The most widely consulted household reference work of the eighteenth century was Terashima Ryōan's adaptation of a Ming-period encyclopaedia called in the original *San cai tu hui*, or in adapted form *Wakan sansai zue*, or the *Sino-Japanese Illustrated Compendium of the Three Powers* – i.e. heaven, earth and humankind. It was first published in Osaka in 1713. The Japanese edition is actually quite different from the Chinese one and, unlike it, includes an entry and figure under '*nanshoku*' (illus. 32). This is placed in the 'human functions'

32 *Criminal, Spy, Nanshoku,* mono-chome woodblock page from Terashima Ryōan, *Wakan sansai zue* (1713).

(*jinrin no yō*) section, together with friends, guests, thieves, assassins etc. – not a wholly honourable crew to be sure, but the point is that *nanshoku* is here a taste, or colouring, overlaying the person, which is dependent on context; it is not a defining characteristic, much less an identity, if the Edo-period person even had a sense of 'identity'. Like the human characteristics that come either side of it, this is a habit, and like other habits it might come and go. Bashō, for example, claimed at the age of thirty (i.e. in 1673) to have lost interest in *nanshoku*, which he had previously practised, only to recover it twenty years later.[3] Another case is that of the daimyo of Echigo, Nihatta Kaikō, who in 1758 fell in love (as so many others did, including the King of Hell) with Segawa Kikunojō, but when the affair did not work out he gave up *nanshoku* and thereafter only slept with women.[4]

We could say the normal Edo sexuality was bisexual, but this is not quite accurate either, for there was scant sense of the binarism which must exist for bisexuality to be able to cross. A body of writing exists about the two types of intercourse – called, in mock epic fashion, the Way of Women (*nyōdō*) and the Way of Boys (*shūdō*, or *wakashūdō*) – which are often structured as debates between those who preferred one over the other.[5] They are couched as arguments for winning converts, as with philosophical and religious 'ways',[6] where any person is a potential advocate of any one, and where reasoned propositions can gain adherents from any pool of people. The terminology of the two sexual 'ways' mirrored each other so as to be complementary, not oppositional, and certainly neither was the other's incommensurable pariah, to be branded 'unnatural' and persecuted out of existence.

The two sets of fairly similar institutions catering for the two tastes also visibly ran in tandem. The Yoshiwara was lexically similar to the main *nanshoku* area of Yoshi-chō. The Yoshiwara was commonly known as the 'five-block area' (*gochō-machi*), from its physical size, and the *nanshoku* one as the 'two-block area' (*nichō-machi*) or, including Kobiki-chō, the 'three-block area (*sanchō-machi*) – one was smaller, but neither was substantively different.[7]

It is important to understand these norms, because they not only have a bearing on senses of gender but also on senses of bodily difference and so underpin the representation of bodies, not least in *shunga*. The extent to which the two sexes

are seen as oppositional and to which sex is thus a confronta-
tion, or a conflation of opposites, is not as strong in Edo *shunga*
as in modern (Japanese or other) pornography. The issues of
nanshoku, even if marginal in some ways, must therefore
detain us, since this is one of the prime loci of slippage
adduceable to prove the non-permanence of Edo gender
absolutes.

Recent study of *shunga* has been undertaken by scholars
rooted in modern sexuality and who have not sought to
remove themselves from it nor to address the Edo context in
the language of alterity. The danger of misunderstanding
pictures by unconsidered application of modern categories
can be shown in a recent commentary on an illustration by
Okumura Masanobu to the *Little Bedroom Patternbook* (*Neya no
hinagata*) of about 1738 (illus. 25). A man penetrates a girl
while licking his finger, seemingly to insert into the anus of a
boy, whose penis he also holds. This is a classic illustration of
Edo sexuality at work, and indeed, as Richard Lane has
shown, Masanobu has borrowed this image from a line of
similar ones in the *shunga* tradition.[8] An otherwise useful
series of Edo pornographic reproductions published in 1995
has the following caption: 'A playboy mounts a female prosti-
tute from behind as she embraces a boy prostitute – a fitting
revenge for this girl who has seduced the boy. The man and
woman seem happy enough, only the boy is unfortunate'.[9]
This narrative imposition on the picture is illegitimate (the
book itself is textless) and the caption is misleading: why is
the boy 'unfortunate' (*fuun*), and wherein lies this 'revenge'?
A more likely scenario is that from the first the three have been
together, and the man may have rented both partners. Our
epistemologies of sex must be right for the period being
discussed.

This Edo ability to flow across what we regard as opposing
sexualities, without even noticing them, allowed great freedom.
In eighteenth-century London, for example, the equivalent of
the Edo *nanshoku* establishment was the 'molly-house'.[10]
There it was common for partnerships to be formed in which
one of the two men assumed a female name ('molly' being a
common one) and 'married' his partner as 'wife'; the two
would then retain this crypto male/female role permanently,
even if they grew old together. In Europe, then, a sexual part-
nership could not be conceived other than as the meeting of

gender opposites, so that even when union was of the same sex, this had to be divided into two polar nodes. Precisely because gender was held to be fixed and non-fluid, this was in turn relegated to the sphere of perversion and penalized by church and state. The 'female' was defined via an analogy with heterosexual intercourse as the one who was penetrated, and that designation might well have been followed by the willing or involuntary adoption of other characteristics deemed female.

Edo writings include few references to same-sex couples living for long periods together, such as until they both grew old, so that the division between penetrator and penetrated was not a permanent division but was a 'natural' extension of age differentials. A youth was penetrated, but he later grew up to become a penetrator, and this required separation from his former partner(s). In Kinjō's words quoted in Chapter Two, a pretty boy (*randō*) grew into a hero; had Ranmaru lived, he would have become a penetrator. The age at which one moved across from passive to active varied with personality, inclination and appearance. Some put the change at *genpuku*, that is, the ritual 'putting-on of the trousers' or ceremonies of adulthood, which however, were also variable, coming between about fourteen and eighteen. In some cases, but not all, this age brought the cessation of *nanshoku* activity. At the beginning of Jippensha Ikku's best-selling novel of 1802, *Down the Tōkaidō on Shanks' Pony* (*Tōkaidōchū hizakurige*), for example, the adult Yajirōbei and boy Hananosuke are lovers living in the country town of Fuchū; Hananosuke then undergoes *genpuku*, takes the adult name Kitahachi, and the two move to Edo, where they continue to cohabit, although nothing further is said about their sleeping habits, and it appears they desist from intercourse with each other – although they continue to make *nanshoku* jokes throughout the work.[11] This is a fictional setting, but the available evidence suggests that most of the working boys in the 'two blocks' were aged between twelve and seventeen, although there were exceptions. Some were thus pre-pubescent (again, we should bear in mind that a child was considered to be one year old at birth and that everyone changed age not on their birthday but on New Year's morning). But a *nanshoku* treatise of 1768, *Sex in the Foothills* (*Fumoto no iro*), told of a prostitute called Ogiya Yashige who was still working at the age of 60.[12]

Saikaku's *Great Mirror* mentions a rent 'boy' still as being penetrated at the age of 38, although that was regarded as too old and provoked laughter upon discovery.[13] No male rented to be penetrated.

To some extent, to penetrate a boy was to treat him as a woman. But the activities, not to mention the sensations, of all parties were different. It is within our modern regime of compulsory heterosexuality that the two are constructed as the same in order that the one can be the mutant shadow of the other. In fact, the model used in Edo times to define *nanshoku* partnerships was less that of a male–female one gone astray than that of master and retainer. A master commanded his retainer and 'forced' (cognate with the verb 'fuck') him in sex as in all aspects of his life, and this was not reversible. It did not mean the retainer took no pleasure in his role, only that he was obliged to accept it, and he was always debarred from the commanding position as long as the relationship endured (which in a real master–vassal one was life, but in a sexual one was negotiated in a piecemeal way). The third shogun, Iemitsu, provoked hostility among the daimyo by his *nanshoku* activities, not because he engaged in them (his father, Hidetada, had caused no stir) but because he liked to be penetrated.[14] As shogun, Iemitsu ought not to have referred this prerogative to a subordinate; he upset the hierarchy as would a master who brought his servant food.

ANATOMICAL DIFFERENCE

Gender is crucial for a consideration of the fields of desire which are the root themes of *shunga*. The possibility of a gender flowing into another, and becoming lost, was bruited at the end of the eighteenth century. More widely, if less apocalyptically, voiced was the assumption of an element of choice in gender. Kabuki actors were the obvious example, for many permanently played the part of females. Unlike today's female-role specialists (*onnagata*), those of the Edo period (called *o-yama*) often dressed as females even in their off-stage lives and outside the theatre district. Culturally, if not anatomically, they were women. The passage in *Modern Inconsistencies* (*Tōsei anabanashi*) mentioned in Chapter Two may be given fully here; it plays on the word *bakemono*, ghost, literally a 'thing transformed':

There are some spooky transformations to be seen about today, such as the larva that sprouts wings and flies off as a mosquito, or the midge that puts them out and takes off as a fly; a cocoon transforms into a butterfly, a prostitute changes into a bourgeois woman and enjoys an outing to the country, while a man turns into a woman and gets to be called a 'female-role specialist' (o-yama).[15]

For a man other than an actor, to assume female dress – like wearing male dress if one were a woman – took one transitorily into the same area of contestation. Most could or would not perpetually confuse their gender, but many might intermittently do so. Kotohito, ex-*shujō* (posthumously called Go-Mizunoo), retired in 1629 and thereafter occasionally dressed as a woman; this was partly a ruse to spy on the scheming courtiers that surrounded him, but partly because he enjoyed it. It was surely an extension of his musings on the oddity of his condition in the contemporary world: having been obliged to marry the shogun's daughter, he eventually resigned in favour of their child Okiko (posthumously: Meishō), who became the first female *shujō* for nearly 1,000 years.[16] Kotohito was the product of an unstable environment. Alternatively, the great Keishi literati artist Ike Taiga, active at the end of the eighteenth century, used to swap clothes with his wife, Gyokuran (also a painter) – an eccentricity that may have helped his works sell for huge prices since the act became part of his standard biography.[17] Taiga's and Gyokuran's gender anomalies were, like their art, quirky but strangely perceptive reinterpretations of human experience.

The end of the century saw the emergence of what is often regarded as the late twentieth-century phenomenon of unisex modes. Edo costume was strictly differentiated by gender and, if the dirt-poor wore uniformly shapeless rags, it was a priority of the decent to wear clothes that accorded with their social body and status (had it not been so, there would have been no meaning to Taiga and Gyokuran's switches); it was this fact that made kabuki actors untouchable, for they donned costumes, that is, borrowed robes. In 1767, Sugita Genpaku recorded the appearance of Edo's first unisex haircut, which he thought 'very charming' even if looking 'lopped off in part by a sword'.[18] As a physician trained in the Sino-Japanese tradition, in which cures were gender-specific,

he was aware of the implications of this style, 'identical for male and female', clouding differences.

Genpaku's words are pregnant, for shortly before writing these comments he had been instrumental in the introduction of the new medical discourse of anatomy and its curative extension, surgery. Indeed, he claimed that he had invented the term that remains the modern Japanese word for anatomy, *kaibō*.[19] These foreign trends were designated the 'European way' (*ranpō*) and were regarded as epistemologically distinct from the previous style, the 'Continental way' (*kanpō*). I have written about this elsewhere, but one distinction related to gender is important here:[20] in *kanpō*, without fixing gender, a patient could not be cured. To the anatomist, however, barring the existence of the womb, males and females were internally identical. Even the sexual organs, it was intriguingly believed, were the same, as Thomas Lacquer has written, with the vagina conceived as an inverted penis, or rather the penis as a pulled-out vagina.[21] Doctors made diagrams to prove this and Vesalius, the 'father of anatomy', famously depicted the vagina as an internalized penis (hence the later rhyme: 'Those whose greatest study it has been/Tell us women are but men turned outside in'). The irrelevance of gender to analysis and cure was a conception that arrived in Japan with the 'European way'.

At the root of developments in mid-Edo-period medicine was a new problematic of gender. This had its implications for healing but was also crucial for the ideology of reproduction, of sex, and so ultimately of libidinous picture-making. It is intriguing to note how closely linked the followers of the new medicine were to the persons who have already been introduced in the preceding pages – the groups overlapped.

The first full translation of an anatomical atlas was undertaken by Genpaku, and he had various illustrations copied for inclusion by Odano Naotake, a young samurai from Akita who was brought to Edo by Hiraga Gennai; Naotake lived there under his patronage and that of the Edo high commissioner (*rusuiyaku*) of Akita, Hōseidō Kisanji; also involved was Katsurakawa Hoshū, the shogunal physician (who was later to interview the Russian returnee Daikoku-ya Kōdayū), and whose brother, Morishima Chūryō, was Gennai's pupil and literary successor.[22] The resulting book was principally derived from the *Anatomische Tabellen* (*Anatomical Plates*) of

the Danzig doctor Adam Kulm (or Kulmus), published in German in 1725 but known in Edo in its Dutch translation of 1734; the Chinese book (it was translated into scholarly Mandarin, not the vernacular) was published in 1774 as the *New Anatomical Atlas* (*Kaitai shinsho*).[23] Odano Naotake expressed anxiety about the quality of his pictures, and with reason, since he was transferring highly intricate copperplate etchings onto woodblock and, moreover, had only been introduced to European modes of representation some months before.[24] History has relieved Naotake of the charge of incompetence, but it is also true that the *Atlas* pictures have nothing to offer in matters of gender. For the good reason that its source books ignore it, it is also silent. An illustration of the womb (at the very end of the book, on a separate page, as a kind of afterthought) is alone in distinguishing male and female bodies, which are otherwise interchangeable, with only the exteriors differing. The *New Anatomical Atlas* is regularly touted as having initiated Japan's encounter with modern medicine, but in fact its primary assumption now appears retrogressive compared with the existing tradition.

Dissections were occasionally carried out, and Genpaku claimed it was after viewing one with Hoshū and others that he determined to begin the arduous task of putting Kulm into Chinese.[25] It would have seemed a matter of no importance whether a female or a male cadaver was used. Corpses were always those of executed criminals, so males were more readily available. In Europe it was regarded as indelicate to dissect females unnecessarily (i.e. unless the womb were being investigated), and there was also the problem of prurience on the part of spectators of female anatomy, so that in Holland – where the costs of medical teaching were defrayed by admitting the public for a fee – it cost more to see a female dissection than a male (they were still better attended).[26] As a rule, Western medical pictures illustrated males for the same reasons, and several of those in Kulm found their way into the *Atlas* complete with facial or body hair (illus. 33). But the dissection that prompted the translation (if Genpaku's reconstruction is to be believed) was that of a woman whose name is recorded as Aocha-baba ('old Mrs Greentea').[27] Genpaku, watching and comparing Kulm's book and the body being cut up, expressed concern that a north-east Asian body might differ from a European one but nowhere wondered if pictures

33 Odano Naotake, *Diaphragm*, monochrome woodblock illustration for Sugita Genpaku *et al.* (trans.), *Kaitai shinsho* (1774 [copy after German original of 1725]).

of males might be misleading when inspecting a female: practitioners of the 'European way' confirmed that gender was immaterial.

This sense of the marginality of gender distinction was beginning to be challenged in Europe just as Kulm's book arrived in Edo. The pioneering work of the Swedish botanist Carl Linnaeus postulated a fundamental sexual division within all things, not just animals, fish or birds but also trees, flowers and grasses. The name of Linnaeus may not yet have been known, but a favoured student of the great scholar from Uppsala University, by name Carl Thunberg, came to Japan as a doctor with the Dutch East India Company in 1775.[28] Thunberg would have introduced this model of a totally gendered universe, and it is known that during the few weeks he spent in Edo in the spring of 1776 he became close to Hoshū and to another of the Kulm translators, Nakagawa Jun'an, addressing them as 'my beloved pupils', donating them his (highly expensive) top-grade Parisian and Amsterdam medical tools and maintaining a correspondence with them for years after his return to Sweden (where he was awarded the Order of the Vasa by King Gustav III).[29] Notions of plants as having genders were not entirely absent from Japan, and this had been discussed since before the arrival of European thought. In China, bamboo was said to be gendered, but this was regarded as a special case.[30] The best Japanese expositions

98

occur in the writings of Hirata Atsutane in the 1810s, after the solidification of some Western concepts, even if he specifically identified his work as indigenous 'field nativism' (*sōmō no kokugaku*). Japanese plant gender was in any case theoretical and non-empirical to the eye, and few books were in agreement on how gender should be assigned, even while accepting that it had some relevance. Japanese plant and seed genders were thus like human ones: real, but difficult to pin down.

In the West, few people yet took account of the new Linnaean postulates. Eventually the fully-gendered world model was absorbed and by the nineteenth century had spawned pornographic extensions, such as stories of women copulating with 'male' plants, or inter-species eroticism in the floral world.[31] Most people lagged behind doctors and continued to regard differences as most saliently external. Kulm's book had been a product of pre-Linnaean constructions and was not a forward-thinking book in any respects (Kulm was not regarded as important in Europe, and the mediocrity of the book may have delayed Japanese 'advances').[32] Although he ignored internal differences in the drawings, Kulm's first two pictures had shown whole, naked figures from front and back, one male, one female (illus. 34). These, if anything, exaggerate *external* sexual differences, as a preliminary to erasing them *inside* the body. The images proclaim sexual difference right across the whole surface, so that even independently of the genitals (which are not even shown) the sex is immediately clear. The female is rounder, plumper, more sloping in the shoulders and larger in the hips; the male is tauter, broadchested, narrow at the waist and hairier. In all genres of

34 Odana Naotake, *The Body, Front and Back*, from Sugita Genpaku *et al.*, *Kaitai shinsho*.

depiction, Western attention to secondary sexual characteristics was highly acute. In Japan, as in all countries that used the pan-north-east Asian 'Continental way', internal differences were enlarged upon and external ones barely illustrated. The respective pornography traditions followed this. In *shunga*, male and female bodies appear virtually identical other than in the genitals; even female breasts are down-played and rarely appear as sites of sexual interest (the only part of the breast depicted as erotic in *shunga* is the nipple itself, that is, the part that is shared with the male – see illus. 57). In Europe, pornographic, like medical, pictures turned the entire area of the outside of the body into a map of the sexual.

The lack of secondary sexual characteristics in Edo erotica is plain enough to see by flipping through the illustrations contained in the present book. What is also important is to recognize the way in which the assimilation of the two bodies made social gender-coding through dress or hairstyle commensurately more important. If a person dressed her- or himself in the clothes of a certain gender, they became a true representative of that gender. To sport a unisex hairstyle was thus to thwart gender itself. The *locus classicus* of this way of thinking is to be found very much further back in a twelfth-century story, the *Tale of Those Who Wished to Change* (*Torikaebaya monogatari*), in which a brother and sister cross-dress permanently and in so doing actually become, socially speaking, if not genitally, members of their new chosen order.[33]

Here we encounter a fundamental difference in ways of construing sex and gender: the Edo sense, and that of its antecedents, was that concerted comportment in a given gender role will shift the person across into that gender; since sex is barely encoded on the outside of the body, this new gender will to all intents and purposes become the person's new sex. As we have seen, the fear at the close of the eighteenth century was that this process had become involuntary and that *all* males, willy-nilly, were sliding into the regiment of females. By contrast, in the Europe of the same period, cross-dressing was common in conditions of masquerade (festival or stage) only as a kind of temporary gag, always ultimately futile as real subterfuge, and generally easily unmasked before any significant error has taken place. The secondary sexual characteristics were taken as inextinguishable.

35 *The Female Body*, monochrome wood-block illustration for Morishima Chūryō, *Kōmō zatsuwa* (1787).

THE NUDE

Morishima Chūryō, Hiraga Gennai's successor and Hoshū's brother, published a popular anthology on Western affairs in 1787 under the title of the *European Miscellany* (*Kōmō zatsuwa*).[34] It contained a section on picture-making, both in paint and copperplate, accompanied by several illustrations culled from an important early eighteenth-century teach-yourself guide to art, *Groot Schilderboek*, known in English as *The Art of Painting in All its Branches*. The author was Gérard de Lairesse, a some-time pupil of Rembrandt who had gone blind. Unable to continue in his airy French Baroque manner, he wrote the book via an amanuensis in 1707 (the English version appeared 75 years later).[35] Two of the images Chūryō used showed naked bodies, one male, one female, included to demonstrate ideal (to the European mind) bodily proportions (illus. 35).

Chūryō explained that learning to draw the human body was regarded as the cornerstone of Western art, and grasping the fundamental differences between male and female was essential. He wrote, 'European pictures are thus: when someone is learning to make them, first they consider the skeletal structure of the male and female, then they practice drawing naked bodies, and finally they put clothes on top of this and produce a complete picture'.[36]

Chūryō might have said more: in Europe, drawing naked bodies was not just the prior spadework for constructing clothed ones, it was an end in itself. The second most highly-regarded Western genre (second to history painting) was the nude, a subject regarded as elite, noble and fine, valued, in part, because of its prominence in the sculpture of ancient

Greece. The dilemma that these images might provoke erotic arousal, vitiating high sentiment, though very apparent, was guarded against by various means, the most extreme being the addition of fig leaves. These were justified by the biblical claim that Adam and Eve had worn them in Eden, after eating the apple of the knowledge of good and evil. The Church was instrumental in much fig-leafing, particularly in the Mannerist period, after the vast Renaissance expenditure of energy on reviving the nude genres. In the 1580s, for example, the archbishops of Milan and Bologna undertook an inspection of the artworks in their respective sees, passing judgement on which were acceptable and which would give rise to obscene thoughts and so must be shielded.[37]

The nude became one of Europe's major themes. But, leaving aside the occasional clerical vituperation, it is notable how deep was the blanket of silence that was piled over the genre, as people progressively refused to see, or pretended not to see, or declined to talk about, erotic value. Mention of sexual charge was turned into something coarse. De-eroticization was of course at variance with the purpose for which nudes were often created. Although much more could be said on this, it suffices to consider a painting by Eglon van der Neer in which a bourgeois Dutch couple stand and sit in their refined home, tastefully appointed, with a *Venus* on the wall behind them; the depicted space is not one in which the sexual implications of this naked female could decently be discoursed upon (illus.36). Passage from a naked painted person to libidinous arousal is not an uncomplicated one, and there is room for interference along the route.

An intriguing anecdote is useful here. In 1613, John Saris of the English East India Company recorded a meeting with some of the ladies of the daimyo of Hirado, Matsura Chinshin. The daimyo had given Saris a banquet, and he reciprocated with a tour of his ship. Most of the Hirado elite were Christian, and when the women came across the painting of a female in Saris's cabin, 'in a great frame', they fell down and performed devotions to it, under the impression that it was the Virgin.[38] However, it was actually Venus, by Saris's admission 'verye lasiuiously sett out', intended for his private delight at sea. It seems that eroticism can very easily be chivied out of view. Saris's story became famous in England as proof of the non-transferability of pictorial conventions

36 Eglon van der Neer, *Portrait of a Man and A Woman in an Interior*, c. 1675, oil on panel.

(Saris did however urge his employers in London to send more erotica to Japan, where he was sure it could be sold for up to £8 a piece).[39] The repercussions of this anecdote are worth recording. Saris's story was picked up in the famous *Green's New Collection of Travels and Voyages*, put into French by Abbé Prevost d'Exiles (later author of *Manon Lescaut*), which in turn was put into Dutch in 1747–50 as *Historische beschriving der reizen*, in which form it was brought to Japan. The Dutch Prevost came into the possession of the Europhile daimyo of Fukuchiyama, Katsuki Masatsuna, who showed it to the scholarly-minded then-daimyo of Hirado, Matsura Seizan, who had the relevant bits dealing with his ancestor translated into Japanese; in the Japanese version, the *Venus* was referred to as 'a *shunga*'. Shiba Kōkan publicized the story for general Edo consumption in 1811, retaining this loaded term.[40]

This tale, which opens a bracket of silence, may be read along with another which, as it were, closes it. Mishima Yukio in 1949 wrote in his fictionalized autobiography how his first act of masturbation came while looking at Guido Reni's *St Sebastian* from the Palazzo Rosso in Genoa, of which his father owned a lithographic reproduction.[41] Mishima was overcome with shame, believing he had desecrated the work. Research into the history of many such nudes, and indeed specifically into depictions of St Sebastian, has now confirmed that Mishima's response may have been the correct one in

103

terms of what artist and patron were gearing the painting towards.[42]

The pretence that nudes were ever 'clean' was finally shattered by Kenneth Clark in his famous book of 1956, *The Nude*, which proclaimed that the genre was unavoidably erotic – the first time an art historian in his position (he was a former director of the National Gallery in London) had said as much.[43] Before this, a 'high' subject from mythology or the past was enough to deem sex as being outside the equation.

NUDES AND *SHUNGA*

The emphasis on external bodily differences meant that seeing any naked body was *ipso facto* seeing something that was sexually impregnated and hence something sexual, which, unless ignorance or wilfulness interposed, could be liberated to become erotic. Perhaps it was the propensity of all parts of the body in the West to make sexual statements, coupled with the tradition of the nude genre, that required such emphatic policing of the join between the two issues. There was no equivalent in Japan; for a start there was no nude genre, and, as we have seen, male and female were not polarized but were said to hold the majority of their bodily traits in common. As the Edo regime of the body attached scant gender-specificity to external parts, it accorded small erotic value to the shapes formed by skin (thigh, waist etc.), so it was not of much use for artists to show them. On the other hand it was possible for artists to draw nakedness without any equivalent need to drown out sexuality. In the absence of any sexual tension in nakedness, there was little need to do so. It is said that *shunga* pay less attention to naked forms than European pornography. This is partially true (although there are *shunga* showing unclothed bodies), but it is better to say that *shunga* dismiss the erotic possibility of skin. Skin might be good to feel, but since the curves and indentations of male and female bodies were taken as being the same, it did not entice the gaze. In fact, as we shall see below, it was clothing that made gender (and erotic) statements powerful.

In Europe, Greek subjects remained the focus of the nude even after its revival in the Renaissance, although Roman (e.g. Venus) and Christian (e.g. St Sebastian) subjects were added. This situation began to break down in the nineteenth century.

An infamous instance is Manet's *Olympia*, completed in 1863 and exhibited two years later, but soon removed from display owing to the public outcry (illus. 37).[44] Manet did play lip-service to classical expectations (the title), but he put the woman into an obviously modern setting, one that was felt to bring the eroticism too much to the fore and render the picture too obviously sexual. This 'Olympia' was clearly a prostitute and not the lofty classical goddess, and thus Manet's work was literally pornography, that is, the representation of prostitution.

The nude, as a genre, appeared in Japan with the introduction of Western painting norms at about the time of Manet (who was himself influenced by Japanese art). The confusion that had recently infested the genre in Europe, which T. J. Clark has referred to as the 'crisis of the nude', entered Japan in tandem with the nude itself;[45] given the absence of any historical assumptions about how the genre was to be interpreted and excused, this provoked signal problems.[46] Kuroda Seiki's *Morning Toilette*, exhibited in 1895 (but since destroyed), is said to have been the first Japanese nude, although the figure coyly seen in back view is a Western woman, not a Japanese (illus. 38). The use of the mirror (as we shall see in Chapter Five) was a common erotic device in *shunga*, but here it has a mitigating, distancing role.

Other artists experimented with bringing the nude into the emerging orbit of what was for the first time being called 'Japanese art'. Already at the end of the Edo period, artists had encountered the nude and tried hooking it into the other genre arriving from Europe (and equally in crisis), which was history painting. In 1842, Kikuchi Yōsai depicted *En'ya Takasada's Wife Leaving her Bath*, a story that was deliberately uplifting (depending on one's politics): Takasada was a retainer of the fourteenth-century shogun Ashikaga Takauji, and while he was absent his wife valiantly attempted to resist seduction by Kō no Moronao, her ultimate failure leading to her death from shame (illus. 39). Yōsai is here mixing genres, rather unsteadily, and seems uncertain how to deal with the eroticism. Moronao's loathsome face, bent on ravishment, peeps from the rear, exactly as the viewer's peeps from the front; this is part history-cum-nude, but part *shunga* of the 'exiting from the bath' type (see illus. 16, 17, 21, 23).

Such experimentations with the depiction of nakedness

37 Edouard Manet, *Olympia*, 1863, oil on canvas.

38 Kuroda Seiki, *Morning Toilette*, 1893, oil on canvas. Original destroyed during WWII.

39 Kikuchi Yōsai, *En'ya Takasada's Wife Leaving her Bath*, 1842, colour on silk. Private collection.

and the capturing of secondary sexual characteristics in their erotic power began with Westernist artists, and Shiba Kōkan was among the first. He did a (now lost) painting of a foreign woman, presumably European, with large rounded hips and thighs, full breasts and stomach, and a soft chin (illus.40). It is not a *shunga*, and the child justifies the exposed breasts, keeping their voluminousness in the domain of motherhood rather than sexuality. But eroticism is not absent, and Kōkan must have known that *shunga* often incorporated children precisely as an extenuating mechanism. This image is an early articulation of a bodily surface totalized by irremovable sexual demarcations.

The Western genre of the nude downplays the genitals. With so much erotic power inherent in the secondary sexual characteristics, it can afford to. Genitals, in a sense, are not really needed (hence the frustration of prelates who feared that fig leaves might not contain all the erotic power). *Shunga*, however, take the reverse path and, in the absence of

40 Suzuki Harushige
(Shiba Kōkan), *Foreign
Woman and Child*, c. 1790,
colour on paper.

secondary sexual characteristics, necessarily rely on genitals
to hold the viewer. This accounts for the great magnification
of them: there is not much else of a bodily kind for *shunga* to
show.[47]

Europeans began to look at pictures of the Floating World
during the period of disintegration of the academic nude.
Untrained Western viewers could not easily appreciate the
erotic power of Japanese prints with their absence of depicted
skin. A tendency to infantilize the represented adult person-
ages is repeatedly seen (the term 'geisha *girls*' remains in
service). The recurrent orientalist fantasy of under-aged sex
partners ripe for the plucking is evident, but language was
often that of androgeny, of women of an age before secondary
sexual characteristics have put them into the category of fully
sexualized existence. *Pace* the French pick-up line 'viens voir
mes estampes japonaises', Japanese prints were often enjoyed
for their exciting compositional arrangement, unexpected
draughtsmanship, or colouring, and it barely entered the
terms of engagement that the themes were male and female
prostitutes. Indeed, Westerners routinely mistook the attrac-
tive boys (*wakushū*) for girls, as do many modern Japanese

41 Cover illustration to *Le Japon artistique*, no. 33 (January, 1891).

viewers.[48] Real connoisseurs attempted to inform Western viewers of the facts and to lock pictures of the Floating World into sex, and artists of the analogous French *demi-monde* such as Toulouse-Lautrec expressed an interest in Japanese prints; Edouard de Goncourt's biography of Utamaro was subtitled '*Peintre des maisons vertes*' (*seirō*, better rendered as 'blue towers', that is, brothels, than 'green houses').[49] But ordinary people continued to frame imported prints and hang them obliviously in their parlours.

A restoration of erotic power to the nude was the aim of painters, like Manet, who were prepared to shock. In this Japanese prints were a useful tool, not because of features inherent in the prints themselves, but because *everything* available was being used as grist to the anti-academic mill. It was shocking enough to propose that Asian art had anything to teach the French. Concurrent with the comments about androgyny made by those who recognized the lack of seemingly adult bodies, was the selecting for prominence by members of the avant-garde of the kinds of prints that most conformed to their ideas of what the nude should now be. Pictures with relatively clear secondary sexual characteristics,

de-accentuated genitals and modern settings were deployed. One case is an Utamaro print used as the cover for the January 1891 issue of the magazine *Le Japon artistique*, issued just months before Goncourt's book (illus. 41). The child is apparently reaching for the breast, and this print resembles Kōkan's woman with an infant, but the child is actually reaching for the woman's skirt as she leans back in apparent excitement. To a Western viewer the child seems far too old for breast-feeding, so that the woman proffers her teat more for the viewer than for him. The picture reads as entirely erotic, the body of the woman is intensely female, and although not much nakedness is seen, this woman of the *maisons vertes* exists comfortably beside Olympia.

CLOTHES

The Western nude emphasizes the secondary sexual charac-teristics over the genitals because that is the best way to make available a palpable, but restrained, eroticism. Pornography, of course, gives more attention to the genitals and, if a male is shown, the penis will generally be erect.

Japanese depictions take the opposite path but for exactly the same reasons. They show figures clothed because that was considered the best way to make available a palpable, but restrained, eroticism. *Shunga* give more attention to the genitals and again, if a male is shown, the penis will generally be erect.

In pictures of the Floating World, the clothes themselves carry sexual weight; in Western pictures, they rarely have this power. In Western representation, clothes must be made to show the shape of the body beneath if any erotic charge is to be effected and so they are made to do so, as Anne Hollander has pointed out, often in defiance of the logic of how drapery really falls.[50]

Some scholars of *shunga* have sought to plot a gradual disappearance of nakedness, beginning about the mid-seven-teenth century.[51] I regard this as unprovable. I have less truck with a statement often heard that the surrender of naked-ness indicates some 'Japanese' aesthetic trait, which prefers semi-concealment to overt display. (In this context, Yoshida Kenkō's remark that the moon is most beautiful when occluded by cloud is cited, or else a generalistic appeal is

made to Zen, and the contemporary Japanese tolerance of highly censored pornography adduced to bring the observations up to date.) The statements seem to me to be ideological polemic, not history.

Yet there are indeed differences between *shunga* and much Western pornography in the relative attention paid to cloth over skin. Some factors accounting for this are pretty evident. For one, there is the technological issue. From Renaissance times right through into the nineteenth century, Western pornography was predominantly copperplate (illus. 42); *shunga* were predominantly woodblock. Different media necessitate different treatments. Woodblock does not allow much rendition of the roundness of form (breasts or thighs), and it is not good at providing shading; on the other hand it excels at patterning on the flat. Copperplate, conversely, can support a great density of line and encourages multiple moulding, and it is generally better at showing undulating surfaces than flat ones. This means that woodblock *shunga* tend to produce bodies in outline, enlivened by clothing patterns, while copperplate produces bodies in curves, better articulated by muscle or fat than pleats of cloth.

Edo-period commentators on Western pictures noted that a major difference in the treatment of the body was in the use of moulding and graded shadow. This was stated in the first Japanese treatise on Western art, written by Satake Yoshiatsu in 1778. Yoshiatsu (who painted in the Western manner, using

the studio name Shozan) was the daimyo of Akita, and so overlord of Hōseidō Kisanji and Odano Naotake. He regretted that 'something not achieved by any of the painting schools' in Japan was the 'three faces of a rounded object'. He cited the case of the nose.[52] Kōkan noted this too, calling the use of a bright surface, a shadowed one and highlights the 'three-faced method'.[53] Satō Narihiro and numerous others wrote the same.[54]

These commentators discussed the face (typically, as Yoshiatsu, the nose), and in their chosen contexts they were hardly able to base their arguments on breasts and buttocks. But representation of all parts of the body was radically altered by the 'three-faced method', that is, the lit and dark sides of an object and the dot or line of the highlights. Through this it became possible to demonstrate at what angle knees were bent, or how far a belly protruded, or whether the limbs were turned inwards or out. Another of Yoshiatsu's examples was architectural: 'this is the first pictorial style', he wrote, 'that can tell the outside from the inside of a tower' (that is, the convex from the concave). Of course he did not say so, but this was not so different from depicting a penis.[55] It would be interesting to know whether Edo audiences would have found sexual excitement in bodies done in the Western way. Kōkan painted at least two *shunga*, but neither was done in the Western manner.[56] One page in the *shunga* album the *Willow Storm* (*Yanagi no arashi*), attributed to Hokusai's (disowned) son-in-law Yanagawa Shigenobu, shows a Western couple, rendered in an imitation of copperplate (illus. 27) – an experiment that came late and was not repeated.[57] An anonymous scroll of about the same period shows several erotic images painted in the Western manner, with Europeans stationed in Japan engaging with local women (see illus. 127), although this too is unique and, significantly, no Japanese males were represented in the idiom.[58]

The medium and the inheritance of style have significant effects on the appearance of a picture. The prominence of clothing in *shunga*, the absence of skin and the enlargement of the genitals may be accounted for in this way, but the observation does not end our investigation, for, as images were consumed, viewers were unwillingly led towards certain conclusions about the body, and away from others with results we must consider.

A sense of the erotic value of cloth is apparent at several moments in Japanese history. In the eleventh-century *Tale of Genji* (*Genji monogatari*), for example, the way a person (male or female) selected and matched their fabrics was the subject of extensive scrutiny. This, of course, is not uniquely Japanese, for even the most 'naked' cultures have their rules of matching and draping clothes. Cloth culture is not just aesthetic but is part of the ritual of attracting and mating. Greece, though thought of as the birthplace of represented nakedness, produced far more clothed sculptures than is generally recognized, and they lose nothing of their erotic power for being clad. It is obvious that Greece was a society that knew the sensual power of well-ordered cloth, not least in women, for the female nude actually appears only after the male in Greek sculpture. Nevertheless, in the period covered by this book, cloth was acutely attended to.

In the days before mass production, good clothing was often inherited. At the higher levels of dress, where items were most formal and expensive, clothing changed little over time. In the 250 years of the Edo period the top echelon of garments barely evolved, and infrequently-worn ceremonial clothes were able to last for generations. For less formal wear, less outlay was required, so people could, and did, mutate their clothes, taking a degree of command over their own appearance in the knowledge that items would, in the end, be disposed of. This is how fashion emerged. But, despite the prominence of fashion in Edo urban life, even fairly casual garments altered relatively little in shape over time. There was no change equivalent to the move in Europe over the same period, from hose and tunic to trousers and frock coat.

The person of the Edo period did not purchase clothing, but cloth. This was then made up at home. General wear could not be more intricate than the ordinarily deft person had the time and skill to sew for themselves. Edo fashion was thus the fashion for changes in *cloth*, with only minor shifts in *cut*.

Pictures of the Floating World contain a significant number of depictions of the handling and touching of textiles. There are views of Edo's main haberdasher's, Echigo-ya, the first shop to sell cloth by the length required rather than by the

bolt, and there are scenes of women sewing, washing and mending. No other household occupation, nor indeed any other activity at all, outside pure entertainment, figures half so much (illus. 26). Cloth was appropriate to the genre not just because it was lovely but because it had erotic value. Dress was intensely personal, and a person's clothes were special to them because they had not only chosen the cloth, or received it as a specific present, but very probably had made it up too; this was especially true of women, not coincidentally the half of humanity that receives the greater scopic attention. It was a woman who bought and made her clothes, and who unpicked them to clean the marks of her body from them when they became dirty, and who then restitched them. In European art, washerwomen appear in genre paintings, but they will be servants working on someone else's clothes; washing was a trade; in Edo it was not. When not being worn, Edo clothing might also be used as ornament and hung up for decorative effect, but it still pertained to the person who normally had it on. Worn-out clothes might be mounted on screens, to retain the aura of a person, and this genre of collage art (which extends to painted cloth, mimicking actual mounted fabrics, drawn on screens) goes by the name of *tagasode byōbu*, literally 'whose sleeves'. The question was rhetorical: one was supposed to know whose sleeves they had been, or at least be able to imagine a human personality, based on the patterns (not cut) of the fabric (illus. 54). The genre would be impossible in Western art. Hung-up clothing might attest to a person's wealth, but it would indicate little of a sensual nature about them as individuals; you could not meaningfully ask, 'Whose sleeves?' The erotic aspect of this was made abundantly clear in the 1770s, when 'buying a whose-sleeves' became slang for hiring a prostitute.[59]

The dominance of the kimono and of a fairly small number of other clothing types (*uchikake, haori, hakama* etc.) meant that Edo-period clothing had to be multi-functional. There was much less dressing and redressing for different activities than was current in Europe. Moreover, the distinction – an important one in *shunga* – between daytime and night-time use was not observed, so that a kimono doubled as a bedspread, as is commonly represented in *shunga*.

Koikawa Harumachi lampooned the fashion-consciousness of the time in a comic work entitled *Useless Fads* (*Muda*

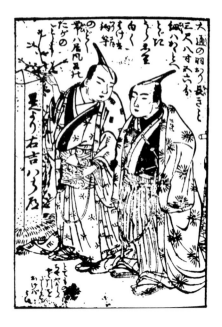

43 Koikawa Harumachi, *The Road to the Yoshiwara*, monochrome woodblock page from his *Muda iki* (1781 or 1783).

iki) and in it reveals how only minor changes in cut (length of hem, width of *obi*) or wearing practice (degree of exposure of the neck) contrasted with the attention paid to new types of cloth and their coordination. In one of the illustrations, which Harumachi produced himself, we see a pair of young sophisticates heading out for a night of fun (a sign reads 'left for the Yoshiwara') in the latest, costly jet-black cloth, but wearing standard clothing types, only cut too amply (showing extravagance, in a way that the reader knew was then all the rage; illus. 43). Over-dressing was the over-use of cloth. (The hair is also incontinently set, with an absurdly long cue, exaggerating the style known as a '*honda*'.) We read:

> a fashionable man has a tunic (*haori*) of 3 *shaku* 8 *sun* 5 or 6 *bu* [*c.* 120 cm], with the hem trailing at his heels, the lining of his collar is white, his trousers (*hakama*) are [striped] like fishing rods, his sash (*obi*) resembles the grip that binds the planks of a bathtub.[60]

None of the clothing items, or the terms for them, would have surprised his great-grandfather.

Harumachi's book was published at a time when people felt the pursuit of ever more expensive cloth was becoming excessive – hence the force of his satire (it was published in either 1781 or 1783). Genpaku wrote in his condemnation of

the age that many spent up to 40 or 50 *kin* (a colossal sum) on a single costume and then wore it only five or six times before buying something new. Different types of cloth appeared, as fabrics that had not previously been seen outside their own localities entered the general market as a result of the improved circulation of goods. Textiles arrived from overseas, bringing new patterns and types. The word for stripe (*shima*) still used in Japanese is a mistaking of the homophone for 'island' and is first attested at this period, referring to the Dutch East Indies, or what is now Indonesia. Other parts of South-East Asia, as well as India, Europe, China and the Ainu lands, were all supplying cloth for the Edo buyer.

An often-repeated formulation had it that the ideal woman should be born in Keishi, have Edo guts (*hari*), live in an Osaka house (larger and less crowded) and wear Nagasaki cloth, that is, cloth imported through the only international port.[61] 'Nagasaki' cloth was expensive, although prices are difficult to determine. There are ample stories of merchants making fortunes in the Nagasaki trade, much of which was the import of cloth as that (together with sugar) was the chief item brought in on the two annual East Indiamen. To be the Nagasaki governor (*bugyō*) was to cream off some of the most lucrative takings in the whole Tokugawa bureaucracy.

As part of the Kansei Reforms, the number of Chinese ships annually permitted to dock in Nagasaki was cut and that of the Dutch East India Company halved to just one ship per annum.[62] This was mostly intended to prevent exhaustion of copper (the main export item), but it also had the effect of driving up the prices of all imports. Foreign cloth became disproportionately expensive. Whereas previously a whole kimono might have been made from some overseas fabric, after the 1790s only the sashes tended to be, or else imported cloth was used for such small accessories as tobacco pouches. Import substitution was also practised. Prints of the Kansei era reveal women wearing meaner sorts of cloth than those of the former age (illus. 44). Sumptuary laws were passed to limit access to these now exorbitantly priced materials. Normal citizens had to be careful, and even prostitutes and actors for whom lavish clothes were professional necessities had to watch out. In 1789, just as the reforms were beginning, Segawa Kikunojō was arrested as he walked home, in over-splendid attire, from the theatre; two years later, all costumes

44 Kitagawa Utamaro, *Three Beauties of the Present Day*, c. 1793, multi-coloured woodblock print.

for a production of the kabuki play *Edo Cherry Trees, the Friends of Sukeroku* (*Sukeroku yukari no Edo-zakura*) were confiscated from the Nakamura-za Theatre because of their lavishness (Ichikawa Yaozō III was to play Sukeroku, Iwai Hanshirō was Agemaki and Onoe Matsusake was Ikyū).[63] The official log of the Dutch East India Company records in exasperation the collapse of demand and cites the example made of a Nagasaki prostitute who had her wardrobe seized for its excessiveness, with 'everything taken away'; someone else was 'put in prison for the same reason'.[64]

CLOTH AND *SHUNGA*

Even in the days when ships were less restricted, the high cost of imported cloth meant that few people wore it much. Lavish clothes were the preserve of two main groups: the extremely rich, and those who needed it as work-wear, that is, actors

117

and prostitutes. The triadic formulation quoted above for the woman of the three cities referred not just to the ideal woman, but the ideal *prostitute*. Other than the rich (who would not be much encountered in the ordinary townsperson's life), then, fine clothes meant the garb of theatricality or of paying sex. The Edo male would have touched finer fabrics in the arms of these two categories of provider than on any other occasion. The sexual power of texture and look in first-rate cloth was commensurately great; it may very well have excelled in excitement the feel of skin, since good cloth was harder to come by than good skin and was more expensive when one did. Even a session with a prostitute would cost less than the value of the clothes s/he wore.

There is no reason to assume that people stripped to have sex. Societies that have easy access to heating and cooling may well enjoy nakedness, but such was not the Edo case. The seasons controlled the temperature, with only minor scope for human intervention by means of braziers or fans. Those who argue that it is a peculiarity of *shunga* not to be interested in nudity tacitly assume sex was performed naked, which is not a credible assumption. Even in Europe, where the sexual power of the bodily surface was strong and the value placed on erotic cloth less, and where both pornography and the tradition of the nude made for a high valorization of nakedness, it still seems that people generally made love with their clothes on, right up into the twentieth century. Of course clothes were opened, but how many and how far depended on the time of year or on other factors such as whether the encounter was rushed and furtive, or with a designated duration, but the likelihood of copulating totally undressed was virtually nil.

This connection between cloth and sensuality made it inevitable that cloth would figure in *shunga*, although the type depicted was probably not that routinely experienced, since in most cases it looks hyperfine and surely exaggerates what would have been worn by any except the very highest-ranking sex professionals (whom few could patronize). Here, imagery is again engaged in myth-making. True, in pictures made in the Kansei era, the quality of depicted dress goes down, but this was more likely because the publishers were being accused of tempting people to overspend. Note how it is the openly marketed 'normal' pictures of the Floating

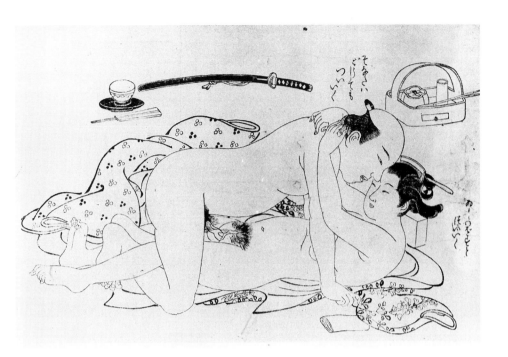

45 Shimokōbe
Shūsui, *Lovers*,
monochrome
woodblock page
from an untitled
shunga album
(*c.* 1771).

World that evince this self-censorship of cloth, while the more covert works of *shunga*, not seen by the authorities, took the reverse course and compensated for the declining quality of fabrics by illustrating preternaturally luxurious ones. Clothing in pictures is never the same as that in real life, especially in real sex, where clothes and bedding become deranged and rumpled, damaged by creasing, stained by sweat or marked by other bodily fluids. Only in pictures are such considerations irrelevant, so that it is in pictures that cloth can run riot.

The prevalence of cloth in *shunga* is not, then, so very hard to explain. Let us go on to consider how such cloth *works*, as it moves and falls to aid in the creation of a specific sexual world.

We may start with an image by Shimokōbe Shūsui (illus. 45). The work is a monochrome woodblock print and the naked bodies look exceedingly whole. Our bodies are full of disjunctions, with places where bones protrude, or sudden changes of angle affect the surface. But *shunga* prefer bodies without such segmentations. The lumps and nodes seen in the illustrations to Aretino's book (which set the norm for generations), where limbs are attached to the trunk, or where tissue

119

protrudes, are simply absent in *shunga* and obscured by all-covering bulges of fat (illus. 42). Shūsui's bodies are whole, Aretino's a collection of parts.

Shūsui and others took advantage of the known features of their print medium to encode bodies in a certain way, one that would be disencoded by the viewer. There are no differentiating secondary sexual characteristics, only the primary genitals, but even there the organs are deeply nested within each other so as to be almost fused; pubic hair aids a sense of slide from one body to another, without differentiation. Note that, unlike in Western pornography, which generally shows the male as hairier than the female, in *shunga* the quantity of pubes is the same for both, which also removes an element of sexual difference.

The viewer of a work such as Shūsui's first sees two wholes, with only minor bodily cuts and folds. But this is not the end, for segmentation does occur in the picture: the pair hold each other at the arms and legs; she puts her arms around his neck, while he raises himself with hands placed to touch the sides of her chest; the legs twist together at the shins. This was the so-called 'fourth position' (*yotsude*).[65] The bodies are marked into three distinct parts: head, trunk (fully half of which consists of the genitals) and shins. The three units are separated by arms and thighs. What appears to be happening is that, as the two bodies join in sex, they exert a mutually deconstructive power. Coupling brings about a shared loss of integrity. The bodies were whole, but now have broken up in a way that is non-anatomical and entirely the result of the embrace, unrelated to the body's natural creases and curves. Aretino's couples are in generally the same position as Shūsui's, but the effect is utterly different. The strong vertical axis that Shūsui gives to the arms cuts the head from the genitals; the vertical thighs counterpoint this, while giving a kind of visual antinomy of the intact heads in the busy tangle of lower limbs. The heads remain apart, the genitals lock, and the legs collapse into a shared heap. The viewer must infer from this that sex is something that takes the body over and quite literally restructures it. The natural breaks are submerged in new lines, traced reciprocally by the one person on the other, via the act of sex. The couple are literally 'giving themselves' to each other. We see less two people than three shared, composite segments.

120

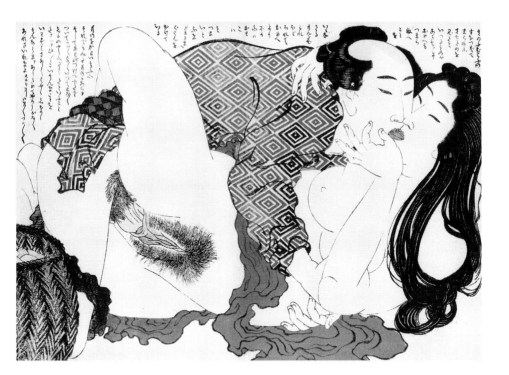

46 Katsushika Hokusai, *Lovers*, multi-coloured woodblock page for *Fukuju sou* (1815).

When clothes are worn, the propensity to deconstruct the individual and fuse it into the partner is also apparent. Clothes are not only included for the thrill of showing their patterning or expense, nor to solicit praise for the performance of the block-cutter in rendering this: they are also there to divide the body segmentally and then fuse it across the couple. Huge swathes of cloth, beneath which no physical shape at all is to be discerned, obliterate the sense of seeing two independent people. There are two heads, two sets of reproductive organs, sometimes two sets of feet and hands, but never two *bodies*. Numerous examples of this manner of depiction occur in *shunga*; in fact, this is the normal way that sex is depicted in the genre.

Kunisada's book of about 1820, *Recitations for the Four Seasons* (*Shiki no nagame*), includes an extreme example of the eradication of the body and its replacement with fused portions (see illus. 12). The cloths (they can hardly be called clothes) swamp the bodies, and the couple grasp hands in a sea of fabric that seems likely otherwise to dissolve them into an indistinguishable mass. The human bodies are not the source of any of the shapes contained in the picture.

The turbulence of cloth has the effect of softening the sense that one partner is coming at, or taking over, the other. The splitting seen in Shūsui is mollified when the mutual divisions are made not by arms and legs but by clothing, enhancing the feeling of commonality and the removal of any adversariality.

Other comparable mechanisms are used by *shunga* artists to weaken the sense of the body, or to lessen its integrity in favour of cross-fusing parts. Hokusai used cloth in this way in *Long Life and Happiness at the Thorny Eaves* (*Fukuju sou*) of 1815, where he produced a patterned kimono written flat across the male body, as if to deny it any epistemological validity (illus. 46). The representation of pattern as flat across folds and pleats was Hokusai's choice; he was able to show how design is effected by bunching where he wished to.

External fabrics and room furnishings contribute to the same effect. Aretino's image was full of exterior fabric, but this did not interfere with, nor even touch, the depicted bodies. In much *shunga*, flynets, sliding doors and screens are used to dismember bodies. Artistic devices are intended to segment and restructure. Note that in most cases where a furnishing divides the bodies, it does so not just anywhere but creates a split between head and genitals. Sometimes there are highly sophisticated, multiple splits, such as in an unidentified loose page from a book illustrated by Rekisen-tei Eiri in the late eighteenth century (illus. 55). The post of an open screen bisects the couple's genital area, partially showing, partially covering a kind of sexual penumbra of pubic hair – it is impossible to tell what is whose. Next comes the semi-translucent substance of the screen itself, behind which only the vaguest notion of body is allowed (one thigh, two arms), lost amongst equally indistinct swathes of cloth. Finally, to the left, are the heads. The viewer moves in four carefully graded steps from the conflated heat of the organs to the separate coolness of the heads. There are no bodies at all.

Once external accessories have assumed power to define the body, any kind of manipulation becomes possible, such as could never be effected in a nude arrangement. *Shunga* depict poses that no body could muster but, in doing so, they send out messages about the body-in-sex. An example is in Utamaro's *Jewelled Hairpin* (*Tama kushige*) of 1801, where we see a couple lying obliquely across the page, feet near the front

47 Kitagawa Utamaro, *Lovers*, multi-coloured woodblock page from *Tama kushige* (1801).

48 Utagawa Hiroshige, *Lovers under the Moon*, multi-coloured woodblock page from a *shunga* album, *Haru no yahan* (c. 1851).

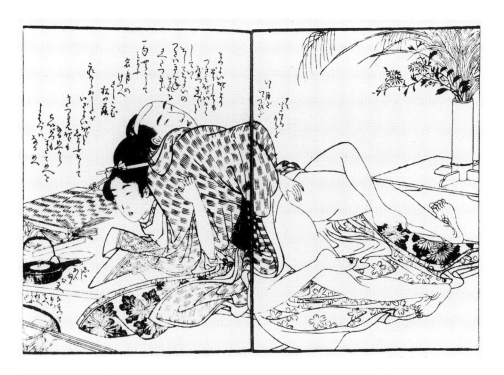

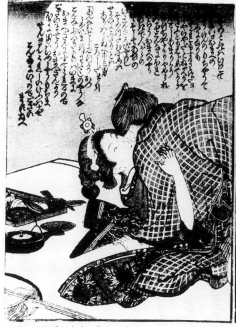
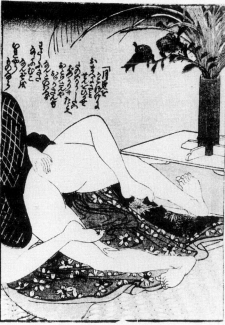

123

and to the right, shoulders to the left and rear (illus.47). The woman is on her back with head turned to the right; the man lies between her legs, facing left. The pose is contortionistic. But the mass of pulled-up cloth dividing legs and buttocks from heads hinders realization of this and discourages the viewer's inquisitiveness: the need to ask how bodies can manage this, or what line must be traced by their backbones, is deliberately obviated.

Hayashi Yoshikazu has intriguingly revealed the later history of Utamaro's picture.[66] Fifty years on, Hiroshige borrowed it for his *Midnight in Spring* (*Haru no yahan*) of about 1851 (illus. 48). The two images are virtually identical except for a large moon, now appearing to the left, befitting Hiroshige's title. The woman also wears more elaborate hairpins, suiting the prevailing style. The man's kimono has a new pattern (though an identical cut). But Hiroshige's main alteration is to the heads: the woman faces 90 degrees left of where Utamaro had shown her, while the man has turned fully 180 degrees.

Why did Hiroshige borrow this picture and why, in borrowing it, did he change it? It seems unlikely, in view of his enormously prolific output, that Hiroshige was just sparing himself labour. He was happy enough to fill the rest of the book with his own compositions (one other page is taken from Utamaro). I surmise that Hiroshige was deliberately referring back to an original he expected his readers to know. If so, then (second question): Was he giving his readers a kind of puzzle to solve, as they remembered having seen the construction somewhere and went to look for it? Hiroshige's adaptation makes sense as a riddle, coupled with clues. But at the same time it is also a rationalization of Utamaro's original. Hiroshige has given the man's body more substance than Utamaro allowed, such that the checkered lines now bend at the sleeves; both these peoples' vertebrae look plausibly joined. Why this move towards anatomical realism? As we shall see in the concluding chapter of this book, just as the history of Edo *shunga* has a beginning, it also has an end, and in the second quarter of the nineteenth century great changes occurred in the genre. Bodies were to lose their looseness and become fixed, and the surrender of self that had defined the earlier pictures disappeared in favour of more brutal personal wholes.

What is odd is not that the period of the divided body came to an end, but that it existed at all, within the field of pornographic images. Twisting and playing with the body might not be peculiar in abstract or symbolistic genres, but this is one that arouses the viewer sexually. It is within the explicit terms of sex that *shunga* propose union as being about the loss of body. Each part will be logically entwined – head with head, thigh with thigh, and of course loin with loin – but these do not form wholes. This is not a regime known to most pornography, either in Japan or elsewhere. Hiroshige was aware of standing at the end of a *shunga* tradition that had reached its peak in the time of Utamaro. In 'quoting' the earlier artist, he invited the reader's meditation on changes in the nature of the pornographic genre, on the status of the body as it had once been and as it had become.

SHUNGA BOOKS

Most *shunga* appeared in book form. The material presence of the book was an important aspect of how the image worked and was something that the artist had to be aware of as he made his imagery. Deluxe albums were bound down one side, so that a full colour page appeared. The run of pictures, however, were printed on two separate sheets, half on either one, and were bound down the central gap. The two sections were held within the line of a frame, with a gutter between. Artists made use of this in the organization of pictures. The book format could be enlisted to aid in deconstruction of the body and its reassembly on other terms, just as cloth and furnishings were. In Utamaro's and Hiroshige's images, the naked legs and (partially seen) organs are on the right-hand side, after which the picture is forced into a hiatus, only to pick up again on the next page, inside the ensuing frame. The right side is the first to be read in the north-east Asian system of viewing, and it contains the nakedness and the sexual aspect; the left has only the dressed bodies and faces (with a minute fraction of the woman's knee).

Pictures were designed whole, but readers who understood book-binding would be aware that they were physically halved for block carving and remained divided until they were sewn together. The bodies literally had to be split in the process of turning them into pictures in a book. Their joining

at loins and heads is close (Hokusai made it closer by adding a kiss), but no connecting backbone links the parts together.

It is necessary to restore the gutter to our consideration of Edo-period book illustrations. Publishers of modern reproductions sometimes elide the two halves, which may make the pictures more palatable to today's viewer but interferes with the rhetorical stance. In Kunisada's *Recitations*, it is as much the gutter as the clothing that threatens to divide the pair; in Terasawa Masatsugu's *Twist of Figured Cloth* (*Aya no odamaki*) the suddenly-appearing couple who intrude on the masturbating Sukejirō open a screen almost coterminous with the page-break (see illus. 11). We will see other examples in later figures.

THE MEANING OF SEGMENTATION

Segmentation, especially of the head from the genitals, is sustained across such a large amount of *shunga* that we are forced to conclude it was a matter of artistic policy.

Where unsanctioned relationships are shown (such as a wife copulating with someone other than her husband), division may make the immorality of the act less culpable. Kunisada also used this in a page of his *Viewing Forms in the Four Seasons* (*Shiki no sugatami*), where the viewer sees a woman's head (and mind) still in bed with her rightful partner, while her genitals – divided by the netting – are outside (illus. 49). Although she is aware of what she does, the status of her sexual act, sectioned off from her head, seems dreamlike, for mental and bodily zones do not match. Pictorially, she is doing nothing wrong.

There may be more. I have suggested that these divisions are intended to diminish the power of the picture to present sex as adversarial. I am also inclined to find a further attempt to counteract a danger, inherent in pornography, of a battle emerging between the partners. One person is penetrating and the other is penetrated. We have seen how Edo society was alert to the power differentials of the two roles. Since *shunga* often show brothel scenes in which one person was paying and the other being paid, the imbalance of power could be grotesque. Those who visited prostitutes knew that, acting aside (and many prostitutes *were* actors), desire was little felt by the one doing it for money. In most contexts, the

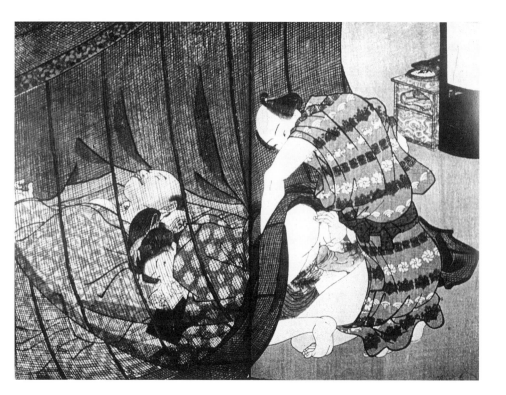

49 Utagawa
Kunisada, *Lovers
and Sleeping
Husband*, multi-
coloured wood-
block page from
Shiki no sugatami
(1842).

penis had to bribe its way into the vagina or anus. By contrast, the head is that part of the body where power is determined by intelligence and wit. Certainly it was the myth of the Yoshiwara that a woman's desirability was indexed by her sparkle and aplomb (*hari*), by which she could turn the tables on the client, for all her lower position. This again was integral to the Yoshiwara contract. *Shunga* show an act of sex in which the penetrator is in control but, at the same time, a female has the capacity to dominate mentally. The body that links these two poles is barely given at all.

I do not conclude from any of the above that Edo love-making was egalitarian. It was not, either in domestic life or in the 'five blocks' or 'two blocks'. The compensatory urge in pornography made *shunga* falsify facts to produce images that inclined the viewer to think for just a moment that all was well, that sex was never contrary to anyone's wish, in sum, that everyone was happily available for intercourse and was not abused and could always have his or her say. The eighteenth-century masturbator seemed to want to feel this. As we shall see, in the nineteenth century the situation

changed, and compulsion and rape begin to usurp the pornographic space and, with them, a pulling apart of the bodies that configure the pair.

As heads and organs were counterposed across the couples, note how they were also given equivalent status. The extraordinary exaggeration of genitals in *shunga* is often commented upon. But this is not, in Steiner's phrase, mere 'phallic prowess', for vaginas are exaggerated too. Above I suggested one reason for distended organs (they are the only sexual characteristics), but a second can be added: genitals and heads are matched in size, such that organs are not merely large, but identical in dimension with the cranium. *Shunga* wishes to propose an egalitarianism of thought and sex-drive.

4 Symbols in *Shunga*

Having looked in the last chapter at the overall construction of the human body in *shunga*, we will now turn to a consideration of the ancillary elements contained in pictures. Any pornographic image is bound to be founded on a representation of the body, but it will also include enlivening, or scene-setting, elements from interior or outside space. These additional elements help the viewer to construct a relationship between sex and the larger world. Different cultures construe this link differently. That created by *shunga* is specific to a time and place.

Shunga are so numerous and appear in so many media, types and styles that it may seem rash to postulate overall tendencies within the parerga, that is, the subsidiary elements, of the pictures. But I believe a pattern can be constructed. Common elements include, for example, musical instruments, tea or tobacco utensils, writing equipment or books; plants may be in the room, while garden or street scenes may be visible outside; motifs may appear on clothing. There are also the tertiary representational levels of pictures within pictures, such as images drawn on screens, or hanging scrolls within the work.

Some elements are consciously introduced as symbols; sometimes there are more haphazard referents – apparently chance items included to give the site of sex the feeling of a real place. But in all cases objects have meaning. The former category, symbols, must be traced to their roots, which will lie in earlier pictures or in literature and folklore; the latter can be read too, for they ripple across fields of signification which – even if ill-defined – created the acceptable purview for *shunga*. Together, the two types of extraneous materials (which actually overlap) go towards building what we might call a discursive space for sex to occupy.

YIN AND YANG SYMBOLS

Sex had one overriding symbol in Edo culture: it was associated with water. The extent to which scenes of erotic encounter are linked to water is striking, and a quick flip through the illustrations in this book will reveal how often water is present; significant numbers of pictures within the picture are of waves. It is hard to know whether brothels really had such designs on their screens, or whether they would be brought out in planned sexual contexts (such as marriage beds). If they were, it would open up an interesting new line of analysis for the many extant paintings of flowing water, some of which are proudly displayed in major museums around the world. Screens of water are known to have been displayed in rooms at other 'female' moments, such as birthing, and perhaps could refer by extension to copulation. Water was the element of *yin*, the feminine, designated as moist, dark and recessive. Sex was discreetly referred to by such *yin* euphemisms as the moment of 'clouds and rain' (*un'u*). Use of an iconography of water extended to figures associated with lakes and falls. To anyone remotely knowledgeable about the cultural tradition, this would lead at once to Li Bo, the Tang-period poet whose verse on viewing a waterfall was famous and who was commonly depicted in the act of looking at a cascade. A page from Ishikawa Toyonobu's *shunga* book of *c.* 1760, *Sexual Sands* (*Iro sunago*), implies that a such a screen might have been deliberately brought out to enhance erotic union (illus. 50). It was only a small step to imagining the Chinese poet being stimulated by the activity taking place and, rather than averting his gaze as here, separating his skirts and adding his own fluid gush. This teasing option was depicted in 1795 by Utamaro in his *Erotic Book: the*

50 Ishikawa Toyonobu, *Lovers and Servant Passing*, monochrome woodblock page from a *shunga* album, *Iro sunago* (*c.* 1750).

51 Kitagawa Utamaro, *Lovers*, monochrome woodblock page from a *shunga* album, *Ehon hitachi obi* (1795).

52 Follower of Keisai Eisen, *O-tsuru and Umejirō*, multi-coloured woodblock page from Shikitei Sanba ('Kōtei Shūjin'), *Nishikigi sōshi* (c. 1825).

Hitachi Sash (*Ehon hitachi obi*), where a standing screen painted with the poet shows him equipped with erection; it is punningly inscribed (as his real portraits often were) 'Li Bo's one shot inspired a hundred' – meaning his verse on the waterfall initiated a slew of similar verses, although here 'one shot' (*ippon*) means something different (illus. 51). This conceit was copied in the 1830s by an anonymous artist in the Eisen line, for the *Brocade Tree* (*Nishikigi sōshi*), which has the same inscription (illus. 52).[1]

The term 'water trade' (*mizu-shōbai*) is still used to refer to the entertainment world and specifically to the centres of commercial sex, which, as we know, were also referred to as the Floating World, being, as it were, pillowed on water. The Floating World was opposed to the fixed domain of officialdom and civic life, which was held to be masculine, or *yang*, and pertained to dryness, light and protrusion. Asai Ryōi's *Tales of the Floating World* (*Ukiyo monogatari*) was published *c.* 1661 and did much to popularize the term; Ryōi defined the mentality of the person who frequented brothels as being 'like a gourd floating on the water'.[2] The hub of the Floating World was Edo's Yoshiwara, and after it was relocated to beyond Asakusa (some four years before Ryōi wrote) it was best reached by boat – hence the scrolls of the River Sumida that Eishi popularized tend to end there (see illus. 22). The traveller could get to the Yoshiwara overland, but the most common way was to be taken by boat, alight at the San'ya Ditch, then walk or be carried to the Great Gateway along a pathway called the Nihon Embankment; originally *nihon* was written to mean 'two paths', denoting that it need not be trodden single file, but this was later rewritten with the meaning 'Japan'.[3] The embankment was raised above marshland, with water visible on either side, on clear nights reflecting the moon (the planet of *yin*). The traveller then turned left and went down a hill called Clothing Slope (Emon-zaka) into the lower, wetter world of the well-clad female, finally crossing into the moated Yoshiwara across more water. It was conventional to depict the Nihon Embankment not only in moonlight (which is how it would have been viewed, since the quarter was only visited by night) but also in the rain – that is, sodden with the elementary force of *yin*. A typical rendition is that of Harunobu's pupil Harushige, later famous under the name Shiba Kōkan (illus. 53). Sunrise on the embankment would

53 Suzuki Harushige (Shiba Kōkan), *Nihon Embankment*, *c.* 1770, multi-coloured woodblock print from the series *Fūryū nana-komachi*.

have been a possible theme (*nihon* literally means 'origin of the sun'), but this was never attempted, for it would have made an absurdity of the symbolism of sex taking place within the pleasure zone.

A traveller boarded his boat to begin this trip at the Willow Bridge near the centre of Edo and ended it at the Looking-back (*Mikaeri*) Willow at the Yoshiwara entrance. The route was bracketed by water-loving (feminine) trees, whose long branches were also said to resemble a woman's tousled hair. In Keishi too, although access to the Shimabara district was not by water, a large old willow graced the entrance and linked the site to the feminine; it was also held that the expression 'willowy waist' (*yanagi-koshi*) to denote slender female hips came from this tree; many *senryū* were written about this.[4]

The association of sex with *yin* was a masculinist notion. It might as well have been argued that the case was the opposite, since for a woman sex would mostly mean associating with *yang*. Here is just another example of how in Edo art males controlled the systems of representation, the dominant modes of expression being phallocratic.

In the early days of Edo, the *yin* aspect of the Yoshiwara led to its depiction in autumn and winter, or the *yin* seasons. This was paired with depiction of the equivalent male district of kabuki at the times of *yang*, i.e. spring and summer. Other cultural constructions supported this division. The Girls' Festival was on the third day of the third month, technically spring but when the weather was still wet and cold, while the Boys' Festival on the fifth day of the fifth month fell after the sun had returned. This sense changed during the late seventeenth century, as the association of female sexuality with cherry blossoms brought the pleasure districts into the orbit of springtime imagery, leaving the *nanshoku* parts of town with summer only. The spring of the Yoshiwara contrasted with the rain of the Nihon Embankment, which implied autumn, since that season was wet and gloomy, as was the visitor in the act of going home to Edo.

NATURAL SYMBOLS

The traditions of sex were old enough to have generated a wealth of established symbols, shared between picture-

makers and writers. Not only was sexual activity represented as taking place at the appropriate season, but this extended to a mapping of extended nature onto the body. Plants and animals were said to pertain to parts of the human form or to stand for its tastes and desires. Certain acts of love might be referred to via vegetal or animal types, with the flora and fauna then said to enjoy a similar sexual thrill to that referred to through it. Symbols were used in pictures to expand the signification of the scene.

Let us be clear though: natural symbols are not the same as 'nature'. I am not proposing a unity of human eroticism with the natural world. I am proposing that *shunga* used constructions of nature as part of their political claims. The plants and animals that figure are in fact notable for being trained and manipulated, not free and loose. Plants are often in gardens or in vases, where they are pruned, cut, pinned, tied and held, and are rarely in 'states of nature'. To the Edo mind, I would maintain, nature was only beautiful in the measure that it was schooled. Wild nature was fearsome. I state this because it is important not to mistake the prevalence of natural entities within *shunga* as somehow indicating an Edo sex that was specially natural, and so what happened later as a decline from this symbiosis.

By way of reinforcing the warning that Edo nature is about construction, let us consider a print by Harunobu from the book *Eight Views of the Parlour, Done Elegantly* (*Fūryū zashiki hakkei*) of c. 1768 (illus. 56). Each scene parodies ('makes elegant') one of the Eight Views of the Xiao and Xang, or the aspects of that Chinese beauty spot celebrated in painting and poetry of the Song period (960–1279). This is scene three, which is properly 'autumn moon over a ravine' but has become, as the inscription indicates, Autumn Moon of the Mirror Stand. It is autumn when the moon is at its best, although the peony on the screen indoors would suggest late spring; it is still warm enough for the couple to sit by the open door of the verandah, the woman half naked. The room is tight and compressed: just the sort of reduced space in which Edoites resided. The half-closed screens increase the sense of constriction, and the couple is pressed into a small upright gap. The peony too flourishes in a constrained, unpropitious site. The woman is doing her hair, binding and controlling her tresses (unlike the natural waving of willow branches).

Control and discipline are essential in this world, and an unschooled freedom is quite impossible.

A second plant, a rock bamboo (*iwatake*), is seen just outside the screens, closer to the viewer. It is invisible to the woman, although like her it is upright, and it is held in place by a frame; its stems try to flop over but cannot. The man holds the woman in a similar way.

Plant and humanity are trained identically into decorative modes of behaviour that, precisely, do *not* come to them naturally. And it is males who do the training. Harunobu presents the man as undergoing no equivalent regime of control: he is relaxed, she is not. This is less a feature of Edo male socialization (which was as rigid as for the female) than an aspect of erotic images made for a male gaze. The Edo period was one of many to regard female sexuality as more rapacious and more dangerous than that of the male (Saikaku's stories are full of men reduced to wrecks by their women's exorbitant demands) and, accordingly, discipline is shown as more heavy on the female to allow the man his dominance. Having ensured the clipping of her sexuality, Harunobu's man is able to arouse her with impunity.

CHERRY AND PLUM

Among standard, recognized symbols, the most famous and obvious was the cherry blossom. This had been familiar in antique times but was revived in Edo, not least in the Yoshiwara where so much historical myth was appropriated and recycled. The associational relocation of the Yoshiwara from autumn to spring made it quintessentially cherry-blossom time. The shift seems to have coincided with the beginnings of *shunga* in the career of Hishikawa Moronobu, so that there are few autumn- or winter-based pornographic works. The main street of the Yoshiwara, leading from the Great Gateway to the T-junction at the end of the enclosure, called Naka-no-chō, was annually decked with big branches, brought in at blossom time from the surrounding hills, making the street alive with cherry. This was one of the hallmarks of the street and consequently of the whole quarter. There are many *senryū* on this theme:

54 Anon., *Whose Sleeves?*, late 18th century, left-hand of a pair of six-fold screens (right screen lost).

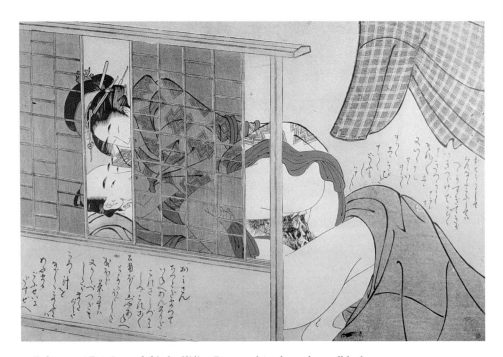

55 Rekisen-tei Eiri, *Lovers behind a Sliding Door*, multi-coloured woodblock
page from an untitled *shunga* album (*c.* 1785).

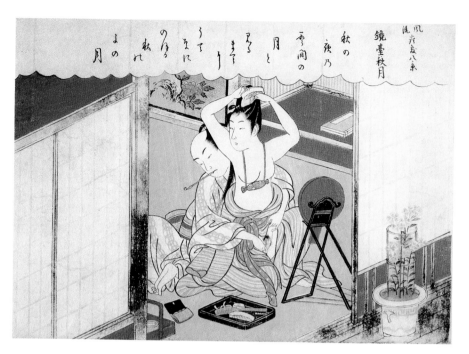

56 Suzuki Harunobu, *Autumn Moon of the Mirror Stand*, multi-coloured page from a *shunga* album, *Fūryū zashiki hakkei* (c. 1768).

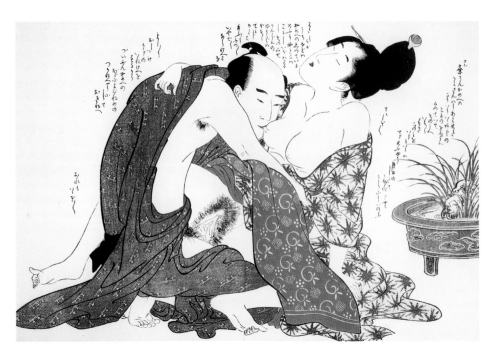

57 Kitagawa Utamaro, *Lovers in Summer*, multi-coloured woodblock page
from Intō-tei no Aruji (Shikitei Sanba?), *Negai no itoguchi* (1799).

58 Ogata Kōrin, *Rock Azalea*, *c.* 1700, hanging scroll, colour and ink on paper.

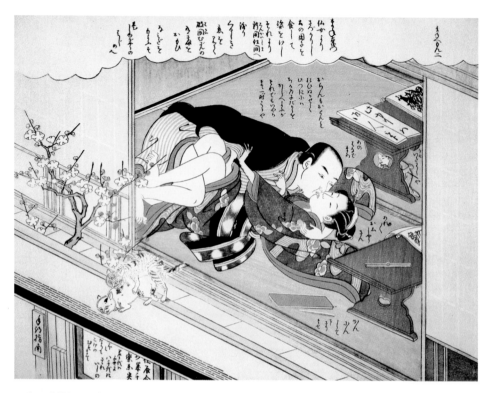

59 Suzuki Harunobu, *Lovers with Rutting Cats*, multi-coloured woodblock
page from Komatsu-ya Hyakki, *Fūryū kōshoku maneemon* (1765).

60 Inagaki Tsurujo, *Women Manipulating a Glove Puppet*, *c.* 1770, hanging scroll, colour on paper.

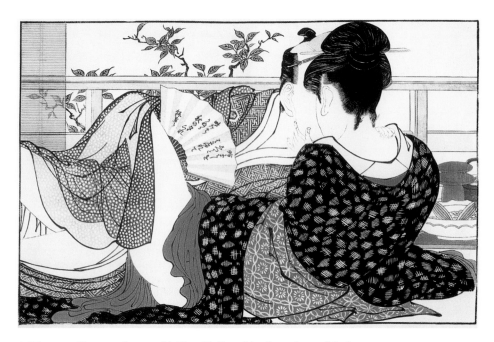

61 Kitagawa Utamaro, *Lovers with Clam Shell*, multi-coloured woodblock
page from a *shunga* album, *Utamakura* (1788).

Year on year, age on age
To call the customers in
They plant them out.

The cherries
Pull people together
At the Yoshiwara.

In the Yoshiwara
Cherries too
Bud on young trees.[5]

The worlds of representation were able to do what the real world could not and defy the actual cycle of the seasons, so that the Yoshiwara was turned into a place of permanent springtime, just as the Nihon Embankment was a place of perpetual autumn (see illus. 22, 53). In Floating World pictures it is almost unknown for either to appear in any other season. On the rare occasions when Yoshiwara women were depicted outside the pale of their district, on a parade to Mukōjima or Ueno, for example, they were shown taking their season with them, followed on their route by blossoms; this convention was only interrupted by a truly overriding reason, such as in a New Year's picture, or a view of summery cooling off by the Sumida.

The symbolism of the cherry is too well known to need much repetition here, and it is repeatedly discussed both in Japan and elsewhere with reference to what are problematically called 'Japanese sensibilities'. The point is, the prettiness of the fine, pure-looking blossoms is short-lived. The aesthetic is coupled with a sense of brevity on the branches and hence of the impermanence (mujō) of beauty. Such was the definition of the loveliness of young women.

In early contexts, the bringing of cherry blossom into the interior of a domestic space was a way of invoking the transience of beauty; from this grew the indication of love, and thence of a sexual act. Breaking a branch stood for the culling of youth and the taking of it into one's own possession before it fell apart. The more hearty nuance of gathering rosebuds was already known in classical times, and a standard referent is in the anthology of *Tales of the Embankment Counsellor* (*Tsutsumi chūnagon monogatari*), thought to have been composed about 1100; one episode is entitled 'The Minor Captain

who Plucked Cherry Blossom' (*Hanazakura oru shōshō*). In it, the plucking, or literally 'breaking' (*oru*), of the cherry blossom denotes the act of seduction, as the Minor Captain kidnaps a girl to sleep with (in fact, the attempt is a failure as he mistakenly seizes her aged nurse).[6] This nuance on the aetiolating cherry blossom was not forgotten in Edo times. Note that Yoshiwara's main street, Naka-no-chō, was not planted with cherry trees, as it easily could have been, but was adorned instead with branches cut and brought in from outside. This meant that the visitor there never saw cherry trees that were not in bloom, but it also ensured that the Yoshiwara became the consummate site of 'broken' branches.

The bestowing of plants as presents was common practice, and fitted into the rhetoric of advancing one's suit, of initiating communications or of giving thanks for favours already granted. Plants could cover the fairly basic motivation of sexual desire with a sugaring of refinement. The *Ise Anthology* (*Ise shū*), of the ninth century makes this clear, where the plant in question is the plum. Lady Ise was shown a painted screen of 'a man meeting a woman and making overtures' and was asked to imagine him 'using plum blossoms as a pretext for making advances' and to invent an exchange of poems. She wrote for him,

> Thinking to meet again
> The one I saw,
> Not one day passes
> When I do not come to where
> The plum blossoms bloomed;

Her fictive woman replied,

> They are plum blossoms
> That you abandoned
> After one short visit,
> And so you may hear that they have scattered,
> But you cannot possibly want to see them now.[7]

Since plum is a winter-flowering tree, it suited the chill aspect of this liaison. There is an additional reason for selection of the plum, and one that remained alive in Edo times: it was considered a male blossom, equivalent to the 'female' cherry. It was noticed that, whereas a young cherry gave the best blossoms, a gnarled old tree was best for plums. This equated with

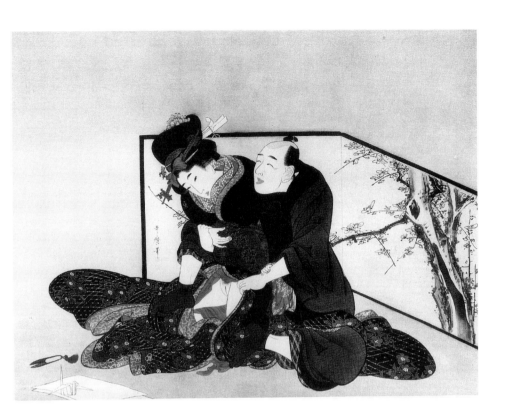

62 Kitagawa
Utamaro, *Man
Seducing a Young
Woman*, 1801–4,
hanging scroll,
colour on silk.

the phallocratic pretence that a young girl afforded the best
sex, whereas males improved with age. The age of the giver of
the plum in the Ise verse is left unstated, but it could be quite
advanced without the imagery collapsing; by contrast, an
older women giving (or 'being') a cherry was the stuff of
humiliation and ridicule (as the Minor Captain knew when he
unmasked the nurse). Utamaro produced a work of an elderly
man with a younger girl shortly after 1800, backed by a fine,
mature, flowering plum (illus. 62). It was the fantasy of older
men to ripen with age and to satisfy women more than youths
could hope to, and it was natural for them to use pictures (and
pictures within pictures) to sustain this implausible con-
tention. As a one-off painting, this may have been commis-
sioned by the man shown; the origami crane, symbolic of
longevity, enhances his thickening capacity. Utamaro has put
the plum itself into the tertiary level of a picture within a pic-
ture, as if the man had brought the screen out prior to engag-
ing with the woman, or as if she had set it there to indicate her
acceptance of the desirability of older men.

147

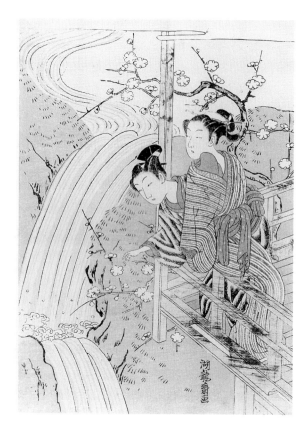

63 Isoda Koryūsai, *Boy Plucking Plum-blossom with Girl*, 1770s, multi-coloured woodblock print.

If the plum most often denoted an adult man, this created the need for a symbol of the younger male. In practice, cherry could also refer to a boy's childish beauty, since that too would not last. The male made a symbolic evolution from this stage to that of the more powerfully libidinous plum, but the female was condemned after the cherry simply to fall away. There is no flower for the older woman.

The contrast of the cherry and the plum also occurs in *nan-shoku* contexts, where the partners were conceived of as an adult man and a boy. A *haikai* (*haiku*) from an anthology of 1672, *Kai ōi*, has this pairing.

> The older man requests a plum,
> And for the boy,
> A cherry[8]

The verse was commented upon unfavourably by the great Bashō (who thought it contrived) but who was nevertheless

sent by it into a musing on his own experiences of *nanshoku*. One hardly needs a clearer instance of how plant symbols serve to naturalize a domain of sex which is both polemical and unequal. Ideological claims are advanced, and then hidden, to serve those in positions of power. In *nanshoku shunga*, plums are held by the younger partner, put on his clothing, or received and arranged to indicate something similar to the plum screen in Utamaro's painting.

Shunga do not often depict older people, preferring to keep that persona apart, no doubt, for the reader. Thus a plum can sometimes stand for male sexuality itself, and attractive youths will 'break' it to offer to another man or a woman (illus. 63); girls can also 'break' plum as a signal that they are open to sexual advances by their peers.

IRIS AND NARCISSUS

The cherry was predominantly, if not exclusively, the referent for sexualized women, while the plum was used for older men. The need for a clearer pointer to young men, as both active sexual partners or as the desired objects of others, led to the adoption of two further plants (often conflated and confused), the iris and the narcissus.[9] Since these bloom in the fifth lunar month, the fifth day of which was the Boys' Festival, they had a long association with the allure of the male sex and indeed were part of the festival decorations. Boys are commonly shown in Floating World contexts standing by iris or narcissus ponds, or holding stems of the plants, or else wearing clothing decorated with them.

A painting by Yamazaki Joryū shows such a scene (illus. 64). The boy is evidently an actor since he wears the hat of that trade, used to disguise the government-enforced shaven forelock of adult males (this pretended boyhood was marketable both on and off the stage). The hat should be purple, but in Joryū's painting, the pigment has turned brown. The boy's kimono is decorated with white plum, while in his hand he holds a narcissus. He is attractive, certainly sexual, but his identity is unknown, and there are no crests or other identifying markings on his clothes or on the painting. This absence of a clear identity is common in paintings for, unlike prints, paintings were commissioned, and the person would be evident enough to the one who had ordered it without labelling.

149

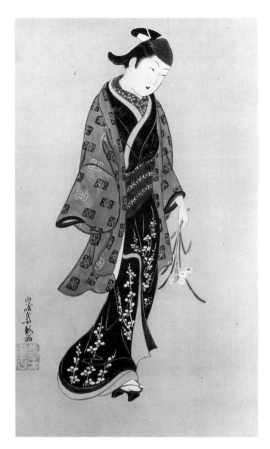

64 Yamazaki Joryū, *Kabuki Actor Holding Irises*, c. 1725, hanging scroll, colour on paper.

In most cases, it is no longer possible to reconstruct name and biography.

The flower is inverted, since that is the best way to carry one before placing it in water. The buyer of this work would look at a boy bearing his own sexuality as a gift, new-broken, to be placed in some shared place, probably before bedding. This buyer must have desired, and probably had, sexual relations with this particular boy and so in every sense had purchased him, retaining in two dimensions a contract that was on-going, or had terminated, in three. The 'double buyer' wants to imagine the boy as a willing partner, not one whose repugnance is overcome only by financial reward, and so has directed the artist to show him with his flower, joyfully given.

The artist is one of the rare female Floating World painters. This would have been recognizable to anyone who read her signature, since the *jo-* of Joryū indicates 'woman' (it was customary for women interloping into 'male' spheres to make

themselves instantly isolatable in this way).[10] Little is known of Joryū. Her seal reads 'Michinobu', with the first two syllables written in characters usually meaning 'three thousand' (*michi*); this suggests a possible link to Tadaoka Michiko, a painter employed as maid by the wife of the daimyo of Sendai.[11] Was the patron also a woman? Do we here have an example of an all-female production of a sexualized image of a man? Did women independently commission such pictures? Or did a man commission it? If so, why should he have been thought best to have it produced by a female hand? Regrettably, none of these questions can be answered, and we must let the matter rest with the frustrating observation that we do not know where the boy, carrying his sexuality in his hand, is bound.

Iris and narcissus stand for young males in any context, but in a Floating World context, or in *shunga*, this will contract to an indication of their sexuality and libidinous value and would often mean males whose sex was for sale. Women were devotees of the kabuki theatre, and there were celebrated love affairs, lubricated by transfer of funds, between senior ladies – even in one instance a lady-in-waiting to the shogun's mother – and rentable males employed in the Floating World.[12] The more common classes of women could easily attend kabuki and form links with actors, and famous in the 1770s was the liaison between Segawa Kikunojō and the attractive teashop waitress Osen. There are pictures of women – more often girls than moneyed matrons – 'breaking' iris stems.

NANSHOKU AND PLANTS

Apportionment of domestic duties put control of cash into the hands of males more often than of females, so that a client able to buy male sexual services was more commonly another male than a female. The employment of actors in extra-theatrical roles was conceived as primarily for the benefit of *nanshoku* enthusiasts and only secondarily for women. In the commissioning and owning of pictures too, men rather than women appear to have taken charge, so that it is reasonable to postulate the representation of eroticized youths as intended for a male gaze.

There were specific *nanshoku* signifiers. The most famous

was the chrysanthemum. The symbolic rationale for this derived not from anything seasonal but was arrived at from the flower's supposed resemblance to an anus, yellow-to-white, tight, and gathered in a small bud, like a boy before he was blemished by hair or by the perennial problem in *nan-shoku* lore (if not fact) – haemorrhoids. The chrysanthemum was not exactly subtle, indeed it was quite crude. The equation of the flower with the anus removed the likelihood of its being much use in signifying females (although it is, theoretically, possible, allowing for female anal penetration). Cherry, plum, iris and narcissus refer to sexuality in general terms and need not indicate subordination. The crudity of the chrysanthemum as symbol lies in the fact that it refers to the boy exclusively as object or gateway to pleasure for another (usually paying) person. Anal intercourse may bring pleasure to the penetrated too, but, in the Edo context, this was seen as limited temporally, for when the boy came of age or amassed the financial wherewithal to leave prostitution and take control of himself, he would no longer seek his sexual pleasure that way but would become a penetrator. The chrysanthemum is thus the symbol of a boy possessed, not possessing.

Politically, anal and vaginal penetration were different. As we shall see later in this chapter, *shunga* regularly adopted pictorial strategies to give an appearance of equality between vaginal and penile ecstasy, such that a penetrated woman and a penetrating man were put on a notional par. But *shunga* never tried to give the penetrated boy the status of the penetrating man. Floating World pictures of boys 'breaking' chrysanthemums exist too, where the plucker is accepting his role, providing himself as a gift to a man, but rarely is his comportment in the sexual act suggestive of bliss (he will frequently not even be shown erect). An interesting print by Harunobu shows a girl in the act of plucking a chrysanthemum, and it is one of the rare instances where the anal motif of this flower enters the sphere of sexualized females; somewhat implausibly, the plant grows on a riverbank (illus. 65). Closer inspection, however, reveals that this work is a ruse: it is the genre known today as *mitate* or 'analogue'; an old, male-based story is retold with eroticized girls taking the parts of the men of yore. Here the story is of Ju Citong, 'the beloved chrysanthemum child', lover of the eleventh-century-BC king Mu of the Zhou, who drank the flower's moisture and

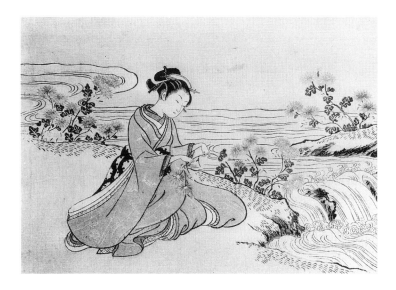

retained his youth perpetually.[13] The viewer of the print
would grasp the reference and read in it the desire to retain
the possessed in a permanent state of pliant infantility.

Being a natural life form with a seasonal cycle, the chrysan-
themum appeared in some seasons and not in others.
Nanshoku episodes or stories would appropriately be set at the
end of summer (ninth lunar month) when the flowers came
out, just as spring was the setting for generic sex with women.
Since ancient times the Chrysanthemum Festival had been
held on the ninth day of the ninth month, and references to
this could serve to clarify, or augment, the erotic orientation of
a story. Ueda Akinari did as much in a short work entitled the
'Chrysanthemum Pledge' (*Kikuka no chigiri*) in his famous
supernatural collection, *Tales of a Rainy Moon* (*Ugetsu mono-
gatari*), completed in 1775.[14] The tale is set during the wars of
the fifteenth century and centres on two friends, a scholar
called Takebe Samon and a samurai, Akana Sōemon. Neither
man's age is given, but the samurai is said to be younger and
is presumably the penetrated one – perhaps his family name,
literally 'red hole', denotes this. The two men make a pledge
to meet at the Chrysanthemum Festival one year hence, then
Sōemon goes off to fight; imprisoned, he is detained too long
to keep the pact so kills himself in order to travel the great dis-
tance as a ghost. (It is important that Sōemon is not a good sol-
dier and so remains proper for the passive sexual role, which
he would have outgrown had his martial valour matured.) In

153

terms of plot, there is no reason for the ninth of the ninth to be selected as the time of reunion, for any day would have done. Akinari does this to make obvious what was otherwise only alluded to, namely that this was a story about sexual interest, not just friendship. The couple is never specifically said to have slept together, and the wilful reader who wished to think they had not was able to do so (as still happens), while the more alert reader knew otherwise.

The problematic question of the mutuality of sexual fulfilment suggested by the chrysanthemum may account for its substitution in many instances by a second plant, the azalea, and specifically the 'rock azalea' (*iwa-tsutsuji*). We have already seen a 'rock' peony and a 'rock' bamboo (see illus. 56), and a rocky bed generally suggested resilience and endurance in love or in anything else. Azaleas do flourish in relatively bleak environments, so they suited the plaintive lover well. Properly, the rock azalea is a separate genus that goes by the unpoetic English name of bilberry (*Vaccinium praestans*). Its association with male love came from its being a summer (*yang*) plant, although there were many of these. The overtones were set by a famous verse contained in the first government-sponsored poetic volume, compiled in 905, the *Anthology of Vernacular Verses Ancient and Modern* (*Kokin wakashū*), in the 'love' section:

> When my feelings go out,
> Like Mt Tokiwa,
> On which a rock azalea grows
> I speak not,
> to my love.[15]

The poet thinks of love but, like an azalea among hostile rock, he will say nothing. The plant serves as a seasonal signifer, which a verse in Japanese (*waka*) must have to meet the criteria of the genre, but it also denoted masculine fortitude via a pun: *iwa-tsutsuji* is like the word *iwaji* ('do not say') and the continuative verb ending (*-tsutsu*), like the English '-ing'. The sound forms an inarticulate sussuration – not quite speech, more like the rustle of petals. The first line is also open to plural interpretations, for the toponym Tokiwa can separate into halves, *toki wa*, signifying something like 'when', and it was used to invoke 'if only'.

The anthology gave this verse as anonymous, and the

gender of the recipient is also unclear. But conventionally it was attributed to a monk called Shinga, who was held to have addressed it to the still-young Ariwara no Narihira, one of antiquity's great lovers. Shinga was a disciple of Kōbō Daishi, the prelate said to have introduced *nanshoku* from Tang China in 806 for the benefit of Japanese monks who had never known male–male love before, but took to it avidly for tantric practices.[16] The rock azalea was used by one of Edo's foremost literary scholars, Kitamura Kigin, in 1676: three years after his revolutionary analysis of the *Tale of Genji*, he published an anthology of *nanshoku* verses culled from classical texts, giving it the title *Rock Azalea* (*Iwa-tsutsuji*).[17] The plant there-after was the chief icon of *nanshoku*. In 1775 Ōta Nanpo updated Kigin's selection and republished it years later in his anthology *Thirty Spokes Make One Wheel* (*Misonoya*) of 1803; Nanpo also included a dig at the classical verse collection, *Anthology of Vernacular Verses Ancient and Modern*, and its cele-brated preface, with a piece of writing taking the word 'anthology of verses' (*wakashū*) and rewriting it with the homonym 'boys'.[18]

SWEET FLAG

The plants we have seen thus far appear both in literary and pictorial manifestations. Pictures, though, are able to support their own systems of symbolism independently of parallels in writing. Some plants appear in *shunga* with what is clearly a sexual meaning but cannot be found analogously in writing. One such is the sweet flag (*sekishō*). It was commonly brought indoors for decoration and, although a summer plant, grows in water and so could have easy sexual nuances of *yin*. The plant has an obvious similarity to pubic hair and, through the water, is associated with that of the female.

Sweet flag appears in many Floating World contexts. As a plant of the heat, it allowed artists to show figures with loose and open clothes, revealing breasts and thighs. A print by Utamaro from the series *Three Classes of Young Female Behaviour* (*Fūzoku sandan musume*) shows two languid women beside a screen adorned with another natural symbol (though hardly a *shunga* one, since paired mandarin ducks designate the constancy of matrimonial devotion – anathema to the devotee of the Floating World) (illus. 66). The crouching

person has a fan that seems to be painted with chrysan-
themums. Would these beckon the end of summer, with its
coolness, similar to the breezy effect of the gauze draped over
the screen? They can hardly stand for an anus, unless it is to
suggest a competition with the flag in the basin; the women
look fondly at the flag while cursorily wagging the fan, as if
this is a rivalry the boy is sure to lose.

The sweet flag figured in the Utamaro print used on the
cover of *Le Japon artistique* (see illus. 41). The child's sexual
precocity in reaching for his mother's pubic region and not
her teat makes the sweet flag appropriate. The same effect is to
be seen in another Utamaro print, from the series *Modern
Beauties in Summer Clothing* (*Natsu ishō tōsei bijin*) (illus. 67).
The woman seems to be giving the child a lesson less in
botany than in what will be expected of him in adulthood. In
another print Utamaro shows a mother asleep, overcome by
the summer heat, while her little boy grabs the sweet flags and
wrenches them out of the basin as if determined, before his
time, to understand what lies beneath them (illus. 68).

66 Kitagawa
Utamaro, *Picture of
the Middle Class*,
multi-coloured
woodblock print
from the series
*Fūzoku sandan
musume, c. 1795.*

67 Kitagawa
Utamaro, *Suited to
Bold Designs Stocked
by the Kame-ya*,
multi-coloured
woodblock print
from the series
Natsu ishō tōsei bijin
(*c.* 1804-6).

68 Kitagawa Utamaro, *Goldfish*, multi-coloured woodblock print from the series *Fūryū ko-dakara awase*, c. 1802.

Any indoor water plant could be turned into a domestic sex symbol by the Floating World artist, and Utamaro himself did this when he depicted an indeterminate weed in a porno-graphic book of 1799, *Unravelling the Thread of Desire* (*Negai no itoguchi*) (illus. 57). To make the symbolism clearer, a vagina-like rock rises up to protrude from the root area and separate the grasses.

Plants exist in the open fields and it is possible that, even though certain ones are used to symbolize something sexual on one occasion, they can still denote nothing at all – or some-thing quite innocent – on another. Plums and cherries, partic-ularly, have a wide range of meaning. Japanese symbolism (unlike that of the West, in my opinion) does not necessarily or permanently link a signifier to its signified. To claim that every picture of a sweet flag means a pudendum – or, even worse, that every painted plum denotes the power of the penis – would be a travesty of Japanese art. To paraphrase Freud, sometimes a plum, sweet flag or even a rock azalea is only a plum, flag or azalea. Sometimes it is genuinely hard to

tell how far to go, and debate could legitimately flourish (although in the current state of torpor in *shunga* studies it generally doesn't). Ogata Kōrin's early eighteenth-century rock azalea by a stream (regarded as a masterpiece and included in many survey histories of Japanese art) cannot definitely be called either libidinous or cleared as sexually unweighted (illus. 58). Of course someone could place sweet flag in their home without provoking titters. But we are not talking of the flowers *per se*, but of their inclusion in pictures, and moreover in pictures in the Floating World genre (Kōrin's is an exception) whose primary feature was to engage with the erotic. If an artist put a certain plant in a picture, or was told by a patron to do so, we are duty bound to ponder its specific weight of meaning.

ANIMALS AND SEX

The scope of many erotic pictures is expanded by inclusion of animals, often in copulatory poses. The animal symbolism used in much academic painting (viz. ducks, which symbolized fidelity and were offered as wedding gifts) lingered on reproduction and the care with which non-human life forms reared their young, so that it was not a large step to move from the paintings of braces of pheasants or prides of leopards that adorned formal interior spaces to the copulatory ones in *shunga*. Plant reproduction may not have been well understood, but that of animals was hardly obscure, and many mammals engaged in demonstrably similar activities to humans, sometimes indeed with them. If animals simply stopped what they were doing to copulate at will, then why need humans confine themselves to specific times and places? Animals legitimated a casual, snatched, irregular sex, but the animals featured were domesticated (i.e. valuable, schooled, not brutish) rather than wild. In this, pornographic images are unlike those of academic painting, which preferred auspicious or 'lofty' beasts. The fauna around the eighteenth-century city-dweller amplified and approved the act of sex. Bestiality appears in erotica, but more often it is the tension of sex radiating from humans that animals absorb (illus. 59). Neither science nor observation can provide evidence for animals reacting to human intercourse in this way, but if the sight of sex is so irresistible that spontaneous nature takes the lead

from human copulation, then the reader need feel no qualms about transferring the book to one hand and beginning auto-amusement. Depictions of animals mating in the spaces of human coupling rendered desire 'natural' and extenuated those cravings society sought to police.

If animals had sex, did they also have sexualities or tastes? Writers were inclined to wonder whether their own private interests were paralleled in the animal world. Was there, for example, masturbation, cunnilingus or same-sex love in the animal world? This last issue was raised by several Edo-period thinkers, who concluded that some animals did prefer same-sex relations and, given the dominance of male dis-course, this meant *nanshoku* (there was no investigation of female–female animal acts). Folklore had it that some beasts kidnapped human males for sexual pleasure (the mythical *tengu*, or long-nosed, bird-like creatures, and *kappa*, water-sprites, were said to do so), and foxes could turn into women to copulate with humans. Saikaku stated in the *Great Mirror of Nanshoku* (*Nanshoku ōkagami*) that male dragonflies stimu-lated each other, and he linked this to the origin of sexual behaviour on earth, which was said to have begun when all unknowing, pre-human divine residents on the Japanese islands saw a wagtail shake its rear end:

> In the first days of the Heaven-shining gods, there was a bird called a 'tail-tweeker' that lived under the Floating Bridge of Heaven, and it was through him that they first learned about the Way of Boys, and fell in love with the divine Little Thousand-Days. Even down to insects, every-thing appeared in the form of a tasty young male of the species.[19]

The Confucian expert Kumazawa Banzan went further to state that male digger-wasps (*jigabachi*) avoided sex with the female ('*onnagirai*'), while the famously '*onnagirai*' Hiraga Gennai, contradicting Banzan, argued for *nanshoku* among foxes, badgers and *kappa*, though not, he insisted, among canines.[20]

The sexualization of natural history is beyond our concern here, which is the use of animals in erotica. There were animal puns. Camels were called *rakuda*, which sounded like the casual expletive '*raku da!*' ('feels comfy!'), and so pictures of camels began to be used to suggest male–female conviviality,

sometimes sexual. The shogunate requested that a camel be imported in 1793, but it was ruled out as too expensive; an American attempt to import a camel in 1803 was rebuffed (the USA had no trading rights), but in 1821 a pair were finally imported by the Dutch East India Company and paraded from Nagasaki to Edo (illus. 69).[21]

Other uses were one-off and did not join the realm of established symbols. In 1798, following torrential rains, a disorientated whale was spotted off Edo Bay; it approached the city. Ieharu, the shogun, was taken to view it from his beach palace on the first day of the fifth month. This caused great excitement. Whale memorabilia were produced and, as the whale was best observed from the Shinagawa, which had a large (unlicensed) brothel area, some of the ephemera was of an

69 Maruyama Ōshin, *Camels*, 1824, hanging scroll, colour and ink on silk.

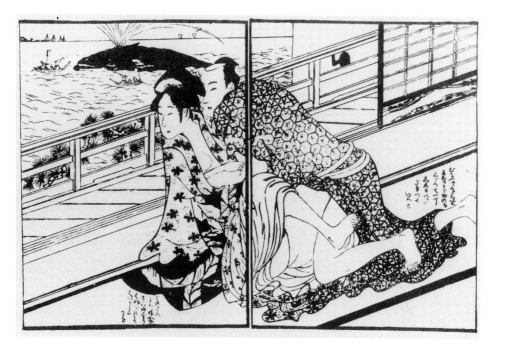

70 Utagawa Toyomaru, *Whale at Shinagawa* (modern censoring), monochrome woodblock illustration for the anonymous *Ehon fubikō tori* (1798).

erotic kind.[22] Coincidence of the arrival with preparations for the Boys' Festival (fifth of the fifth) might have nudged speculation in a certain direction, but spurting is a whale's most notable feature. Utagawa Toyomaru included an image of this in his coyly entitled *Picture Book: Illustrations of Maternal Beauty and Affection* (*Ehon fubikō tori*); boats try to drive the whale back out to sea (eventually they were successful), while a couple in a Shinagawa brothel are a match for its blowing (illus. 70).

The whale did not survive as a sexual symbol. We may ask why. There is a certain mechanics about why some items function and others do not. In Holland, by contrast, the whale was a symbol of plenty and, with it, of sexual potency and Dutch pictures of beached whales are well attested. They always include a person measuring the penis: the whale had been killed, making man master of the world's hugest beast, symbolized by adjudication of its penis. But what worked in Holland would not necessarily work in Edo. Perhaps those who saw the whale off Shinagawa, as they paid their way with the indentured women there, wished to resist all implication that male spurting is tied to the cumbersome and the out of control.

I have stressed that the division between pornography and what I have called 'normal' pictures of the Floating World ought not to be considered absolute. Even pictures that look innocent may be discovered to have a coded erotic content, and it is incumbent on this study to examine them. Again, the point is not to compile a glib list of lost phallic or vaginal symbols but to discover what kind of world is being proposed by the extraneous materials for the activity of sex. In many pictures sex is implicitly referred to, even when not seen. Non-natural symbols can contribute to this sense as well as natural ones.

We may begin with a print by Harunobu showing a woman playing the *shakuhachi*, or upright flute (illus. 71). The woman is warmly dressed, and her kimono has a design of snowy branches with white egrets perching on a tree. It is winter. She has a crest on her sleeve by which she would have been identified, although this has not been reconstructed. The term '*shakuhachi* curve' was used for a large or strong penis.[23] There was also a *senryū*,

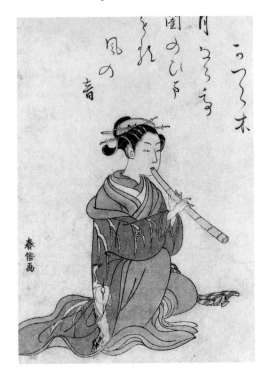

71 Suzuki Harunobu, *Woman Playing the Shakuhachi*, 1765–70, multi-coloured woodblock print.

> Erecting like
> The upwards curve of a
> Threatening *shakuhachi*.[24]

It is impossible to date the appearance of the expression 'playing the *shakuhachi*', used today to mean fellatio, but it was certainly in use by the mid-nineteenth century. Whether Harunobu had heard it is unsure. Nevertheless, I think we are justified in reading the instrument as phallic and this picture as consciously provocative. The inscription identifies the woman only as Katsuragi (a prostitute's, not a townswoman's, name):

> In the light of the moon,
> Her idle plaything in the bedroom,
> Breezy sounds.[25]

The woman's fingers play gently upon the tube; she puts the end against her lips. The character read here as 'bedroom' (*keya*) might also be pronounced *bobo*, which was slang for the pudendum, so that the line can be retranslated as 'the idle plaything with her vagina'. For the male viewer, it is not difficult to imagine more than just sound emerging from his pipe if he could gain admission to the bedroom and be so handled in the instrument's place.

The *shakuhachi* was usually played alone. It was associated with the religious fraternity of *komusō*, itinerant monks who wandered in search of alms, piping to solicit donations. Unlike most monks, who resided in the contemplative space of temples, *komusō* wandered through the world, mixing with the secular and moving along the fringe between holiness (*kū*) and profanity (*iro*). Being monks, they sought to keep themselves pure as they made these transits, and to do so they hid their head in a deep hat, keeping sensory contact to a minimum. The *komusō*'s eyes, ears, nose and mouth were invisible, and his face could never be seen.

They were routine members of urban life but, given the ambivalent manner of their engagement with it, they also had an aura of mystery. In kabuki, their costume was often donned by those who needed disguise for some illicit purpose (they would be unmasked to effect a dénouement). Theatrical prints attest to the frequent appearance of *komusō* on stage (illus. 72). In real life, there was always speculation about what might happen if the hat were removed and how the man

72 Torii Kiyomitsu, *Nakamura Tomijūrō in the role of Shirotae*, mid-18th century, three-tone woodblock print.

might look. There were probably attractive and ugly *komusō*, but in popular myth they were always beautiful, and those who heard the eerie music imagined themselves sadly deprived of the pleasant sight of ravishing looks. Some women tried ruses to gain a look, or at any rate pictures of the Floating World suggest they did. Harunobu showed the unlikely encounter of a prostitute and her trainee with a *komusō*; the print was first published as a calendar for 1766 and then reissued without date markings (illus. 73). The monk and child were in fact borrowed from Okumura Masanobu's *Floating World Picture Book: The Female Bird That Flies Away* (*Ukiyo ehon nuku medori*) of about twenty years earlier.[26] Is the monk in the pleasure quarter or are the women in the city? The situation is fanciful. But the women do not much heed the Buddhist message. They are of the Floating World and only have erotic thoughts in their minds.

Since *komusō* seemed not to have eyes, mouth, nose or ears, they were disenfranchised from this world. They came and went, no one knew exactly how. Their whole identity was ambiguous. The *komusō*'s sensory capacity was transferred to his pipe – it was all that ever touched his lips and its sound was the only noise he made. The *shakuhachi* was the most absolute part of the *komusō*: his root, as the penis was to the man.

73 Suzuki
Harunobu, *Komusō
with Prostitute and
her Trainee, c.* 1766–7,
multi-coloured
woodblock print.

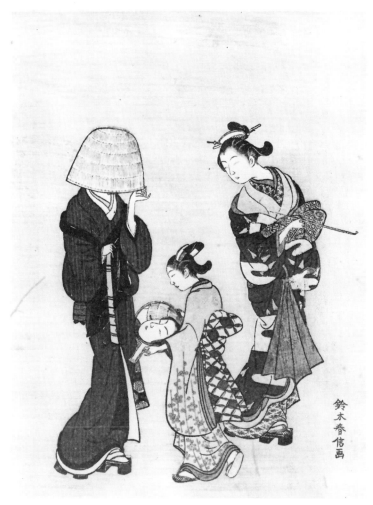

Sexualization of the *komusō* is evident in pictures, and not just those that replicate the kabuki stage. Inagaki Tsurujo painted a young woman with a *komusō* glove puppet (illus. 60). The artist is thought to have been a pupil of the celebrated Osaka painter Tsukioka Settei, although this not certain, and the hypothesis is based largely on the similarity of their styles. But, if it is right, since Settei died in 1787 at the age of 77, Tsurujo would probably have been a contemporary of the Edoite Harunobu (this is consistent with the design on the women's kimono).[27] Interestingly, one of Settei's representative paintings shows a woman operating a puppet, although it lacks erotic content.[28]

This idea of depicting women playing with puppets was

165

74 Kitagawa Utamaro, *Umegawa and Chūbei*, multi-coloured woodblock print from the series *Ongyoku koi no ayatsuri*, c. 1800.

picked up by other artists. Koryūsai produced one showing women using puppets representing young males.[29] In about 1800 Utamaro produced a set of prints entitled *Manipulating Love to Music* (*Ongyoku koi no ayatsuri*), giving nine images of mixed-sex couples operating puppets, all but one of which were of well-known lovers from the stage (illus. 74). The puppets are not just toys but extensions of the users, and the male operates the male puppet, the female the female, as their self-image or *alter ego*.

The construction of Tsurujo's picture is rather different. Firstly, she was a woman (the *-jo* in her name is the same as that in Ryūjo's). To 'manipulate' a puppet (Utamaro's '*ayatsuri*') is to exert a dominating control over it. Tsurujo turns the tables on the norms of gender control. But the painted woman is not actually manipulating the puppet: she merely holds it. The woman, not the puppet, is the mobile entity as she twists her head to the side while the puppet remains stationary. If she turned to face it, she would see right under the hat. Most of her forearm is inserted into the glove, which was necessary

to keep the puppet upright, and she reaches to its middle. It is also possible to imagine the woman's fingers brushing what, in a real person, would be the genital area. She seems aware of this, for the look on her face is one of sexual gaming, even erotic satisfaction, a tickling of her fancy.

I read this painting as every bit as erotic as an overtly *shunga* work. I think we can also find in it an articulation of female sexuality in the genuine voice of a woman. Inside the puppet, the hand secretly plays with his '*shakuhachi*' as he, soundlessly, plays his 'real' *shakuhachi*. But his is more real, for this is only a puppet in a painting. He has no priority over his own sex organ, since the multi-layers of representation deny the *shakuhachi* a fixed meaning on any level. She has the look of pleasure, while he lacks all scope for expression and reveals nothing. Tsurujo's woman does not take the puppet of a handsome bourgeois male to be her delight (as Koryūsai's did), nor of a beautiful woman, to suggest the perfection of herself (as Utamaro's did); the puppet is neither she as offered to another nor a male that could be her lover, brother, father or future husband. Tsurujo has resisted showing a temporary reversal whereby the woman manipulates the kinds of man who in reality would control her and also resists showing the woman adopting socially sanctioned self-idealizing roles. Rather, the entity of the controlling male is completely expunged, and the varieties of manhood that would surround her in life are gone. The woman provides for herself, in a way that circumvents the social organization of Edo-period life. Her illicit sexual thrill is enjoyed without the slightest fear of exposure (*komusō* blow but do not speak) with a man built to her own demands. She uses him, and his pleasure is not germane.

Being a painting, not a print, Tsurujo's work must have been made on commission. It is unclear how much freedom artists had in theme and composition, and so whether the conception was hers or that of her patron is unknown. It is also unclear whether the patron was male or female. What does seem to be the case, though, is that the painting was a vehicle for working out, within the medium of the pictorial system of a Floating World that made sexual gratification for men easier than for women, a means to symbolize the fulfilment of female sexual appetite on female terms. This picture seems more suited to a female gaze. Tsurujo's solution was

successful enough for it to be demanded of her a second time, and two virtually identical examples of the painting exist.[30]

Tsurujo's woman (unlike Harunobu's) does not insert the *shakuhachi* into her mouth, and fellatio is not suggested. There is little actual fellatio in Edo erotic works, and it is possible that the convention of representing the male organ as large and the female mouth as small made it difficult to depict (as Gary Leupp has suggested but Paul Schalow has denied).[31] Some fellatio imagery exists. More overwhelming is the number of pictures of eroticized women or boys placing phallic objects in the mouth, the *shakuhachi* being only one.

Some objects placed in the mouth of figures in Floating World pictures are of a kind that, properly primed and manipulated, will indeed produce an emission: music for the *shakuhachi* or, in other cases, more semen-like substances. There are plentiful pictures of, for example, bubble blowing, a game that became popular in the eighteenth century.[32] Bubbles were a pastime for children, but there is a surprising number of pictures of women blowing. Harunobu made one in the late 1760s; Koryūsai did so too, about the same time, using the 'pillar-print' format.[33] Shiba Kōkan showed a woman on a verandah blowing bubbles in about 1780, in his early Harunobu manner, although elements of the Western style he was later to adopt are already present (illus. 75). All have a child but blow for their own sake, not for his. Or rather, they blow for the titillation of the male viewer.

The inscription on Kōkan's painting acquiesces in this sexual reading. Although written academically in Chinese and couched in elegant phrases, the verse is erotic. It is signed Tankyū, which must be Akutagawa Tankyū, a Keishi Confucian scholar who died in 1785:

> The young girl, with her lips
> Blows through the bamboo tube.
> One bubble after another,
> Flies dancing on the fragrant breeze.
> The child watches,
> His fingers clutching her petticoat.
> And then he sees a blush of shyness
> Faintly colouring her beautiful cheeks.[34]

As with many Floating World children, his sexual awakening is precocious. But it is not really the child who feels what he is

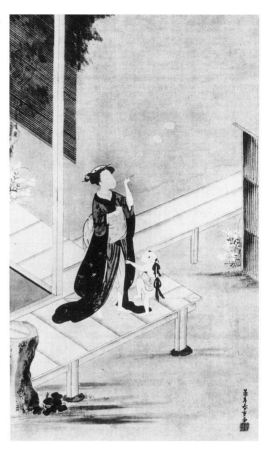

75 Suzuki Harushige (Shiba Kōkan), *Women Blowing Bubbles with Child*, c. 1780, hanging scroll, colour on silk.

supposed to feel but the male viewer, as an adult libido is wished onto him – for example that of Tankyū.

Blowing is also seen in depictions of another game: blow-darts. Stalls where one could play were common in cities, and it was no doubt unexceptional to enter one and have a go. The alleys required you to hit a string that would unhook on impact to release a doll, which was the prize. In Edo these were the special feature of the Shiba Shinmei, a popular shrine whose patronal festival lasted for most of the ninth month and gave rise to considerable festivities.[35] But pictures of dart-blowing, like pictures of bubble-blowing, are not depictions of the facts of urban recreation but have a deeper status. Consider a diptych of a blow-pipe alley produced by Harunobu (illus. 76). A woman runs the booth and she has three customers, a boy with a shaven head (who appears to be a young monk), an older youth and a girl of similar age.

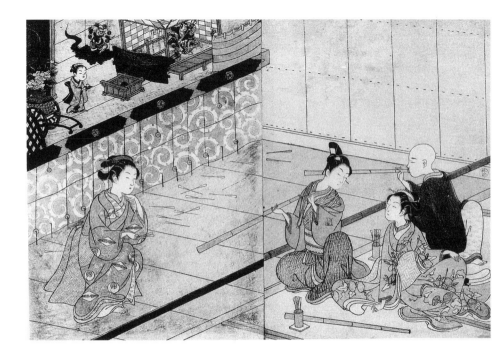

Several scattered darts attest to earlier shooting, and three of the targets have been hit. The acolyte blows, while the secular pair only look at each other, the boy probing the end of his pipe with risqué gestures, pushing in an arrow. His costume is ornamented with a pentagram from the series known as the 'Genji fragrances', fifty in all, one standing for each chapter in the *Tale of Genji*; this is the 'Early Ferns' (*Sawarabi*) chapter, which takes place in the first month. The girl's dress has a design of morning glories – she too, like the boy, is at the dawn of sexuality; he, still unsure if he has mastered his pipe, is fresh and ready. Just right for a New Year's picture (lunar new year fell later and beckoned spring), and this was originally issued as a calendar for the year 1765 (then republished without markings). It is only the young monk (in Edo lore a typical candidate for early *nanshoku* involvement) who is trained to blow securely.

The prize dolls Harunobu shows are the standard auspicious type: a flower-carriage, the arrow-sharpening scene from the New Year's play *Yanone*, a well-head. But the dolls were sometimes replaced by more symbolic ones, or at least those of extrapolatory minds were given to suggesting background signification for the dolls, which were properly called

76 Suzuki Harunobu, *Blow-pipe Alley*, diptych, multi-coloured woodblock prints, 1765–70.

170

77 Kitao
Shigemasa, *Blow-
pipe Alley*, mono-
chrome woodblock
page for Santō
Kyōden, *Ningen
banji fukiya no mato*
(1803).

'ghosts' (*bakemono*). Santō Kyōden wrote a comic story in 1803
(illustrated by his art teacher Kitao Shigemasa) entitled *Blow-
dart Targets: Ten Thousand Things about Human Beings* (*Ningen
banji fukiya no mato*) (illus. 77). Kyōden noted that a trip to the
Shiba Shinmei shrine had prompted him to write the book. In
the author's preface, he observes that whatever you aimed
for, you always ended up hitting something worse or, at least,
the thing that fell out of the bottom was never very good, and
perhaps showmen were tricking customers by attaching in-
ferior items to the strings ('you're sure you've hit [the strong-
boy] Kintoki, but you get a spook; you think [the giant]
Asahina will come out, but it's just a goblin'). He went on to
attribute profundities of human life to the booth:

> You suspect that this difference emerges in the flashing of
> the swift arrow. The heart has an arrow too, and calamity
> and happiness are the targets; good, bad, falsity and verity
> are the dolls won. This is what they mean by the karma of
> the Three Worlds. Hit the strings of the twelve karmic links
> and real forms will plentifully appear. This is in the flash-
> ing of a human life. The tube of existence is just a six-*mon*
> blowpipe.[36]

171

In the context of a mock-moralizing book, Kyōden has no room for sexual interpretations (he equates winning impressive or trivial prizes with the wages of sin and virtue). But, himself a Floating World print-maker (under the name Masanobu), he was alert to the erotic lode that many quotidian actions could sustain.

The motif of blow-pipe as penis crossed *nyoshoku* and *nanshoku* eroticism, as did most sexual symbolism. The *nanshoku* interpretation however was strongly felt and appears in Harunobu's print. One of Edo's better-known male brothels was called Blow-dart Beach (Fukiya-ga-hama), where, as it were, the customer's dart shot from his pipe and came to berth in its target. Fukiya-chō was one of Edo's two main *nanshoku* districts (along with Yoshi-chō) and, although the characters used to write this were different (*fuki* 'thatched' + *ya* 'house' not 'blow' + 'arrow'), the homophony was unmissable. Fukiya-chō had started out as one of the three licensed kabuki areas, although already by the end of the seventeenth century it was as well known for boys on futon as on stage; in 1675, Saikaku wrote the following as part of his *Thousand Haikai Composed Solo in a Single Day* (*Haikai dokugin ichinichi senku*):

> It's a dream, a dream.
> Bring me drink, bring me servant girls,
> Bring out entertainers.
>
> In the morning, at the theatre
> We'll go crazy over boys.
>
> Even the winds of sex go
> Exactly as you want them –
> The Fukiya district.[37]

Saikaku used phonetic graphs, not characters (as was often done), thereby obscuring the difference between the two 'fukiya', and briding the gap between the placename and the blow-pipe.

Pipes came in many shapes and sizes and had many functions. One was for real shooting: the gun. From its barrel came a projectile of lethal power. Guns were not handled by women, and a female beauty holding one would make for an odd picture, nor – it may be supposed – would it be successful for erotic purposes. Guns formed part of a male preserve and

78 Nishikawa Sukenobu, *Kabuki Actor with Gun*, monochrome woodblock page for Nankai Sanjin (Sukenobu?), *Nanshoku yamaji no tsuyu* (1730s).

so might have been suited to sexual contexts where the female was not desired. At least one image of this type exists, made by the great pornographer Nishikawa Sukenobu for inclusion in his magnum opus, *Dew on the Mountain Path of Nanshoku* (*Nanshoku yamaji no tsuyu*) (illus. 78).[38]

A gun is an instrument of violence and too destructive to exist happily within the codified, non-adversarial regime of Floating World constructions. Perhaps this is why, apart from Sukenobu's image, it was never used. The inherent violence is mitigated here by the boy ramming powder down the barrel, not firing, but the sense is different from Harunobu's boy who performs a similar task in the dart alley. And a gun is not for putting in the mouth.

I do not necessarily think it legitimate to go through the sum of pictures of the Floating World and propose every long, thin object as a phallic symbol. Nevertheless, the above readings are legitimate, and I wish to furnish two others, and then add a warning. One item is the glass drum and the other the tobacco pipe. The drum, or popin, is a glass tube, flared at one end and sealed across so as to bend in and out as one blew, with a clicking sound. It is clearly erotic in Utamaro's print of around 1800 from the series *Ten Physiognomic Types of Married Woman* (*Fujo jinsō juppin*) (illus. 79). Sadly, Utamaro did not write in the cartouche placed ready for the inscription and we lack information as to which 'type' this is – an omission common to several of this series. But he did sign it 'Utamaro the Physiognomist Depicted This after Careful Thought'. Was this the lascivious type?[39] Trinkets like popins were bought and played with when fun was in the air, usually at fairgrounds; they were soon abandoned. The popin was for off-work moments when drinking and lovemaking abounded. It matched the erotic space of 'floating' very well, although this is a *married* woman.

79 Kitagawa Utamaro, *Woman Blowing a Popin*, multi-coloured woodblock print from the series *Fujo jinsō juppin*, c. 1800.

Different cultures draw different lines around what is acceptable and what is obscene, and the practice of putting objects into the mouth is usually (though variously) controlled. The tobacco pipe was much associated with the Floating World, and tobacco could be called 'courtesan grass' (*keisei-sō*), referring to top-class prostitutes' dependence on its stress-relieving properties.[40] The Yoshiwara stalwart Kyōden was a dealer in smoking accessories and often signed his Floating World fiction with references to this, or even had his shop depicted in prints.[41] Yet in the Edo case, tobacco pipes do not seem to have acquired sexual resonances. Perhaps they were too long and thin to sustain the interpretation, or they were just too common. In Europe, however, the pipe was regarded as phallic (European pipes are shorter and thicker than Edo ones, and their larger bowls made for concentrated, intermittent smoking, not near-permanent puffing). In many parts of Europe women were prohibited from smoking pipes, or, if they did do so, it was a deterritorialization of manhood

and associated with witchery or lesbianism. The returnee from Russia Doi Tsūdayū (who had experiences as remarkable as the more famous Daikoku-ya Kōdayū) stated of the situation he had seen in St Petersburg at the turn of the eighteenth century, that women did not smoke pipes; his editor, Ōtsuki Gentaku, checked the accuracy of this comment with Westerners in Japan and interpolated a note, 'Dutchmen have confirmed that in no European country do women smoke'.[42] Western heterosexual males seem to have found the sight of women smoking a kind of castration. The Western pipe is gripped in the teeth, not hand-held at the lips like an Edo one (European males had long since tortured themselves with the fetish of the *vagina dentata*, the vagina with teeth as well as lips). Cigars (chewed at the end) were never much smoked by women either, and it was only after the arrival of the cigarette (with its diminutive feminizing suffix) that Western women began to smoke heavily and openly.

PENISES AND VAGINAS

There are some types of object that will not function symbolically in *shunga*, either because of the particular social world that surrounded the object internally, or else because of some matter relating to the exterior politics of sexual desire. It is notable that motifs of force are scarce. Not only is the gun absent but, even among natural forms, flowers and blossoms are preferred to towering trees; gentle waves are more common than crashing falls. There is nothing like the consistent use of the oak in European pornography to mean the penis, nor the briar for the vagina; there is not even an equivalent to the mildly bellicose Ming-period metaphors, such as that captured in the pornographic book title *Variegated Battle Arrays of the Flowery Camp (Hua ying jin zhen)* – although that work was known in Japan.[43] Occasional rigid or stout motifs do appear (such as the pillars of a shrine gate, for instance), but this is quite rare. When, in 1963, Mishima Yukio used the metaphor of the heavily tiled temple roof for a penis in *The Sailor Who Fell From Grace with the Sea (Gogo no eikō)*, he was deploying a nativist idea that seemed to him somehow traditional but which was alien to Edo thinking.[44]

The most famous work of pornographic writing of this period in English is John Cleland's *Memoires of a Woman of*

Pleasure (also known from the protagonist's name as *Fanny Hill*), published in 1748–9. It contains a large number of phallic symbols, but these are invariably materialistic and unyielding: 'instrument', 'engine', 'nail', 'weapon', 'truncheon', 'battering-ram' etc. Confrontation is stressed and sex is a war, not even the flower war of China but a real one. And all the weaponry is on the male side. Cleland's metaphors for the vagina stress its yielding, and its welcome (repulsion is useless) of the male attack: it is a 'berth', a 'housing', a 'room'. Cleland's book is unillustrated, but we may note that, whereas the male imagery gives rise to ready pornographic visual equivalents, the female images do not, for they are vacancies waiting to be crammed.

In European pornography, the large penises are such a mismatch for the virginally tight vaginas that readers can only wonder how they manage to penetrate at all. The image accordingly appears in Europe of the all-controlling phallus, too large to be ever successfully 'berthed', and to which women can only pay homage. One of the illustrations to Aubrey Beardsley's unpublished series of *c.* 1896, *Lysistrata*, is

80 Aubrey Beardsley, *Adoramus*, an unpublished drawing for *Lysistrata*, *c.* 1896.

81 Isoda Koryūsai, *Lovers in Fukagawa District*, multi-coloured woodblock page from *Haikai meoto maneenon* (*c*. 1770).

82 Katsushika Hokusai, *Lovers with Mirror*, *c.* 1810, multi-coloured wood-
block page detached from an unknown *shunga* album.

83 Okamura Masanobu, *Lovers beside Paintings of* The Tales of Ise, hand-coloured woodblock page from a *shunga* album, *Neya no hinagata* (c. 1738).

84 Suzuki Harunobu(?), *Customer with Osen – Shunga Version*, 1765–70,
multi-coloured woodblock print).

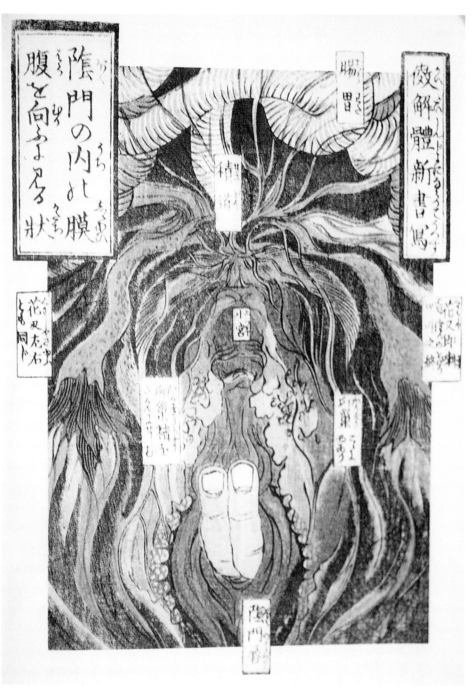

85 Keisai Eisen, Copied from Kaitai shinsho, multi-coloured woodblock page from his *Makura bunko* (1832).

86 Utagawa Kunisada, *Vaginal Inspection*, multi-coloured woodblock page from a *shunga* album, *Azuma genji* (*c.* 1837).

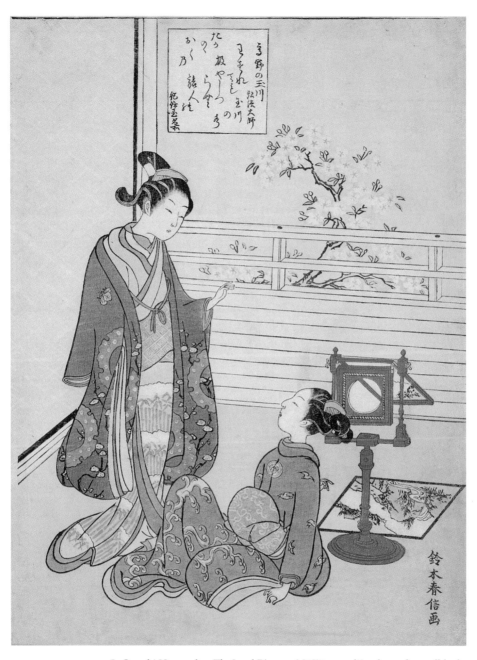

87 Suzuki Harunobu, *The Jewel River on Mt Kōya*, multi-coloured woodblock print from the series *Mu-tamagawa*, 1765–70.

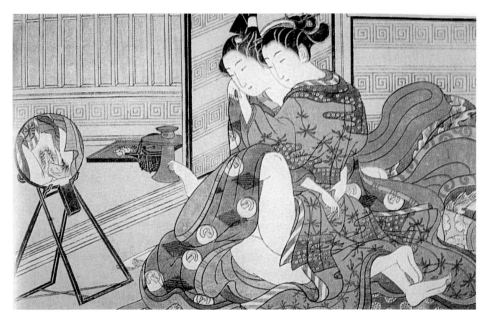

88 Torii Kiyomitsu, *Lovers Using a Mirror*, multi-coloured woodblock
illustration from an untitled *shunga* album (*c.* 1765).

a good example, aptly entitled *Adoramus* ('we praise thee'); the woman, whose vagina will never accommodate it, is reduced to kneeling to kiss the object she can never match (illus. 80). The camp appearance of the male adds another layer of misogyny: he has won what he does not even want.

Shunga and other pictures of the Floating World are different from what I take to be the norms of early modern European pornography in three respects. Firstly, even though the penis is depicted as large and hard, this is mitigated by its association with soft symbols – indeed, we might say that the point of much of the symbolism found in *shunga* is to soften the penis. Secondly, the vagina is shown as equal in power and size to the penis; in Cleland the women are 'split' and 'broken open'. Thirdly, *shunga* create a *visual* realm of vaginal symbols too, so that the female organs are not merely inert enclosures.

Over-sizing of the organs is a feature of *shunga*, but they are not depicted as universally large. More realistically sized ones appear, mostly on younger people or on the very old (see illus. 16, 26). *Shunga* abet the fantasy of the adult male who wishes to imagine himself larger than a youth to compensate for the latter's greater potency and stamina and also still safely distanced from dotage. In point of fact, there is little real evidence of Edo-period women's fetishization of penis size, nor indeed of males', who never seem to have mentioned it as a source of pride; boys were rented on the basis of their 'chrysanthemum seat', not their phallus. An anonymous Floating World story of 1755 does comment on the large penis of the actor/prostitute Minenojō, the dimensions of which were said 'to match the young actor's talents', but this is almost unique.[45]

One print is worth investigating in more detail for its genital symbolism. Utamaro's *shunga* set of *c.* 1788, the *Pillow of Verses* (*Utamakura*), includes a couple in an embrace where the sexual act is barely visible, and all the libidinous aura is transmuted into the surrounding objects (this is one of the many pictures that evince the extent of overlap between pornographic and 'normal' Floating World pictures) (illus. 61). The clothing is fine and light and splendidly rendered in the polka-dot gauze to the left. The couple are pressed up to the front, and little is seen beyond them. Some items can be observed, and to the right is a *sake* flask with two stacked cups and a bowl. Cups are often included in *shunga* (see illus. 57) to

show the couple has drunk a love vow, and stacking is the way that they were stored. But there is also a reference to the mounting of the couple, one upon the other, and the insertion of a 'leg' of one into the 'basin' of the other. Bowls of all kinds are common in eroticized pictures, for the shape can be made to seem vaginal. Let us consider an example of this before returning to Utamaro. Koryūsai's depiction of a young man stopping for tea at a roadside stall and being served by a modest woman includes the handling of a teacup that sug-gests a tacit understanding of imminent progress to another stage of familiarity (illus. 89). The print is from a set of eight, *Eight Views of Morality of the Modern Kind* (*Imayō jinrin hakkei*);

like Harunobu's *Eight Views of the Parlour* (see illus. 56), this set parodies the classic *Eight Views of the Xiao and Xiang*, this one being 'Evening Glow in a Fishing Village', the last of the eight. 'Morality of the modern kind' includes the possibility of fairly free sex, especially when evening closes and work has ended – for the man (the woman is still working) – and in country places the women can be easily overawed. The man handles the cup gently, but via it he seeks access to the vagina – which in the picture is gladly offered, her cheeks in an 'evening glow'.

Utamaro shows something more than this. The bowl in front of the nested cups contains a clam shell. The 'bowl' now holds the means of redress if the man maltreats it, as the open clam warns the male. This is clear from the verse composed for the print by Meshimori (poetic name of Ishikawa Masa-mochi), which is inscribed on the man's fan:

> In the clam,
> His bill is firmly
> Caught.
> The snipe cannot rise up.
> Autumn evening.[46]

Koryūsai suggested a woman freely encouraging a man, the relation was one of inequality with a samurai exploiting a woman, a low-level waitress. Utamaro shows the woman as having equal power to the man. The clam can deprive the snipe of liberty and stop it reaching inside for the flesh. There is a parity of symbols (if anything with the vagina granted the greater force). But the shell is open with the snipe allowed to remain at large. The only object that might serve to balance the vaginal clam (the snipe is gone) is the paper fan held more or less where the man's penis would be.

SLEEVES AND SOFTNESS

A number of pictures show powerful vaginal imagery. The tendency, however, was not to make the vagina strong but to effect equality by showing the penis as weak, bringing it 'down' to the purported recessiveness of the vagina.

The most common vaginal symbol is not the clam, nor even the bowl or tea cup, but the more pliant and bending sleeve. The link of the sleeve to sex was apt, for when a kimono was

cast off the sleeve fell wide, leaving tempting openings, as is suggested by many *shunga* (see illus.13, 45). Cloth has been discussed above, in Chapter Three, but the sleeve has a special significance within the rhetoric of fabric. Since ancient times the sleeve was the recipient of flooding emotional outbursts, and the expression to 'wet one's sleeve' (*sode o nurasu*) described the culmination of high feeling in classical tales. Female sleeves trailed out of enclosed court carriages, as continued to be represented in literature and painting long after the practice had ended, and often were the only clues to the identity and taste of the person ensconced within: one knew a woman by her sleeves. The painting genre 'Whose sleeves?' (*tagasode*) perpetuated the myth that these were the most revelatory part – the genre is not called 'whose *clothes*' (see illus. 54). The masturbator (see illus. 4) puts the sleeve of the costume to his face. It was sleeve length that indicated a woman's sexual availability, since upon marriage the long-sleeved kimono would be put away in favour of a short one.

Pornographic phallic symbolism matches the sleeve's softness. Since medieval times the mushroom was invoked. The shape is vaguely penile but it is easily squashed, and one could not envisage it enjoying viability in the economy of symbols of eighteenth-century Europe. The mushroom was rustic and so was little used in the self-consciously elegant dispensation of the Floating World. But it appears in sexual contexts where it was acceptable to display a more rude energy and is common on carved toggles (*netsuke*) which men inserted into their sashes to suspend hanging pockets (*inro*). Mushrooms are to be found as phallic symbols in *senryū* verses relating to the mushroom-gathering festivities. This ritual was engaged in by country people but mimicked by finer ladies, including members of the shogunal harem (the *ōoku*), who would scan the confines of Edo Castle for fungi carefully laid out for them to find.[47] In Keishi, where the custom originated, the main gathering site was Mt Inari, hence:

> Man Mountain
> Might be a better name for
> Mt Inari

Or,

90 Anon., *Lovers at Asukayama* (modern censoring), monochrome woodblock page from Furukawa Koshōken ('Kibi Sanjin'), *Edo meisho zue* (1794).

Dear, oh dear,
The bride can't pull one up;
Mt Inari.

Again, in an amusing feminization of the tale of the warlock who lost his powers after seeing a woman's well-turned thigh,

Mt Inari,
Powers evaporate
For the woman-wizard.[48]

Another symbol was the umbrella (or parasol). This fitted better into the world of the pleasure districts. Umbrellas have erectility but, like fans, they are very easily broken. Large numbers are found in *shunga*. The geographer and pornographer Furukawa Koshōken ('Kibi Sanjin') included one in a parody guide to Edo, where each site becomes a venue for sex. Asukayama was famous for its cherry trees, and a couple have taken an umbrella to protect themselves from falling petals; the man inserts while the woman fondles its form (illus. 90). The only text on the picture is the woman's voice ('oh, oh, thank-you so much!'). The colossalness of the sexual act (the genitals have been subject to modern censoring) ripples into the rock and trunks, but this is tenderized in the

91 Suzuki Harunobu, *Ibaraki-ya*, c. 1767/8, multi-coloured woodblock print.

umbrella. It does not matter if it is his or hers (this is another aspect of the *shunga* egalitarian myth) – and it is not even erect. Certainly, women fondling, caressing or clinging to umbrellas are legion both in overt pornography and in 'normal' pictures of the Floating World (illus. 91).

Saikaku had a story entitled the 'Umbrella Oracle' (*Karakasa no go-takusen*) contained in *Saikaku's Tales of Many Countries* (*Saikaku shokoku-banashi*) of 1685. An umbrella is taken over and possessed by the Sun God (not goddess, as was proper in Japanese lore), who demands a woman in offering:

The hale young women shed tears, expressing their reluctance with cries of, 'we hold dear to our lives'. They were not unaware of the shape this divinity has chosen to manifest himself in. In the village was a lusty widow, and as they were lamenting, she said, 'Since it is the will of the god, I am prepared to take the people's place'.[49]

But this unexpectedly brutal umbrella fears the pent-up sexuality of the widow, so that 'although she passed a whole night in the sacred place, nothing came at her, to which she took exception'. The widow then storms into the inner sanctuary and grabs the umbrella, yelling, 'so, your body's not up to it, then!?' and shreds it in frustrated rage, tossing the tatters on the floor. Umbrellas may be weird (Japanese mythology has the figure of the 'umbrella spook'), but they are incapable of sustained malice and remain defenceless.

SWORDS

I have been arguing that *shunga* project an image of non-violent, consensual sex, and I must therefore account for the prominence of the sword, for like a gun it is an instrument of violence. It is also exclusively male and class-specific. How can it fit into the regime of pictures I am proposing? In earlier erotic writing, the sword was invoked to signify violent sexual entry, with a penile thrust likened to a stab. In *Fanny Hill* and also, repeatedly, in the Arabic *Thousand and One Nights*, this phraseology is used. A verse of 1523, for example, written by Sōchō contains this:

> The boy I engaged
> Does reciprocate [my feelings].
> Clutching him
> I would like to make a stab,
> And have things different.
> Even more than I,
> [The celestial youth] Cetaka
> Grew lonely awaiting boys.
> Yet my body also yearns
> In the hopelessness of love. [50]

Still, there is no reference to a blade. Recently, Leupp has unhelpfully recycled Donald Keene's free-wheeling translation of 1977, rendering the critical lines, 'I would like to

thrust in my sword/And die from the thrust'.[51] Actually, Sōchō's metaphor is weak. As a monk, moreover, he was not a sword-wearer himself. Certainly there is nothing equivalent to Sheherazade's call to 'pierce me with your rapier'.

Shunga that seek to re-create the historic world of civil war show warriors engaged in sex wearing full battledress, as noted in Chapter Two, but this is not done when depicting the contemporary moment (see illus. 24, 45). By Edo times, the sword was very rarely drawn from the scabbard and had become ornamental; it was vestigial and barely connoted the slash. I have discussed the 'anachronism of the cut' elsewhere, together with the problematic linkage of swords to peace-time male identity.[52] It is not necessary to reiterate my arguments, but it should be noted that in Edo *shunga* the sword is denied the capacity to inflict damage by invariably being depicted with the pommel, not the blade, towards the partner. When a sword was worn, the blade would point behind, away from the interlocutor and out of sight, and only the hilt would intrude visually. Accordingly, it was the pommel that bore meaning. The situation was unchanged when the sword was unslung and when it is depicted as removed prior to the act of sex. Women hold swords in the same way they hold umbrellas. A hilt is a grip, pleasant to touch. It cannot cut, indeed it is there precisely to protect from cutting. With a bit of help from the artist, it could be made to point in unison with an erect penis – with the same vector and size. The sword is no phallic symbol in *shunga*, though the hilt might be.

5 The Scopic Regimes of *Shunga*

The common experience for some Edo-period people was to have servants attend them wherever they went. It was the common experience of a larger number to be obliged to follow. The two categories were not mutually exclusive, since higher servants had their subordinates, and even the word 'samurai' comes from the verb *saburau*, 'to be in waiting'. Seeing and being seen was an exchange payable in the eighteenth century in a different coin from today. Privacy had also not yet been invented. The more wealthy the person, the less likely they were to find space out of sight and sound of others. The rich could have everything in company, but nothing alone, while the poor shared their pittance in crowds.

WATCHING AND WAITING

Servants entered a chamber without signalling entry and expected to see, hear or smell their employer's most personal activities. (Hokusai illustrated this in a rare satirical view of a samurai excreting while his servants wait outside, fingers in noses.)[1] Servants were trusted to be loyal enough not to divulge what might compromise their master's dignity, but most bodily functions that we would wish to perform in private were not thought prejudicial or embarrassing. What of sex? What are the politics of seeing, or of peeping? Who were voyeurs and who 'voyees'? How do facts of architecture and locale mesh with the compensatory visual world set up by pornography?

There was no single, homogeneous 'life of a servant', but there were collective myths. Servants imagined their employers to be foolish, and this is the stuff of kabuki as much as of Molière. Employers imagined their servants loved them. The truth is that few masters thought about their servants at all, and the diaries and jottings of Edo literary figures make no mention of servants; the reader is far more likely to learn about the details of a person's household furnishings or

works of art than about the names of their underlings. The significance of these facts and fictions of early modern life concerns us insofar as they relate to the representation of sex.

The master's myth of servants happily undergoing hardships for their sake finds expression in sexual contexts, and a trope is that of the servant waiting resolutely outside while the master besports himself indoors. For the servant's response, I have not found anything as colourful as Leporello's aria in *Don Giovanni*, the premiere of which took place in Prague, far removed from Japan but identical in time to our period (1789, first year of the Kansei era):

> I work all night and day
> For someone who takes no notice of it.
> I have to contend with wind and rain,
> Eating badly and sleeping rough.
> I want to be a man of means
> And don't want to serve any more.
> Some fine gentleman!
> Inside there with the pretty woman
> While I have to play watchman![2]

When recounted from the master's side, the story emerges differently, and here there are Japanese examples. Commonly a *nanshoku* ingredient was added to justify the selfless attendance, such that the master chose to believe his servant not only happy to wait outside, but happy because he loved the master physically and transferred his craving onto the person of the (female) consort. Unlike with Leporello, it was the master, not his mistress, that the servant was expected to want to embrace. One often-repeated story was that of a page to the late sixteenth-century warlord, Hideyoshi, called the Taikō; the servant was known as Tōkichirō; he was to have waited in the snow while Hideyoshi slept with a woman and, although himself freezing, expended his dying body's heat on keeping his master's shoes warm by clutching them to his breast.[3] Servile devotion and sexual yearning were conjoined. The eroticized gloss placed on samurai loyalty remained common throughout the Edo period, and Tōkichirō appeared in the standard biographies of Hideyoshi, such as the *Illustrated Chronicle of the Taikō* (*Ehon taikō-ki*) of 1797–1802 (a book which was to have a major impact on the Floating World and on its policing: see Chapter Six).[4] There are other tales of a

92 Nishikawa Sukenobu, *The Maid*, monochrome woodblock page from *Makurabon taikei-ki* (*c.* 1720).

similar nature in *Hidden Among Leaves* (*Hagakure*), and the *Great Mirror of Nanshoku* (*Nanshoku ōkagami*). A version of Tōkichirō's sacrifice was told of Sakai Tadakatsu, the young daimyo of Shimōsa-Oyumi, who served the third shogun, Iemitsu.[5] Tadakatsu also warmed Iemitsu's shoes in his clothes, substituting them for the body of the master he could not (yet) embrace – (later Takamitsu became a friend and advisor of Iemitsu and a member of the Council of Elders, *rōjū*).

The availability of dependent retainers would have led to sexual abuse. The *senryū*

> The young master
> 'Worships' her by night,
> But shouts at her by day[6]

attests to an expectation of exploitation, funnier to those on one side than on the other.

Waiting outside did not necessarily mean being out of eyesight or earshot since wooden architecture was not soundproof and chinks offered opportunities for peeping (Western architecture, being of brick or stone, offered little more than the keyhole, which indeed, figures as a point of access in much European pornography). Images of the servant outside watching the act of sex within, and responding to it by masturbating, are current (illus. 92). These might have been enjoyed in cases where *shunga* were used by couples as foreplay, with voyeuristic pictures flattering them that their privileged acts were the object of others' fantasies, not disgust. But it is also possible that Japanese pornography was made to relieve those habitually kept waiting. It may be for this reason that the scenario of the door opening and the

195

93 Hishikawa Moronobu, *Through the Screens*, monochrome woodblock page from *Koi no mutsugoto shijū-hatte* (1679).

attendant being invited to join the play also occurs, or else of the master going to sleep and his insatiate partner beckoning the person outside in for further enjoyment. Whether or not waiting servants had a book in one hand, voyeurism is a recurrent theme in *shunga*, where it is introduced as a stimulant to masturbation.

A sexual position called 'through the screens' (*shōji-goshi*) appears in Moronobu's *Forty-Eight Positions in the Secrets of Love* (*Koi no mutsugoto shijū-hatte*) of 1679 (illus. 93). The text reads, 'screens are hard and fast to thwart acts of love, so try this coital position secretly'. If people really practised this, it would have been a way of enacting the fantasy of the one outside wanting to come in, effecting a kind of transgression, linked to the fetish of voyeurism. The couple come together while playing at separation, both denied and permitted, both frustrated and fulfilled. This seems more masturbatory than copulatory, and it is unsure whether Moronobu's book is offering real instruction in sexual technique or the more normal thrills of pornographic images. The breach in the screen that was just right for the penis was also just right for the eye.

The pleasure districts catered for voyeurism too, for brothel

architecture was similar to domestic in offering a sequence of interiors that were unsealed visually and aurally. Not much special effort was made to ensure couples were kept apart. The top establishments had fully private rooms, and the definition of the highest grade of prostitute was that she had her own suite (*zashiki-mochi*), but these were not really 'private' in any modern sense. Plays and fiction are full of people spotted or overheard while with a prostitute, and it was a normal part of the representation of the quarters for this to happen. The belief that one was subject to a prying gaze was solicited, for it heightened the thrill. All these possibilities appear in erotic images.

In some of the smaller brothels, or in the unlicensed districts, rooms were shared, with just a folding screen set down the middle. There is no evidence this was regarded as a problem. A room of this sort is seen in a page from Koryūsai's second *shunga* book of about 1770 (illus. 81). It contains a mini female figure to whom we will return since she has an obvious role in the construction of voyeurism, but note here the screens. Normally one screen is adequate to divide a room, and it would be decorated on only one side to create a hierarchy of space before and behind. Here, two screens are positioned back-to-back to allow decorated surfaces to show both ways, to even up the space. This is necessary because couples are to right and left, as the pack of tissues and what look like knees under the bedding reveal. The view outside the window has a stream and bridge, indicating that this is not the Yoshiwara, but probably the lower-grade, extra-legal Fukagawa quarter, and that this is not a top-class place. All the same, it is a two-storey edifice, which the most modest kind were not, the screens are good and the double futon has a lavish red cover. The room-sharing is not the necessary result of economies but forms part of the couple's regime of desire, creating a sense of seeing and being seen and perhaps gaining two partners (or three) for the price of one.

THE HISTORICAL 'THIRD PERSON'

The myths perpetuated in *shunga* constitute encoded ways of helping the reader deal with the fact that he or she is alone, with nothing but themselves in hand. These codes play games with real conditions and graft truths onto unrealities. By

raising the possibility that there was, or might be, something behind the next screen or that one's sexual acts might be the object of arousal to those outside, *shunga* heightened sexual tension, which – for a masturbator – often needs aiding. *Shunga* equivocate between seeing and being seen, cleverly refusing to take sides on who is voyeur and who 'voyee' and whether the roles are fixed.

Sometimes it is problematic to assess whether viewers of a *shunga* image would have identified with the one who sees another's act within the space of the picture or with the one who acts. Male and female viewers might have reacted differently, and it would have depended on the class and status of the various parties too. Any one picture might have been used in many ways. But the various possibilities had to be identified and negotiated by the artist, who would need to know what the market for the picture was and to organize the imagery accordingly, while always leaving room for the possibility that the book would be passed about among different classes, age-groups and perhaps genders.

One way of dealing with – or circumventing – these issues was to relocate the third person within the picture not as a servant but in some surrogate form. By investing the gaze in some other, non-human or humanoid form, artists could provide a point of entry into the picture for any viewer. Various experiments in this were attempted, one interesting case being Hokusai's illustration to an unknown book; additional elements in the picture include a mirror and the man's personal effects – pipe, tobacco pouch and a toggle carved in the

94 Detail from Hokusai, *Lovers with Mirror* (illus. 82).

shape of the lucky god Putai (illus. 82, 94). These are not so much discarded as prominently disposed at the lower front of the picture, at just the point where a reader's gaze would catch them. Hokusai shows the couple as exceedingly handsome and fashionable, and few viewers would have had the confidence to see themselves like this. Hokusai gives so ideal a vision of social and sexual sophistication that the viewer might be rebuffed. Access is found via the beady peep of Putai. The use of secondary, immobile figures inhabiting a different level of existence from the copulators, but within the same field of representation, is used in the pornographic traditions of many cultures. Something similar is brought about in the staring, sculpted busts in the illustrations to Aretino's book (see illus. 42). But Hokusai's picture warrants closer attention, for it displays clever juggling with configurations of the gaze.

Putai is placed to look from right to left. This is also the direction of sight that the viewer would use, as he or she leafed through the book (this is not a single-sheet print) to arrive at this page after turning over the previous one (northeast Asian books go 'backwards'). But what does Putai see? His gaze does not alight on the sexual act itself, which seems to be obscured for him by the woman's nearer leg: he peeps at it in the secondary representation of the reflection in a mirror. There are several levels to the meaning in mirrors, as we shall see, but note how it is used here to build a parallel between Putai and the viewer of Hokusai's picture, who also does not see 'real' sex, only its reflection in a picture. If Putai and the viewer make do with the reflection, so too does the couple, who are watching themselves in the mirror. The mirror image is utterly absorptive, more interesting to the couple than their real knotted organs. If the reflection is enough to discharge the needs of their sexual thrill, then the viewer of Hokusai's book is entitled to feel fulfilment also.

Shunga make extensive use of such interposed figures, not quite human but nearly so, who view what is occurring. Painted screens within the pictures regularly have figures on them and, as with the use of the pictures within pictures discussed in Chapter Three, human or humanoid figures are used to enlarge *shunga*'s domain, in this case their scopic complexity. These pictures replicate the facts of genuine interior decoration and, as such, tend to contain historical subjects

such as the Seven Sages of the Bamboo Grove, or Li Bo, which were common in rooms. But they do not just capture the realities: they are there to pluralize gazing (see illus. 21, 50–52). Masanobu's Little Bedroom Pattern-book (Neya no hinagata) of c. 1738 includes a screen depicting Ariwara no Narihira, recipient of the 'Rock-Azalea' verse, now an adult and passing by Mt Fuji on his celebrated 'descent to the East' recounted in the Tales of Ise (Ise monogatari; illus. 83): exiled from the capital and forced to wander, Narihira came to Musashi. Narihira is not named in the Tales and is just called 'the man', but the identification had become traditional. He was one of classical literature's great lovers, and pursued amours of a variety of orientations. By the Edo period, his wanderings in exile were construed as sexual exercises or a 'carnal pilgrimage' (iro shugyō). He and his companions gazed up at Fuji's lofty peak on a journey that was of sexual, not geographical, discovery. The historical figure of Narihira was central to the valorization of Edo-period sex, not least because Musashi was where the city of Edo was built. Masanobu has made the 'descent to the East' sit across the corner of the room, taking up three sliding doors; one panel is three-quarters open, but despite this, the line of Fuji's slope joins up perfectly, as does the coastline. Masanobu gives both a proper view of Fuji and the lake below, and an opening through which the 'real' space of the next room, with another screen (subject carefully omitted), is exposed. Typically, in the next room there will be a lurking peeper or listener, operating in tandem to us. By having the screen open, Masanobu breaks the integrity of Narihira's space so that his gaze cuts across the open screen; to see Fuji, he must look across a hole, as a result of which his gaze will tumble into the room where the couple are having sex. This rip in representation is accentuated by the scene's depiction across a corner of the room: although the construction is not very logically arranged, the line of Narihira's gaze can only take him to Fuji across the bodies of the prone couple. Like us, that is what he is really looking at.

The Tales of Ise (not to be confused with the Ise Anthology) was a common source for pictures within shunga. Another example is a page from an untitled book of about 1684 by Sugimura Jihei which includes a hanging scroll of the same episode (illus. 95). The genderless travellers (they should be male but look female) hang above the head of a sleeping

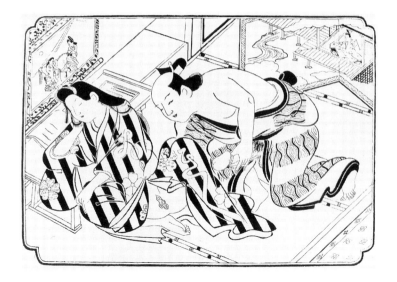

95 Sugimura Jihei, *Erect Man Approaching Sleeping Woman*, monochrome woodblock page from an untitled *shunga* album (*c.* 1684).

woman; her skirts are open. (We will suspend analysis of the role of the approaching male until later.) Watching her is a courtly figure painted on a folding screen that seems to divide the room from one to the right; the man is seated in a palace with a stream running past and is clearly the man (Narihara?) who loved the 'person who lived in the West Wing' who is the subject of one of the *Tale*'s most haunting sections, which also contained an exceptional poem:

> The moon is here,
> And the spring is
> The spring of yore.
> But my body alone
> Is the body it was before.[7]

The man is the only body at the now-deserted house, the woman is dead; he wept until morning came. No Edo viewer would have failed to recognize the two references set out by Jihei. The two scenes are not only linked by their shared source but more immediately in the pictorial logic of the moon: it should be shown above the West Wing but is transposed to the other story – which in terms of the actual *Tales* is incorrect, since the troupe pass Fuji in daytime (night is said to begin to fall at the end of the episode). The moon is pushed across to frustrate isolation of different representational spaces. Jihei has ordered these two scenes to form a dialogue that passes over the body of the sleeping woman. This brings

the viewer in, for this is a world in which ontologies of gaze can leap each other's boundaries. The vagina of the sleeping woman points to the corner of the room, which is bisected by the frame of the picture, providing a point of entry for the viewer's peep.

The complexity of this image does not stop here. The sleeping woman may refer to the person in the West Wing whose body is changed, but she also goes naturally with the *Tales* in toto: Narihira was said to have been forced into exile because of an indiscretion with a shrine maiden, who after the seduction sent him a poem:

> Did you come,
> Or was it I who went to you?
> I cannot imagine.
> Was it a dream or not?
> Was I asleep or awake?[8]

He wrote a similarly ambiguous reply. Perhaps this woman is dreaming of sex, perhaps of sex with Narihira, or perhaps she is enjoying the excuses that somnolence gives. Narihira was so famous a lover, anyone might imagine themselves him, a truism that was the subject of a painting by Eishi (existing in more than one copy)[9] showing a woman dozing off while reading the *Tales of Ise*, one volume in her hand, a box containing the rest beneath her elbow (illus. 96); her dream is clarified in the bubble, and we see she has wished herself into the twelfth episode, where Narihira carried off a lady to the province of Musashi (soldiers with torches are seen tracking them).[10] The *Tales of Ise* are not explicit, but in this woman's dream her libido has run riot and copulates with Narihira in the long grass. Moronobu had already established this scene as one of outright sex in his bawdy retelling of *Ise* (and *Genji*), possibly published the same year as Jihei's work (1684) (illus. 97), and in 1687 Jihei was to do so in an intriguing illustration to his *Pillow of the Sexual Zodiac* (*Sansei aisho makura*), which also suggests that screens ornamented in this way might have been set up in sites of pre-arranged sex; a woman born under the Water sign couples with a man of Wood (illus. 98).

We may be in danger of wandering too far from our topic of voyeurism here. But seeing and being seen can take many forms. In Sugimara Jihei's first image, the woman appears destined for a shock for, as she dreams, a man sneaks up on

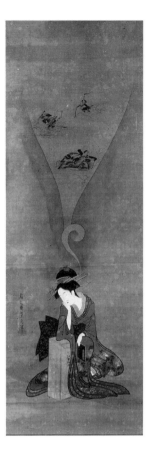

96 Chōbunsai Eishi, *Woman Dreaming over The Tales of Ise*, *c.* 1800, hanging scroll, colour and gold on silk.

her out of nowhere, penis poised for insertion. He mimics the sight-line of the lover of the person in the West Wing, but he may refer rather to the other painting where, oddly, Narihira's horse is riderless. Is this a modern Narihira that the woman has dragged from his mount into the present? The two spaces of the *Ise* pictures are in dialogue but seem also to have spilled into the picture itself. This legitimates the conceit of the user of this picture, imagining himself entering the picture (and the woman) too.

Such play with *Ise* was current throughout the Edo period for it was the perfect work of mediation. Not only was the whole story the result of a sexual encounter seemingly made in dreams, but it was also (untypically) written in the present tense. *Ise* hung suspended in time and in existential dimension. Through *Ise*, history met the present, time became suddenly synchronic, and the old and the new looked at each other. Jihei's second picture, and perhaps Moronobu's,

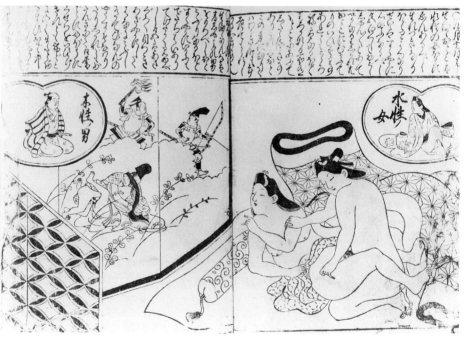

appeared in 1684, two years after Saikaku published his hugely successful modernization of *Ise* under the title of *Life of a Sex-mad Man* (*Kōshoku ichidai otoko*). At the end of Saikaku's book, the resurrected Narihira, now called Yonosuke ('Man of the World'), leaves Japan to sail to the Isle of Women, a kind of dream world for the brusque male libido, just as *Ise* itself provided a dream world for females. The link to the *Tales* was made explicit by Saikaku for when Yonosuke sets sail, he takes with him not much besides 300 copies of *Ise*, dildos, mopping-up paper and a large selection of *shunga*.[11]

In playing with the interior levels of pictures, pornographers were able to unsettle the division between viewer and picture itself. Viewers are muddled. A similar conceit has already been seen in the page from Terasawa Masatsugu's *Twist of Figured Cloth* (*Aya no odamaki*), where a similar play of gazes caters, I think, to a different taste (see illus. 11). The couple behind the sliding paper door have heard what the boy is doing when he was supposed to be practising singing and have interrupted him. Scurrying off frightenedly into the distance at the other end of the door is a figure in Chinese guise, with attendant. He is hard to identify but would seem to be more than generic, and I suppose him to be one of the Four Greybeards of Mt Shang (*Shōzan shikō*); the other three are lost in the opened section (albeit the landscape elements of tree and rock join up, with nothing lost in the overlap). The four sages ('greybeards') were men who fled the collapse of the Qin dynasty in 206 BC and had taken refuge on Mt Shang. After Qin was replaced by Han, the founder of the dynasty passed over his rightful successor, Huidi, in favour of the son of a concubine; Huidi's mother appealed to the greybeards for help and they came down from the mountain to preserve the birthright. This was a good Confucian theme, inculcating the twin duties of fleeing unrighteous regimes and of putting oneself at the disposal of those who sought to root out corruption, and it was painted by many artists of the government's Kano School (illus. 130).[12] An excrescence on the story was often told too, emphasizing less the morality of the sages than their erotic interest in Huidi, said to be a very pretty boy and conventionally referred to as the greybeards' 'bride'. From this world of history, one of the old men has popped out to take a modern Edo boy as his own (perhaps as the viewer of Masatsugu's picture wanted to do), only to run off guiltily

205

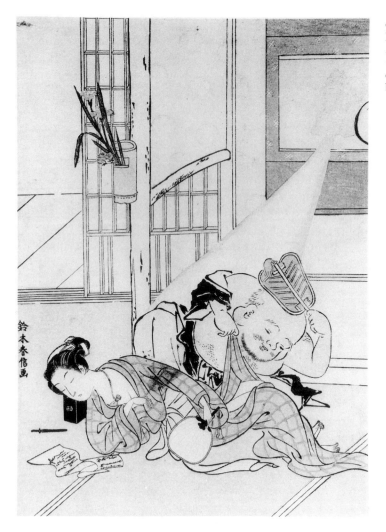

99 Suzuki
Harunobu, *Putai
Exiting a Painting*,
1765-70, multi-
coloured wood-
block print.

when the parents appear; the solitary greybeard takes back
into the picture's space (like an inversion of Narihira leaving
his horse and entering the sleeping woman's room) a painted
boy to sleep with.

One final picture within a picture may detain us. A print by
Harunobu from the close of the 1760s contains a particularly
interesting configuration of pictorial realities and imaginings
(illus. 99). Many works by Harunobu attest to an enthusiasm
for problematizing representation itself, perhaps stemming
from his own work in the invention of multi-colour printing,
by which the world of picture-making was turned on end.
It was Harunobu's pupil Harushige (later known as Shiba

Kōkan) who first introduced copperplate printing and pioneered the unsettling novel manners hailing from Europe.

Harunobu parodies and sexualizes the paradigmatic myth that artistic greatness lay in the ability to paint forms that lived. This was the mythical power ascribed to Wu Daozi of the Tang period and subsequently to any artist deemed superlatively good.[13] Wu had painted a dragon that stirred on the page; in Japan similar feats were ascribed to Sesshū, Kano Motonobu, Maruyama Ōkyo and others. The classical artists painted beasts that lived as noble examples to all who saw them. But in the modern sex-mad world it is Putai, the lucky god (with special responsibility for pleasure), who comes to life, evincing a thorough venality.

The painting hangs in the ornamental alcove, while Putai (originally a monk from the popularized Zen canon) has come out of the picture, leaving his iconographic attribute (a bag) and his shadow behind on the silk. Harunobu jokingly attributes to himself the stupendous powers of Wu Daozi, but it is the power of Putai's lust rather than the skill of the artist that has transmogrified him into the room, seemingly a normal home where a young woman has fallen asleep reading a letter (from a lover?). Harunobu's woman is so desirable that anyone seeing her tries to gain entry into her space and be with her. Putai succeeds in liberating himself, thanks to the Wu myth, but the viewer tries to do the same: any user of erotica relies on the picture to kindle fantasies of possession. Putai and the woman are both the stuff of pictures, and the barrier between their two worlds is not as absolute as that between them and the viewer. But erotic thoughts allow the painted body to become, if not substantial, at least real enough to provoke reaction in our thoughts and, perhaps, in our bodies.

THIRD PERSON PRESENT

The stake in within-picture figures was increased by Harunobu in 1770 in his first work using the homunculus figure (see illus. 59, 120). The book was entitled *Elegant, Sex-mad Maneemon* (*Fūryū kōshoku maneemon*) and issued in two volumes with 24 full-colour illustrations. An accompanying text was probably written by the Floating World author Komatsu-ya Hyakki. The publisher was the fashionable Nishimura-ya. The result must have been expensive.[14] Koryūsai adapted this

for a female version, as seen earlier (illus. 81), and Harunobu himself was working on a sequel based on a successor called Mamesuke, when he died, leaving only 12 pictures of the probable 24 complete (the truncated set was published posthumously, with the tentative title of *Mamesuke*). Both titles pun on *mane* ('imitation') and *mame* ('bean' or small-sized); *-emon* is a male name ending, *-suke* a suffix denoting, usually, a younger son. The figures are little enough to move about undetected and, rather than inspiring people to higher things, they mimic the sexual foibles of Edo.

Harunobu's innovation was to leap over the use of porno-graphic figures painted within pictures (which were inevitably historic) and replace them with an up-to-date, 'elegant' (*fūryū*) man; he appears independently, moving from event to event, as an ambiant *voyeur*. This 'bean imitator' cannot be seen or touched by the 'real' people in the picture and his existence is recognized by the reader only, for whom he forms the crack in the imagistic seal that allows them to enter. Maneemon (and later Mamesuke) is the book's glue, for his presence is the narrative link in what is otherwise a disparate collection of *shunga*. Normally in *shunga* albums it was the viewer who bound the set together, his hand or eye was the device that made the book's parts (cast and story breaking from page to page) cohère. Harunobu makes readers delegate their role to the homunculus.

Maneemon (along with his derivatives) is both the internal, eponymous hero and the external, extraneous interloper into a depicted world in which he has no right to be. He is both in and out of the scenes, which are all depictions of sex. Maneemon replicates the viewer's ambivalent and intrusive presence. He is never an actor in the story, but he sees everything; he is unable to have any effect on what occurs, but he himself is affected by it and imitates it. Maneemon can respond to the sexual stimulation of what he sees, on his own, privately and unwitnessed, just like the stimulated viewer. One image shows him with an erection, proportionately as large as any in *shunga*, but inadequate for anything but self-indulgence. Maneemon never has a partner, in which, too, he is like the pornographic viewer left to manage alone.

A factor that the viewer today is likely to miss is that Maneemon is not only a modern man rather than a god, sage or hero of the past but he also looks exactly as the viewer

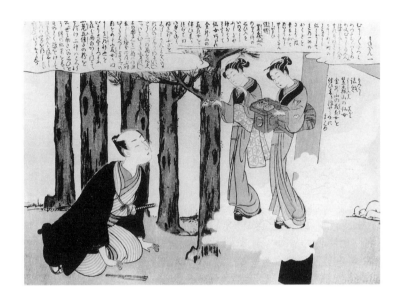

100 Suzuki Harunobu, *Ukiyonosuke's Visitation at the Kasamori Shrine*, multi-coloured woodblock page from Komatsu-ya Hyakki, *Fūryū kōshoku maneemon* (1765).

would wish to look; he has no defining characteristics and is an Edo everyman with whom any eighteenth-century male reader could aspirationally identify. This copyist of the actions of florid sex, both repelled and beckoned by the story, is the reader himself.

The pictures in the Maneemon volumes are not quite as disconnected as those in regular *shunga* but form a kind of encyclopaedia of sexual behaviour. Rather than being a set of loose erotica, they attempt to cover all bases sequentially and, if this still does not amount to a story, Hyakki bills it as the erotic education of Maneemon. The beanman starts as a normal human being who goes to prays for sexual enlightenment at the Kasamori Inari Shrine, which was not far from Ueno, on the land route from Edo to the Yoshiwara (illus. 100). In response to his prayers, two divinities appear and offer him a magic potion, which he drinks, finding himself suddenly reduced to a tiny size and thereby able to pass through the world undetected. These 'divinities' are real women of Edo – Osen, who was a waitress at The Wealth, a teashop by the Kasamori shrine, and Ofuji, who worked at The Willow, a tooth-cleaning goods shop near Asakusa.[15] These are not great courtesans but city women, as he is a common man. Very likely such townswomen were the first sex symbols admired by a young Edoite, encountered long before he had ventured into the Yoshiwara or 'other places'. Edoites would have

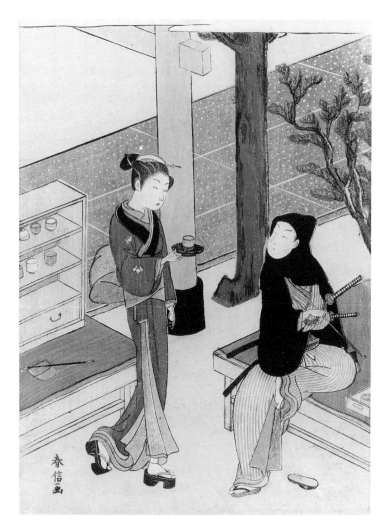

101 Suzuki
Harunobu, *Samurai
Customer with Osen*,
1765–70, multi-
coloured wood-
block print.

learned the thrill of voyeurism (if not actual sex) by watching
women like these, and indeed Harunobu had made some-
thing of a speciality of pictures of these two women, via which
he circulated news of their loveliness (and advertised their
shops) (illus. 101). Harunobu's student's view of the Nihon
Embankment shows a picture of Osen being studied in the
Yoshiwara itself (see illus. 53). One such print of Osen was
adapted by Harunobu himself, or by a follower, to carry a
higher erotic content. This must have been an illicit publica-
tion, since making such imagery of an identifiable bourgeois
woman could not have been legal; the man (not now a samu-
rai) ought to be identifiable from his prominent crest (illus.

84).[16] Harunobu made a very similar print of this cool customer at Ofuji's shop, although no *shunga* version of it is known.

Harunobu and Hyakki referred to the icon of sexualized liminality, Narihira, in giving Maneemon the pre-shrinkage name of Ukiyonosuke, a portmanteau of *ukiyo* (the Floating World) and *-nosuke*, another common suffix for male names, but which refers to Ihara Saikaku's up-dated Yonosuke. Saikaku's work had re-contextualized Narihira in Osaka at the turn of the seventeenth century, and this is now further revised to the Edo of a century later. The first page by Hyakki is also a parody of the opening of the *Tales of Ise*.

Maneemon learns about love. First he sees a calligraphy master copulating with his female student: the premise is that all education leads to sex. Secondly he watches a young couple making love, while behind them are an old man and woman, he burning moxa on her back to relieve aches and pains: the image is of the handing on of sexual activity from one generation to the next, as the tired bodies of the elderly make way for the vibrancy of youth. The next picture shows a pregnant wife (the results of procreative sex), again suggesting the transfer from one generation to another, here not yet born; the woman will become a mother, while the man is not yet ready to relinquish sex without complaint and has been caught wandering into recreational love with a servant. The next scene shows non-procreative sex *par excellence*, that is, one productive only of pleasure, *nanshoku*. Maneemon has flown up on a kite and looks into an upper room where a boy and an older man are engaging in intercourse; the text makes a humorous reference to Harunobu's friend, Hiraga Gennai, using his pen name Fūrai Sanjin, who was known for his *nanshoku* writings.[17] The other pictures move through various categories and stages: an old, but still sexually active couple; a blind monk; sex indoors and outdoors. By the end of the first volume, the reader has passed through the sexual life of a civic person in all its variants.

Volume Two takes place in the Yoshiwara. At first, seen engaged with a courtesan, is a youth referred to in the text as Rokō, that is Kikunojō; despite his interest in female company, he has chrysanthemums (*kiku*) on his costume, partly for his name but also because, as an actor, he was available for male sexual blandishment. Maneemon climbs up a tree and farts –

having only just arrived in the Yoshiwara, he vulgarly behaves as he would in town, as yet unaware of how effete codes govern the quarter, as blankets to hush its real economy. Maneemon is then led though the various stages of procuring a prostitute until he has acquired more aplomb, and by picture 18 he is able to watch as a client finally meets one of the women of the ludicrously expensive and rarefied category called *oiran*. By picture 21 he witnesses the man provoking her anger by renting another woman, and by picture 23, now getting tired, Maneemon sees the end of a night's revelry as a couple have sex outside the gates of a brothel before the man makes for home.

Harunobu and Hyakki's book came out in the same year as another that merits mention in the context of voyeurism. In 1770, Koikawa Harumachi produced *Master Moneypenny's Dreams of Glory* (*Kinkin sensei eiga no yume*), said to be the first work in the *kibyōshi* ('yellow covers') genre, a style of short, amusing books on faddish themes with text written over the illustrations; *kibyōshi* were to dominate Floating World fiction for the rest of the century.[18] Harunobu was active in the moves leading up to this kind of book, as two years before he had illustrated Ōta Nanpo's *Dohei the Sweet-seller* (*Ameuri Dohei den*), the principal *kibyōshi* precursor. Nanpo had begun with the magical appearance of Osen to Dohei descending from the clouds, which was surely the root of Maneemon's mystical encounter; Harunobu's illustration to the opening of *Dohei* is very like that to Hyakki's *shunga* volume. The story of 'Master Moneypenny' (*Kinkin sensei*) is like that of Maneemon in forming a progress from innocence to sexual sophistication, only Moneypenny is visible, part of the 'real' represented world. Rather like the hero of William Hogarth's almost coeval *Rake's Progress*, he exhausts his good luck and his friends' forgiveness and comes to debauchery and ruin.[19] Harumachi ends with Moneypenny being disinherited by the rich man who had adopted him and made his lifestyle possible; Hogarth's rake ends in penury. But whereas Harumachi's and Hogarth's tales counselled against excessive behaviour, Hyakki avoided the sour note and, this being a pornographic work, the pricking of the bubble of fantasy does not take place within the story. Maneemon is weary at the end, but not ruined, and he closes by announcing that next season he will try going to the 'other place' at Fukagawa.

The link of Ukiyonosuke via Yonosuke to Narihira is made explicit by Hyakki in the opening of the Maneemon book, the first page of which is a spoof of the beginning of *Ise*: 'Once there was a man of the Floating World; on Musashi stirrups [the strongest kind] he went to the village of Azuma, overwhelmed by the blossoms, he offered prayers to the moon'.[20] The original begins, 'Once there was a man; after coming of age, he left the capital of Nara and went to hunt in the village of Kasuga, where he owned property'.[21] Ancient concerns have dissolved into modern ones. But the connection brought Maneemon into the direct lineage of erotic dreaming. The importance of dreaming had two sources: one was *Ise*, but the other was a Chinese story that twisted illusion and wordly success, known from a *nō* play, *The Pillow of Kantan* (*Kantan no makura*). Harumachi borrowed his second model for Moneypenny's dreams of glory which were indeed dreams, for he had only seen his rich adoption and his fall while asleep (this distances him from Hogarth's rake). The *Kantan* story original told of a country youth who came to the capital to seek his fortune; on the way he napped while waiting for a meal of millet to steam, and dreaming of glory and final ruin; he then awoke, realized the insubstantiality of success and returned home. Moneypenny's dream was the same, only modernized, and he falls asleep at a rice-cake shop in Meguro just outside Edo. The main feature of the modernization is that the Kantan dreamer had seen himself assuming the top ranks of government, whereas Moneypenny only wants cash and copulation.

References to Kantan are also apparent in the Maneemon story, and Hyakki wove the two dreaming classics together. His clue might have been some of several recent works that told of men who became able to see normally hidden aspects of the world, thanks to dreamlike states. This had been used *c*. 1710 in *shunga* in the writing of Ejima Kiseki in his *Pocketman's Kontan Sex Play* (*Kontan iro asobi futokoro-otoko* – Kontan was a variant of Kantan) – illustrated by Nishikawa Sukenobu.[22] The 'pocketman', called Mameemon (*mame*, 'bean', + -*emon*), travels through the country enjoying abnormally free access to all manner of sex (*nyoshoku* and *nanshoku*), thanks to being so small as to be almost imperceptible.

There is a double aspect of fantasy inherent in these works. The literal dreaming of the protagonist joins with the self-delusions of the reader-cum-masturbator, a fact that was made clear even before Kiseki by the anonymous author of *The Sex-mad Man Born Under This Year's Star Sign* (*Kōshoku toshiotoko*), a work that appeared in 1695; since the zodiac circulated every twelve years, the man is either pubescent or, more likely, has just turned 24. The 'man born under this year's star sign', Toshiotoko, is normal-sized and visible but has undergone a strange transformation by taking a magic potion offered him in the same way as that received by Ukiyonosuke (which turned the latter into Maneemon); Toshiotoko goes to pray at the shrine of Tenjin on Fifth Avenue in Keishi and is turned into an apparent female, while retaining male genitalia. This false appearance allows him access to women-only situations, of which he takes advantage. Upon being transformed, Toshiotoko takes the name Osome, which sounds plausible, but literally means 'dyed': he is stained female to the view but is still male, as it were, in the weave. Osome visits various cities, sleeping with other people's wives and daughters 'in great numbers'.[23] The escapades are cut short when he is grabbed by a *tengu* (a flying, long-nosed demon) and whisked off into the air. It looks about to drop him, and in fear Osome closes his eyes and grabs its nose tightly. The nose of the *tengu* was a standard phallic symbol and occurred in many situations where earthy sexual symbolism was in order (such as folk items or toggles). This *tengu* is more exactly the embodiment of Osome's sexuality. Though looking female, Osome has been in thrall to the phallus until it has dominated him and carried him off, looking likely even to cause his death. He grabs the *tengu's* 'nose', that is, for the first time he takes control of his penis. Osome grabs the nose as a sign that he is bringing his rampant sexuality back under control and that, instead of searching perpetually for fraudulent and deceitful access to women, he will approach them in a mature and open way. As he grabs the 'nose', Toshiotoko wakes up, for here too the whole story has been a dream. He discovers that what his hands have been holding as he slept was truly his erect penis.

Slinking bean men, then, have their pedigree, and it is one linked more to masturbation than to partnered sex. Hyakki's story, and more particularly, Harunobu's pictures were what

propelled the trope publicly into the Floating World, giving it the aura of the Yoshiwara. But *Maneemon* was a work to be read at home, and it is mistaken to flush out the auto-erotic musings that from the first permeated the stories of invisible, non-interactive intruders who forced their way into voyeuristic encounters with other peoples' acts of sex.

The *Maneemon* publication was a hit, as the aborted *Mamesuke* would surely have been had it been finished. Ironically, in view of the meaning of *mane* (imitation), copies ensued. Koryūsai changed the story to a female. Why he did this is not clear, unless, as a samurai (which, unlike Harunobu, Hyakki *et al.*, he was), he could not identify with the townsman Maneemon and so went the whole hog and reset the gender (the publisher would probably not have seen much future in a Maneemon from the upper class). Koryūsai's book looked just like Harunobu's, however, with 24 pictures bound in two volumes with an (uncredited) text. Although aesthetically on a par with Harunobu's pictures, the different signification of female peeping was something that Koryūsai could not successfully resolve, and one is left wondering who would want such a book. The change in gender radically altered the politics. Koryūsai equivocated over the extent of this female's scopic freedom by referring to her as half of a bean couple (*meoto*), although the husband is kept scarce. A female reader could not be expected to be much aroused by (much less identify with) the beanwoman's movements through brothel zones in which all the women having sex were compelled to do so because of legal contracts signed on their behalf while they were children. The book did not relate well either to female masturbation nor indeed to surrogate male lesbian fantasies. The beanwoman did not survive Koryūsai's attempt, whereas beanmen went on and on. Among others to follow Harunobu and Hyakki was Hōseidō Kisanji (also a samurai), who published a *Funny Beanman Who Avoids Girls* (*Onnagirai hen na mameotoko*) in 1777, illustrated by Koikawa Harumachi (another samurai); the same year saw a *Beanman's Glorious Springtime* (*Mameotoko eiga no haru*); in 1782, Ichiba Tsūshō wrote *Beanman Tours Edo* (*Mameotoko Edo kenbutsu*), illustrated by Torii Kiyonaga; and ten years later Santō Kyōden produced *Whose Heart? A Bean to Hurl at Demons* (*Tagokoro oni uchimame*).[24]

These stories work out a whole new system of how to relate

to the pornographic image. Through their play of seeing and not being seen, of intruding and not intruding into an erotic picture, they gave *shunga* a new dimension, relieving the fantasy-craving mind of the pornographic reader and legitimating its enraptured entry into the world of unrealities.

PEEPING AND LENSES

New mechanisms of viewing became available to the voyeur in the course of the eighteenth century. The import of semi-scientific optical equipment, from telescopes and microscopes to peep-boxes and prisms, profoundly altered Japanese constructions of the meaning of sight, as I have argued elsewhere.[25] Harunobu's pupil Kōkan was one of the great popularizers of the visual sub-branch of the new body of empirical learning called 'Dutch studies' (*rangaku*). (The Dutch East India Company had exclusive trading rights with Japan.) The lensed peep was an artificial peep, marvellous and uncanny to the Edo-period viewer. But there was nothing magical about a lens, for it was simply a kind of mechanical eye, as Kōkan wrote in his *Talks on the Principles of Heaven and Earth* (*Tenchi ridan*), completed in 1816:

> The interior of the eye is dark, and the pupil like a pinhole in it, sinews covering it like glass. Thin [at the edges] and fat [in the middle], it is like the lens at the end of a telescope; it is transparent and scratch-resistant. Such are the workings of the eye. [Terrestrial] telescopes, microscopes, celestial telescopes and so on, have all been built after the natural workings of the eye.[26]

To use a lens was to see beyond the confines of the self, as one's gaze travelled alone, far off into the distance, while one's body remained in place.

Saikaku may have been the first to use the then-novel telescope in an erotic context when in *Life of a Sex-mad Man* he told of Yonosuke's first sexual awakening as he watched a maid entering her bath. (Saikaku was given the name 'Oranda' [Holland] Saikaku because his verses were supposed to betray the fiendish cleverness associated with such imported instruments.) In his ninth year, and significantly on the evening of the fourth day of the fifth month (the eve of the Boys' Festival), Yonosuke climbed onto the roof of a pavilion

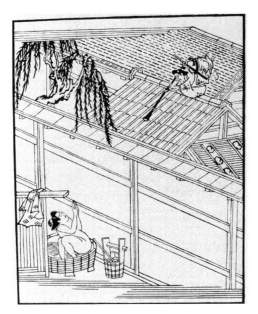

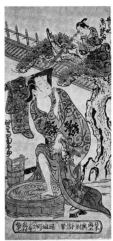

102 Ihara Saikaku(?), *Yonosuke Watches the Maid through a Telescope*, monochrome woodblock illustration for his *Kōshoku ichidai otoko* (1682).

103 Okumura Toshinobu, *Sodesaki Kikutarō in the Role of the Maid, and Ichikawa Masugorō in the Role of Yonosuke*, 1730s, hand-coloured monochrome woodblock print.

and spied on a maid in the bath; again significantly, he hid behind the branches of a willow and noticed that the woman had dunked fragrant narcissus in the tub (the female and male plants). 'Perched on the roof of the hut, he brought out the telescope they kept in it, and looked at the woman, seeing everything she was engrossedly doing.'[27] In the picture that accompanied the story (possibly drawn by Saikaku), the reader sees Yonosuke peeping and the maid, aware of him, protesting (illus. 102).[28] The gaze through the telescope allowed the user to steal something that ought properly to be hidden. Saikaku's book was turned into a kabuki play in the 1730s, with the role of Yonosuke performed by Ichikawa Masugorō (who later became famous under the name Danjūrō III) and Sodesaki Kikutarō as the maid. A print was made by Okumura Toshinobu in commemoration, enhancing the repute of the story (illus. 103).

During the following half-century lenses became quite commonly available, bringing the experience of hyper–natural viewing to many people. In 1783, a shogunal employee with interests in the Floating World, one Suzuki Shōnosuke, wrote a story in which he linked the still popular Maneemon-type figure with the new world of the lens. Shōnosuke published under the pen name Namake no Bakahito ('lazy fool'). The work was illustrated by Utamaro and came out with the

densely punning title *Stolen Away by a Goose – What a Pack of Lies* (*Uso shikkari gantori chō*).[29] A man called Kinjūrō is taken off one day by a massive goose, which drops him in a land of giants. Kinjūrō is thus not really bean-sized but only looks small; he is a regular Edoite male, like the probable reader. It also becomes clear that this 'land of giants' is actually the Yoshiwara, where Edo's gigantically trendy and rich passed their time. Kinjūrō enters this as the midget that a real Edo townsman with scant funds would feel himself to be in the overawing top brothel that Kinjūrō falls into. He is small, but not invisible, and when the giants discover him they begin an investigation of his little body in the manner of Dutch studies enthusiasts probing their entomological samples. They turn the lens to Kinjūrō's effects, inserting into a microscope the love letter he is carrying from his lover, Utagiku (illus. 104). Utagiku's feelings for Kinjūrō are all laid out, as the giants inspect the emotional life of Edo. This is less love than sexual desire, for Utagiku is not Kinjūrō's fiancée but a Yoshiwara prostitute. The probing lens finds more libido than heart, and Utagiku's embraces are paid for and not sincere. (The microscope looks like a telescope but is of the eighteenth-century type where an object was pinned between two sheets of glass and viewed held up to the light.)

An analogous treatment of the lens to procure illicit sights appears in an anonymous *shunga* book illustrated by Kunisada, the *Carnal Pilgrimage to Kamigata* (*Kamigata iro shugyō*) of *c.* 1813. The title harps on Narihira again, turning the sexual

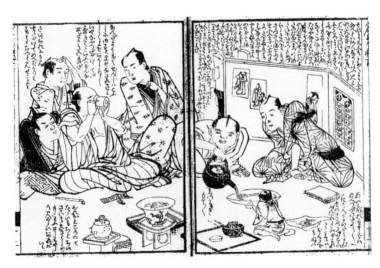

104 Kitagawa Utamaro, *Kinjūrō's Letter is Inspected*, monochrome woodblock page from Namake no Bakahito, *Uso shikkari gantori chō* (1783).

journey he had made to the East into one to the West (Kamigata). The preface plays with the idea of modern technology, couching it in the characteristic pornographic language of denial, and addressing the reader directly:

> Everyone likes the Way of Sex, and has daily recourse to pornographic books (*ehon*), being most grateful for them. I myself turn out a number of pictures, taking my ideas of how to make them from what the market wants, and I trust I can count on your continued support. Concerning that thing that you all most like to look at, I am sometimes uncharitably asked whether when artists make *ehon* if they directly inspect the 'jewelled gateway'. It's not as if we take a telescope into the toilets. But, well, what are we supposed to do? One night, I mustered my acumen and brandishing my artistic prowess I finally made some life sketches of a pudendum. Please inspect them in my forthcoming volume.[30]

Naturally, the awaited volume never appeared. This recalls the *senryū*, 'For artists of the Floating World/Even looking at pussy/Is called work'.[31] But the writer now is teasing with the new language of precision-viewing and picture-making. In 1826 Kunisada's associate Utagawa Kunitora illustrated another anonymous *shunga* book, the *Virgin's Likeness* (*Otome sugata*), in which an old artist peers at 'pussy' (*bobo*) through spectacles; he claims the work is different from pornography since it is done by 'true copying' (*shō-utsushi*), but then puns on the term 'capturing from life' (*ikedori*), or sketching, which literally meant 'taking in hand the living thing'.[32]

Shunga books quite often played a double game with the tools of discovery and Dutch studies. Some of Keisai Eisen's illustrations to the *Pillow Library* (*Makura bunko*), a massive compendium of erotica of 1824–32, for example, purport to be copied from the celebrated adaptation of Kulm's anatomical text, published by Sugita Genpaku and his team sixty years before. One of the arrantly pornographic pictures offers a medicalized interior view, such as the scalpel and lens secured, carrying the absurd label 'copied from the *New Anatomical Atlas*' (illus. 85). About five years later Utagawa Kunisada gave somewhat odd, interiorized erotic views in his *shunga* book *Genji of the East* (*Azuma genji*) (illus. 86). This is a peculiar book in many ways, and the reader was presented

from the first image with unusual content. Instead of the Edoites that people most *shunga*, here we find classical courtiers from the time of Genji. After a few scenes, this does move into the modern world, matching what would have been the buyer's expectations, but then suddenly the last two figures of volume one (out of three volumes) include lenses. The female subject is lost in the massive close-up, as the gaze is dramatically forced down. The lens enlarges but also looks inside the vagina (illogically), showing an index finger tickling. Kunisada made these two lensed pictures half the size of the other images in the book. The field of vision actually constricts. Kunisada sets the viewer athwart two discourses, the medical and the pornographic, in just the way that his title had prefigured by confusing time and space so that the historic Genji from Keishi was now part of the present, Edoite east.

The hand-held loupe Kunisada depicted was not a household instrument and would most often have been encountered in the contexts of physiognomy, when a master read the hand or face for illumination of character. This was a serious and credible science. The Floating World was famously a place of deceit and subterfuge, where all were trying to seem different from what they were, and above all where the female contingent of prostitutes lied like truth and swore bonds of love for money. This is one reason why paintings and prints of the Floating World expunge all recognized physiognomic features from depicted people, preferring unreadability. The woman's face would need to be read by the client anxious to form a liaison with her. But in this erotic picture her vagina is being read, right to its genuine interior, since that is all the revelation the viewer needs to gain.

Perhaps Kunisada's interior vaginal analysis refers to the burgeoning practice of anatomy, since physiognomists did not invade the body but looked only at its surface. The opening of the vagina seen in both the above illustrations detracts from their libidinous purpose, and they were not much emulated. Non-invasive physiognomic parodies, truer to the practice of how readings were made, also appear in *shunga*, such as where the face now reveals not character type but type of genitals (illus. 105). Utamaro's signing himself on some of his 'normal' Floating World prints with the sobriquet 'Utamaro the physiognomist' may indicate claims to sexual

105 Utagawa Kunisada, *Penises of Ichikawa Danjūrō and Iwai Hanshirō*, multi-coloured woodblock page from a *shunga* album, *Takara awasei* (1826).

aperçus about the women (although the series was *not* of courtesans), and he shunned all physiognomic indicators in the faces, making character undetectable (see illus. 79)). About two years earlier, *c.* 1800, he had produced the series *Five Physiognomic Types of Beautiful Woman* (*Bijin gosensō*), in which a magnifying glass is drawn in the top corner, with the series title written in the space of the lens.[33]

TELESCOPES

It was the special power of the telescope to allow inspection of other people at close quarters without oneself being seen. By the eighteenth century, many cities had special viewing points where telescopes could be rented for a fee, or where large-barrelled ones, fixed in place, could be used. In Edo, the best views were at Atago, Shinagawa and Yushima; in Keishi it was the Shōbō-ji above the Kiyomizu-dera at Yasaka. Shikitei Sanba included the cry of a telescope renter in his *Barber's Shop of the Floating World* (*Ukiyo-doko*), a novel issued in instalments from 1811, where, perhaps typically, the man promises more than could really be seen (the cry may be mixed with that of a peep-box operator):

Now then, everybody, come and have a look! Here's the branch factory of the [Dutch East India] Company in Jakarta. There's the look-out post where they use their

telescopes, with its two pine trees, and you can see as far as those three girls over there. All contrived inside this little box [. . .] These lenses will give you a ten-league European stare.[34]

It is interesting that Sanba identifies the stolen peep with foreignness. Europeans in Japan were famous for their love of telescopes, highly necessary at sea, and so brought in good numbers. For the most part, even locally made telescopes (like the one Yonosuke used) were fitted with imported lenses, although there was a small amount of lens-grinding performed in Japan. But there is also a sense here, I think, that the covert gaze, which altered normal vision, was alien in itself, not just in the material allowing its acquisition. Those who used rental telescopes did not just look at big trees, or ships in Shinagawa Bay, but sought out people, as Sanba's crier advises, and not only unusual-looking figures but those engaged in unusual acts. Salacious views were hunted down with the brusque dismissals of propriety available under telescopic voyeurism. The possibility of seeing into someone's secret room is mentioned in several texts. In 1790 Utamaro and Shunchō collaborated on a *shunga* book that introduced the idea of a 'before' and 'after' picture: a two-page spread showing a group of women sharing a telescope (text: 'In the second storey of that house over there is a man and a woman having a chat – oh, they're hugging – oh really! I'm jealous! Their lips are meeting. More!? Oh, now he's putting his hands down there. Goodness! Really! Shouldn't be watching this!') and then the reader turns over to see the couple in full swing, watched via the lens, despite the prohibition (illus. 106, 107).[35]

Once the instrument had been taken in hand and extended, it was hard to know what might be seen. A *shunga* book by Utei Enba II, illustrated by Toyokuni, told of a fire watchman who consistently used his telescope for the purpose of looking into bedrooms as he sat atop his tower.[36] The practice emerged of giving *shunga* the circular frame of an optical device, sometimes with a prior page showing the voyeur. Kunisada tried this in a parody of Takizawa Bakin's best-selling novel of 1814–41, the *Eight Dogs of the Satomi of Nansō* (*Nansō satomi hakkenden*). Hayashi Yoshikazu has argued that Kunisada knew Utamaro and Shunchō's earlier book.[37] Bakin's story included a moment when Satomi Yoshizane looked down

106 Kitagawa Utamaro and Katsukawa Shunchō, *Three Women in an Upstairs Room*, monochrome woodblock page from Shōden-ga-Shirushi, *Ehon hime-hajime* (1790).

107 Kitagawa Utamaro and Katsukawa Shunchō, page following illus. 106, from Shirushi, *Ehon hime-hajime*.

108 Utagawa Kunisada, *Yoshizane Uses a Telescope*, multi-coloured woodblock page from Kyokushū Shūjin (Hanakasa Bunkyō), *Koi no yatsubuchi* (1837).

109 Utagawa Kunisada, page following illus. 108 from Shūjin, *Koi no yatsubuchi*.

from Mt Toyama and saw his daughter, Princess Fuse, cavorting with Yatsubusa. In the parody, Fuse (whose name literally means 'lying down') is engaged in coitus with a dog – justified by Bakin's title, although he had not written about real canines but about men with the character 'dog' in their names (illus. 108, 109).[38] In the 1820s, Kunisada turned this idea to a more saleable theme, showing riparian idlers at the holiday house of the protagonist, Jihei, with Oharu picking out copulation in a boat (illus. 110, 111).[39]

110 Utagawa Kunisada, *At a Summer House*, multi-coloured woodblock page from the anonymous *Shunjō gidan mizuage-chō* (1836).

111 Kunisada, page following illus. 110 from the anonymous *Shunjō gidan mizuage-chō*.

The telescope offered a rather easy domain for sexual joking because of its phallic shape. Like an umbrella, it erected then shrunk back, although, better than an umbrella, it expanded lengthways. Another *senryū* seems to play on the telescope's shape:

> The telescope
> Such bumptiousness!
> Then eyes return to normal.[40]

112 Suzuki Harunobu, *Motoura of the Yamazaki-ya*, multi-coloured woodblock print from the series *Ukiyo bijin hana no kotobuki*, 1765–70.

The notion of the eyes inflating with pride and then going back to their former positions seems to play on penile expansion. A telescope would not be folded away until some exciting sight had been seen, like the penis which, once erect, would not contract until ejaculation.

The brothels in Shinagawa often had telescopes out for clients to play with, since the view was good, with constant coming and going of ships. Harunobu depicted the Yamazaki-ya brothel there in a print from the series *Beauties of the Floating World – Long Life for Blossoms* (*Ukiyo bijin hana no koto-buki*); the prostitute Motoura passes time with a trainee by looking out into the bay (illus. 112). Telescopes made sense in Shinagawa, but their fit into any sexual context was snug. The castaway Daikoku-ya Kōdayū reported that this was also so in Russia, where brothels (he claimed) had telescopes out for clients to use.[41]

Harunobu's rationale for depicting Motoura with a tele-scope is not restricted to the banal reason that such instruments were used in Shinagawa. Floating World pictures routinely expand their field with paraphernalia of erotic overtones. There is a quantity of images of women holding

telescopes in eroticized ways, in or outside brothel settings, and this observation leads to another: there are rather few showing males doing so. In a Floating World context, a man holding a telescope would be open to two interpretations: masturbation or *nanshoku*. The latter made sense, for Yushima Hill was popular both as a look-out place for telescope-users and as a locale for male prostitution (Yushima was the largest *nanshoku* area outside the 'two blocks'). One *senryū* reads simply,

> Where we're heading now –
> Yushima
> And its telescopes![42]

Was it the lenses that excited the speaker, or was it the boys' 'telescopes'? Another *senryū* makes these *double-entendres* clear in a verse that must refer to Yushima although it does not specify a location:

> Pick out the one you want,
> And then do it with him
> By telescope.[43]

Prayers for sexual knowledge of females might be offered at the Fifth Avenue Tenjin Shrine or at the Kasamori Inari, with a response received via Osen or Ofuji, but prayers for knowledge of *nanshoku* were proper at Yushima where there was indeed a shrine, also to Tenjin, whose iconic attribute was the (male) plum. This was discussed in 1787 by Sharakusai Manri, a male *geisha* from the Yoshiwara, in a work entitled *A Festival Tray: What a Feast for the Eyes* (*Shimadai me no shōgatsu*). The illustrations were by Manri's friend Kitao Masanobu (Kyōden), who also supplied the preface:

> You can use a Dutch telescope to spy out bits of loose change that've dropped in the road, and finding something you think to yourself, shall I go and pick it up or not? Manri of the Yoshiwara slung together this little three-part work only devoting to it the time it took him to have a smoke. Glasses perched on the end of his nose, he peered at 'islands' substantial and insubstantial. Lost somewhere in the middle is the matter of the sincerity of those elegant cypress-scented boudoirs on the Central Street. Read it out with a loud voice![44]

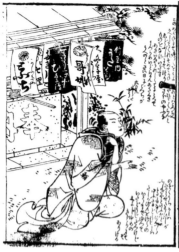

113 Kitao Masanobu (Santō Kyōden), *Boyish God Offers Tsūsaburō a Magical Telescope*, monochrome woodblock page from Sharakusai Manri, *Shimadai me no shōgatsu* (1787).

Sharakusai and Kyōden were more men of the *nyoshoku* than of the *nanshoku* districts (Central Street is the Naka-no-chō, or main street of the Yoshiwara), but the story is of truth and falsehood in all places of entertainment ('island' was slang for brothel). The tale unfolds as the path to realization by a wealthy man called Tsūsaburō ('trendy younger son'), who goes to pray for help at Yushima. One picture shows him kneeling beside the ritual wash basin on which flags donated by the local working boys are flying (illus. 113). The one on the extreme right reads 'Utagiku from the Takeya', which is identical to the name of Kinjūrō's girl from the giant story, but as it means 'singing chrysanthemum' it is better suited to a boy prostitute than to a girl. A god with charming mien then magically appears, chrysanthemum patterning on his clothes, and lends Tsūsaburō a telescope which, he tells him, if properly handled, will allow a thorough investigation and understanding of the ways of the Floating World. The heuristic language of Dutch studies is legitimated via the telescope, although the trope is identical to the visitations discussed above.

PEEP-BOXES

Another optical instrument was the peep-box, not in fact one device but several, generically described by Edo writers as 'Dutch glasses' (*oranda-megane*). They were instruments used to make pictures look three-dimensional and real. Several sorts had been popular in Europe from the mid-seventeenth

century and they were imported to Japan in the succeeding decades, where they were circulated and copied. One representative device (relatively late and common only from the 1760s) was the *optique*, a standing vertical lens with a mirror mounted at 45 degrees to it, which would be placed over a picture set on a table or floor. The user looked through the lens at the picture reflected in the mirror. Harunobu showed one in use in a print from the late 1760s, in his series the *Six Rivers with 'Tama' in Their Name* (*Mu-tamagawa*) (illus. 87). Those who used the device were full of praise for its enhancement of realism, which was best when the scene was drawn in rigorous perspective – a European technique that was scarce in Japan, so any image would do at a pinch, as Harunobu suggests. In Europe, *optiques* were used with topographical views and had been invented to enliven sights of far-off places which the user would never visit. Harunobu suggests this practice also prevailed in Edo, where a view of Mt Kōya is being looked at.

There is no evidence that *shunga* were placed in peep-boxes, nor are there any extant *shunga* drawn in Western perspective. But some stray anecdotes do link 'Dutch glasses' to situations of sex. As with the telescope, these seem to be as much *nanshoku* as *nyoshoku*, although it is less clear in this case why. Kōkan stated (frustratingly briefly) in his *Diary of a Pleasurable Journey West* (*Saiyū nikki*), the record of his trip to Nagasaki, that he took an *optique* and a pile of his own perspective views to show *en route* and raise funds to continue the trip. In the baking eighth month of 1788, he wrote,

> Just as I was thinking I would go off to the girls' brothel I had been to before, and was beginning to make my way there, a dozen or more female impersonators (*o-yama*) came and formed a group around me, in a circle. I found this exceedingly annoying. Maybe such is the custom in these parts, but without even offering me drinks or a snack, they began importuning me in a forceful manner. In the end they did bring out *sake* and something to nibble on, after which conversation got more relaxed. I brought out my *optique*, and showed them views of Ryōgoku Bridge and people cooling off at Nakazu, which really amazed these *o-yama*. In the end, we all got on fine, so I told them to call around the following morning, and went off home.[45]

'*O-yama*' properly meant a kabuki female-role actor, but Kōkan was in the depths of the countryside (Futami-ura) where *bona fide* actors would not be found; by extension the term referred to male prostitutes, which is what Kokan must mean. He may be making a simple statement of fact. But why the linking of *optiques* to *nanshoku*? The question requires further research, but the same connection is found in Harunobu's print. The two figures have crests on their clothes, which ought to make them identifiable, although this had not been done. Both are boys, and we are upstairs in a male brothel. Mt Kōya had a River Tama to justify the inclusion, but it was more significantly the site of the temple complex founded by the prelate Kōbō Daishi, teacher of the Shinga who wrote the 'Rock Azalea' poem to Narihira. Kōbō Daishi was said to have introduced *nanshoku* from China, and in the Edo mind, he and *nanshoku* went hand in hand. For example, the anonymous *Seven Casual Talks on Manners and Customs* (*Fūzoku shichi yūdan*) of 1756 included the observation,

It was transmitted to this realm long ago by Kōbō Daishi. When he was still called Kūkai, he went to the Tang, and studied Buddhist esotericism under Huiguo. At that time, the Way of Boys was very popular in the Tang, and when Kūkai was not engaged in his learning, he got to the bottom [*sic*] of the precepts of that path too. On returning to this land, he established the Sixty [exercises] of Kōya and the Eighty of Nachi, and expanded the Way.[46]

Many *senryū* picked this up, and Harunobu was relying on a tradition.[47] His print includes an (opaque) verse by Kōbō Daishi in the cloud:

> If he should forget,
> He scoops up drops to drink,
> The traveller
> In the depths of Takano
> At the River Tama.[48]

Takano is Kōya. This was a famous verse, although difficult to untangle. Matsura Seizan offered a learned analysis of it that hinged on the fact that the River Tama there was poisonous.[49] Only one who forgets this would drink. But the forgetting is also love, lost in the currents of life. Harunobu's viewers, though, would have expected some Floating World punning,

and this is easy to find: in the 'depths' (literally 'inner part') of Takano was the inner shrine (oku-no-in) which was code for the anus, and 'praying at the inner sanctum' a standard euphemism for anal intercourse; the last two lines can elide to read 'inner River Tama', or literally 'the jewelled [tama] river [i.e. passage] of the anus'. More readily, tama ('jewels') meant testicles; water (mizu) is homophonous with 'unseen', so this could be twisted to mean 'the unseen passage at the rear of the testicles'. Further connections of this sort must wait until we have considered one other optical device.

PEEPING-KARAKURI

Somewhat easier to understand is the device known as a peeping-karakuri (nozoki-karakuri), where karakuri meant a mechanical construction or automaton. This is the instrument that Sanba mixed with the telescope renter's cry in the Barber's Shop of the Floating World. It was also a peep-box and, although originally inspired by an import, acquired significant indigenous adaptations during the eighteenth century; it was still often referred to as an 'oranda [Dutch] karakuri'. It was a large enclosed box containing pictures, viewed through one or more holes cut in the front, sometimes fitted with a lens. The user might see several images in sequence as they were dropped down from above by the showman, who released them to the accompaniment of music or a chanted story.

Many peeping-karakuri pictures survive, and others are attested in texts. One of the best depictions is by Kyōden, included in his Trade Goods you Know All About (Gozonji no shōbaimono) of 1782 (illus. 114). The operator sits on a box marked 'perspective pictures' (ukie), and he bangs a drum to accompany the act or call up customers; a cyclops has just sprung from behind a lantern-shade, probably to mark the beginning of the show. One child crouches at a hole while another draws up. The wings read 'Great Dutch Karakuri' and form a triptych with a European-looking waterfront, in perspective, behind which is the fly-tower for the additional scenes. The dropped pictures are lit through the paper roof.[50] Peeping-karakuri had a lighting trick that allowed scenes to switch from day to night. If the back panel was removed, light came from the rear, shining through the cut-out windows and lanterns of the depicted buildings.

114 Kitao Masanobu (Santō Kyōden), *Peeping-Karakuri*, monochrome wood-block page from his *Gozonji no shōbai-mono* (1782).

Kyōden's picture implies the usual viewers were children and, if so, pornography was unlikely to have been used, but there is also evidence that more titillating material was shown. As early as 1730 Hasegawa Mitsunobu, in Osaka, wrote that, 'The ones looking in are supposed to be young lads, but in reality you'll find it's servant girls, eyes popping behind their hats'.[51] The women behave embarrassedly because they are seeing pictures unfit for children.

The ability to show places of night-time revelry encouraged brothel views, especially those of the Yoshiwara. Morishima Chūryō quoted a showman's cry: 'If you tarry, we will change to night-time scenes showing the establishments [of the Yoshiwara], with the tok-tok of their wooden bells and the plinky-plonk of brothel tunes – we'll even make light appear in the lanterns'.[52] Were the brothels delineated complete with erotic acts going on inside? Possibly there were different types of show, or seemly pictures alternated with (or were followed by) erotic ones, or maybe the occasional piece of pornography was slipped in unexpectedly to give a shock. The real point was that until you had paid the fee and hunkered down, you never knew what was inside.

Masuho Zankō included the following in his *Mirror of the Way of Sex* (*Endō tsugan*) of 1715, with reference to some men using an early-model peeping-karakuri:

> Covering their tracks and making out they are the law, some toughs [use a] peeping-karakuri; [it has] no glass [in the apertures] so that they see the scenes, drawn as Ōtsu pictures, bare.[53]

This is a complex web of puns: 'covering tracks' (*o o inshite*), literally 'hiding their tails', means anal intercourse; 'making out they are the law' (*hō o uru*) literally, 'selling the law', or 'selling methods', is prostitution; 'toughs' (*ōkamidomo*), literally 'wolves', sounds like 'same-sex orientated males' (*okamadomo*); 'glass' (*biidoro*) also means telescope, the established phallic symbol; 'Ōtsu pictures' (*Ōtsu-e*) are pilgrimage icons from that city, but here used to pun on 'big rod' (*ō-tsue*) or penis; 'bare' (*nama*) is also 'naked' (that pun at least works in English), and 'scenes' (*keshiki*) separates into 'hairy' (*ke shiki*).[54] Unpacked, we read,

> Having anal intercourse and engaging in prostitution, the same-sex orientated males [use a] peeping-karakuri; not [putting] pricks [in the holes], so they see the penises, hairy and naked.

Again, *nanshoku* is to the fore.

Pornography was common in the equivalent European boxes, and although we cannot necessarily extrapolate that it was also so in Japan, the privacy of the peep-box (compared with the *optique*) must have encouraged the showing of explicit views. Peep-boxes containing erotic pictures became common in the nineteenth century and may have originated well before. In Europe, the peep-holes might be made in the shape of keyholes to give a sense of prying into private spaces, and such boxes came to be called 'what the butler saw'. It is improbable that the eighteenth-century peeping-karakuri was primarily a device for viewing *shunga*. But it is clear it had associations with scurrilousness. It was an attribute of sex, offering a kind of peeping that was always suspect.

MIRRORS

The scopic regime of *shunga* enmeshed one further item of seeing equipment that may be considered here to terminate

this chapter. The instrument figures widely in pornographic pictures of the Edo period. We have already seen it in two works (Harunobu's *Eight Elegant Parlour Views* [*Fūryū zashiki hakkei*] and Hokusai's illustration with the Putai *netsuke)* (see illus. 56, 82).

The place of mirrors in the pornographic tradition of *shunga* is strong. In Chapter Three we examined how segmentation of the body created an effect of non-adversariality between the partners, their heads and genitals joined in a process that also detached them from their respective bodies. Mirrors contributed to this segmentation. The eighteenth-century mirror was small and could not show both genitals and heads at the same time, so that artists had to make a choice. Either desire and the power of the organs were captured, or else the ratiocinating head. In many illustrations, the mirror served to enhance divisions already effected in cloth, furnishings or architecture.

Mirrors were used in erotic contexts, as they still are. The mirror turns an actor into a voyeur of him- or herself, locked in an embrace with the partner. Users are both doers and seers. A small Edo mirror showed one's own genitals detached and exposed as well as at an angle that could not be achieved with one's naked eye. The organs were objectified, even as sensations were felt in them; it was difficult to appreciate they were one's own, even in climax. When a mirror is shown in a picture, the implications are different. Inclusion allows the viewer to see the depicted sexual act from a second angle, or extra erogenous areas to appear, such as the back of the woman's neck where the hairline met the skin (deemed erotic in the Edo period). A notable feature of *shunga* is to show the genitals *only* in the space of the mirror, thus relegating them from regular space in the picture; this was so in Hokusai's image. A page by Torii Kiyomitsu works similarly (illus. 88). Genitals are in fact rarely shown twice. In Harunobu's *Parlour Views* the organs are depicted, so the mirror is turned away to reveal nothing. The viewer is, then, not given double exposure of any one part of the body but a fractured view of the body in multiple sections. Momentarily confusion reigns over ownership of the parts, and the capacity for adversarial encounter, once again, is diminished.

Changes in mirror technology occurred in the later eighteenth century and may account for the extreme porno-

graphic interest that became apparent. Artists include the traditional sort of mirror in *shunga* (round and made of a bronze/zinc alloy), and these would have remained the norm in most homes. But modern-style glass mirrors with mercury backing had begun to arrive from the middle of the century, and they figure on all ledgers of imports by the Dutch East India Company and in local lists of what was available for purchase.[55] Carl Thunberg commented on how many were smuggled in by European sailors for private sale.[56] A well-polished metallic mirror offered a good reflective surface, and Thunberg phallocratically states, 'members of the fairer sex may view their lovely persons in it, as well as the best looking-glass'.[57] But there were three principal shortcomings. Firstly, a bronze/zinc mirror distorted an object placed more than about 30 cm from it; in point of fact, almost all mirrors shown in *shunga* offer views that are impossible to achieve. Secondly, tarnishing was rapid, so mirrors had to be kept covered when not in use, which meant they had to be brought out and used as part of a prepared strategy of looking and could not be to hand in any chance way (as Thunberg said, 'mirrors do not decorate their walls'); often people would stare frustratedly into mirrors that needed a brisker buffing than they had recently received. Thirdly, bronze mirrors do not reflect colour well but give a sepia tint to all objects.

These limitations would not have been noticed until the arrival of mirrors of the better type. The mercury alternatives offered users views of themselves from far away (allowing the whole body, not just the face – or organs – to be shown); they were also permanently bright, as well as faithful in hue. All of these features enhanced the sense that, when one looked in a mirror, it was something fundamental and important that was being seen.

In the late eighteenth century some members of Floating World artistic circles were advancing the concept that the mirror was a psychological means of access to a more complete personal awareness. Kyōden wrote of this in a story illustrated by himself and published in 1788, the year after he had worked on his friend Sharakusai Manri's book, from which he may have got the idea. The two works are similar, only the technology is different, for instead of Tsūsaburō's insights coming through a telescope, a youth called Kyōya Denjirō gains them through a mirror, now referred to as of the

mercury type (*unubore-kagami*). Rather than using an every-man character, Kyōden particularized the hero in himself, for Kyōya Denzō was Kyōden's real business name, and -*jirō* the designation 'second son', so that this is the author's surrogate or offspring. Further, Kyōden stresses that the magic mirror was real and 'could be bought at the Koshigawa-ya in Ueno'.[58] Looked at carelessly, the title of the book is *The Pocket Mercury Mirror* (*Kaichū unubore kagami*), but the first word is actually *kaitsū*, a non-existent term decipherable as 'opening' (*kai*) a 'person of the world' (*tsū*). The story is of how an unimpressive Edoite lad is turned into a person of prestige and probity. He heads straight for the Yoshiwara and reflects 'truths' (*makoto*) about the denizens of the quarter becoming awakened to deceit.

The inclusion of a mirror in an erotic picture is also a way of playing with the viewer's (as much as the sitter's) relationship with the world. Figures in the pictorial space may look at their own bodies with an air of partial detachment, but this is also how the viewer will see them. A mirror in a pornographic image establishes a level of separation that beckons viewers in, displaces them from the quotidian surroundings of their sites of viewing, encompassing them in the painted world. Dislocation is shared across the passe-partout of the frame, and the viewer can engage with the reflections (which in *shunga* are often the genitals) just as the coupling figures do.

6 Sex and the Outside World

Sex gets rough when it moves outdoors.

We have seen a good number of *shunga* in the course of the preceding pages. It is clear that they form a varied, inventive corpus that is difficult to categorize. Yet there are features recurring in the structure and arrangement of the works that have given me the confidence to make certain inferences and postulates about the group as a whole.

There is one further feature I would like to note, and which I shall take as the point of departure for this chapter, namely, the tendency of *shunga* to confine sexual encounters to enclosed spaces. Of the scores of figures reproduced in this book so far, only one or two are set out of doors, and this is typical of the ratio within *shunga* as a whole. We must investigate this insistence on interiority before we proceed to a special group of *shunga* that do engage with the outside world and which, I shall argue, emerge with the breakdown of the non-adversarial regime of Edo pornography in about the second decade of the nineteenth century.

THE INTERIORS OF *SHUNGA*

Shunga construe sex as something that occurs within walls. This may have been a fact of life, except that erotic pictures do more than depict such facts – they also compensate for them. For the Edo-period male, the chief locales of sexual fetishization were the brothel areas, of which Edo's Yoshiwara was the summit. All red-light districts were stockaded and most were surrounded by moats, ostensibly to protect against fire (since they operated by night) but in practice formally sealing the space off from its respective city; gates and bridges across the moats were shut firmly at night (the objective being to get locked in). Regulations posted at the entrances commanded removal of aspects of civic clothing and badges of rank, as well as dismounting from palanquins, so that men did not enter or leave the Floating World in everyday guise.[1] Women did not go in or out at all. The quarters were capsules that

237

floated outside the normative polities of the cities and were sometimes quite removed from them physically: the Yoshiwara was over an hour from Edo proper. Interactions with the non-floating, or fixed, worlds were governed by codes.

The artistic genre that we call pictures of the Floating World were in their own day often called simply 'Edo pictures', and although they came to be imitated elsewhere, they focused on sites in Edo; being an erotic genre, they gave due attention to the Yoshiwara, with commensurately scant interest in the larger world outside. The emergence of the out-door sex scene in *shunga* coincides with the beginning of woodblock prints of landscape subjects associated with Hokusai and Hiroshige from the 1830s, but these are conceptually removed (if technologically similar) from the libidinous depictions that initiated the printing boom. Before this transformation, almost the only Floating World imagery showing outside spaces are of water – literal flotation – in boats, on the cooling banks of the Sumida during Edo's sweltering summers, or on bridges over it. The association of Edoite relaxation with waterfronts has been examined by Jinnai Hidenobu, and Asai Ryōi's epoch-making *Tales of the Floating World* (*Ukiyo monogatari*) likening the spirit of the person of that mental frame to a gourd bobbing on a stream has already been cited.[2] By contrast, sober-minded people were referred to in the Edo language as preferrers of fixity. The physician Ōtsuki Gentaku, for example, was known as one who despised 'floatation' (*ukitaru koto*).[3] Floating World art ruled in what Gentaku ruled out, and it defined its parameters as that which was in drift. In depicting again and again the Yoshiwara as the paramount site of sexual tension, pictures effectively strip sex off the streets of Edo itself. Pictures cover up the possibility that flirting, *passeggiatas* or 'cruising' went on in civic environments, and the *flâneur* does not appear as an identified type (as he was to be so in the following Meiji period with invention of the activity known as *ginbura*).[4] The city is sexually inert.

Pictures of the Floating World, and erotica as such, do not refuse contact with bourgeois women, and Harunobu made Osen and Ofuji famous. And yet both those women, once depicted in the floating genre, passed osmotically into the orbit of erogeny, such that they prefigured Maneemon's sexual education, or were admired in the Yoshiwara, or were

238

actually redrawn pornographically without authorization (see illus. 100, 84). This also occurred with the underhand sliding of erotica in and out of theatrical contexts. Women would not go to the Yoshiwara, so it was irrational to depict them there, but they are shown dressing their children in kabuki garb or in clothes with actor's crests, beckoning the family into 'floatation'. Further, when Utamaro depicted wives (*fujo*), not prostitutes, in a floating manner they appear on the paper with an unashamed eroticism that would have shocked (see illus. 79).

The depiction of city women was curtailed as part of the Kansei Reforms. Thereafter, no female other than a prostitute could be depicted and, even then, their names could not be given (although, as we have noted, publishers resorted to rhebuses to circumvent this).[5] The 'routine' townsperson was unbuttoned from sex, which was sealed back in its Yoshiwara box.

If sex was largely unrepresented in Edo's townscape, it was even less pertinent to representations of the larger world, or nature as a whole. The wealth of flower, plant and animal imagery in *shunga* presents forms dislocated from their environment, either culled and brought in, or potted and domesticated. Tertiary depictions on screens positioned within the pictorial space offer snippets of nature constructed for symbolic purposes, contrast markedly with Ming-period

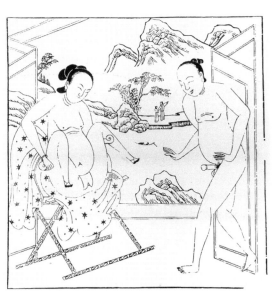

115 Anon., *Lovers Before a Screen*, monochrome woodblock page from *Hua ying jin zhen*, Chinese, Ming dynasty, early 17th century.

Chinese paintings where screens back couples to give the flavour of copulation in the wild, although it actually takes place indoors (illus. 115). The only Japanese pictures within pictures of open nature seen among the illustrations to the present volume come from images where, precisely, they create an environment where sex does *not* overtly take place (see illus. 8, 9). Unaccommodated nature, in virtually every case, is debarred.

Harunobu and Hyakki included just three outdoor scenes among the twenty-four in *Maneemon* – which, in fact is a high proportion by most standards, since few books included any. They can be accounted for by the aspiration to show a full encyclopaedia of sex, serving as Maneemon's education, so that the work aimed at an exhaustiveness that most did not. In the most thoroughly countrified scene, subterfuge is included, and the rustic insertor is actually a more urbane youth (note the sword) wearing a grotesque mask; the landscape looks like a stage set (illus. 120). Maneemon senses the abnormality and the text remarks on 'this strange sort of love that makes you laugh out loud'.[6] Maneemon is dressed for travel and will not be staying long in this place called New Ricefields, which has little to teach. He next goes to a place called Still Trying for It (Kibakari), signalling hopeless attempts at sex, where he sees a superannuated couple making love. Sexual refinement, of the kind *shunga* viewers wanted, is incompatible with these locations.

In his other erotic works, Harunobu attempted few similar settings, and even in *Maneemon* his inspiration seems not to have been kindled by the three country episodes which Hyakki's text required him to illustrate. The scene with the mask-wearer (which barely makes sense) is lifted in its entirety from Sukenobu's *Pillow Book: A Record of a Great Opening* (*Makurabon taikai-ki*), where it forms part of a reasonable plot (illus. 116).[7] Harunobu was an inveterate borrower of imagery, but here it seems that his muse could not function in the production of exterior views.

The authorities wished to instil a sense that sex was best kept off the streets and confined to the pleasure districts or, if absolutely necessary, to the 'other places'. But the more the streets were cleared, the more people went indoors, and if 'normal' Floating World pictures played along by seldom sexualizing markets or roadsides, could hardly be banished from

116 Nishimura Sukenobu, *Lovers in a Ricefield*, monochrome woodblock page from the anonymous *Makurabon taikai-ki* (c. 1720).

eroticism from the home, since (reproductive) sex at least was a civic duty. *Pictures* of the Floating World brought flotation into domestic spaces. The Yoshiwara was expensive and far away, and the sexually-active young or badly-off, financially prudent and busy would not go; the 'other places' offered some respite from the extortionate Yoshiwara prices, but it was cheaper and quicker to find something nearer to home or work. *Shunga* supply images of this, suggesting that chance callers, friends, neighbours or, of course, one's spouse offered snatched delights. It may be that the prohibition of erotic streetlife made the home a centre of fantasy, so that staying put to copulate stoked more passion than travelling to it did. Pornography filled the lacunas between aspiration and fact.

Shunga adopt systems of space that play with the notion of inside versus outside. Haga Tōru has discussed this as a preference for 'awkward' (*kiwadoi*) places for sexual encounters; the Japanese term covers nuances of both restriction and anxiety.[8] Sex, though contained, is in imminent danger of breaking out. Its housings are always on the point of falling away. The very pictures that uphold the belief that sex can be pinned indoors also exhibit its confinement as susceptible to collapse: sliding doors are open, and screens are positioned obliquely so that they fail to shut out views beyond (see illus. 59, 83, 88). Paying sex, and possibly most sex, was performed at night, but *shunga* show events in daytime; in monochrome renditions it may be argued there is little difference, but lamps are infrequently drawn in, so that rooms are not closed up for the night with shutters pulled across to give a finality to walls; the weather is invariably warm (which is not true of spring – *shunga*'s general time frame), and spaces are wide open. Indoors gives readily onto the outside.

241

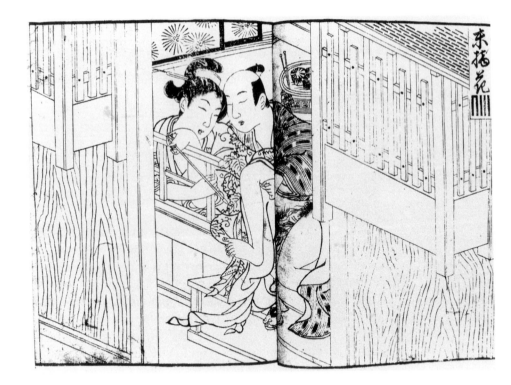

Human figures are pushed near to the openings that punc-
ture their rooms. They do not spread futons in the middle of
the room, as logically they might, but lay them up against
doors and windows, as householders generally did not. There
is a propensity in *shunga* to set couplings in parts of rooms
where spaces overflow with each other, as if tumbling across,
such as at the top of stairs or on verandahs (illus. 117). These
are boundaries, or lines of liminality, and should not be read
as factual renditions of Edo-period habits. Sex is represented
as unstable and perennially verging on the uncontained. Even
in the house, it 'floats'.

This feature of *shunga* is in marked contrast to many other
pornographic types and genres. Ming-period pornography is
set in well-fenced gardens into which access could not be
gained, as any would-be intruder into women's quarters
knew; in equal measure, efflux was impossible. Ming pictures
stress a householder's rightful enjoyment of his (multiple)
female consorts. In Cleland's *Fanny Hill*, Fanny roams London
as a prostitute, in which she is unlike a stockaded Yoshiwara
woman; but at moments of sex she goes inside, locks the

117 Hayamizu
Shungyōsai, *The
Safflower*, mono-
chrome woodblock
page from the
anonymous *Onna
kōshoku kyōkun
kagami* (1790s).

242

windows and doors and hermeticizes her space. Sex leaks out only once in *Fanny Hill* (via a peep through the wall of an inn bedroom), and this too is presented as perversion, since Fanny witnesses that way in the book's only homosexual encounter (other than her own lesbian initiation into erotic desire).[9] These are three systems of dealing with enclosure, but *shunga* alone offer shut spaces – and in many cases the consummately enclosed Yoshiwara – and then break the seal, rendering the whole unit unstoppably porous.

SEX AND HISTORY

The act of sex might be projected onto a larger plane by linking it, not to the surrounding present, but to the surrounding past. The Yoshiwara fed on mythologies of the glorious classical time today called the Heian period (the ninth to twelfth centuries), and its supposed ideals of femininity were extensively deployed. Sustained attempts were made in society as a whole to co-opt the aura of the *Tale of Genji* (*Genji monogatari*), composed before 1100 and well-known from selective representation in many genres of 'Genji picture' (*Genji-e*), which would be given to young women as part of their marriage trousseau. Sex is implicit in *Genji* throughout, for all that, in the words of an early English commentator, it is 'astonishingly free of erotic passages'.[10] There was a sexualization of *Genji* or a 'Genjization' of sex in the Floating World. Use of this myth, however, was controlled as a Yoshiwara privilege: Yoshiwara women borrowed names used in the *Genji* as their professional sobriquets (such as 'Ko-murasaki' or 'Ukifune') and they wore *Genji* motifs on their clothes (like the '*Genji* fragrances', whereby each of the fifty chapters was signified by a pentagram – see illus. 76, 117); women in the 'other places' had common names ('Tama' or 'Motoura' – see illus. 112) and did not borrow from *Genji*. In the mid-1750s the ranking prostitute at the top-class Yoshiwara brothel, the Kadotama-ya, Segawa III, invented a system of using *Genji* chapter titles to refer to common objects, so that cash was called 'heartvine' (*Aoi*), a secret lover a 'broom-tree' (*Hahakigi*), 'flares' (*Kagaribi*) meant a procurer, and tobacco was 'sagebrush' (*Sakaki*).[11]

Genji myth was the icing over much less pleasant realities, as was made clear in a bitter verse on the poor health of some working women, among whom syphilis was endemic. The

verse applied *Genji* chapter headings in a quite different way: the surface meaning was bland:

> To the village of falling flowers
> The son travels in
> A boat upon the waters.

'Village of falling flowers' (*Hanachiri-sato*) and 'Boat upon the waters' (*Ukifune*) are *Genji* chapters; the verse relies on the truism that wealthy sons were for ever going upstream to the bepetalled Yoshiwara. But, cruelly, *hana* means 'nose' as well as 'flower', and syphilis eats away at noses.[12] Far from becoming like Genji and his wife Murasaki, people ran the risk of turning into ghouls, and perhaps it was this that gave rise to another verse from 1705:

> Even *Genji*
> Can be a poison
> To young minds.[13]

Outside the pleasure quarters, *Genji* erotica circulated, as it had from within two centuries of composition. Early sexualized renditions were collected and copied in the seventeenth century, sometimes for publication, and Yoshida Hanbei's *Genji's Sexual Play* (*Genji o-iro asobi*) of 1681 is a famous example. Hatakeyama Kizan's *Great Sexual Mirror* (*Shikidō ōkagami*) of three years earlier billed itself as a 'sequel' (*zokuhen*) to *Genji*.[14] *Genji*-related works might be pretty tangential, and more and more distant references appeared, such as Hayamizu Shungyōsai's book of the 1780s, where a series of loose modern-day encounters, were captioned by a *Genji* chapter title and with the appropriate '*Genji* fragrance'; a page has already appeared here (see illus. 117). The use of *Genji* was part of Shungyōsai's attempt to extenuate the contents of his book (as also evinced in his title, *Sex Education for Women* (*Onna kōshoku kyōiku kagami*)), but his mind was not on it and he was so slipshod that, in the page reproduced here, the captioning reads 'Safflower' (*Suetsumuhana*, or Chapter Six), while the fragrance is for 'Heartvine' (*Aoi*, Chapter Nine).[15] Books might seek generally to outline the sexual positions possibly adopted by Genji with his (many) lovers, although this was entirely hypothetical, since none are stated in the text. Master Teikin (who occasionally signed his name with characters meaning 'testicles'), in his collection of 'laughing

education ?

244

118 Suzuki
Harunobu,
'Analogue' of
'Evening Faces',
1776, diptych,
multi-coloured
woodblock
print.

pictures' of the 1820s, discussed making love on a covered verandah spanning a stream (*wataridono* – a very 'awkward' location), recommending it to the reader as the position tried by Genji when he slept with Oborotsukiyo, daughter of the Minister of the Right, at the Small Villa in Kokiden's mansion.[16] Perhaps this prompted emulation, although few Edoite homes had a *wataridono*.

A major sub-genre of pictures of the Floating World was the rescripting of classical themes in the present. These were called by various names (*imayō/tōsei/fūryū*) but in modern scholarship are referred to as *mitate-e* and in English as 'parody' or 'analogue'.[17] Dragging literature into the Floating World necessarily eroticized it, and there was a tendency to do this to eleventh-century subjects, often from *Genji*. Harunobu produced a diptych as a calendar for the year 1776, 'analogizing' the *Genji* chapter 'Evening Faces' (*Yūgao*), where the hero goes to visit a woman of that name (illus. 118). Genji is now a wealthy son and Yūgao a modern girl; his ox-cart conveyance has become an insect box, while her namesake flower (properly in English, moonflower) covers the gate, alerting viewers to the allusion; the waves on the boy's kimono provide water imagery of the sort common in erotic settings. The buyer of Harunobu's twin sheets brings the

245

couple together. The end of the eighteenth century marked one of the first intensive bursts of scholarship on *Genji*, particularly in the work of the nativist Motoori Norinaga, whose *Little Jewelled Comb for the 'Tale of Genji' (Genji monogatari tama no ogushi)* of 1796 was influential in defining an aesthetic of unfulfilled love and melancholia (*mono no aware*) as the central theme; the great critic Hagiwara Hiromichi wrote with retrospective admiration in 1854,

> There has never been anything like it. The way he picks out those passages where the author hints obliquely at her intentions, then brings them all together and explicates their significance – this in particular is an unprecedented piece of scholarship. His [conclusion] too – that understanding *mono no aware* is the whole point of the novel – is not to be found in any previous commentary.[18]

This had been prefigured by Kitamura Kigin, whose *Moon on the Lake Summary of the 'Tale of Genji' (Genji monogatari kogetsushō)* of 1673 was a landmark attempt to render the text itself comprehensible. But both writers stripped *Genji* of the sexual overlay (both Yoshiwara-related and marital) that had accrued to it over the last centuries; Kigin balanced the blatantly heterosexual Genji (who sleeps with only one man in the book, and then by default)[19] with the compilation of his anthology of male–male love, *Rock Azalea*, while Motoori Norinaga turned the whole into something evocative and resonant but not libidinous.

 Genji was difficult and long, and few read it. There were other period works, and the *Tales of Ise (Ise monogatari)* was perhaps the softest option since it comprised only short sections of text and poems. *Ise* had a strong whiff of sex because of the association of the unnamed protagonist (called 'the man') with the Narihira who had committed an indiscretion with the shrine maiden and been exiled. The Edo construction of Narihira's subsequent wanderings as a 'carnal pilgrimage' (*iro-shugyō*) implied that he had not learned his lesson and still very much enjoyed himself.[20] Moreover, the wilderness he settled in (Musashi Plain) was to become modern Edo, so that by the latter part of the seventeenth century people were loath to consider his exile morbid, nor with Edo then among the world's most vibrant cities could they readily conceive it so.[21] *Ise* also had the advantage over *Genji* that Narihira was not so

aggressively masculinist in his sexual behaviour. The text did not require the counterposing of the *nanshoku* work that Kigin provided. *Ise* has some 7 *nanshoku* episodes which, although constituting under 5 per cent of the total (125 sections), focus on a prominent string from the 82th to the 85th parts.[22] Fifteen years after Kigin's commentary, Saikaku was to announce that Narihira was not really in love with the shrine maiden at all, but with her brother Daimon, with whom he had conducted a five-year affair (Narihira had indeed sent Daimon love poems).[23] The duality of Narihira could be appropriated to legitimate bipolar Edo sexuality as *Genji* could not, and Saikaku analysed (anal-ised) *Ise*'s first verse to provide a twin reading:

> At Kasuga moor
> The young violets
> [Seem to account for] the prints upon my robe,
> While the wildness of my longing
> Knows no boundaries at all.[24]

Saikaku insisted that the young violet flowers that printed their pattern onto the clothing referred proleptically to the violet headcloths worn by kabuki actors; this allowed him to make the transhistorical claim that Narihira had known *nanshoku* and was the spiritual father of its modern commercial purveyors.[25]

No attempt to strip *Ise* of sexual nuance was made, and Narihira's entry into what became the Edo region (his 'descent to the East') remained part of the iconography of Edo sex. We have encountered it in more than one *shunga* context in the 1660s and, if a print by Utamaro is to be believed, it continued to adorn imaginary feminine spaces and sites of paying sexual encounter at least up to the beginning of the nineteenth century (illus. 119).[26] By having passed Mt Fuji, Narihira literally put Edo on the erotic map. Since many Edo residents were not indigenous but had made their own 'descents' from the Osaka–Keishi region, he was the template for the present. Narihira might be referred to generically as 'the gentleman' (*on-kata*), which was a homophone with a common word for dildo, which certainly brought the ancient courtier into the sphere of modern living and especially of female compensatory solace.[27] Genji had less import. Narihira's travelling life made him a model for the modern male,

119 Kitagawa Utamaro, *Group of Women around Screen of* The Tales of Ise, 1800, multi-coloured wood-block print.

who moved through the safety of the shogun's realm making money and having pleasure. Koikawa Shōzan made this explicit in a book on the theme of travel, *A Travel Pillow for the Fifty-three Stations* (*Tabimakura gojūsan tsugi*), whose title refers to the stops on the Edo–Keishi highway, the Tōkaidō:

> All journeys in all directions begin from the centre of Great Edo – this place here. As far as Third Avenue Bridge in Kyō [Keishi] it is 124*ri*, 15*chō*; there are fifty-three stations. This is what is called the Tōkaidō. The standards of the many lords go forth, devout confraternities go to the Ise Shrine, others go up to Kyō to see the sights, or those of Osaka; they travel around Yamato. From whatever direction, they make what they call their 'descent to the East' as that superlative gentleman long, long ago went down on his carnal pilgrimage. Many are those who make their own ascents or descents, and hordes of the populace move round and about.[28]

Ise provided myths for the sequestered female and for the dynamic, mobile male, for female–male and male–male love.

SEXUAL HISTORY PAINTING

Writing from the Korean and Chinese kingdoms was the source of much historical lore in Japan, and anecdotes and pictures of Continentals (*karabito*) were well known. The erotic life of this erudite history was represented even in official painting through the generic figure of the 'Continental beauty' (*kara-bijin*). Among individuals from the past known for their appeal, first and foremost was Yang Guifei. Guifei

120 Suzuki Harunobu, *Lovers in a Ricefield*, multi-coloured woodblock page from Komatsu-ya Hyakki, *Fūryū kōshoku maneemon* (1765).

121 Utagawa Kunisada, *Beanman and Beanwoman Prepare to Attack the Vagina*, multi-coloured woodblock illustration for Naniyori Sanega Sukinari, *Sentō shinwa* (1827).

123 Katsushika Hokusai, *Maruyama*, multi-coloured woodblock print from the series *Nana yūjo*, 1801–4.

124 Chōbunsai Eishō, *A European and a Maruyama Prostitute*, c. 1790s, multi-coloured woodblock print.

125 Kitagawa Utamaro, *European Lovers*, multi-coloured woodblock page from *Utamakura* (1788).

126 Kawahara Keiga, *The Blomhoff Family*, 1817, standing screen, colour on paper.

127 Kawahara Keiga(?), *Captain Blomhoff with a Japanese Woman*, after 1817, section of handscroll, colour on paper.

256

lived in the eighth century and was the lover of the founder of the Tang dynasty, Taizong, but depictions of her abound throughout the Edo period (she is recognizable by her phoenix tiara), such as one by the Keishi artist Maruyama Ōkyo, dated to 1782 (illus. 122). As a concubine, not a wife, she had a sexual not a dynastic persona, and indeed indulgence with her would have cost Taizong his state, but she was assassinated. Like Helen, whose face 'launched a thousand ships', Yang Guifei was a *femme fatale* whose sexual presence interrupted peace and perverted politics. The myth was embedded in the world of modern sex, since Guifei's designation *'qingzhong'*, she who 'made the castle bend' (*keisei* in Japanese), was in use throughout the Edo period to designate high-class prostitutes; red-light districts were called *'keisei*-blocks' (*keisei-machi*). (These words found their way into the argot of the Dutch empire as *keesjes* and *keiseimatz*.)[29]

The power of sensuous women did not change over history. It constituted a recurrent flaw in the phallocratic regime of control. As was said in Edo parlance, women could even lead an elephant by a single one of their hairs (this was also made into a subject of pictures).[30] But, as to be expected of Edo sex badinage, the *nyoshoku* comment was paralleled by a *nanshoku* one, and attractive boys were humorously called ones who 'made the temple bend' (*keiji*), as monks who were forbidden intercourse with women were thought disposed to lose self-control over youths.[31] Note that Guifei's recognizable tiara is worn by the prostitute-god in Manri's story (see illus. 113).

The paradigmaticness of Guifei ensured her frequent depiction, but when made for a Japanese audience one thousand years removed in time she had to be adapted to remain plausible and attractive. This had to do with pictorial style but also with sexual taste. Overtly erotic versions produced as 'analogues' revealed the danger of the antique beauty losing her charge for the modern person, if not updated. Utamaro placed Guifei and her royal lover in their frequent posture of 'blowing the flute together' in his *Comparisons of Sincerity: the Eroticism of Famous Beauties* (*Jitsu kurabe iro no minakami*). All other members of the series showed contemporaries, so it was vital to ensure the antique figures enjoyed the same erotic level; both are given faces thought lovely by the new standards of the time of publication (about 1798) (illus. 128).[32]

128 Kitagawa Utamaro, *Emperor Xuanzong and Yang Guifei*, multi-coloured wood-block print from the series *Jitsu kurabe iro no minakami*, 1799.

Ōkyo (who was not a pornographer) was celebrated for his ability to transcend time and instilled genuine emotion in viewers of paintings on even obstruse themes. An admirer recorded that his practice was to use normal people as models for historical or foreign personages and then 'add an overlay of Chineseness' afterwards, as culled from scholarly reference books.[33]

Writing in the 1850s, Kitagawa Morisada observed the following of all pictures of past persons, citing as examples the great Tang beauty Xishi, as well as Komachi of ninth-century Japan:

> The appearance of men and women is not the same in past and present, for it changes with the time. Fashions come and go. We do not know how Komachi and Xishi were in olden days, but the beauties seen in historic pictures look pretty different from people now in their features, and right down to their nose and eyes [. . .] Probably the kind of people we call beauties today will not seem so in the future.[34]

The responsibility of maintaining conviction in figural subjects lay with the painter.

258

Artists of the shogunal academy, or Kano School, painted plentiful historical themes, which might include Guifei, for it was one of the purposes of their art to offer moral lessons taken from the past for ornamentation of formal spaces in castles and halls. Their subject-matter necessarily included lessons in sexual restraint. A source book was the *Mirror for Rulers, Illustrated and Explained* (*Teikan-zusetsu*), originally published in the Ming period but brought to Japan in the sixteenth century and printed for Hideyoshi.[35] The small woodblock illustrations were expanded over walls and screens, impressing on viewers the danger of corruption and emphasizing that the libido was an impulse that all too easily became history's main dynamic. One episode was 'Sisters of the Concubines Ruining Government' (wheedling on behalf of unworthy family members), which might be twinned with the horrendous gluttony of 'the Forest of Meats and the Lake of Sake' with which bad kings regaled their mistresses (illus. 129).

Good kings are included (they are more numerous),[36] and the *Mirror* showed both the evil of excess and the civilizing

129 Anon., *The Forest of Meats and Lake of Sake*, monochrome woodblock illustration for Zhang Juzhen, *Teikan-zusetsu*, 1606 (copy after a Ming original of 1573).

value of pleasures taken modestly. Non-conjugal sexual relations were assumed among the elite, and these could be inspirational as well as deleterious, as the *Mirror* shows.

All rulers in the *Mirror* are male, and the book assumed female temptresses. This was only half the story for Edo, and in 1623 when Kano Ikkei compiled a list of 'Continental' figural themes to be used in his school, he included a section on the male–male liaisons that had left models for later history.[37] Seventeen themes were given, and although not all appear in extant Kano painting, a frequently rendered story was that of the Chinese government minister Su Dongpo (also called Su Shi), an amateur poet, who met the official Li Jieqiao (also called Li Bi) for sessions of love and writing in the secluded Geomantic Cave; without such relaxation and renewal, both careers would have floundered, to general detriment. Some years before Ikkei compiled this list, his teacher Kano Mitsunobu (d. 1608) produced a pair of screens twinning the Geomantic Cave with a *nanshoku* theme omitted by Ikkei, the 'Four Greybeards of Mt Shang' (illus. 130). This pair could well sit in a palace hall to suggest the ennobling power of restrained sexual activity.

Unlike on the Continent, Japan had a (truncated) history of female rulership, and the role that sex had played in this was not forgotten. Most famous was the *shujō* Abe (posthumously: Kōken) who almost ruined the state as completely as ever the Tang ruler did, through her infatuation with a handsome monk called Dōkyō; this resulted in her deposition, after which no women ruled for 900 years until the practice was revived, as mentioned above, in the person of Okiko (posthumously: Meishō) in 1629. Whatever the historical facts, it was believed that what Abe had really liked about Dōkyō was his penis, said to be mammoth. This scurrilous insinuation, already current in the thirteenth century, was popularized in the eighteenth.[38] As a *senryū* writer put it:

130 Kano Mitsunobu (d. 1608), *The Geomantic Cave and The Four Greybeards of Mt Shang*, pair of six-fold screens, colour and gold on paper.

260

'Dōkyō,
Is that your arm?'
Quoth she![39]

All rulers influenced the course of history through fondnesses and favouritism as much as through policy. The two could not be kept apart. It was pointed out by another *senryū* writer that this also had relevance for the one-handed pornography enthusiast too: an anonymous verse of 1780 noted that the shogunal regents of the Hōjō dynasty, who assumed power late in the twelfth century, abdicated in their early teens:

First wank
And the Hōjō are
Due for a change.[40]

Not only love but masturbation forced the hand of history.

A re-sexualization of even the quite recent past was a spin-off from the Floating World and many of its media participated – *senryū*, *shunga*, prints and paintings. Sex was adduced as valid explanation for inconsistencies in history, and totally fictitious *amours* were invented to breathe life into the names of the dead, especially when their acts had been unpredictable. The true history of the 47 avengers, known as the *Treasury of Loyal Retainers* (*Chūshingura*), contained no adequate explanation as to why the insult that began the vendetta had been made, and so the story was retold as stemming from an act of non-consensual intercourse between Kō no Moronao and Kōgogawa Honzō.[41] Saikaku did a lot of mythical match-making *ex post facto* and bound time onto the grid of his own agenda that made no objective sense, claiming, for example, that the great medieval diarist and cleric Yoshida Kenkō had been the lover of the centuries-earlier lady Sei Shōnagon's brother.[42]

Tales of rulers bore on the elite and so had to be treated sensitively in any popular context. Like the puppet and kabuki enactments of the *Treasury* story, which were guaranteed to pack houses for many decades, it was prudent for authors and artists to transpose political works into different historical moments (the *Treasury* was based on real eighteenth century events, but was reset temporally). This was the reverse of the Floating World's preferred tendency to contemporize via 'analogues'. If a historicized setting of a recent event helped diminish the severity of any punishment due the

publisher, the modernization of history could bring swift penalties. *Shunga* on court themes were absolutely forbidden (though occasionally encountered). *Genji* or *Ise* did not impinge on real political people, but where a treatment of a member of an actual governing elite, even if deceased, was insufficiently discreet, artists were called to account. Notorious was Utamaro's creation of a print or prints in 1803–4 showing Hideyoshi in an eroticized light. It/they were taken from a fictionalized biography of Hideyoshi, written anonymously and published without censure perhaps that year; in 1803 there is some other evidence of a Hideyoshi fad, and both Jippensha Ikku and Ōta Nanpo put out versions, probably stimulated by the biography.[43] Utamaro's offending work cannot satisfactorily be traced, since there are no accounts dating back to the period, but two titles contend: the triptych *Hideyoshi and His Five Wives Viewing Cherry-blossom at Higashiyama* (a true event that occurred in 1598), put out by the famous publishing house the Kaga-ya; and an untitled set of five large-size portraits of persons prominent in the

131 Kitagawa Utamaro, *Hideyoshi and his Five Wives Viewing Cherry-blossom at Higashiyama,* c. 1803–4, triptych, multi-coloured woodblock prints.

132 (right)
Kiyagawa
Utamaro, *Machiba Hisayoshi*, c. 1803–4, multi-coloured woodblock print from a series based on the anonymous *Ehon taikō-ki*.

biography of Hideyoshi (thinly disguised under the name of Hisayoshi), published by another celebrated press, the Mori-ya (illus. 131, 132).[44] What could be ignored when lost in the pages of a long book could not be tolerated as sumptuous single-sheet prints (the biography had also been published in Osaka, where controls were weaker). Worse, the triptych showed Hideyoshi's wives dressed as modern prostitutes.[45] Whether preferable or not cannot be said, but the Mori-ya set showed Hideyoshi with his hand fondling the wrist of a page-boy (an older warrior addresses a woman at the rear). The Osaka book was then banned, and Utamaro, Ikku and some others put in manacles for 50 days.

SEXUAL BEGINNINGS

Japanese traditions established an immediate link between the world's creation and human sexuality. The canonical story told of Izanagi and Izamami in the eighth generation of gods. They were the first to be visible and the first to procreate by

133 Yanagawa Shigenobu, *Gods on the Floating Bridge of Heaven Watch a Wagtail*, multi-coloured woodblock page from Detara-bō, *Ama no ukihashi* (*c.* 1825).

sexual union. The narrative appears in the eighth-century *Chronicles of Japan* (*Nihon-gi*), where it states how Izanagi stood on the Floating Bridge of Heaven and dipped his 'jew-elled spear' (*uobatsura*) into the formless water, shook it and withdrew, the falling drops coagulating into Ono Gorojima, that is, the Japanese archipelago – the first land. It had always been accepted that the 'spear' was his phallus. Importantly, although the female Izamami was beside him, Izanagi did not create land through intercourse (which he was still ignorant of) but by masturbation. The god only then sees a wagtail's rear movements and understands how to copulate. Much could be written on this, but our concern is pornography, so we may note only how germane the story is to the solitary male. So ingrained had this validation of masturbation become that some suggested that Izanagi knew all along how to copulate but preferred to act alone, and further Edo-period eroticizations of the myths often proceeded along those lines.[46] Saikaku tried to insinuate a *nanshoku* element here too, proposing that what Izanagi learned from the wagging of a bird's rear would have more to do with anal than vaginal intercourse.[47]

134 Keisei Eisen, *Gods on the Floating Bridge of Heaven Watch a Wagtail*, multi-coloured woodblock page from his *Makura bunko* (1822–32).

Dipping of the 'spear' and watching the bird were sequentially separate in the narratives but came to be depicted synchronically in the pictorial tradition (illus. 133). This conjoined masturbation and copulation temporally, removing any sense that one preceded the other or that the discovery of the latter had devalued the former. Eisen suggested this at the front of his massive pornographic compilation, the *Pillow Library* (*Makura bunko*), where the gods clasp each other on the bank of clouds, wagtail already to the left, as Izanagi points his spear (illus. 134); two elemental peaks called Male Mountain and Female Mountain rise behind.

During the decade it took to bring Eisen's work to fruition, Yanagawa Shigenobu illustrated a set of three *shunga* volumes with the telling title *The Floating Bridge of Heaven* (*Ama no ukihashi*). He included a picture of two gods on the bridge watching the bird, with Izanagi holding the spear. It is identical to the way that any serious artist would depict the scene, indeed, it is the image seen already here (illus. 133). It needed no eroticizing, for the story concerned sex at its very root. The preface to the book traces all of history from this first sexual event, right up to the present and to the very gates of Edo's

sexual enclave, the Yoshiwara. The dual lure of sex with others and with oneself governs all that has ever happened. We read,

> Wherefore, at the beginning of the world, the two gods stood on the Floating Bridge of Heaven and dropped in the celestial spear, and probed with it in the blue seas. The drips formed Ono Gorojima. The two gods descended to this island and looking at a wagtail understood how to make union of male and female. They opened the pathway of husband and wife and procreated lands, earth, mountains, rivers, grasses and trees. [. . .] Later, people grew foolish and [. . .] sex confused such intelligence as they had. In ancient China, King Zhong lost his lands through infatuation with a courtesan, and [in Japan, Taira no] Kiyomori found no self-control before Tokiwazu, leading to the eradication of his line. The prelate Mongaku became a monk after falling in love with the Cassock Courtesan [. . .] So, in the later times, everything that has occurred can be put down to sex, and we should not laugh at those who act from a craving for it [. . .] So let's all head out then, 'hey, palanquin man! this way!'[48]

SEX ON THE ROAD

As pornography sought a larger space to occupy and the world of the pleasure districts came to seem insufficient, sex moved increasingly rapaciously through space as sex and *shunga* moved outwards. This book has drawn on pictures up to the second quarter of the nineteenth century to substantiate its points about non-adversariality and balance. The truth is that pictures supporting that ideological stance dwindled severely and had all but disappeared by about 1840. In their place were images of aggression and struggle, often set in a landscape outside the confines of brothels or of Edo itself. To consider this change (which marks the end of *shunga* as I have been defining it), we must isolate some prior shifts in the Edo topography of desire.

Edo-period Japan, called 'the Tenka', or that which lay beneath heaven, was highly diverse – more a collective of cultures than a nation state. From the later eighteenth century, travel increased and places known only by hearsay

entered the realm of actual experience. The old 'stories of the unseen capital' (*minu kyō monogatari*), meaning tall stories, literally far-fetched, were replaced by first-hand reportage. The shogunal official Kimuro Bōun travelled to Keishi (the 'Capital') on business in 1780 and returned to write a book aimed at dispelling myth by accurate statement; he gave the work the emblematic title *Stories of the Seen Capital* (*Mita kyō monogatari*).[49] Travellers noticed how aspects of life differed according to region, from family habits to diet, from work to the taking of leisure. Sexual behaviour was not the same everywhere.

The two basic orbits of the Tenka were the Edo region (the Kantō) and that of Keishi–Osaka (the Kamigata). Even in the days before much empirical travel was undertaken, the fundamental distinction between these two places was recognized and, importantly, was constructed as an alterity rooted in gender dynamics. Shogunally enforced demography, with daimyo and entourages stationed in Edo for long periods, made that region predominantly male, and it was said in cliché that Kantō men were tougher and more military. But this sense extended to women too, who were said to display a characteristic quality of 'guts' (*hari*) that was missing in the Kamigata. As Shiba Kōkan, an Edoite, wrote after visiting Keishi in 1813, 'they are weak and cold and lack heroic temperament, and that is why they make poor soldiers', whereas 'the Eastern male [*azuma-otoko*, or Edoite] is an excellent fighter'.[50]

Bōun was unable to find any sexual tension in Keishi, not only on the street (where it was disciplined in Edo too) but even in the pleasure quarters; he described the Shimabara brothel district as 'utterly forlorn' (*hanahada sabishiki*).[51] Bōun was amazed that young women walked alone in the streets at night without the least fear of sexual harassment – as was quite impossible in Edo – and he saw weakness in the way the men walked hand-in-hand with women, not asserting the prerogative, as they did in Edo, of having the women walk behind. Edo was homosocial and predatory towards the opposite sex, Keishi heterosocial and unmolesting, and Bōun was shocked by monks consorting with women and sleeping with them (not with each other or with boys as in Edo). It was as if a constant tap of femininity was required to keep the Keishi male operative.[52] If Kantō women tended towards

the masculine, Kamigata men showed the opposite tendency.

The insipidity of men in Keishi had widely felt effects on the population, for it was noted that the city had imperceptibly drifted into being 60 per cent female. A *yin*-dominated society gave birth to female children, a *yang* one to male. Edo was initially male-dominated because of shogunal policy, but this became self-perpetuating, as so many samurai and attendants resulted in more births of boys.[53] This conclusion was sometimes reached in the West too (although on an individual, not a collective level), as in when Macbeth says to his courageous wife, 'thy undaunted mettle should compose nothing but males'.

The Edo = hard, Keishi = soft split was a trivializing one, for the situation was far more complex. In any case, the Kamigata had two major cities, both mightily different in flavour. The binarism was sometimes supplemented so as to allow for this truth, with a division into what were called the Three Capitals (*santo*) or Three Ports (*santsu*). This was also found to be inadequate with wider travel. The Tenka was huge and pretty nearly infinitely varied.

Guides to the mores of different places were produced and these might cover issues of sex or be dedicated solely to them. In the 1750s the anonymous *Opening the Treasure of Female Delights* (*Onna tairaku takarabako*) included a supplement 'Appendix of Red-light Districts in the Three Ports' (*Sangatsu irosato chokufū*), which despite its atavistic title included 24 locales all across the Tenka, from Aizu to Nagasaki. It appeared as an insert in a pornographic work and was in--tended to give assistance to actual travellers.[54] Around a decade later Hiraga Gennai provided an equivalent for the *nanshoku*-orientated traveller, prefaced by Kappa Sanjin. Gennai covered the Three Capitals and then apologized, 'beyond these, there are places of *nanshoku* in China, India, Holland, Jakarta, among the Four Barbarians and Eight Primitives and elsewhere, which ought to have been dealt with too'.[55]

The road network was one of the great achievements of the Tokugawa administration, and travel was easy and generally safe as long as one stuck to the designated Five Highways (*gokaidō*), foremost among them the Tōkaidō. Conquering powers (of which the shogunate was one) need roads to bind seized lands together, and the Tokugawa (like the Romans)

roaded wherever they could. Official agents (like Bōun) had priority and, when top members of the elite travelled, some roads could be entirely shut to other traffic (like the Nakasendō – called the 'Princess Highway' for this reason).[56]

The chance of officials abusing power and demanding special favours on the road was great, and this included additional sexual provision as well as pack-horses and porterage. A shogunal directive of the mid-century enjoined travelling officials to show basic forbearance, ordering 'abstinence from intercourse with males and females'.[57] Fifty years earlier Engelbert Kaempfer encountered one who had not taken the lesson to heart and who stopped the retinue escorting the East India Company to Edo to commandeer sex: the official's 'affected gravity never permitted him to quit his Norimon [palanquin], till we came to our Inns', but when they got to Okitsu on the Tōkaidō, where 'two or three young boys, of ten or twelve years of age, well dress'd, with their faces painted, and feminine gestures, kept by their lew'd and cruel masters for the secret pleasure and entertainment of rich travellers, the Japanese being much addicted to this vice', he suddenly 'could not forebear to step out at this place, and to spend half an hour in company with these boys'.[58]

Travellers, whatever their status, cut off from the bonds of family and friends, may well compensate for the isolation of foreign places through sex. The deeper psychological needs to indulge could not be suppressed. The anonymity of the road and the small likelihood of partners re-entering one's life, coupled with a desire to sample local produce in people, as well as food or drink, all militated against the exercise of control. For commoners sex seems to have been quite openly touted as a delight of transit, and even a motivation for it, and the precedent of Narihira's carnal pilgrimage loomed large. Kaempfer was startled by the superfluity of supply: 'numberless wenches, the great and small inns, tea-booths, and coop-shops, chiefly in villages and hamlets, in the great island of Nipon are abundantly and at all times furnsh'd withal'.[59] These women were called 'waitresses' (meshimori), but their activities did not cease at the termination of meals.

Shunga treatments of the road begin in the latter part of the eighteenth century. They replicate the triple division of non-pornographic thought and also emulate its final collapse. In c. 1775, for example, Katsukawa Shunchō illustrated an

anonymous work, *Sexual Pathways of the Three Ports* (*Iromichi santsu den*), where 'Santsuemon' (whose name is *santsu*, 'three ports' + *-emon*, the male suffix) goes on his own 'carnal pilgrimage'.[60]

The Yoshiwara lay to the north-east of Edo and was largely irrelevant to long-haul travel, Kamigata being to the west. By contrast, the 'other places' at Naitō-Shinjuku and Shinagawa were nodes where highways emptied into the city. Shinagawa was where the Tōkaidō entered Edo, and its sexual aura was like a ball-and-socket joint of transit and stillness. The air was impregnated with movement, and depictions in word and image treat it in that way. The sound of straw travelling shoes, not the clogs worn in town, were heard and, instead of bird-song, dreams were shattered by horses' neighs.[61]

The definitive text of Edo commoner travel was published in 1802 by Jippensha Ikku, previously a little-known writer, under the slangy title *Down the Tōkaidō on Shanks's Pony* (*Tōkaidōchū hizakurige*) – in other words, on foot. Immediately Ikku became one of Edo's most famous men, and his portrait was placed on the book's inside cover (illus. 135). The story is not pornographic, but its premise is sex: the two heroes, Yajirōbei and Kitahachi ('Yaji' and 'Kita'), are lovers from the old shogunal bastion of Sunpu who come up to Edo and make it their home together before embarking on travels. The entire preface to the book is a series of sexual puns, in this case *nan-shoku* ones, all related to the word 'bottom' (*shiri*) – particularly Kita's, as Yaji is the penetrator; their home is in Edo's Hatchō-bori (*bori* coincidentally meaning anal intercourse).[62] This run-away success was probably the inspiration for Hokusai's equally famous print series, *The Fifty-three Stages of the Tōkaidō* (*Tōkaidō gojūsan tsugi*) which, although avoiding all lewdness, does include 'waitresses' with inviting features, such as one at the 37th station, Akasaka (illus. 136). Ikku began with travel to the Kamigata (that is where the Tōkaidō led), but he did not end there and, as if in proof that binary divisions were now defunct, he continued writing sequels for almost twenty years as the pair went all over the landscape. The last volume appeared in 1821.

The healthy picaresqueness of *Shanks's Pony* was carried further in arrantly sexual spin-offs. They were slow in coming but eventually rose to a flood. The first example appeared in 1812 under the title of *In the Vagina through Slippy Thighs*

135 Ichiraku-tei Eisui, *Portait of Jippensha Ikku*, monochrome woodblock page for Jippensha Ikku, *Tōkaidōchū hiza-kurige* (1802).

136 Katsushika Hokusai, *Akasaka*, multi-coloured woodblock print from the series *Tōkaidō gojūsan tsugi*, c. 1810.

(*Keichū hizasurige*), where the sound of the title almost exactly doubles Ikku's. The main characters are 'Kujirōbei', or 'Ikku 2nd' (*ku* of Ikku + -*jirōbei*, 'second son'), and 'Shitahachi' (*shita* meaning 'tongue'). The unknown author signed himself Azumaotoko Itchō, or 'One Serving for the Man of the East' (i.e. the Edoite). This book was actually even longer-selling than its model, for its sequels did not die until 1851, by which time the author was 'Itchō 3rd'.[63] This too spawned its imitators, and an undated *Diary of Slippy Thighs* (*Hizasuri nikki*) appeared, illustrated by Utamaro II (illus. 137).[64]

But it was Koikawa Shōzan who became the prime topographer of sex. He published numerous books from the 1820s, using various pen names, and illustrated the stories himself.[65] The most sumptuous effort was Shōzan's *Travel Pillow for the Fifty-three Stations* of the 1850s, a splendid work of no less than 54 multi-coloured pages, one for each station of the Tōkaidō, plus a flyleaf.[66] Each picture showed an Edoite copulating with another traveller, a 'waitress' or some country girl. The series culminated in a trend exemplified by Tamenaga Shunsui in his *Comparisons of Sex on the Flowery Road to the Capital* (*Irokurabe hana no miyakoji*), equally lavish, although this time in smaller format, perhaps to give the appearance of being a real pocket road guide; the illustrations were by Kunisada (illus. 138). Shōzan also produced a succinctly named *Fifty-three Stations of the Tōkaidō* (*Tōkaidō gojūsan-tsugi*), unifying the shogun's chief highway and the libido. Kunisada alone produced a similarly unequivocally named *Shunga Fifty-three Stations* (*Shunga gojūsan tsugi*), the wrapper of which was a real map of the road, with the stations marked, overlaid with places of note, selected for their possibility for sexual puns: the river Insui (semen), the temple of Ikezu-Kannon ('can't ejaculate') and tellingly, when the job is done, the 'the bell of casting aside' (*muen-no-kane*) (illus. 139): these are not relationships based on responsibility.[67] Inside, the pictures depicted a sexual act with the locale prominently marked and then illustrated in its own right (illus. 140). The sex which had been banished from the streets of Edo, and had never been much in evidence in those of Keishi, now stalked the highways.

The shift to the outdoors was political. In all cases, the sequence goes from Edo to the outside, reversing Narihira's vector and also the normal parlance by which Keishi had

137 Kitagawa
Utamaro II,
Kagegawa, multi-
coloured wood-
block page from a
shunga album,
Hizasuri nikki
(1820s).

138 Utagawa
Kunisada, *Odawara*,
multi-coloured
woodblock page
from Tamenaga
Shunsui, *Irokurabe
hana no miyakoji*
(late 1838).

139 Utagawa
Kunisada, multi-
coloured wood-
block wrapper for
a *shunga* album,
Shunga gojūsan tsuji
(c. 1820).

140 Utagawa
Kunisada, *Oiso*,
multi-coloured
woodblock page
from a *shunga*
album, *Shunga
gojūsan tsuji*
(c. 1820).

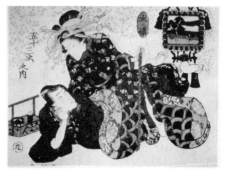

priority and one went 'down' to Edo. Edo is now the origin, and somebody from there passes through the countryside ending at Keishi which, however, no longer constitutes an objective for travel, since the person may as well continue without a halt. Edo's privileged position is that it is the shogun's lap (*hizamoto*), as the saying went; from the 1770s the sense of being an 'Edoite' (*Edokko*) began to emerge, and 1791 marked the earliest shogunal attempt to define and delimit the city of Edo, constructing for the first time an outside.[68] Thanks to the shogunal highways, the Edoite can 'slip' (*suri*) into the cordoned land, the whole country seen as 'thighs' to be pushed apart, not as sites of higher norms. This Edo traveller is always male. He takes possession of the locales he visits, notches up a conquest and moves on. His partners survive only as souvenirs or statistics. Narihira took love as he found it, his wandering poetic as well as sexual, and not lecherous. The term pilgrimage (*shugyō*) meant schooling for a final purpose, that is, a discipline of betterment, even if the 'pilgrimage' was carnal. But the Edoite traveller is a single-minded quantifier of sex – one 'serving' at each station until, at the end of the fortnight that it took to walk the Tōkaidō, he could answer for 53 encounters; this averages one sexual act per 10 km. This traveller bears comparison with Don Giovanni, whose ledger, read by Leporello to the weeping Donna Elvira, is 640 in Italy, 230 in Germany, 100 in France, 99 in Turkey and 1003 in Spain. Similar lists occur in nineteenth-century *shunga*, where they parody the literary genre of notional travels conducted via punning associations of place-names; the puns become sexual not etherial.[69] By 1820 geography was implicated in the coincidence of this kind of pornography with real travel and guide-book writing. The foremost geographer of the turn of the century was Furukawa Koshōken and, as we have seen, he was also a pornographer, one of whose fullest *shunga* works was a mock guide-book.[70]

The Edoite moved out to cull his women – Don Giovanni's greatest head-count was in his home country – and the books treat sex as exclusive to the hinterland, like guidebooks which are not necessary in one's local place. Shōzan began the *Travel Pillow* with copulation at Nihon-bashi, the hub of Edo, but this was presented as a farewell, not a new experience, and it occurs like a ritual of leave-taking the night before the trip. Other books evince protagonists unable to get out of Edo fast

enough. Ikku's stage-setting tale bears examination on this point: he did not even include an Edo scene but had Yaji and Kita directly in Shinagawa. Once they leave Edo, moreover, they cease to be lovers and switch their amorous attentions to locals of the places they visit.

Ikku's construction of the personas of Yaji and Kita includes a second and important element. On leaving Edo they discard *nanshoku* for *nyoshoku*. Although jokes relating to bottoms and anuses continue throughout the book, Edoite sex on the road is about taking women. Once the shogunal city has been defined and the outside identified, it becomes the site of abundance which must be provisioned; Edo is a place of non-yield. Production and reproduction stand against un-fecundity. The eradication of *nanshoku* is a feature of the early nineteenth century, much harped on by writers of the time and also by more recent scholars who have sought to explain it. I would doubt the solidity of arguments for eradication in fact but agree that there was a thorough purging of its repre-sentation. The *Travel Pillow* contains only one *nanshoku* scene, which would have seemed impossibly low fifty years earlier, and significantly that encounter is with an Edoite boy on pil-grimage, not a local: the embrace takes place in a within-city context, and the boy's motivations for journeying are of the old religious, not the modern acquisitive type, and he is anyway too young to breed.[71] Local people must produce, or rather, lay their productive capacity out, for Edo, and con-comitantly it is the duty of the Edoite to take it.

Country matters. The women in travel *shunga* are presented as coterminous with their landscape, part of its agricultural, mercantile or service economies. Sexual acts are imposed on views similar to Hokusai's and later Hiroshige's famous land-scapes of the 53 stations. Utamaro II divided his pictures into three, the top left section showing the location, the top right giving a description of the local women and the lower half depicting the sex act itself. Kunisada's *Shunga Fifty-three Stations* had the local element like a framed picture on the wall (illus.140). Ikku researched the places he wrote about, even persuading his publisher that this was essential enough for his travel expenses to be reimbursed.[72] Later *shunga* reveal nothing of the factual condition of the countryside, for they are not about realities of place but the arrogation of it. Notwithstanding the general rise in travel, the topographical

pictures within pictures in *shunga* suggest no site inspections. Ikku himself had been born in Sunpu and was therefore no Edoite, and his boisterous humour at the expense of regional habitats was not predicated on any desire to rape them. But Azumaotoko Itchō is all and only phallus, as the opening page of his *In the Vagina*, parodying the portrait of Ikku, makes clear (illus. 141). Once he leaves Edo, he becomes one with his organ.

Tokugawa legislation stressed the fundamental obligation on peasants to produce, and it was stated that, if they failed, they would not be able to fulfil tax quotas, leaving their only recourse to sell their women into prostitution.[73] Sexual exploitation of rural areas had always been kept back as the city's privilege of last resort. As the Edo period progressed, villages were depopulated, not only from people entering into urban prostitution, but from the more general demands for labour. Government policy did not so much seek to stem the flight as stimulate the rural birthrate. In 1800, 10 per cent of the entire shogunal expenditure on rural areas went on assistance to increase childbirth.[74] With the fears of depopulation came changes to the acceptability of masturbation, which newly became an instance of waste. The author Teikin was one of the first to note this when he referred to auto-eroticism as 'profitless' (*mueki*); another author, Tokasai, referred to it in 1834 as a 'poison' (*doku*), albeit one practised by all males.[75]

Large families had long been regarded as an absolute good, but masturbation had not been imagined as a retardant to procreation. This changed. Masturbation was pushed into the domain of the pubescent and the aged. Under the title of 'Production' (*sakugyō*) Teikin wrote, 'every drop of semen is the seed of a child, and you must sow it in the good furrow of women to reap a bountiful reward of offspring'.[76] The words are all the more startling because they appear in a *shunga* book. It may well be that the mythology of erotica as an instrument to encourage sex between men and women (and of limited interest for any other gender combination or for independent personal use) begins at this time as a means of defending the genre against attack.

Teikin was the first author to integrate agricultural terminology into a *shunga* book. His one-page vignettes are headed by a label punning on crop terminology: trimming the pubes is called 'clearing the field' (*kaisaku*), first-love is 'early stooks' (*hayase*), and all these experiences are garnered into life's rich 'granary' (*dozō*), illustrated on the final page. The marriage age at this time was going down, which might have saved the losing of too many seeds but which also provoked anxiety of a 'herbaceous' kind. Shiba Kōkan, circulating popular medical lore, wrote that, whereas marriage used to occur at about 30 for men and 20 for women – 'which is roughly the same as on the Continent and in Holland' – and was natural, in Japan it had dropped. People were marrying in their teens and producing children too young, which put the Japanese at a racial disadvantage: 'children born to the under-twenties will not grow up intelligent, whereas those born to maturer people will infallibly be clever'. Herbology then takes over as a new governing metaphor: procreation is 'as with plants, where the fruit is good when ripe, but not before'.[77]

At the moment that the deliverability of the after-effects of sex becomes a concern, the motif of violence against those who will not supply it begins to appear. Eighteenth-century *shunga* never entertained the possibility that a partner might be unwilling; no one was forced. As sex moves outdoors, a gap opens up between men and women, everyone stands to one side or the other, and the taking begins. Depicted partners pull away from each other and the fusing of bodies that we noted before is lost (illus. 142). The figures gain firmer and more integrated bodies, resist mutual absorption, and neither

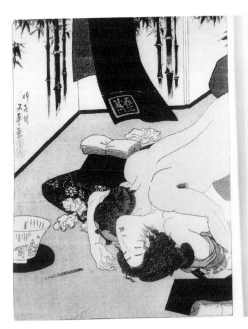
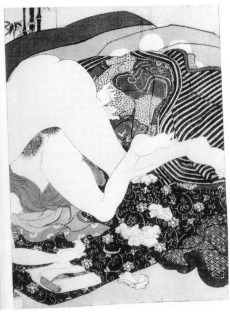
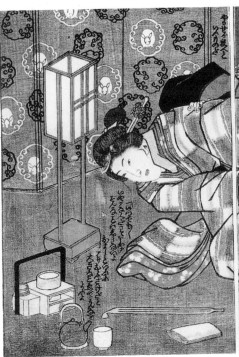
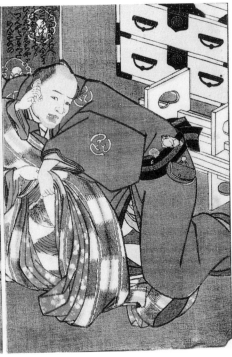

142 Utagawa Kunisada, *Lovers*, multi-coloured woodblock page from a *shunga* album, *Azuma genji* (c. 1837).

143 Utagawa Kunimaru, *Woman Resisting Intercourse*, multi-coloured woodblock page from Koikawa Shōzan, *Keichū ō-karakuri* (c. 1835).

144 Keisai Eisen, *Rape*, multi-coloured woodblock page from *Waka murasaki* (1830s).

clothing nor additional elements can fuse them into each other any more. Actual rape becomes a *shunga* fetish, either by friends and relatives or by burglars and cut-throats. A woman cries out at her employer, 'Why do you keep doing this? I hate you! Stop it and let go or I'll scream and bring everyone in' (illus. 143). While a wife calls 'Robbers!', the intruder comes back with 'Nice spud! Keep on calling and we'll have some real skewered potato!'; not only has the country tuber become a metaphor for vagina, but the terminology of stabbing has entered the language too and swords, twisted or unsheathed, point their blade *towards* the victim (illus. 144). Even Beanman turns nasty, his world becoming a place of slash and burn in which he cannot progress by sentimental education but only by killing. In Kunisada's use of the homunculus in his *New Tale of the Welling Waters* (*Sentō shinwa*) of 1827, Beanman must draw his sword to fight off a monster vagina that threatens to engulf him until, quelled, it surrenders to his bidding (illus. 121).[78]

In 1741, London experienced a pornographic hit in *A Voyage to Lethe by Captain Samuel Cock, Sometime Commander of the Good Ship Charming Polly* – a barely disguised parody of Cook's voyages.[79] Tales of discovery bred natural counterparts in tales of eroticism, and discovery, linked to empire-building, was also linked to sex. Fourteen years later, Samuel Johnson was to designate 'ambassador' (the career traveller) in his path-breaking *Dictionary of the English Language* punningly as 'a man sent to lie abroad for his country'.

Few Japanese of the period travelled abroad and fewer returned, so that an encounter with foreigners meant meeting on home turf. Nagasaki had a fairly international feel, with its contingent of Chinese and a small group of Europeans and their enslaved Indonesian workers; of the latter two, all were male. *Shunga* viewers were interested in these communities, and all appear (though not with equal frequency) in images and stories.

The Indonesians have left the smallest impression on the historical record; they were housed in conditions deplored by the Japanese (so Thunberg claimed) and were allowed little chance for fraternization with the local community, sexual or otherwise. The problematic officer Jan-Baptist Ricard (whom we shall meet below) tried to ban the frustrated 'slaves' from the Company's garden because they took advantage of its location for 'gesturing' to people across in the city.[80] The shogunate made repeated attempts to have one of these men sent to Edo to be viewed, although the wish was never met; more prurient scopophilia is also apparent.[81] A carved toggle has been preserved which offers what was perhaps a rare, and certainly rarely represented, sexual encounter between an Indonesian and a Japanese.

As many as one in five Nagasakiites may have been Chinese.[82] Furukawa Koshōken went there to see things for himself and enquired specifically as to their sex life. Koshōken took as his data the passage of prostitutes from Nagasaki's brothel district, the Maruyama, to the Chinese quarter; apparently, a limit of 35 at a time was set.[83] Chinese must also have accounted for a proportion of the clients who went to the district (as distinct from summoning women home), and *shunga* show this. The Chinese tradition of *shunga* seems not to have

affected Japanese depictions, although surely Chinese in Nagasaki possessed items. There were some famous love affairs between Japanese and Chinese, and the biographies of some mixed-race children were recorded (semi-fictionally), such as the Ming general Coxinga and the 'Indian' Tokubei.[84] Chinese had mixed with Japanese until the fringes of the division between them blurred.

Different in every way were the Europeans, referred to as 'Dutch' since they came as members of the Dutch East India Company (known by the initials of its name – Vereenigde Oostindische Compannie – as the VOC), although from many European countries. They numbered about a dozen for most of the year, but when the two annual ships were in port, this swelled to over two hundred.[85] The VOC went bankrupt at the end of the century and sailings to Japan became more *ad hoc* and also more mixed, with American ships often being used (it was remarked how American 'blacks' – *kuronbō* – looked different from European ones).[86]

The all-male situation in the VOC compound increased the need for interaction with the host society, and the men had a huge impact on Edo-period life in many respects, including on its sexual pictures. These men may have brought Western pornography, of which Amsterdam was the centre of production. At least one illustrated book certainly entered the country, and was acquired by Matsura Seizan – Voltaire's *Pucelle d'Orléans*, which had scandalized Europe after its publication in 1755.[87] Stories circulated in the European East Indies that Japan was a pleasant place for making quick liaisons (although venereal disease was rife), and sailors formed bonds with Nagasaki women; importantly for us in this study, they also had portraits made to take home with them. Satō Narihiro, who visited Nagasaki, told of one example:

> While I was there, the Europeans summoned artists and had them make portraits exactly as in life of the features of the prostitutes they had been with. These were for taking home with them so that they would always remember what the women looked like.[88]

Of course, these would not have been pornographic, but they were surely eroticized to some degree, with sitters posed in alluring ways. No such pictures seem to survive, but as they were commissioned from local artists they would have had an

impact on Nagasaki painting as a whole. Portraiture was widely believed to be the preeminent Western genre (it was not greatly practised in North-east Asia). *Shunga* were also commissioned, and an episode in the diary of the supervisor of the Chinese compound for the summer of 1779 tells of his finding a pornographic painting done on glass, prepared for export on a VOC ship; this caused a stir until the Nagasaki governor ruled there was no law prohibiting the export of *shunga*. Japanese *shunga* existed on the Asian continent in large quantities, presumably openly exported.[89] Some of the first pieces of Japanese art brought to Europe were *shunga*, when in 1613 John Saris bought 'certaine lisciuious bookes and pictures', as was quoted above.[90] 'Normal' pictures of the Floating World were collected overseas too.[91]

More relevant than the foreign history of *shunga* collecting is the effect of European men on Japanese pornography. Most Western sailors, who had spent many weeks at sea during which they only had each other for sexual partners (which was forbidden), wanted female company. Koshōken wrote that the Nagasaki women were often seen hanging around the VOC compound and, when the Europeans appeared, 'the wives and children of the locality who were loitering at the gate, all began to amuse themselves by calling out sexual innuendos (*ekoto*)'.[92] Bourgeois women were unlikely to get any closer than this, but prostitutes had access to the compound and were permitted up to three consecutive nights there.[93] Nagasaki's two brothel areas (the Maruyama and the smaller Yoriai-machi) were patronized by the Europeans as by the Chinese, but the special feature of the two was that women were able to go out to their clients, which made for visible toing and froing in the streets. Some Europeans knew a little Japanese and some Nagasakiites Dutch, although the *lingua franca* of the South China Seas was Malay. Isaac Titsingh, head of the Nagasaki station in the early 1780s, spoke fluent Japanese and perhaps because of that became the first European to successfully woo a woman of *tayū* rank (the top grade of courtesan, which had died out in Edo through over-pricing, and who had the – perhaps only theoretical – right to deny unwelcome customers); the woman was fifteen and called Ukine.[94] The difficulties of international communication can be exaggerated, for those who speak the 'language of love'.

The three senior members of the VOC visited Edo annually, and the trip there and back took about a quarter of every year. They provoked interest, not least it was claimed from women, and persons as high as the wife of the daimyo of Satsuma (mother-in-law of the shogun) requested in 1769 that the men parade before her; seven years later, Thunberg claimed in Shinagawa the women 'made up to us in shoals' and 'formed around us, shut up as it were in our Norimons, a kind of encampment'.[95] Physical encounters would have often been paying ones, and Kōkan patronized a brothel in Osaka which had as its claim to fame that a Dutchman had once stayed there.[96]

It was only the Maruyama that was defined by its internationalism, and for which multi-ethnic copulation was its badge of difference. The illustration of the Maruyama in the supplementary guide to *Opening the Treasure* showed a woman with a Dutch client; this was the book's only picture to have a woman accompanied and it was surely made so for evocative purposes, since Dutch clients must have been infinitely fewer than Japanese (or Chinese) (illus. 145). This was the Maruyama's image. When Hokusai produced a series of prints of the seven best quarters in 1801–4, it was again the Maruyama alone that he showed with a client present, again a Dutchman, and he included an inscription in the 'mad-verse' (*kyōka*) style (illus. 123):

> The foreigners too,
> Drawn lovingly to these lands,
> In soft springtime
> Meet the pleasure ladies.[97]

There are also many *senryū* (less high-flown in idiom than *kyōka*), for example:

145 Tsukioka Settei, *Maruyama*, monochrome woodblock illustration for his *Onna tairaku takarabako: shokoku irosato chokufū* (c. 1780s).

The Maruyama woman
Receives a letter
Ṣhe cannot read.

He brings his interpreter along
The Maruyama
Client.

Maruyama clients –
13,000
Leagues.[98]

Phallic rivalry is apparent, with local males unhappy at 'their' women being taken. Koshōken reported the belief that women always slept with Europeans unwillingly.[99] But the limitation of the Europeans to paying sex coloured the way their sexuality was imagined. The role of prostitutes in disseminating information about the men prejudiced the kind of facts that circulated.

There is a sub-genre of explicitly European-related *shunga*. Kōkan painted one, as did the shogunal official and Western-style artist Ishikawa Tairō.[100] They had never witnessed anything like the events portrayed. The Edo market was avid, and mass-produced printed pornographic images were issued. In all cases the male is European and the female Japanese – which was the only kind of encounter to openly occur. Chōbunsai Eishō's print of the 1790s includes a dialogue for the amusement of the viewer (illus. 124). The woman states, 'I can't understand what you are saying at all. Push! Do it harder!' To which the man replies in gibberish, 'oken kera kera kenkera tou yoka yoka yoka yoka'.

Difference, in general, was the theme, whether of bodies, sexual habits or, ultimately, the language in which desires were expressed. Instances of weirdness found their way rapidly into print, as in the supposedly European custom of having a bowl to hand to catch vaginal secretions for medicinal use. Eisen referred to this in his *Pillow Library*, announcing a 'Method for Producing the European Life-Prolonging Ointment'. The cost of ingredients was about five small coins. He wrote: '. . . smear it onto the glans about one hour before intercourse; certainly apply it when becoming flacid; works miracles'.[101]

There is also a *senryū* of 1791:

146 Nagahide, *Europeans Collecting Vaginal Juices*, monochrome woodblock page from the anonymous *Rakutō fūryū sugatakurabe* (c. 1810).

147 Yanagawa Shigenobu, *A Continental Couple Collecting Vaginal Juices*, multi-coloured page from Kōtei Shūjin (Shikitei Sanba?), *Yanagi no arashi* (1822).

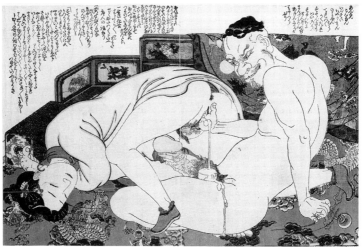

The foreigner
Plants a vase
By the woman's behind.[102]

I know of no evidence to support this endlessly repeated notion, but a sense of how the proceedings went were often drawn; one instance is in the anonymous *Comparisons of Elegances in West Raku* (*Rakutō fūryū sugatakurabe*) of *c.* 1810, illustrated by an artist known only as Nagahide and unusual in being published in Keishi (the city he refers to by its old poetic name of 'Raku') (illus. 146). Yanagawa Shigenobu showed a Continental couple trying the same experiment

285

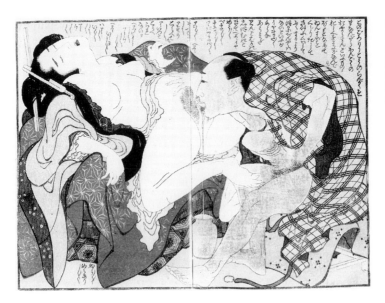

148 Katsushika Hokusai, *A Couple Collecting Vaginal Juices*, multi-coloured page from *Enmusubi izumo no sugi* (1830s).

(illus. 147). An undated *shunga* book illustrated by Hokusai suggests the practice was emulated in Japan itself, for he shows two Japanese involved; the woman's gasps make it clear this was not irksome, while the man announces 'Recently I've been going in for a bit of European studies' (illus. 148).[103]

Utamaro might have been one of the first to move to a consideration of how Westerners interacted with their own kind. His *Pillow of Verses* (*Utamakura*) includes a wind-blown seadog with a woman seemingly of his own ethnic group although dressed in the costume of a different epoch (illus. 125). Most travellers with the VOC were in their thirties, but this man looks older. Still, Utamaro never went to Nagasaki, so he would not have seen a European at close range, if indeed at all.[104] This is from the non-adversarial period, but even by the standards of those *shunga*, the bodies are almost totally absent, as if Utamaro lacked the confidence to attempt them, although the heads are carefully rendered. As with all the pictures in the album, it is without text.

The first European women came to Japan until 1817 and were at once painted (illus.126). One was none other than the wife of the VOC head in Japan, Jan Cock Blomhoff, who brought her on his second trip (on the first, which ended two years previously, he had not been so faithful and had fathered a child by a Maruyama woman called Itohagi).[105] His wife came with two maids and a child. They were soon expelled,

although not before the important Nagasaki artist Kawahara Keiga could make a formal portrait. Although the dating cannot be proven, it seems that the painting was immediately remade pornographically (illus. 149). The *shunga* version has also been attributed to Keiga.[106] This is part of a set of twenty pictures showing Europeans in many situations, with each other and with Japanese. The Blomhoffs' lion-legged sofa comes up a second time, where a sailor and a Maruyama woman romp on it (illus. 127).

The series has no homosexual scene, and I have found no Western-related *nanshoku* imagery. This is perhaps odd, perhaps not. The surge of interest in Europe coincides with the beginning of the suppression of *nanshoku* representation. As part of the 'moving outside' of *shunga*, the bulk of foreign-related pornography is beyond the pale of non-adversarial, inclusivist *shunga* and the age of compulsory heterosexuality approaches. However, the links between those who studied the West and those who favoured *nanshoku* are oddly close. Gennai was famous as both. Dutch studies circles wrote much about *nanshoku*, and especially about its enforced excision in the West. Morishima Chūryō gave an entry in his *European Miscellany* (*Kōmō zatsuwa*) entitled 'Prohibition of *Nanshoku*', writing,

> In their countries *nanshoku* is ferociously prohibited. They say it is counter to human ethics. There was someone

149 Kawahara Keiga(?), *Captain and Mrs Blomhoff – Shunga Version*, after 1817, section of handscroll, colour on paper.

found guilty of it then [time unspecified] who was burned at the stake, and the youth was drowned in the sea. Apparently, this is still done. My source is this year's scribe, Rikarudo.[107]

Surprise and nonplussment greet the news imparted by this 'Rikarudo' – who was actually Jan-Baptist Ricard cited above, who was in Japan in 1784–5, back in 1786, and in Edo the following year when he must have met Chūryō. (He was again in Nagasaki in 1794.)[108] What Ricard was doing talking about this subject to an important man like Chūryō (brother of the shogun's body physician) is unclear, as indeed is his own stake in the matter.[109] Later Chūryō published in another book that *nanshoku* prohibitions extended to the Western colonies too.[110] Daikoku-ya Kōdayū could vouch for their severity, since he happened to arrive in Yakotsk just as a senior official, one Smolyanof, was being tried for sodomy; it was Chūryō's brother who edited Kōdayū's narrative and expressed shock that the man was found guilty although the boy was a willing partner.[111]

Europeans, who so punctiliously plotted the world, sailed through all seas and categorized what they found, also ruled things out. To categorize was also to exclude. *Shunga* in their heyday eschewed the construction of barriers. As the new regime of limited and coerced sexuality emerged from within the shogunal state, it met the draconianism of an outside doing the same with equal rigour. *Shunga* came to an end, although pornography of another kind continued to flourish. The period treated in this book was not a golden age of sex, for all relationships were founded on inescapable disequilibriums of power. But it may have been one of the finest times in the history of erotic pictures. The late eighteenth century was at least an age when parties wished to represent sex as pleasurably shared and mutually sustaining, and when they were relatively indifferent to the combinations shown pictorially. We should consider the possibility that it was the very commercialism of Edo sex, and the self-evidence of its not being the result of people choosing to come together, that required erotica to compensate with such profuse lies. But the lies appear so plausible, for the pictures are so unfantastic and circumscribed, that perhaps their visions were even believed – as they often continue to be.

References

INTRODUCTION

1 Peter Wagner, *Eros Revived: Erotica and the Enlightenment in England and America* (London, 1988), p. 6. This point is also made in Lynn Hunt, 'Obscenity and the Origins of Modernity, 1500–1800', *The Invention of Pornography: Obscenity and the Origins of Modernity, 1500–1800* (New York, 1993), pp. 9–18.

1 EROTIC IMAGES, PORNOGRAPHY, *SHUNGA* AND THEIR USE

1 Ernest Satow (ed.), *The Voyage of Captain John Saris to Japan, 1613* (London, 1967); pp. lxvii–xviii. I am grateful to Derek Massarella for bringing this to my attention.
2 Craig Clunas, *Pictures and Visuality in Early Modern China* (London, 1997), pp. 151–2. These words are from Li Xu, 1597.
3 Kamigaitō Ken'ichi, 'Nikkan zenrin gaikō no keifu, pt 2', pp. 4–10. Choi Park-Kwang, 'Japanese Sexual Customs and Cultures Seen from the Perspective of the Korean Delegations to Japan', *Imaging/Reading Eros* (Bloomington, IN, 1995), pp. 76–8; in 1711 the Korean Sin Yu-Han, in *Hayyulok*, recorded the existence in Japan of a song which included the lines, 'Show me the erotic, vivid pictures / You're hiding in your bosom. / I enjoy comparing us with those pictures / . . .', quoted in Choi, *ibid.*, p. 77.
4 Ihara Saikaku, *Nanshoku ōkagami*, p. 36.
5 This term was invented by Steven Marcus in *The Other Victorians: A Study of Sexuality and Pornography in Mid-Nineteenth-Century England* (New York, 1974), pp. 44–5.
6 Ihara Saikaku, *Shoen ōkagami*, pp. 274–5. The work is also known as *Kōshoku nidai otoko*.
7 Anon., *Kōshoku tabi nikki*, unnumbered last page from copy in National Diet Library, Tokyo.
8 Nishizawa Ippū, *Yakei tomo-jamisen* (1708), p. 317.
9 'Ogamu te ni koe no mura utsu makurabon'; quoted in Hanasaki Kazuo and Aoki Meirō, *Senryū no shunga-shi*, p. 106.
10 Azuma – 'the East' – means Edo. For the *azuma-gata*, see Tanobe Tomizō, *Igaku mitate edo no kōshoku*, pp. 177–9.
11 Ihara Saikaku, *Kōshoku ichidai otoko*, p. 211 (including an illustration of the models on display in Nagasaki, where locals and foreigners are viewing them).
12 The preface is reproduced in Tsuji Nobuo *et al.* (eds), *Ukiyo-e hizō meihin-shū: Utamakura*, p. 53. For the illustrations see Kobayashi Tadashi (ed.), *Ukiyo-e soroi-mono: Makura-e*, vol. I, pp. 39–49.
13 For Kiyosaburō's career, see Nojima Jūsaburō (ed.), *Kabuki jinmei jiten*, p. 30. In the story, Kiyosaburō's name is written with the character *yo* meaning 'generation' rather than 'world', which is anachronistic since he changed upon adopting the name Arashi (previously Hanai).
14 This inscription appears in 'Hanazuma of the Hyōgo-ya' from the series *Gonin bijin aikyō kurabe* (*c.* 1795–6). For a reproduction, see Shugo Asano and Timothy Clark, *The Passionate Art of Utamaro* (London, 1995), p. 171.

15 Julie Nelson Davis, 'Drawing His Own Ravishing Features: Kitagawa Utamaro and the Construction of a Public Identity in Ukiyo-e Prints', PhD thesis, University of Washington, Seattle (1998), esp. pp. 172–292.

16 'Nigao-e de ateire o suru naga-tsubone'; quoted in Kimoto Itaru, *Onanii to nihonjin*, p. 42.

17 Tanobe, *Igaku mitate*, p. 177.

18 The *ōtsubi-e* exists as a genre showing close-ups of genitalia; as far as I am aware, it has not previously been suggested that these derive from *ōkubi-e*, but the dating fits.

19 Hiraga Gennai, *Nenashi-gusa kōhen*, pp. 124–6.

20 See Howard Link, *The Theatrical Prints of the Torii Masters: A Selection of Seventeenth- and Eighteenth-Century Ukiyo-e* (Honolulu, 1977), pp. 31–6. Dating of the lives of early Torii artists is problematic, and several different people seem to have used the same names.

21 For a full translation, see Timothy Clark, *Ukiyo-e Paintings in the British Museum* (London, 1992), pp. 24–6.

22 From 1793, non-Yoshiwara women could not be named, and in 1796 no women could be: see Suzuki Jūzō, *Ehon to ukiyo-e*, pp. 433–61.

23 For a discussion of this and other prints that move to (and more specifically from) *shunga*, see Richard Lane, '"Kiesareta shunga" o abaku', *Geijitsu shinchō* (June 1994), pp. 3–47.

24 These have been partially studied by Hayashi Yoshikazu, *Edo no makura-e no nazo*, pp. 38–63. However, Hayashi only considers the post-Toyokuni sort. Shikitei Sanba states in the preface to *Hayagawari mune no karakui* (1810) that Toyokuni was reviving a style popular when he (Sanba) was young (Sanba was born in 1776); quoted in Tanemura Suehiro, *Hakonuke karakuri kidan*, p. 47.

25 Timon Screech, *O-Edo ijin ōrai*, pp. 177–89, and 'Edo and Madame Tussauds' (forthcoming). See also Paula Findlen, 'Humanism, Politics and Pornography in Renaissance Italy', *The Invention of Pornography*, ed. Lynn Hunt, p. 61 (with illustration).

26 There are several *senryū* on the similarity of titles, see Hanasaki and Aoki, *Senryū no shunga-shi*, pp. 43–4.

27 For a reproduction and transcription of the story, see Hayashi Yoshikazu, *Katsukawa Shunshō*, p. 147–83, especially pp. 153–5. Hayashi interprets the book being used as a guide to the Yoshiwara (*saiken*), although the text refers to it as a *makura zōshi*.

28 Three classics are Kimoto, *Onanii to nihonjin*, Fukuda Kazuhiko, *Edo no seiaigaku*, and Tanobe, *Igaku mitate*.

29 Tokasai, *Shikudō kinpi shō*, ed. Fukuda Kazuhiko, vol. II, p. 62. The old master is called Inpon.

30 See Fukuda's comments, *ibid.*, p. 63.

31 For a transcription of the inscription and a (poor) reproduction, see Sasaki Jōhei, *Ōkyo shasei gashū*, p. 177; the sketch is from his *Jinbutsu seisha sōhon* (1770).

32 'Makura-e o takara ni yomu shikareru'; quoted in Yamaji Kanko, ed., *Suetsumehana yawa*, p. 28.

33 'Makura-e mainichi kawaru okidokoro'; quoted in Hanazaki and Aoki, *Senryū no shunga-shi*, p. 49.

34 Because of the abraded quality of the original, this translation is tentative.

35 See Hanazaki and Aoki, *Senryū no shunga-shi*, pp. 69–70.

36 Clunas, *Pictures and Visuality*, p. 157.

37 Anzai Un'en, *Kinsei meika shōga dan*, p. 384.

38 Ōta Nanpo (*et al.*), *Shunsō hiji*, p. 6.

39 Henry Smith, 'Overcoming the Modern History of "Shunga"', *Imaging/ Reading Eros*, p. 27.

40 Ihara Saikaku, *Kōshoku ichidai otoko*, p. 116.

41 Takeda Izumo *et al.*, *Kanadehon chūshingura*, p. 368.
42 *Ibid.*, headnote. The editor who makes this comment is Otoba Hiromu.
43 Smith, 'Overcoming the Modern History of "Shunga"', p. 28; Hanasaki and Aoki, *Senryū no shunga-shi*, pp. 113–14.
44 Quoted in Asano and Clark, *The Passionate Art of Utamaro*, p. 285 (adapted).
45 Jean-Jacques Rousseau, *Confessions* (1782); quoted in Joan DeJean, 'The Politics of Pornography', *The Invention of Pornography*, ed. Lynn Hunt, p. 110.
46 Shiba Kōkan, *Saiyū nikki*, p. 70.
47 'Zashikimochi nise Tan'yū o kakete oki'; I am grateful to Kasuya Hiroki for supplying me with this verse; in the *Yanagidaru* it is no. 21/4/4/omote.
48 'Baka fūfu shunga o manete te o kujiki; muri ni shunga no mane o shite tsujichigai'; quoted in Hanasaki and Aoki, *Senryū no shunga-shi*, p. 13.

2 TIME AND PLACE IN EDO EROTIC IMAGES

1 Robert Darnton, *New York Review of Books*, December 1994; quoted in Smith, 'Overcoming the Modern History of "Shunga"' , p. 26.
2 Hayashi Yoshikazu, *Edo no makura-e no nazo*, p. 164. Asano Shūgō and Shirakura Yoshihiko, 'Shunga shuyō mokuroku', *Ukiyo-e soroi-mono: Makura-e* (1995), pp. 32–42. More fully (arranged chronologically, not by illustrator) is Shirakura and Kogawa Shin'ya (eds), '[Makura-e] nenpyō', pp. 129–37.
3 Matthi Forrer, 'Shunga Production in the 18th and 19th Centuries', *Imaging/Reading Eros*, table on p. 23.
4 *Ibid.*, p. 24.
5 Nakano Eizō, *Edo jidai: kōshoku bungeibon jiten*, p. 230.
6 Nakano Mitsutoshi, 'Kyōho kaikaku no bunka-teki igi,' pp. 53–63. All relevant publishing controls are quoted.
7 For a recent study on the birth of the multi-coloured print, see Edo-Tokyo Museum (ed.), *Nishiki-e tanjō: Edo shomin bunka no kaika* (exhibition catalogue, 1996).
8 See for example, Takizawa Bakin, *Kiryo manroku*, p. 207.
9 Forrer, 'Shunga Production', p. 24.
10 See note 1/33 above.
11 This generalized figure is now accepted by almost all sources.
12 Samuel Pepys, Diary, 13/1/1668 and 9/1/1668; see *The Shorter Pepys*, ed. Richard Lathan (Harmondsworth, 1986), pp. 873, 875.
13 Until recently, scholars misread *ehon* (erotic book) as *enpon*, a possible, though incorrect pronunciation; some continue to do this, but it obliterates the double meaning.
14 Takuchi Makoto, 'Festivals and Fights: The Law and the People of Edo', *Edo and Paris: Urban Life and the State in the Early Modern Era*, ed. James L. McClain *et al.* (Ithaca and London, 1994), p. 402. More generally, see Noguchi Takehiko, *Edo no wakamono-kō*.
15 See Fujita Satoru, *Matsudaira Sadanobu*, p. 111.
16 Matsudaira Sadanobu, *Uge no hitokoto*, p. 112.
17 'Utamaro no bijin fusuma de toshi o yoru'; quoted in Timothy Clark, 'Utamaro and Yoshiwara', *The Passionate Art of Utamara*, p. 45 (my own translation).
18 Ishino Hiromichi, *Esoragoto*, p. 270.
19 Engelbert Kaempfer, *A History of Japan together with a Description of the Kingdom of Siam* (London, 1727), p. 206.
20 Muro Kyūsō, *Kenzan hisaku*, pp. 263–64.
21 Moriyama Takamori, *Shizu no odamaki*, p. 240.
22 *Ibid.*, p. 242. For the expansion of theatrical styles, see also C. Andrew Gerstle, 'Flowers of Edo: Kabuki and its Patrons', *18th Century Japan* (Sydney, 1989).

23 Moriyama Takamori, *Ama no yakimo no ki* (1798), pp. 706–7.

24 Yuasa Genzō, *Kokui-ron* (1793?), p. 36.

25 Moriyama Takamori, *Ama no yakimo no ki*, pp. 706–7.

26 Matsura Seizan, *Kasshi yawa*, vol. II, p. 31. The family name is sometimes given as 'Matsuura'.

27 This event is reported in Sugita Genpaku, *Nochimigusa*, p. 77. For a parody of the *shinjū* fad, see Santō Kyōden, *Edo umare uwaki no kabayaki* (1785), pp. 176–7.

28 See above note.

29 Anon., *Tenmei kibun, kansei kibun* (date unknown), p. 194. The building is referred to as a *chaya* built in the style of those on Naka-no-chō (the Yoshiwara's central street), complete with *engawa* and *sōmagaki* (verandah and blinds).

30 I refer to Saikaku's novels *Kōshoku ichidai otoko* (1682), *Kōshoku ichidai onna* (1686) and *Kōshoku gonin onna* (1686).

31 Anon.,*Tenmei kibun, kansei kibun*, p. 194.

32 For Eishi, see Kobayashi Tadashi, 'Gazoku no koō: honga to ukiyo-e', pp. 367–9. For Michinobu, see Timon Screech, *The Shogun's Painted Culture* (forthcoming). Eishi's father was *kanjō bugyō* (chancellor the exchequer) and Michinobu was *oku-eshi* (painter-in-attendance on the shogunal house).

33 See Kobayashi Tadashi, *Hanabusa Itchō*, pp. 23–7. It was only after his return that he took the name Itchō.

34 For this incident, see Naitō Masato, 'Chōbunsai Eishi no iwayuru "Yoshiwara kayoi zukan" ni tsuite', *Nikuhitsu ukiyo-e taikan* (1996).

35 Kobayashi Tadashi, '"Sumida gawa ryōgan zukan" no seritsu to tenkai', *Kokka*, 1172 (1993), pp. 5–22.

36 Asaoka Kyōtei, *Zōchō koga bikō* (c. 1845), quoted in Naitō Masato, 'Chōbunsai Eishi no iwayuru "Yoshiwara kayoi zukan" ni tsuite', p. 240.

37 Timothy Clark, 'The Rise and Fall of the Island of Nakazu', *Archives of Asian Art*, 45 (1992), pp. 72–91.

38 Sugita Genpaku, *Nochimigusa*, p. 81.

39 Matsura Seizan, *Kasshi yawa*, vol. V, p. 67.

40 Anon., *Tenmei kibun, kansei kibun*, p. 260.

41 Sugita Genpaku, *Nochimigusa*, pp. 84–5.

42 Matsudaira Sadanobu, *Taikan zakki*, p. 40.

43 Moriyama Takamori, *Ama no yakimo no ki*, p. 606.

44 Matsudaira Sadanobu, *Seigo*, p. 273.

45 'Yanebune mo yakata mo ima goyōsen chitchin wa naku tsuchi tsunde iku'; quoted in Saitō Yukinari, *Bukō nenpyō* (1849), vol. II, p. 3. For the Nakazu policy generally, see Shibusawa Eiichi, *Rakuō-kō den*, p. 155, and Clark, 'Rise and Fall'. The verse was later attributed to Ōta Nanpo, see Clark, *ibid.*, p. 89.

46 Matsudaira Sadanobu, *Uge no hitokoto*, p. 143.

47 *Ibid.* See Timon Screech, *The Shogun's Painted Culture* (forthcoming).

48 Matsudaira Sadanobu, *Shugyō-roku*, pp. 184, 190, 192.

49 Shibusawa Eiichi, *Rakuō-Kō den*, p. 187.

50 'Tenaga ga ashinaga ga hairikomu no furo no uchi'; quoted in Yamaji Kanko, *Suetsumuhana yawa*, p. 206.

51 See, for example, Shiba Kōkan's letter of 1813 to Yamaryō Kazuma, reproduced in Nakano Yoshio, *Shiba Kōkan kō*, p. 43.

52 'Onna yū no shōjigata wa anadarake'. I am grateful to Kasuya Hiroki for alerting me to this verse.

53 For a selection of *ukiyo-e* showing bathing, see Hanasaki Kazuo, '*Nyūyoku' hadaka no fūzoku-shi*.

54 James McClain, *Kanazawa: A Seventeenth-Century Japanese Castle Town* (New Haven and London, 1982), pp. 113, 143 . This had not always been the case,

see *ibid.*, p. 64. Kanazawa technically did have bathhouses, but they were permitted to open only six days per month.

55 Katsuragawa Hoshū, *Hokusa bunryaku*, p. 584.

56 Satō Narihiro, *Chūryō manroku*, p. 160. Narihiro is also called Chūryō.

57 For Toryō (or Toryū, more often called Hōitsu), see Naitō Masato, 'Sakai Hōitsu no ukiyo-e', *Kokko*, 1191 (1995), pp. 19–27. For the (mistaken) claim about Sōtatsu, see Hiroshi Mizuo, *Edo Painting: Sōtatsu and Kōrin*, trans. John M. Shields, vol. XVIII of *Heibonsha Survey of Japanese Art* (1972), p. 45: '[Sōtatsu] never seems to have concerned himself with depicting the life and manners of his own time'. This has become a cliché of Sōtatsu lore.

58 For Shigemasa's *shunga* titles, see Asano Shūgō and Shirakara Yoshihiko, 'Shunga shuyō mokuroku', pp. 135–6.

59 *Tōshōgū engi emaki*; the work is now in the Tokyo National Museum.

60 For Keisai, see Uchida Kinzō, 'Kuwagata Keisai kenkyū: okaka eshi jidai no katsudō o megutte', *Kokka*, 1158–9 (1992), and Henry Smith, 'World Without Walls', *Japan and the World* (London, 1988).

61 Santō Kyōzan, *Itchō ryū-teki kō*; ms in National Diet Library, Tokyo. For Hōseidō Kisanji's novels, see Koike Masatane *et al.* (eds), *Edo no gesaku ehon*, vol. III, pp. 107–42; for Nanpo's verse, see Hanada Giichirō, *Ōta Nanpo*, p. 130. For the history of this set of scrolls, see Asakura Hidehiko, *Edo shokunin-zukushi*, pp. 1–9.

62 See Robert Campbell, 'Poems on the Way to Yoshiwara', *Imaging/Reading Eros*, p. 95.

63 This text appears at bottom left of illustration 30.

64 Matsura Seizan, *Kasshi yawa*; quoted in Asakura Hidehiko, *Edo shokunin-zukushi*, p. 2.

65 Matsudaira Sadanobu, *Taikan zakki*, p. 35. The term rendered 'vulgarity' is *iyashiki*.

66 Moriyama Takamori, *Shizu no odamaki*, pp. 251–2. The books referred to are *Kusunoki ichidai ki*, *Yoshitsune ichidai ki*, *Hachikazuki*, *Kareki ni hanasaki jiji*, *Sarugane kassen* and *Kinbei*.

67 For the death of Iemoto, see Blussé *et al.* (eds), *The Deshima Dagregisters* (Leiden, 1995), vol. IX, p. 232.

68 The motto comes from Yamamoto Tsunemoto: see below, note 77.

69 For a discussion, see Eiko Ikegami, *The Taming of the Samurai* (Cambridge, MA, and London, 1995), pp. 253–64.

70 Tachibana Nankei, *Hokusō sadan*, pp. 204–5.

71 Furushima Toshio, 'The Village and Agriculture during the Edo Period', p. 498.

72 Yuasa Genzō, *Kokui-ron*, pp. 6–8.

73 *Ibid.*

74 Matsudaira Sadanobu, *Seigo*, p. 255.

75 For Nankei's anatomical work, see Nihon Ishi Gakkai (ed.), *Nihon iji bunka shiryō shūsei*, vol. II, pp. 37–52.

76 Matsudaira Sadanobu, *Taikan zakki*, p. 158.

77 Yamamoto Tsunemoto, *Hagakure*, p. 44. The source of the comment was the doctor Jun'an (d. 1660).

78 Sharakusai, *Tōsei anabanashi*; quoted in Nakamura Yukihiko, *Gesaku-ron*, p. 121.

79 Takizawa Bakin, in *Kiryo manroku*, p. 43, reported seeing a play of Ranmaru's life performed in Osaka.

80 Ōta Kinjō, *Gosō manpitsu*, p. 250. The battle was Fukushimaguchi taikassen.

81 Ihara Saikaku, *Nanshoku ōkagami*, p. 593.

82 Ōta Kinjō, *Gosō manpitsu*, pp. 152, 250–1.

83 Nishiyama Matsunosuke *et al.* (eds), *Edo-gaku jiten*, p. 557.

84 'Yoshichō no shōji ni utsuru gozōshi'; quoted in Shunro-an Shūjin, *Edo no shikidō* (1996), vol. I, p. 108. Yoshitsune is referred to as Gozōshi.

85 His legends were collected in the *Giheiki*; see Helen Craig McCullough (trans. and ed.), *Yoshitsune: A Fifteenth-Century Japanese Chronicle* (Stanford, CA, 1996).

86 Ihara Saikaku, *Nanshoku ōkagami*, p. 593.

87 This was interestingly suggested (perhaps unwittingly) in the recent Takarazuka play *Shinsengumi*, in which the Meiji reformers begin creation of a new state by killing all the homosexuals among them.

88 Shikitei Sanba, *Shikitei zakki* (1811); quoted in Teruoka Yasutaka, 'The Pleasure Quarters in Tokugawa Culture', *18th Century Japan* (Sydney, 1989), p. 27, and more generally in Celia Segawa Seigle, *Yoshiwara: The Glittering World of the Japanese Courtesan* (Honolulu, 1993), pp. 204–23.

3 BODIES, BOUNDARIES, PICTURES

1 George Steiner, 'Night Words: High Pornography and Human Privacy', *Language and Silence: Essays on Language, Literature and the Humanities* (New York, 1977), p. 70.

2 Ihara Saikaku, *Kōshoku ichidai otoko*, p. 41.

3 Matsuo Bashō in *Kai ōi* (1672) makes the first claim,while his *Saga nikki* (1691) records his love for one Tsuboi Tokoku; see Iwata Jun'ichi, 'Haijin bashō no dōsei-ai', p. 260.

4 Katsushika no Inshi, *Tōdai edo hyaku bakemono*, p. 393.

5 Paul Schalow, 'The Invention of a Literary Tradition of Male Love: Kitamura Kigin's *Iwatsutsuji*', *Monumenta Nipponica*, XLVIII (1993), pp. 1–31.

6 For the teleology of 'ways', see Konishi Jun'ichi, 'Michi and Medieval Writing', *Principles of Classical Japanese Literature*, ed. Earl Miner (Princeton and Guilford, 1985), pp. 181–208.

7 The 'five blocks' were Edo-chō 1 and 2, Kyōmachi 1 and 2, and Sumi-chō (there had been five blocks in the old Yoshiwara and, although the new Yoshiwara had a sixth block, Ageya-chō, the former name persisted). The 'two blocks' were Yoshi-chō itself and Fukiya-chō.

8 Richard Lane (ed.), *Okumura Masanobu:' Neya no hinagata'* (1996), pp. 34–5. The specific reference is to the anonymous *Aikyō sanmen daikoku* (early 1740s); see *ibid.*, fig. 22.

9 Kobayashi Tadashi and Asano Shūgō (eds), *Ukiyo-e soroi-mono: Makura-e*, vol. I, p. 19. A different, unattributed translation is given there.

10 For a full treatment, see Rictor Norton, *Mother Clap's Molly-house: Gay Subculture in England, 1700–1830* (London, 1992), pp. 92–106.

11 Jippensha Ikku, *Tōkaidōchū hizakurige*, pp. 22–3. The reader should be aware that this is censored out of the only English translation – *Hizakurige or Shank's Mare*, trans. Thomas Satchell (Rutland, VT, and Tokyo, 1960).

12 Gary Leupp, *Male Colors*, p. 138.

13 Ihara Saikaku, *Nanshoku ōkagami*, p. 552–7.

14 Koike Tōgorō, *Kōshoku monogatari*, p. 265. The two retainers involved are Sakabe Gonzaemon and Hotta Masamori (later made *rōjū* [shogunal counsellor]); they are referred to as *nen'yū no koshō* or 'boy lovers'.

15 Sharakusai, *Tōsei anabanashi*; quoted in Nakamura, *Gesaku-ron*, p. 124.

16 Konoe Ieharu, *Kiki* (mid-seventeenth century); quoted in Tanemura Suehiro, *Hako-nuke karakuri kidan*, p. 26. The previous female *shujō* was Kōken (r. 749–58).

17 Ban Kōkei, *Kinsei kijin-den* (1790), p. 301.

18 Sugita Genpaku, *Nochimigusa*, p. 65.

19 Sugita Genpaku, *Rangaku kotohajime* (1816), p. 496.

20 Timon Screech (trans. Takayama Hiroshi), *Edo no jintai o hiraku* (1997).

21 Thomas Lacquer, *Making Sex: Body and Gender from the Greeks to Freud*

(Cambridge, MA, and London, 1990), pp. 7–113.

22 For this nexus of personalities, see Timon Screech, *The Western Scientific Gaze and Popular Imagery in Later Edo Japan: The Lens within the Heart* (Cambridge and New York, 1996), p. 28 and *passim*.

23 This event is well known. See, among others, Sugimoto Tsutomu, '*Kaitai shinsho no jidai*'. For Kulm, see A. M. Luyendijk-Elshout, '"Ontleedinge" (Anatomy) as Underlying Principle of Western Medicine in Japan', *Red-Hair Medicine: Dutch-Japanese Medical Relations*, ed. H. Beukers *et al.* (Amsterdam and Atlanta, 1991); the Dutch translation of Kulm was entitled *Ontleedkundige Tafelen*.

24 Sugita Genpaku *et al.* (trans. and ed.), *Kaitai shinsho*, p. 323 (illustrator's preface).

25 Sugita Genpaku, *Rangaku kotohajime*, pp. 489–95; it is not certain that Hoshū was present at the dissection, since on one occasion Genpaku says he was, but on another he leaves his name off the list.

26 William Heckscher, *Rembrandt's Anatomy Lesson of Dr. Nicolaas Tulp* (New York, 1958), p. 32.

27 Sugita Genpaku, *Rangaku kotohajime*, p. 492. I have argued that Genpaku's reconstruction of events is not quite credible: see Screech, *Edo no jintai*, pp. 162–8.

28 For Thunberg's biography, see Catharina Blomberg, 'Carl Peter Thunberg: A Swedish Scholar in Tokugawa Japan', *Contemporary European Writing on Japan: Scholarly Views from Eastern and Western Europe*, ed. Ian Nish (Ashford, 1988).

29 Charles Thunberg, *Thunberg's Travels*, trans. F and C. Rivington (London, 1795), vol. III, pp. 178, 201.

30 Jennifer Robertson, 'Sexy Rice: Plants, Gender, Farm Manuals, and Grass-roots Nativism', *Monumenta Nipponica*, XXXIX (1984), p. 236.

31 Peter Wagner, *Eros Revived*, p. 42.

32 Luyendijk-Elshout, '"Ontleedinge" (Anatomy) as Underlying Principle', pp. 27–8.

33 For an English-language analysis, see Gregory M. Pflugfelder, 'Strange Fates: Sex, Gender and Sexuality in *Torikaebaya monogatari*', *Monumenta Nipponica*, XLVII (1992), pp. 347–68.

34 I have also translated the title as 'Red-fur Miscellany': see Screech, *Western Scientific Gaze*, p. 21.

35 For Gérard de Lairesse, see Alain Roy, *Gérard de Lairesse (1640–1711)*.

36 Morishima Chūryō, *Kōmō zatsuwa*, p. 479.

37 Paula Findlen, 'Humanism, Politics and Pornography in Renaissance Italy', p. 57.

38 Ernest Satow (ed.), *The Voyage of Captain John Saris to Japan* (London, 1967), p. 83.

39 *Ibid.*, p. 204. Saris states 200–300 mas; 1 mas = 6d. I am grateful to Derek Masserella for alerting me to this reference.

40 I am grateful to Matsuda Kiyoshi for the details of these books. Full particulars will appear in his forthcoming *Yōgaku no shoshiteiki kenkyū* (Kyoto: Rinsen Shoten, 1998). For Kōkan, see Shiba Kōkan, *Shuparō hikki*, p. 58. Kōkan claims to have read the story in *ueirerudo beshikereihingu (wereld beschrijving)* in the possession of the daimyo of Fukuchiyama, Katsuki Masatsuna, although he surely read it in the Japanese translation.

41 Mishima Yukio, *Kamen no kokuhaku*, pp. 189–92. This book is known in English as *Confessions of a Mask*.

42 Mishima also noted that images of St Sebastian often had this autoerotic purpose, see *ibid.*

43 Kenneth Clark, *The Nude* (Harmondsworth, 1956), pp. 6–7. By the time the book was written, Clark was chairman of the Independent Television Authority.

44 T. J. Clark, *The Painting of Modern Life*, pp. 79–146.
45 *Ibid.*
46 Satō Dōshin, 'Nihon bijutsu' no tanjō, pp. 132–8.
47 For another interpretation of the large size of genitals, see below.
48 A famous case are the Harunobu boys (misread as girls) in the Kōya print from the *Mu-tamagawa* series – see illus. 111 below.
49 Edouard de Goncourt, *Outamarou, peintre des maisons vertes* (1891). For the term *seirō*, see Timothy Clark, 'Utamaro and Yoshiwara: the "Painter of the Greenhouses" Reconsidered', *The Passionate Art of Utamaro*, p. 35.
50 Anne Hollander, *Seeing Through Clothes* (Berkeley, Los Angeles and London, 1993), pp. 6–12.
51 Asano Shūgō, 'Shunga no jidai kubun' (unpublished paper).
52 Satake Yoshiatsu (Shozan), *Gahō kōryō*, p. 102.
53 Shiba Kōkan, *Seiyō gadan* (1799), p. 403. He used the phrase *sanmen on hō*.
54 Satō Narihiro, *Chūryō manroku*, p. 76.
55 Satake Yoshiatsu (Shozan), *Gahō kōryō*, p. 101.
56 For reproductions, see Naruse Fujio *et al.* (eds), *Shiba Kōkan zenshū* (1992), vol. IV, figs 102–3. One is a line drawing, the other is executed in the Floating World manner.
57 For attribution of the work, dating and assignment of the title, see Hayashi Yoshikazu (ed.), *Shigenobu 'Yanagi no arashi'*, pp. 1–3.
58 For this scroll, as well as further remarks on the depiction of foreigners, see Chapter Six.
59 Yuasa Akeyoshi, *Tenmei taisei-roku*, p. 210. The phrase was 'yūjo tagasode o kaiage'.
60 Koikawa Harumachi, *Muda iki*, pp. 116–17.
61 Yanagisawa Kien, *Hitorine* (c. 1710), p. 156; Ōta Nanpo, *Hōton chinkai*, quoted in Hanasaki Kazuo and Satō Yoshito, *Shokoku yūri zue*, p. 276.
62 Matsudaira Sadanobu, *Uge no hitokoto*, p. 102.
63 Ruth Shaver, *Kabuki Costume* (Rutland, VT, and Tokyo, 1966), pp. 77–8.
64 Blussé *et al.* (eds), *Deshima Dagregisters*, vol. X, pp. 8–9.
65 So named in Masanobu's categorization, see Chapter Five. There were said to be 48 sexual positions (*shijū hatte*), although which was what depended on the writer.
66 Hayashi Yoshikazu, *Edo no makura-eshi* (1987), p. 276. Fukuda Kazuhiko refers to the same book under the title of *Haru no sewa*: see his *Ukiyo-e: edo no shiki* (1987), pp. 110–11.

4 SYMBOLS IN *SHUNGA*

1 Hayashi Yoshikazu attributes the pictures to a follower of Eisen and the text to Tamenaga Shunsui; see his *Edo ehon o sagase* (1993), p. 106. Otsuru is seen cavorting with the boy next door.
2 Asai Ryōi, *Ukiyo monogatari*; quoted in Howard Hibbett, *The Floating World in Japanese Fiction*, p. 11.
3 Hamada Giichirō (ed.), *Edo bungaku chimei jiten*, p. 371.
4 Muroyama Genjirō, *Kosenryū ni miru kyō, ōmi*, pp. 57–61.
5 'Toshidoshi saisai kyaku o yobu tame ni ue; Sakura ni hito o tsunagu yoshiwara; Yoshiwara e hairu sakura mo wakaki nite'; quoted in Satō Naoto, *Senryū yoshiwara fūzoku zue*, pp. 84–6.
6 Fujiwara no Kanesuke (attrib.). 'Hanazakura oru shōshō' is contained in his *Tsutsumi chūnagon monogatari*, pp. 4–101.
7 Quoted in Richard Bowring, 'The *Ise monogatari*: A Short Cultural History', *Harvard Journal of Asiatic Studies*, 52 (1992), p. 413. I am grateful to Cynthia Daugherty for pointing this passage out to me
8 'Anibun ni ume o tanomu ya chigozakura'; quoted in Iwata Jun'ichi, 'Haijin bashō no dōsei-ai', p. 260.

9 Note that the narcissus in Japanese (*suisen*) has none of the indications of narcissism which come from Greek legend.

10 Patricia Fister, *Kinsei no josei gakatachi* (1994), p. 222. Joryū's name is sometimes inverted as Ryūjo.

11 *Ibid.*, p. 195.

12 See Donald H. Shively, 'The Social Environment of Tokugawa Kabuki', *Studies in Kabuki: Its Acting, Music, and Historical Content* (Honolulu, 1978), pp. 29–45; the lady was Ejima, the actor Ikushima Shingorō, and at the time of the event (1714) she was 33 and he 43. The shogun was Ietsugu.

13 In the eighteenth century, Ju Citong (Jap. Kikujidō) was often taken as the ancestor of *nanshoku*; see, for example, the anonymous *Fūzoku shichi yūdan* (1756), cited in Shunro-an Shūjin, *Edo no shikidō*, vol. I, p. 34.

14 Ueda Akinari, *Ugetsu monogatari*, pp. 47–58.

15 'Omoi izuru tokiwa no yama no iwatsutsuji wa neba koso are koishiki mono o'; see Ki no Tsurayuki (ed.), *Kokin wakashū*, p. 205.

16 For the Kōbō Daishi myth, see Chapter Five below.

17 For Kigin's *Genji* scholarship, see Thomas J. Harper, 'The *Tale of Genji* in the Eighteenth Century', *18th Century Japan*, pp. 106–7, and for *Iwa-tsutsuji*, see Paul Schalow, 'The Invention of a Literary Tradition of Male Love: Kitamura Kigin's *Iwatsutsuji*'.

18 Ōta Nanpo, *Iwa-tsutsuji*, pp. 367–86. The *wakashū* text was by Hosokawa Genshi, *ibid.*, pp. 479–82.

19 Ihara Saikaku, *Nanshoku ōkagami*, p. 25. For the source of this myth, see Chapter Six.

20 Kumazawa Banzan, *Shūgi washo* (late 1740s); quoted in Gregory M. Pflugfelder, 'Cartographies of Desire: Male–Male Sexuality in Japanese Discourse, 1600–1850', PhD thesis, Stanford University, CA, 1996, p. 190, n. 23, and Hiraga Gennai, *Nenashi-gusa kōhen*, p. 150.

21 Suzuki Hiroyuki, 'Rakuda o egaku', *Bijutsu-shi*, 338 (1987), pp. 128–46. For the 1793 request, see Blussé *et al.* (eds), *The Deshima Dagregisters*, vol. x, p. 38.

22 The arrival of the whale and the shogunal viewing are recorded in the anonymous *Tenmei kibun, Kansei kibun*, p. 280. For other popular celebrations, see Screech, *Western Scientific Gaze*, pp. 244–6.

23 Nakano Eizō, *Edo higo jiten*, pp. 242–3. The term was '*shakuhachi sori*'.

24 'Age-sori no ada shakuhachi no yō ni soe'; *ibid.*

25 'Katsuragi: tsuki tarade keya no himamono kaze no oto'.

26 See Hillier, *Suzuki Harunobu*, p. 82 (with illustration). *Ehon uku medori* dates from *c.* 1743.

27 For Inagaki Tsurujo, see Fister, *Kisei no josei gaka-tachi*, p. 223 (where the Idemitsu Museum version of this painting is illustrated).

28 For a reproduction see Sawada Akira, *Nihon gaka jiten: jinmei hen*, p. 341.

29 The series is entitled *Hinagata wakana no hatsumoyō*.

30 The Tokyo National Museum version is illustrated here; for the Idemitsu Museum version see above, note 27.

31 Gary P. Leupp, *Male Colours*, p. 121; Paul Schalow, 'Review of Gary P. Leupp, "Male Colors"', *Journal of Japanese Studies*, 23 (1997), p. 199. Schalow takes issues with Leupp's assumption that fellatio necessarily occurred. However it certainly did, as is attested by an untitled manuscript by Okada Shōgi (ignored by the above writers) dated to 1794, which refers to heterosexual fellatio as 'silk trembling'; the relevant section is quoted in Stephen and Ethel Longstreet, *Yoshiwara: The Pleasure Quarters of Old Tokyo* (Rutland, VT, and Tokyo, 1988), p. 78, although they provide inadequate bibliographic details. For a continuation of the Leupp–Schalow debate, see *Journal of Japanese Studies*, 24 (1988), pp. 218–23.

32 See Timon Screech (Murayama Kazuhiro, trans.), *Edo no shikō kūkan* (Seidosha,1998), pp. 161–98, and Mori Yōko, 'Nihon no shabon-dama no gui to sono zuzō', *Mirai*, 344 (1995), pp. 2–15.

33 For reproductions see Screech, *ibid.*

34 Translated in John M. Rosenfield and Shūjirō Shimada, *Traditions of Japanese Art: Selections from the Kimiko and John Powers Collection* (Cambridge, MA, 1970), p. 362. Rosenfield and Shimada also identify Tankyū as Akutagawa Tankyū, although suggesting a slightly earlier date for the painting.

35 See, for example, Namiki Gohei, *Tomigaoka koi no yamabiraki* (1798), quoted in Hamana Giichirō, *Edo bungaku chimei jiten*, p. 186.

36 The preface is transcribed, with publication data, in Tanahashi Masahiro, *Kibyōshi sōran* vol. III, p. 151.

37 Ihara Saikaku, *Haikai dokugin ichinichi senku*, p. 154.

38 *Nanshoku yamaji no tsuyu* is signed Nankai Sanjin, thought to be Sukenobu's pen name; see the version edited by Omura Shage (1978), pp. 1–6.

39 For the publishing history of this series (which changed publisher part way though) see Asano Shugo and Timothy Clark, *The Passionate Art of Utamaro*, p. 235. Although he calls the types physiognomic, in all cases it is the actions of the women that betray them, not their faces. The inscription reads 'Sōmi Utamaro kōga'.

40 Ōta Nanpo, *Hanga kandan* (1804), quoted in Teramoto Kaiyū, *Nagasaki-bon: Nanban kōmō jiten* (Keishōsha, 1974).

41 For example, *Hitogokoro kagami no utsushi-e* (1796); see Screech, *Western Scientific Gaze*, p. 117.

42 Ōtsuki Gentaku, 'Kankai ibun', p. 531.

43 Clunas, *Pictures and Visuality*, p. 155. The book was found in Japan in 1945, although its period of entry (and the date of the book itself) is unknown. There are some concerns about its authenticity, see *idem.*

44 Mishima Yukio, *Gogo no eikō*, p. 308. John Nathan's translation, *The Sailor who Fell from Grace with the Sea* (Harmondsworth, 1970), p. 12, misrepresents this image, however, by rendering Mishima's 'temple roof' as 'temple tower'.

45 Leupp, *Male Colours*, p. 175; characteristically Leupp does not properly source this anecdote, so I am not able to confirm its authenticity.

46 'Hamaguri ni hashi o shitsuka to hasamarete shige tachikanuru aki no yūgure'.

47 Shirahata Yōsaburō, *Daimyō teien*, p. 165 (with illustration).

48 'Otoko-yama to mo iisō na Inari-yama; Oya-oya to yome torikaneru Inari-yama; Inari-yama tsū o ushinau jo-sennin'; quoted in Muroyama, *Kosenryū ni miru kyō, ōmi*, pp. 143–6. The warlock referred to is Kume-sennin.

49 Ihara Saikaku, *Saikaku shokoku-banashi*, pp. 263–388 (with illustration).

50 Sōchō, 'Saijō no bōmon nite', in *Sōchō shūki*, p. 805. Sōchō is best known as Ikkyū Sōjun's *renga* partner (*renga* are linked verses composed sequentially, usually by two or more poets).

51 Leupp, *Male Colours*, p. 41, quoting Donald Keene, 'The Comic Tradition in Renga', *Japan in the Muromachi Age*, ed. John W. Hall and Toyoda Takeshi (Berkeley, Los Angeles and London, 1977), p. 275.

52 Screech, *Edo ni jintai o hiraku*, pp. 30–45.

5 THE SCOPIC REGIMES OF *SHUNGA*

1 Regretably no readily available reproduction of this image exists. It is contained in *Hokusai manga*.

2 'Notte e giorno faticar,/Per chi nulla sa gradit,/Piova e vento sopportar,/Mangiar male e mal dormir./Voglio far il gentiluomo/E non voglio piu servir./Oh che caro galantuomo!/Voi star dentro colla bella,/Ed io far la sentinella!'

3 Ujiie Mikito, *Bushidō to erosu* (1995), pp. 11–14.

4 *Ibid.*

5 *Ibid.*, pp. 14–16.

6 'Waka-danna yo wa ogande hiru shihari'. Yamaji Kanko (ed.), *Suetsumu-hana yawa*, p. 25.

7 'Tsuki ya aranu haru ya mukashi no haru naranu waga mi hitotsu wa moto no mi ni shite': *Ise monogatari*, p. 82.

8 'Kimi ya koshi ware ya yukiken omohoezu yume ka utsutsu ka nete ka samete ka'. Ki no Tsurayuki (ed.), *Kokin wakashū*, p. 230.

9 As well as the British Museum version reproduced here, there is a virtually identical one formally in the Azabu Museum of Arts and Crafts, Tokyo, and a third in the Museo d'Arte Orientale 'Edoardo Chiossone', Genoa.

10 Anon., *Ise monogatari*, pp. 91–2.

11 Ihara Saikaku, *Kōshoku ichidai otoko*, p. 213.

12 See Kendall H. Brown, *The Politics of Reclusion: Painting and Power in Muromachi Japan* (Honolulu, 1997), pp. 73–161. Brown stresses the *nanshoku* elements of the story.

13 Onishi Hiroshi, 'Nihon, chūgoku no geijitsuka densetsu', *Geijitsuka densetsu* (1989), pp. 213–16.

14 For the publication details, see Hayashi Yoshikazu, *Edo makura-e no nazo*, pp. 235–65.

15 The original names are Kagiya and Yanagiya. The iconography is that Osen is by a red shrine pillar, while Ofuji has gingko leaves scattered on the ground.

16 For an analysis of publishing controls of this kind, see Suzuki Jūzō, *Ehon to ukiyo-e*, pp. 433–61.

17 Komatsu-ya Hyakki, *Fūryū kōshoku maneemon*, p. 122. The text also refers to Kappa Sanjin, author of *Nanshoku saiken: kiku no sono* (1764).

18 For the text, see Koike Masatane *et al.* (eds), *Edo no gesaku ehon*, vol. I, pp. 11–30.

19 Hogarth's set was published in 1735. Sumie Jones has examined the links between these two works in 'William Hogarth and Kitao Masanobu: Reading Eighteenth-Century Pictorial Narratives', *Yearbook of Comparative and General Literature*, XXXIV (1985), pp. 37–73.

20 Komatsu-ya Hyakki, *Fūryū kōshoku maneemon*, p. 122.

21 Anon., *Ise monogatari*, p. 79.

22 For a modern edition, see Kimura Shage (ed.), *Hihon: Edo bungaku-sen*, vol. II.

23 Anon., *Kōshoku toshiotoko*, quoted in Hayashi, *Edo makura-e no nazo*, p. 239. The analysis of the story that follows is my own.

24 For details, see Tanahashi Masahiro, *Kibyōshi sōran*, vol. I, p. 137.

25 Screech, *Western Scientific Gaze*.

26 Shiba Kōkan, *Tenchi ridan*, p. 246. See also Screech, *Western Scientific Gaze*, p. 172.

27 Ihara Saikaku, *Kōshoku ichidai otoko*, pp. 44–5.

28 For another, similar illustration to the tale, dating to the early seventeenth century, see Hayasahi, *Edo ehon o sagase*, p. 40.

29 For the text, see Koike Masatane *et al.* (eds), *Edo no gesaki ehon*, vol. I, pp. 251–80. For an explanation of the title, see *ibid.*, p. 250.

30 Anon., *Kamigata iro shugyō*, quoted in Hayashi, *Edo makura-e no nazo*, p. 183.

31 'Ukiyo eshi bobo o miru no mo shigoto nari'; quoted in *ibid.*, p. 174; a similar *senryū* appears in Hanasaki and Aoki, *Senryū no shunga-shi*, p. 83.

32 Anon., *Otome sugata*, transcribed in Fukuda Kazuhiko, *Ukiyo-e edo no shiki*, pp. 48–9. For a reproduction of the illustration, see Screech, *Western Scientific Gaze*, p. 190.

33 For a reproduction, see Screech, *ibid.*, p. 178.

34 Shikitei Sanba, *Ukiyo-doko*, p. 289. I have discussed this in Screech, *Western Scientific Gaze*, p. 125.

35 Shōden-ga-Shirushi, *Ehon hime-hajime*; for a transcription with illustrations, see Hayashi Yoshikazu, *Kitagawa Utamaro*, pp. 251–92.

36 Utei Enba II, *Oyo gari no koe*; see Hayashi Yoshikazu, *Edo no makura-eshi*, pp. 186–7.

37 Hayashi Yoshikazu, in his *Utagawa Kunisada*, suggests the second spread in the earlier book was copied by Kunisada as an illustration to *Sangoku myōto ishi* (1826), see pp. 109–10, including pictures.

38 Hanakasa Bunkyō, *Koi no yatsufuji* is described in *ibid.*, pp. 115–20. Bunkyō signed the work 'Kyokushū Shūjin' in parody of Bakin's pen name, Kyokutei Shūjin.

39 Ryūtei Tanihiko, *Shunjō gidan mizuage-chō*; for a description, see Hayashi, *Utagawa Kunisada*, pp. 101–3. It is not certain in which order these two books appeared, but they may both be from 1836.

40 'Tōmegane jiman wa moto e me ga modoru'; I am grateful to Kazuya Hiroki for informing me of this verse; in the *Yanagidaru* it is no. Hō/ten/10/2.

41 Katsuragawa Hoshū, *Hokusa bunryaku*, p. 196.

42 'Ima iku tokoro o Yushima no tōmegane'; quoted in Okitsu Kaname, *Edo senryū*, p. 257.

43 'Harasanza mite tomo ni yaran tōmegane'; I am grateful to Kazuya Hiroki for informing me of this verse; in the *Yanagidaru* it is no. Ten/3/chi/2.

44 Sharakusai Manri, *Shimadai me no shōgatsu*, p. 1 recto. The author is not to be confused with the print-maker Tōshūsai Sharaku.

45 Shiba Kōkan, *Saiyū nikki*, p. 53.

46 *Fūzoku shichi yūdan*, quoted in Shunrō-an Shūjin, *Edo no shikidō*, vol. 1, pp. 34–5.

47 For a selection of *senryū*, see *ibid.*, pp. 36–7.

48 'Wasurete mo kumu yashitsuramu tabibito no takano no oku no tamagawa no mizu'. This is an extremely difficult verse, from which modern commentators have shied away. My translation is tentative.

49 Matsura Seizan, *Kasshi yawa*, vol. VI, p. 85.

50 For the text, see Santō Kyōden, *Gozonji no shōbaimono*, p. 227.

51 Hasegawa Mitsunobu, *Ehon otogi shina kagami*; quoted in Oka Yasumasa, *Megane-e shinkō*, p. 96.

52 Morishima Chūryō, *Shin yoshitsune saiken no ezo*, quoted more fully in Screech, *Western Scientific Gaze*, p. 131.

53 Quoted in Oka Yasumasa, *Megane-e*, p. 89. I erred in *Western Scientific Gaze* by referring to this book as anonymous and dating it to 1735; see p. 124.

54 My decipherment of these puns is partially indebted to Julian J. Lee, 'The Origin and Development of the Japanese Landscape Print: A Study of the Synthesis of Eastern and Western Art', PhD thesis, University of Washington, Seattle, 1977, pp. 56–8, although we differ on some points, and he does not offer any *nanshoku* interpretation.

55 Timon Screech, 'Glass, Paintings on Glass, and Vision in Eighteenth-Century Japan', *Apollo*, XLVII (1998), pp. 28–32.

56 Thunberg, *Thunberg's Travels*, vol. III, p. 49.

57 *Ibid.*, p. 284.

58 Santō Kyōden, *Kaitsū unobore kagami*, p. 1 recto.

6 SEX AND THE OUTSIDE WORLD

1 For a translation of regulations pertaining to the Yoshiwara, see Seigle, *Yoshiwara*, pp. 23–4. There was a guardhouse inside the gates to ensure rules were observed.

2 Jinnai Hidenobu's ideas are most succinctly summarized in English in his 'The Spatial Structure of Edo', *Tokugawa Japan: The Social and Economic Antecedents of Modern Japan* (Tokyo, 1990). Asai Ryōi, *Ukiyo monogatari*; quoted in Hibbett, *The Floating World in Japanese Fiction*, p. 11.

3 Sugita Genpaku, *Rangaku kotohajime*, p. 505.

4 For the *flâneur* and his relation to painting, see Timothy Clark, *The Painting of Modern Life*, pp. 23–78; for the issue of gender, see Griselda Pollock, *Vision and Difference: Femininity, Feminism and Histories of Art* (London, 1988), pp. 50–91. *Ginbura* is a contraction of Ginza (the street) and *bura-bura* ('wander'); see Edward Seidensticker, *Low City, High City: Tokyo from Edo to the Earthquake, 1867–1923* (Harmondsworth, 1983), pp. 264–7.

5 The text of this supposed injunction has not been located: see Suzuki Jūzō, *Ehon to ukiyo-e*, pp. 433–61.

6 Komatsu-ya Hyakki, *Fūryū kōshoku maneemon*, p. 122.

7 For the *Makurabon taikai-ki*, see Richard Lane *et al.* (eds), *Shinpen shiki hanga: makura-e*, p. 63.

8 Haga Tōru, 'Precariousness of Love: Places of Love', *Imaging/Reading Eros*, pp. 97–103. The inferences drawn from Haga's observation are my own. 'Precarious' is Haga's own translation of his term *kiwadoi*.

9 Cleland, *Fanny Hill*; for the homosexual encounter, see pp. 193–6, for the lesbian awakening, pp. 48–50. It is worth noting the persistent belief that Cleland was himself homosexual.

10 G. B. Sansom, *Japan: A Short Cultural History* (London, 1931), p. 213.

11 See Seigle, *Yoshiwara*, p. 123; these refer to chapters 9, 2, 27 and 10 respectively.

12 This famous (regrettably undated) verse is quoted in many secondary works: see, among others, Seigle, *Yoshiwara*, pp. 213–14.

13 'Wakaki ko ni yomashita Genji mo doku ni nari'. I am grateful to Kasuya Hiroki for introducing me to this verse.

14 Hatakeyama Kizan, *Shikidō ōkagami*, p. 403.

15 For a table of the *Genji-kō*, see Nihon Ukiyo-e Kyōkai (ed.), *Genshoku ukiyo-e dai hyakka jiten*, vol. IV, p. 57. The former pentagram should have one single vertical with four linked ones (not two and three, as here).

16 Teikin, *Teikin waraie-shō*; I am grateful to Ellis Tinios for introducing me to this book. This is the *Hana-no-En* ('Blossom Banquet') chapter of the *Tale of Genji*. Needless to say, normal *Genji* pictures of this scene (which were common) did not include a sexual act: see Mieko Murase, *Iconography of the 'Tale of Genji'* (New York and Tokyo, 1983), pp. 79–80.

17 For this important aspect of *ukiyo-e*, see Kobayashi Tadashi, *Edo no e o yomu* (1989), Shinoda Jun'ichi, *Nise monogatari-e* (1995) and Timothy Clark, '*Mitate-e*: Some Thoughts and a Summary of Recent Writings', *Impressions*, 19 (1997), pp. 6–27.

18 Hagiwara Hiromichi, *Genji monogatari hyōshaku*; quoted in Harper, 'The Tale of Genji in the Eighteenth Century', p. 108 (adapted).

19 This event crosses between Chapter 2 ('Boomtree') and Chapter 3 ('Lady of the Locust Shell'). Genji sleeps with the brother of Utsusemi (the Lady of the Locust Shell) because she herself refuses him.

20 For a history of readings of *Ise*, see Bowring, 'The *Ise Monogatari*: A Short Cultural History'.

21 I believe the preponderance of depictions of Narihira arriving in Musashi and passing Mt Fuji is to be taken as an Edo appropriation of *Ise*.

22 Anon., *Ise monogatari*, pp. 160–63.

23 Ihara Saikaku, *Nanshoku ōkagami*, p. 25. The brother, Daimon no Chūjō, also called Koretaka, appears in section 69 of *Ise*.

24 'Kasugano no wakamurasaki no zurikoromo shinobu no mitare kagiri shirarezu'; *Ise monogatari*, p. 79.

25 Ihara Saikaku, *Nanshoku ōkagami*, p. 25. Saikaku misquotes the verse, giving *karikoromo* (hunting robe) for *zurikoromo* (printed robe).

26 This is an ambiguous print, since it shows a collection of women who could never have sat together in a room (for historical and social reasons); I interpret it as a work in the 'exhaustive depiction' (*tsukushi*) genre. Asano and Clark have noted this, writing 'there seems to be some hidden

meaning to this picture, but it has not yet been deciphered': see *The Passionate Art of Utamaro*, p. 207.

27 *Kata* means either gentleman/lady or 'shape'; 'fine shape' (*on-gata*) was a dildo, see Tanobe Tomizō, *Isha mitate edo no kōshoku*, pp. 158–77.

28 Koikawa Shōzan, *Tabimakura gojūsan tsugi*, quoted in Hayashi Yoshikazu, *Ehon kikō: tōkaidō gojūsan tsugi*, pp. 35–6.

29 Engelbert Kaempfer, *History of Japan*, p. 260. See also Koga Jūjirō, *Maruyama yūjo to tōkōmō-jin*, vol. I, p. 720.

30 See Hattori Yukio, *Sakasama no yūrei*, pp. 115–67 (with illustrations).

31 See, for example, a *senryū*: 'bijo wa shiro binan wa tera o katamukeru'. Quoted in Hiratsuka Yoshinobu, *Nihon no okeru nanshoku no kenkyū*, p. 15.

32 For the complete series, see Asano and Clark, *The Passionate Art of Utamaro*, pp. 195–8.

33 Yūjō, *Banji*, quoted in Sasaki Jōhei, *Ōkyo shasei gashū*, p. 155. Yūjō, prince–abbot of the Enman-in, was a pupil and sponsor.

34 Kitagawa Morisada, *Morisada Mankō*; cited in Takeuchi, *Nihon no rekishi*, pp. 9, 13.

35 See Kashiwabara Satoru, '"Teikan-zu" shokai', pp. 124–37.

36 Originally, the book contained 81 good rulers and 36 bad, although in Japan, where they were sometime made into good and bad paired screens, the number was evened out. The work was published in 1583, although the 1606 edition subsequently became more famous in Japan.

37 Kano Ikkei, *Kososhū*, pp. 724–5. I am grateful to Kendall Brown for drawing my attention to this work.

38 For a Kamakura-period source, see the anonymous *Kagaku-shū*, cited in Tanobe, *Isha mitate*, p. 208.

39 'Dōkyō sore wa ude de nai ka to mikotonori'; quoted in *ibid.*, p. 210.

40 'Senzuri o kaku to Hōjō tokkaeru'; Yamaji Kanko (ed.), *Suetsumuhana yawa*, p. 259.

41 *Chūshingura yanagidaru no kami* (early nineteenth century); cited in Shunro-an Shūjin, *Edo no shikidō*, vol. I, p. 82 (with illustration).

42 Ihara Saikaku, *Nanshoku ōkagami*, p. 25. Kenkō, author of *Tsurezure-gusa*, died in the mid-fourteenth century, some 300 years after Sei Shōnagon's brother Sei no Wakamaru; Sei Shōnagon was author of *Makura no sōshi* ('the Pillow Book').

43 The anonymous prior work *Ehon taikō-ki* was illustrated by Okada Gyokuzan. Jippensha Ikku, *Bakemono taikō-ki*; Ōta Nanpo, *Taidai taikō-ki*, see Davis, 'Drawing His Own Ravishing Features', p. 341.

44 For an overview of the documents, see Suzuki, *Ehon to ukiyo-e*, pp. 433–61. For a recent reassessment, see Davis, *ibid.*, pp. 337–47.

45 This was noted by Shikitei Sanba, *Iwademo no ki*, quoted in Davis, *ibid.*, p. 338. For convenient illustrations of the triptych and three of the set of five, see Asano and Clark, *The Passionate Art of Utamaro*, pp. 243–5; it is possible that the five-piece set originally had other (now lost) members.

46 These ideas appear in *senryū*. 'Shitteiru kuse ni sekirei baka na yatsu' (He knew all along and the wagtail was just wasting its time), quoted in Hayashi Yoshikazu, *Geijutsu to minzoku ni arawareta seifūzoku*, p. 14. Also, 'Senzuri o Kunikototachi-no-mikoto kaki' (Kunikototachi-no-mikoto had to wank), in Yamaji Kanko (ed.), *Suetsumuhana yawa*, p. 138; Kunikototachi-no-mikoto was the first god.

47 Ihara Saikaku, *Nanshoku ōkagami*, p. 25.

48 Anon., *Ama no ukihashi*, p. 62. The preface writer is the otherwise unknown Unkyū.

49 Kimuro Bōun, *Mita kyō monogatari*, pp. 563–81. Bōun is also called Nidō-tei. The work was published in 1789.

50 Shiba Kōkan, letter to Yamuryō Kazuma, reproduced in Nakano Yoshio, *Shiba Kōkan kō*, pp. 42–3.

51 Kimuro Bōun, *Mita kyō monogatari*, p. 568.

52 *Ibid.*, p. 569.

53 *Ibid.*

54 The supplement only is reproduced in *Edo shunjū*, 7 (1978), pp. 14–28; illustrations by Tsukioka Settei.

55 Hiraga Gennai, *Nanshoku saiken mitsu no asa* (1768), p. 111.

56 *Hime-kaidō*. For a general treatment see Constantine Vaporis, *Breaking Barriers: Travel and the State in Early Modern Japan* (Cambridge, MA, 1994), especially pp. 42–3.

57 Cited in Ujiie Mikito, *Bushidō to erosu*, p. 106.

58 Kaempfer, *History of Japan*, p. 53.

59 *Ibid.*, pp. 345–6.

60 For a partial reproduction see Hayashi Yoshikazu, *Ehon kikō: tōkaidō gojūsan tsugi*, pp. 50–51.

61 For *senryū* on this, see Okitsu Kaname, *Edo senryū*, pp. 301–302. For a discussion of the Shinagawa brothel area, see Hayashi, *ibid.*, pp. 42–55.

62 Jippensha Ikku, *Tōkaidōchū hizakurige*, pp. 22–3.

63 For the history, see Hayashi, *Ehon kikō*, pp. 18–24.

64 *Ibid.*, pp. 23–4.

65 For a bibliographical study of Koikawa Shōzan, see Hayashi, *Edo ehon o sagase*, pp. 62–78.

66 Regrettably, I have been unable to secure a copy of this book, or reproductions, but see Hayashi, *Ehon kikō*, p. 36; see also below, note 71.

67 For a discussion of this book, see Hayashi Yoshikazu, *Utagawa Kunisada*, pp. 178–81.

68 For the Edoite, see Nishiyama Matsunosuke, *Edokko*. For Edo's boundaries (first plotted in 1791 but only finalized in 1811), see Katō Takashi, 'Governing Edo', pp. 42–5.

69 For example, *Ehon hana no oku* (1825), p. 35 (illustrations by Eisen). For the literary genre itself, see Jacqueline Pigeot, *Michiyuki-bun: Poétique de l'itinéraire dans la littérature du Japon ancien* (Paris, 1982).

70 Kibi Sanjin (Koshōken), *Tōto meisho zue* (1794); see above, illus. 82.

71 For the illustration to this episode, see Shunro-an Shūjin, *Edo no shikidō*, vol. I, p. 88; interestingly, virtually the same image appeared in a book of the following year (1856), *Kisō kaidō tabine no temakura*, where it represents sex on the Kisō highway at Fushimi, see *ibid.*, p. 74.

72 Hayashi, *Ehon kikō*, p. 14.

73 Tsuji Tatsuya, 'Politics in the Eighteenth Century', *Cambridge History of Japan*, ed. John W. Hall (Cambridge, 1991), vol. IV, p. 468.

74 *Ibid.*, p. 471.

75 Teikin, *Teikin warai-e shō*; Teikin's remarks are inscribed on the page with illus. 3 above. Tokasai (Fukuda, ed.), *Shikidō kinpishō*, vol. II, p. 32.

76 Teikin, *ibid.*

77 Shiba Kōkan, *Shunparō hikki* (1811), p. 69.

78 For an edition of the whole work, see Hayashi Yoshikazu (ed.), *Edo meisaku ehon: Sentō shinwa*.

79 Peter Wagner, *Eros Revived*, p. 86.

80 Blussé *et al.* (eds), *The Deshima Dagregisters*, vol. X, p. 161.

81 *Ibid.*, pp. 22, 38, 55.

82 For my calculation of this figure, see Screech, *Western Scientific Gaze*, p. 256, n. 41.

83 Furukawa Koshōken, *Saiyū zakki*, p. 164.

84 The story of the former has been translated by Donald Keene, *The Battles of Coxinga*.

85 For example, on Thunberg's ship (the largest, he says, for many years) there were 110 Europeans and 34 Malays; see *Thunberg's Travels*, vol. III, pp. 11–12.

86 Blussé *et al.* (eds), *Deshima Dagregisters*, vol. x, p. 94. This occurred in 1797.

87 I am grateful to Matsuda Kiyoshi for this information. For Voltaire's book, see Robert Darnton, *Edition et sédition: L'Universe de la littérature clandestine au XVIIIe siècle* (Paris, 1991).

88 For an interesting conversation recorded *c.* 1790 between an unnamed Dutchman and Satō Narihiro on sexual mores in Japan, see Satō, *Chūryō manroku*, p. 69.

89 *Tōjin ban nikki*, see Koga Jōjirō, *Maruyama yūjo*, vol. I, p. 561; also Clunas, *Pictures and Visuality*, p. 150.

90 Satow (ed.), *The Voyage of Captain John Saris to Japan*, pp. 47–8.

91 Nicole Rousmaniere, 'The Accessioning of Japanese Art', *Apollo*, CXLV (1997), pp. 23--9.

92 Furukawa Koshōken, *Saiyū zakki*, p. 164.

93 Koga, *Maruyama yūjo*, vol. I, p. 768; later the limit was increased to five nights.

94 *Ibid.*, p. 454. The price would have been 15 *monme,* half going to the shop.

95 Blussé *et al.* (eds), *Deshima Dagregisters*, vol. VIII, p. 74; Thunberg, *Thunberg's Travels*, vol. III, pp. 168–9.

96 Shiba Kōkan, *Saiyū nikki*, p. 71.

97 'Kono kuni no nami ya shitawan karabito mo yawaraku haru no yūshi goken ni'. The verse appears to be signed Sansui-ya Satoseme.

98 'Maruyama ya onna ni yomenu fumi ga kuru; Tsūji o tsurete Maruyama no kyaku; Maruyama no kyaku wa ichiman sansen ri'; quoted in Hanasaki Kazuo and Satō Yoshito, *Shokoku yūri zue*, pp. 278–82.

99 Furukawa Koshōken, *Saiyū nikki*, p. 164.

100 For a reproduction of Kōkan, see Naruse Fujio *et al.* (eds), *Shiba Kōkan zenshū*, vol. IV, pp. 118–19, and for Tairō, see Koga, *Maruyama yūjo*, vol. I, frontispiece.

101 Keisai Eisen, *Makura bunko*, p. 74.

102 'Mōtōjin onna no shiri e bachi o oki'; quoted in Hanasaki and Satō, *Shokoku yūri zue*, p. 282.

103 *Rangaku*, or 'Dutch studies'.

104 For the youth of VOC operatives in Japan (and the mistakes about Western life expectancy this caused) see Satō Narihiro, *Chūryō manroku*, p. 124; see also Screech, *Ō-Edo ijin ōrai*, pp. 79–84.

105 For Blomhoff see Koga, *Maruyama yūjo*, vol. I, p. 790ff.

106 Fukuda Kazuhiko so attributes it (verbal communication).

107 Morishima Chūryō, *Kōmō zatsuwa*, p. 467.

108 I am grateful to Cynthia Viallé for supplying details of Ricard's biography.

109 Ricard's diary is not of much help here, but it is included in Blussé *et al.* (eds), *Deshima Dagregisters*, vol. x, pp. 158–69.

110 Morishima Chūryō, *Bankoku shinwa* (1789), p. 254.

111 Katsuragawa Hoshū, *Hokusa bunryaku*, p. 236; the offence was compounded by being committed before an altar in church on Easter Day.

Bibliography

Following the East Asian norm, names are given with family first throughout this book. However, Japanese convention is to refer to historical persons by their given names.

Anon., *Ama no ukihashi*, in *Edo meisaku ehon*, Gakken (1996)
—, *Ise monogatari*, in *Taketori monogatari/Ise monogatari*, ed. Horiuchi Hideaki, Shin koten nihon bungaku taikei, Iwanami Shoten (1997), vol. XVII, pp. 79–195
—,*Tenmei kibun, Kansei kibun*, in *Mikan zuihitsu hyakushū*, ed. Mitamura Engyō, Chūō Kōron-sha (1976), vol. IV, pp. 255–98
Anzai Un'en, *Kinsei meika shōga dan*, in Nihon garon taikan, ed. Sakazaki Tan, 2 vols, Arusu (1927), vol. I, pp. 330–460
Asakura Hidehiko, *Edo shokunin-zukushi*, in *Sōsho bijutsu no izumi*, Iwanami Bijutsu-sha (1980)
Asano Shūgō and Kobayashi Tadashi, eds, *Ukiyo-e soroi-mono: Makura-e*, 2 vols, Gakken (1995)
Asano Shugo and Timothy Clark, *The Passionate Art of Utamaro*, 2 vols (London, 1995)
Asano Shūgō and Yoshihiko Shirakura. 'Shunga shuyo, mokuroku', in *Ukiyo-e soroi-mono: Makura-e*, ed. Asano Shugō, Gakken (1995), vol. II, pp. 132–42
Ban Kōkei, *Kinsei kijin-den*, Kyōiku-sha (1981)
Blomberg, Catharina, 'Carl Peter Thunberg: A Swedish Scholar in Tokugawa Japan', in *Contemporary European Writing on Japan: Scholarly Views from Eastern and Western Europe*, ed. Ian Nish (Ashford, Kent, 1988), pp. 16–22
Blussé, Leonard, Paul van der Velde and Cynthia Viallé, eds, *The Deshima Dagregisters* (Leiden, 1995)
Bowring, Richard, 'The *Ise monogatari*: A Short Cultural History', *Harvard Journal of Asiatic Studies*, LII (1992), pp. 401–80
Brown, Kendall H., *The Politics of Reclusion: Painting and Power in Muromachi Japan* (Honolulu, 1997)
Campbell, Robert, 'Poems on the Way to Yoshiwara', in *Imaging/Reading Eros: Sexuality and Edo Culture, 1750–1850*, ed. Sumie Jones (Bloomington, IN, 1995), pp. 95–7
Choi, Park-Kwang, 'Japanese Sexual Customs and Cultures Seen from the Perspective of the Korean Delegations to Japan', in *Imaging/Reading Eros: Sexuality and Edo Culture, 1750–1850*, ed. Sumie Jones (Bloomington, IN, 1995), pp. 76–9
Clark, Kenneth, *The Nude* (Harmondsworth, 1956)
Clark, Timothy, '*Mitate-e*: Some Thoughts and a Summary of Recent Writings', *Impressions*, XIX (1997), pp. 6–27
—, 'The Rise and Fall of the Island of Nakazu', *Archives of Asian Art*, 45 (1992), pp. 72–91
—, *Ukiyo-e Paintings in the British Museum* (London, 1992)
—, 'Utamaro and Yoshiwara: the "Painter of the Greenhouses" Reconsidered', in *The Passionate Art of Utamaro*, ed. Shugo Asano and Timothy Clark (London, 1995), pp. 35–55

Clark, T. J., *The Painting of Modern Life: Paris in the Art of Manet and his Followers* (Princeton, NJ, 1984)

Cleland, John, *Fanny Hill, or Memoires of a Woman of Pleasure* (Harmondsworth, 1985)

Clunas, Craig, *Pictures and Visuality in Early Modern China* (London, 1997)

Davis, Julie Nelson, 'Drawing His Own Ravishing Features: Kitagawa Utamaro and the Construction of a Public Identity in Ukiyo-e Prints', PhD thesis, University of Washington, Seattle, 1998

DeJean, Joan, 'The Politics of Pornography', in *The Invention of Pornography: Obscenity and the Origins of Modernity, 1500–1800*, ed. Lynn Hunt (New York, 1993), pp. 109–24

Eisen 'Ehon hana no oku', in Hayashi Yoshikazu, ed., *Teihon: ukiyo-e shunga meihin shūsei*, Kawade Shobō Shinsha (1997)

Evans, Tom, and Mary Evans, *Shunga: the Art of Love in Japan* (London, n.d.)

Findlen, Paula, 'Humanism, Politics and Pornography in Renaissance Italy', in *The Invention of Pornography: Obscenity and the Origins of Modernity, 1500–1800*, ed. Lynn Hunt (New York, 1993), pp. 49–108

Fister, Patricia, *Kinsei no josei gaka-tachi*, Shibunkaku Shuppan (1994)

Forrer, Matthi, 'Shunga Production in the 18th and 19th Centuries: Designing "un enfer en style bibliotheque"', in *Imaging/Reading Eros: Sexuality and Edo Culture, 1750–1850*, ed. Sumie Jones (Bloomington, IN, 1995), pp. 21–6

Fujita Satoru, *Matsudaira Sadanobu: seiji kaikaku ni itonda rōjū*, Chūkō Shinsho (1993)

Fujiwara no Kanesuke (attrib.), *Tsutsumi chūnagon monogatari*, in *Ochikubo monogatari/Tsutsumi chūnagon monogatari*, Nihon koten bungaku taikei 13, Iwanami (1957), vol. XIII, pp. 365–431

Fukuda Kazuhiko, *Edo no seiaigaku*, Iwade Bunko (1988)

——, *Ukiyo-e: edo no shiki*, Kawade Shobō Shinsha (1987)

——, ed., *Shikidō kinpi shō*, 3 vols, Ukiyo-e gurafikku, KK Besutoserā (1990)

Furukawa Koshōken, *Saiyū zakki*, in *Kindai shakai sōsho*, Kaizōsha (1927), vol. IX, pp. 140–67

Gerstle, C. Andrew, 'Flowers of Edo: Kabuki and its Patrons', in *18th Century Japan*, ed. C. Andrew Gerstle (Sydney, 1989), pp. 33–50

Haga Tōru, 'Precariousness of Love: Places of Love', in *Imaging/Reading Eros: Sexuality and Edo Culture, 1750–1850*, ed. Sumie Jones (Bloomington, IN, 1995), pp. 97–103

Hamada Giichirō, *Ōta Nanpo*. Jinbutsu sōsho, Yoshikawa Kobun-kan (1963)

Hamada Giichirō, ed., *Edo bungaku chimei jiten*, Tōkyōdō Shuppan (1973)

Hanasaki Kazuo, *'Nyūyoku' hadaka no fūzoku-shi*, vol. LXX of Kodansha Culture Books (1993)

—— and Aoki Meiro, *Senryū no shunga-shi*, Taihei Shobō (1989)

—— and Satō Yoshito, *Shokoku yūri zue*, San'ichi Shobō (1978)

Harper, Thomas J., 'The "Tale of Genji" in the Eighteenth Century: Keichū, Mabuchi and Norinaga', in *18th Century Japan*, ed. C. Andrew Gerstle (Sydney, 1989), pp. 106–23

Hatakeyama Kizan, 'Shikidō ōkagami', in *Zoku enseki jisshū*, Kokusho Kankō-kai (1909), pp. 403–50

Hattori Yukio, *Sakasama no yūrei. Image Reading Sōsho*, Heibonsha (1989)

Hayashi Yoshikazu, *Edo ehon o sagase*, Kawade Shobō Shinsha (1993)

——, *Edo makura-e no nazo*, Kawade Bunko (1988)

——, *Edo no makura-eshi*, Kawade Shobō (1987)

——, *Ehon kikō: tōkaidō gojūsan tsugi*, Kawade Bunko (1986)

——, *Geijitsu to minzoku ni arawareta seifūzoku*, in *Hishi: seitai fūzoku-sen*, vol. X, Nichirin-kaku (1992)

——, *Katsukawa Shunshō*, in *Edo makura-eshi shūsei*, Kawade Shobō Shinsha (1990)

——, *Kitagawa Utamaro. Edo makura-eshi shūsei*, Kawade Shobō Shinsha (1990)

——, *Utagawa Kunisada. Edo makura-eshi shūsei*, Kawade Shobō Shinsha (1989)

——, ed., *Shigenobu 'yanagi no arashi'*, Teihon ukiyo-e shunga meihin shūsei, Kawade Shoten Shinsha (1996)

Heckscher, William S., *Rembrandt's Anatomy Lesson of Dr. Nicolaas Tulp* (New York, 1958)

Hibbett, Howard, *The Floating World in Japanese Fiction* (Rutland, VT, and Tokyo, 1959)

Hillier, Jack, *Suzuki Harunobu* (Philadelphia, 1970)

Hiraga Gennai, *Nanshoku saiken mitsu no asa*, in *Nihon shomin bunka shiryō shūsei*, San'ichi Shobō (1974), vol. IX, pp. 101–11

——, 'Nenashi-gusa kohen', *Fūrai sanjin-shū*, ed. Nakamura Yukihiko, Nihon koten bungaku taikei, Iwanami Shoten (1961), pp. 97–151

Hiratsuka Yoshinobu, *Nihon no okeru nanshoku no kenkyū*, Ningen no Kagaku-sha (1987)

Hollander, Anne, *Seeing Through Clothes* (Berkeley, Los Angeles and London, 1993)

Hunt, Lynn, 'Obscenity and the Origins of Modernity, 1500–1800', in *The Invention of Pornography: Obscenity and the Origins of Modernity, 1500–1800*, ed. Lynn Hunt (New York, 1993), pp. 9–45

——, ed., *The Invention of Pornography: Obscenity and the Origins of Modernity, 1500–1800* (New York, 1993)

Ihara Saikaku, *Haikai dokugin ichinichi senku*, in *Teihon saikaku zenshū*, ed., Ebara Taizō, Chūō Kōron-sha (1964), vol. X, pp. 107–88

——, *Kōshoku ichidai otoko*, in *Saikaku-shū*, vol. I, ed. Itasaki Gen, Nihon koten bungaku taikei, Iwanami (1957), pp. 37–126

——, *Kōshoku nidai otoko*, in *Kōshoku nidai otoko/Saikaku shokoku-banashi*, Shin nihon koten bungaku taikei, Iwanami (1991), vol. LXXVI, pp. 3–262

——, *Nanshoku ōkagami*, in *Ihara Saikaku-shū: 2*, Nihon koten bungaku taikei vol. XXXIX, Shogakkan (1973), pp. 351–597

——, *Saikaku shokoku-banashi*, in *Kōshoku nidai otoko/Saikaku shokoku-banashi*, Shin nihon koten bungaku taikei, Iwanami (1991), vol. LXXVI, pp. 263–388

——, *The Great Mirror of Male Love*, trans. Paul Gordon Schalow (Stanford, CA, 1990)

Ikegami, Eiko, *The Taming of the Samurai: Honorific Individualism and the Making of Modern Japan* (Cambridge, MA, and London, 1995)

Itaru Kimoto, *Onanii to nihonjin*, Intanaru Shuppan (1984)

Ishino Hiromichi, *Esoragoto*, in *Enseki jisshū*, vol. V, Chūō Kōron-sha (1987)

Iwata Jun'ichi, 'Haijin bashō no dōsei-ai', in *Honchō nanshoku-kō*, Toba: Iwata Sadao (1974), pp. 253–67

Jinnai Hidenobu, 'The Spatial Structure of Edo', in *Tokugawa Japan: The Social and Economic Antecedents of Modern Japan*, ed. Chie Nakane *et al.*, University of Tokyo Press (Tokyo, 1990), pp. 124–46

Jippensha Ikku, *Hizakurige or Shanks' Mare: Japan's Great Comic Novel of Travel and Ribaldry*, trans. Thomas Satchell (Rutland, VT, and Tokyo, 1960)

——, *Tōkaidōchū hizakurige*, vol. LXII of Nihon koten bungaku taikei, Iwanami Shoten (1988)

Jones, Sumie, 'William Hogarth and Kitao Masanobu: Reading Eighteenth-century Pictorial Narratives', *Yearbook of Comparative and General Literature*, XXXIV (1985), pp. 37–73

Jones, Sumie, ed., *Imaging/Reading Eros: Sexuality and Edo Culture, 1750–1850* (Bloomington, IN, 1995)

Kaempfer, Engelbert, *A History of Japan together with a Description of the Kingdom of Siam*, trans. Johannes Scheuchzer (London, 1727)

Kamigaito Ken'ichi, 'Nikkan zenrin gaikō no keifu, pt 2', *Kankoku Bunka*, 159 (1993), pp. 4–11

Kano Ikkei, *Kososhū*, in *Nihon garon taikan*, ed. Sakazaki Tan, 2 vols, Arusu (1927), vol. I, pp. 703--67

Kashiwabara Satoru, *'Teikan-zu shokai'*, in Machida City Museum, ed., *Kinsei nihon kaiga to gafu*, Machida City Museum (1994), pp. 124–37

Kato, Takashi, 'Governing Edo', in *Edo and Paris: Urban Life and the State in the Early Modern Era*, ed. James L. McClain, John M. Merriman and Ugawa Kaoru (Ithaca and London, 1994), pp. 41–67

Katsuragawa Hoshū, *Hokusa bunryaku*, Iwanami Bunko (1990)

Katsushika no Inshi, *Tōdai edo hyaku bakemono*, in *Nihon zuihitsu taisei*, Yoshikawa Kōbunkan (1973), vol. II, pp. 389–407

Keene, Donald, 'The Comic Tradition in Renga', in *Japan in the Muromachi Age*, ed. John W. Hall and Toyoda Takeshi (Berkeley, Los Angeles and London, 1977), pp. 241–78

——, ed. and trans., 'The Battles of Coxinga', in *Major Plays of Chikamatsu* (New York, 1961), pp. 195–269

Ki no Tsurayuki, ed., *Kokin wakashū*, Nihon koten bungaku taikei, Iwanami Shoten (1958)

Kimura Shage, ed., *Nanshoku yamaji no tsuyu*, in *Hihon: edo bungaku-sen*, Nichirin-kaku (1975)

Kimuro Bōun, *Mita kyō monogatari*, in *Nihon zuihitsu taisei: 3* (1929), vol. IV, pp. 563–82

Kobayashi Tadashi, *Edo no e o yomu*, Perikan-sha (1989)

——, 'Gazoku no kōō', in *Nihon no kinsei*, ed. Nakano Mitsutoshi, Chūō Kōron-sha (1993), vol. XII, pp. 351–76

——, *Hanabusa Itchō*, vol. CCLX of *Nihon no bigaku*, Chibundō (1966)

——, '"Sumida gawa ryōgan zukan" no seritsu to tenkai', *Kokka*, 1172 (1993), pp. 5–22

—— and Asano Shūgō, eds, *Ukiyo-e soroi-mono: Makura-e*, 2 vols, Gakken (1995)

Koga Jūjirō, *Maruyama yūjo to tōkōmō-jin*, 2 vols (Nagasaki, 1968)

Kogawa Shin'ya and Shirakura Yoshihiko, '[Makura-e] nenpyō', in *Ukiyo-e soroi-mono: Makura-e*, ed. Kobayashi Tadashi, Gakken (1995), vol. I, pp. 130–7

Koikawa Harumachi, *Muda iki*, in *Edo no gesaku ehon*, 6 vols, ed. Koike Masatane *et al.*, Gendai Kyōiku Bunko (1983), vol. I, pp. 113–44

Koike Masatane *et al.*, eds, *Edo no gesaku ehon*, 6 vols, Gendai Kyōiku Bunko (1983)

Koike Tōgorō, *Kōshoku monogatari*, Nichirin-kaku (1975)

Komatsu-ya Hyakki, *Fūryū kōshoku maneemon*, in *Ukiyo-e soroi-mono: Makura-e*, ed. Kobayashi Tadashi, 2 vols, Gakken (1995), vol. I, pp. 122–4

Konishi Jun'ichi, 'Michi and Medieval Writing', in *Principles of Classical Japanese Literature*, ed. Earl Miner (Princeton and Guilford, 1985), pp. 181–208

Lacquer, Thomas, *Making Sex: Body and Gender from the Greeks to Freud* (Cambridge, MA, and London, 1990)

Lane, Richard, '"Kiesareta shunga" o abaku', *Geijitsu shincho* (June 1994), pp. 4–52

—— *et al.*, eds, *Shinpen shiki hanga: makura-e*, Gakken (1995)

——, ed., *Okumura Masanobu 'Neya no hinagata'*, Teihon: ukiyo-e shunga meihin shūsei, Kawade Shobō Shinsha (1996)

Lee, Julian J., 'The Origin and Development of the Japanese Landscape Print: A Study of the Synthesis of Eastern and Western Art', PhD thesis, University of Washington, Seattle, 1977

Leupp, Gary P., *Male Colors: The Construction of Homosexuality in Tokugawa Japan* (Berkeley, Los Angeles and London, 1995)

Link, Howard, *The Theatrical Prints of the Torii Masters: A Selection of Seventeenth and Eighteenth-Century Ukiyo-e* (Honolulu, 1977)

Longstreet, Stephen, and Ethel Longstreet, *Yoshiwara: The Pleasure Quarters of Old Tokyo* (Rutland, VT, and Tokyo, 1988)

Luyendijk-Elshout, A. M., '"Ontleedinge" (Anatomy) as Underlying Principle of Western Medicine in Japan', in *Red-Hair Medicine: Dutch-Japanese Medical Relations*, ed. H. Beukers *et al.* (Amsterdam and Atlanta, GA, 1991)

Marcus, Steven, *The Other Victorians: A Study of Sexuality and Pornography in Mid-Nineteenth-Century England* (New York, 1974)

Matsuda Kiyoshi, *Yōgaku no shoshiteki kenkyū* (Kyoto, 1998)

Matsudaira Sadanobu, *Seigo*, in *Kinsei seidō-ron*, Nihon shisō taikei, Iwanami Shoten (1976), vol. LXXVIII, pp. 3–49

——, *Taikan zakki*, in *Zoku nihon zuihitsu taisei*, ed. Mori Senzō, Yoshikawa Kōbun-kan (1980), vol. VI, pp. 11–253

——, *Uge no hitokoto/Shugyō-roku*, Iwanami Shoten (1982)

Matsura Seizan, *Kasshi yawa. Tōyō bunko*, 5 vols, Heibonsha (1978)

McClain, James L., *Kanazawa: A Seventeenth-Century Japanese Castle Town* (New Haven and London, 1982)

McCullough, Helen Craig, *Yoshitsune: A Fifteenth-Century Japanese Chronicle* (Stanford, CA, 1966)

Mishima Yukio, *Gogo no eikō*, in *Mishima Yukio zenshū*, Shinko-sha (1973), vol. XIV, pp. 299–461

——, *Kamen no kokuhaku*, in *Mishima Yukio zenshū*, Shinko-sha (1973), vol. III, pp. 161–362

——, *The Sailor Who Fell from Grace with the Sea*, trans. John Nathan (Harmondsworth, 1970)

Mizuo, Hiroshi, *Edo Painting: Sōtatsu and Kōrin*, vol. XVIII of *Heibonsha Survey of Japanese Art*, trans. John M. Shields, Heibonsha (1972)

Mori Yōko, 'Nihon no shabon-dama no gui to sono zuzō', *Mirai*, 344 (1995), pp. 2–150

Morishima Chūryō, *Bankoku shinwa*, in *Kōmō zatsuwa*, ed. Ono Tadashige, Sōrin-sha (1942), pp. 177–277

——, *Kōmō zatsuwa*, in *Bunmei genryū sōsho*, ed. Hayakawa Junzaburō, Kokusho Kankō-kai (1913), vol. I, pp. 455–85

Moriyama Takamori, *Ama no yakumo no ki*, in *Nihon zuihitsu taisei: 2*, Yoshikawa Kōbun-kan (1974), vol. XXII, pp. 199–264

——, *Shizu no odamaki*, in *Nihon zuihitsu taisei: 3*, Yoshikawa Kōbun-kan (1976), vol. IV, pp. 225–67

Murase, Mieko, *Iconography of the 'Tale of Genji'* (New York and Tokyo, 1983)

Muro Kyūsō, *Kenzan hisaku*, vol. VI of *Nihon keizai taiten*, Meiji Bunken (1966)

Muroyama Genjirō, *Kosenryū ni miru kyō, ōmi*, Miki Shobō (1996)

Naitō Masato, 'Chōbunsai Eishi no iwayuru "Yoshiwara kayoi zukan" ni tsuite', in *Nikuhitsu ukiyo-e taikan*, ed. Kobayashi Tadashi, Kodansha (1996), vol. III, pp. 240–7

——, 'Sakai Hōitsu no ukiyo-e', *Kokka*, 1191 (1995), pp. 19–27

Nakamura Eizō, *Edo higo jiten*, Keiyūsha (1993)

——, *Edo jidai: kōshoku bungeibon jiten*, Yūzankaku (1988)

Nakamura Yukihiko, *Gesaku-ron*, vol. VIII of *Nakamura Yukihiko chobetu-shū*, 2nd edn, Chūō Kōron-sha (1982)

Nakano Mitsutoshi, 'Kyōho kaikaku no bunka-teki igi', in *Nihon no kinsei*, ed. Nakano Mitsutoshi, Chūō Kōron-sha (1993), vol. XII, pp. 48–57

Nakano Yoshio, *Shiba Kōkan kō*, Shinchōsha (1986)

Naruse Fujio *et al.*, eds, *Shiba Kōkan zenshū*, 8 vols, Yasaka Shobō (1992)

Nihon Ishi Gakkai, ed., *Zuroku nihon iji bunka shiryō shūsei*, 5 vols., San'ichi Shobō (1977)

Nihon Ukiyo-e Kyōkai, ed., *Genshoku ukiyo-e hyakka jiten*, Ginka-sha (1980),

Nishiyama Matsunosuke, *Edokko. 'Edo' sensho*, Yoshikawa Kōbun-kan (1980)

—— *et al.*, eds, *Edo-gaku jiten*, Kōbundō (1994)

Nishizawa Ippū, *Yakei tomo-jamisen*, in *Edo jidai bungei shiryō*, vol. II, Hayakawa Junzaburō, ed., Kokusho Kankō-kai (1916), pp. 315–53

Noguchi Takehiko, *Edo no wakamono-kō*, Sanshō-dō (1986)

Nojima Jūsaburō, ed., *Kabuki jinmei jiten*, Nichigai (1988)

Norton, Rictor, *Mother Clap's Molly-house: Gay Subculture in England, 1700–1830* (London, 1992)

Oka Yasumasa, *Megane-e shinkō*, Chikuma Shobō (1992)

Okitsu Kaname, *Edo senryū*, Jiji Tsūshin-sha (1990)

Omura Shage, ed., *Kontan iro-asobi futokoro-otoko*, in *Hibon: edo bungaku-sen*, vol. II, Nichirin-kaku (1978)

——, *Nanshoku yamaji no tsuyu*, in *Hibon: Edo bungaku-sen*, Nichirin-kaku (1978)

Onishi Hiroshi, ed. and trans., '*Nihon, chūkoku no geijitsuka densetsu*', Perikan-sha (1989)

Ota Kinjō, *Goso manpitsu*, in Nihon zuihitsu zensh, Kokumin Tosho (1928), vol. XVII, pp. 1–330

Ota Nanpo, *Iwa-tsutsuji*, in *Misonoya*, 4 vols, Kokusho Kankō-kai (1917), vol. I, pp. 367–86

—— *et al.*, 'Shunsō hiji', in Okada Hajime, ed., Shinsei shunga-koromo, Biwa Shoten (1953)

Otsuki Gentaku and Shimura Kōkyō, 'Kankai ibun', in *Hyōryū kidan zenshū*, ed. Ishii Tamoshi, Zoku teikoku bunko, Hakubun-kan (1900), pp. 387–694

Pepys, Samuel, *The Shorter Pepys*, ed. Richard Lathan (Harmondsworth, 1986)

Pflugfelder, Gregory M., 'Cartographies of Desire: Male–Male Sexuality in Japanese Discourse, 1600–1850', PhD thesis, Stanford University, 1996

——, 'Strange Fates: Sex, Gender and Sexuality in "Torikaebaya monogatari"', *Monumenta Nipponica*, XLVII (1992), pp. 347–68

Pigeot, Jacqueline, *Michiyuki-bun: Poétique de l'itinéraire dans la littérature du Japon ancien* (Paris, 1982)

Pollock, Griselda, *Vision and Difference: Femininity, Feminism and Histories of Art* (London, 1988)

Robertson, Jennifer, 'Sexy Rice: Plants, Gender, Farm Manuals, and Grass-roots Nativism', *Monumenta Nipponica*, XXXIX (1984), pp. 233–60

Rosenfield, John M., and Shūjirō Shimada, *Traditions of Japanese Art: Selections from the Kimiko and John Powers Collection* (Cambridge, MA, 1970)

Rousmaniere, Nicole, 'The Accessioning of Japanese Art in Early 19th-century America: *Ukiyo-e* Prints in the Peabody-Essex Museum, Salem', *Apollo*, CXLV (1997), pp. 23–9

Roy, Alain, *Gérard de Lairesse (1640–1711)* (Paris, 1992)

Saitō Gesshin, *Bukō nenpyō. Tōyō bunko*, 8 vols, Heibonsha (1982)

Santō Kyōden, *Edo umare uwaki no kabayaki*, in *Edo no gesaku ehon*, ed. Koike Masatane *et al.*, Kyōiku Bunko (1983), vol. II, pp. 147–82

——, *Gozonji no shōbaimono*, in *Edo no gesaku ehon*, ed. Koike Masatane *et al.*, Kyōiku Bunko (1983), vol. I, pp. 215–48

Sansom, G. B., *Japan: A Short Cultural History* (London, 1931)

Sasaki Jōhei, *Okyo shasei gashū*, Kodansha (1981)

Satake Yoshiatsu (Shozan), *Gahō kōryō*, in *Nigon garon taikei*, ed. Sakazaki Tan, Arusu (1927), vol. I, pp. 100–101

Satō Dōshin, 'Nihon bijutsu' no tanjo, Kodansha Sensho Mechie (1996)

Satō Naoto, *Senryū yoshiwara fūzoku zue*, Shibudo (1976)

Satō Narihiro (Chūryō), *Chūryō manroku*, in *Nihon zuihitsu taisei: 3*, Nihon Zuihitsu Taisei Kankō-kai (1929), vol. II, pp. 1–335

Satow, Ernest, ed., *The Voyage of Captain John Saris to Japan* (London, 1967)

Sawada Akira, *Nihon gaka jiten: jinmei hen*, 2 vols, Kyoto: Daigakudo, Shoten (1987)

Schalow, Paul, 'The Invention of a Literary Tradition of Male Love: Kitamura Kigin's Iwatsutsuji', *Monumenta Nipponica*, XLVIII (1993), pp. 1–31

——, 'Review of Gary P. Leupp, "Male Colors"', *Journal of Japanese Studies*, 23 (1997), pp. 196–201

Screech, Timon, *Edo no jintai o hiraku*, trans. Takayama Hiroshi, Sakuhin-sha (1997)

——, *Edo no shikō kūkan*, trans. Murayama Kazuhiro, Seido-sha (1998)

——, 'Glass, Paintings on Glass, and Vision in Eighteenth-century Japan', *Apollo*, 433 (1998), pp. 28–32

——, *O-Edo ijin ōrai*, trans. Takayama Hiroshi, Maruzen Books (1995)

——, *O-Edo shikaku kakumei*, trans. Takayama Hiroshi and Yanaka Yūko, Sakuhin-sha (1998)

——, *Shunga: katate de yomu edo no e*, trans. Takayama Hiroshi, Kodansha Sensho Mechie (1998)

——, *The Western Scientific Gaze and Popular Imagery in Later Edo Japan: The Lens within the Heart* (Cambridge and New York, 1996)

Seidensticker, Edward, *Low City, High City: Tokyo from Edo to the Earthquake, 1867–1923* (Harmondsworth, 1983)

Seigle, Cecelia Segawa, *Yoshiwara: The Glittering World of the Japanese Courtesan* (Honolulu, 1993)

Shaver, Ruth, *Kabuki Costume* (Rutland, VT, and Tokyo, 1966)

Shiba Kōkan, *Saiyū nikki. Tōyō bunko*, Heibonsha (1986)

——, 'Seiyō gadan', *Yōgaku* 2, Nihon shisō taikei, Iwanami Shoten (1976), vol. LXV, pp. 489–97

——, *Shunparō hikki*, in *Nihon zuihitsu taisei*, Yoshikawa Kōbun-kan (1928), vol. XI, pp. 395–467

——, 'Tenchi ridan', in *Shiba Kōkan zenshū*, vol. IV, Yasaka Shobō (1994), pp. 277–323

Shibusawa Eiichi, *Rakuō-kō den*, 2nd edn, Iwanami Shoten (1983)

Shikitei Sanba, *Ukiyo-doko*, in *Sharebon, kokkeibon, ninjōbon, Shōgakkan* (1971), vol. XLVII, pp. 255–369

Shinoda Jun'ichi, *Nise monogatari-e: e to bun/bun to e*, Heibonsha (1995)

Shirahata Yōsaburō, *Daimyō teien: edo no kyōen*, Kodansha Sensho Mechie (1997)

Shively, Donald H., 'The Social Environment of Tokugawa Kabuki', *Studies in Kabuki: Its Acting, Music, and Historical Context*, ed. William P. Malm and Donald H. Shively (Honolulu, 1978)

Shunro-an Shūjin, *Edo no shikidō: seiai bunka o himotoku kidan no ezu to senryū*, 2 vols, Yobun-kan (1996)

Smith, Henry, 'Overcoming the Modern History of "Shunga"', in *Imaging/ Reading Eros: Sexuality and Edo Culture, 1750–1850*, ed. Sumie Jones (Bloomington, IN, 1996), pp. 26–35

——, 'World Without Walls: Kuwagata Keisai's Panoramic Vision', in *Japan and the World*, ed. Gail Bernstein and Haruhito Fukui (London, 1988), pp. 3–19

Sōchō, *Socho shūki*, vol. XI of *Gunsho ruiju*, Keizai Sasshi-sha (1899)

Steiner, George, 'Night Words: High Pornography and Human Privacy', in *Language and Silence: Essays on Language, Literature and the Humanities*, ed. George Steiner (New York, 1977)

Sugimoto Tsutomu, *'Kaitai shinsho' no jidai*, Waseda Daigaku Shuppan-bu (1987)

Sugita Genpaku, *Nochimigusa*, in *Nihon shomin seikatsu shiryō shūsei*, ed. Mori Kihei and Tanigawa Ken'ichi, San'ichi Shobō (1970), vol. VII, pp. 55–86

——, *Rangaku kotohajime*, in *Taion-ki/Oritaku shiba no ki/Rangaku kotohajime*, Nihon koten bungaku taikei, Iwanami Shobō (1964), vol. XCV, pp. 451–516

—— *et al.* (trans.), *Kaitai shinsho*, in *Yōgaku* 2, Nihon shosō taikei, Iwanami Shoten (1972), vol. LXV, pp. 207–359

Suzuki Hiroyuki, 'Rakuda o egaku: maruyama ōshin rakuda-zu o megutte', *Bijutsu-shi*, 338 (1987), pp. 128–46

Suzuki Jūzō, *Ehon to ukiyo-e*, Tōkyō Bijutsu Shuppan (1979)

Tachibana Nankei, *Hokusō sadan*, in *Tōzai yūki/hokusō sadan*, Yōhōdō Shoten (1913), pp. 1–207

Takeda Izumo *et al.*, 'Kanadehon chūshingura', *Jōruri-shū: 1*, Iwanami Shoten (1960), vol. LI

Takeuchi Makoto, 'Festivals and Fights: the Law and the People of Edo', in *Edo and Paris: Urban Life and the State in the Early Modern Era*, ed. James L. McClain, John M. Merriman and Ugawa Kaoru (Ithaca and London, 1994), pp. 384–406

——, vol. x of *Nihon no rekishi*, Shōgakkan (1989)

Takizawa Bakin, *Kiryo manroku*, in *Nihon zuihitsu taisei. 1*, vol. I, Yoshikawa Kōbun-kan (1975), pp. 138–256

Tan'o Yasunori, 'Honchō nanshoku bijutsu-kō', *Hikaku bungaku nenshi*, 26 (1990), pp. 164–88

Tanahashi Masahiro, *Kibyōshi sōran. Nihon shoshi-gaku taikei*, vols XXXXVIII (I)–XXXXVIII (IV), Seishōdō Shoten (1994)

Tanemura Suehiro, *Hako-nuke karakuri kidan*, Kawade Shobō Shinsha (1991)

Tanobe Tomizō, *Igaku mitate bakumatsu no makura-eshi*, Kawade Shobō Shinsha (1997)

——, *Igaku mitate edo no kōsoku*, Kawade Bunko (1989)

Teruoka Yasutaka, 'The Pleasure Quarters in Tokugawa Culture', in *18th Century Japan*, ed. C. Andrew Gerstle (Sydney, 1989), pp. 3–32

Thunberg, Charles (Carl), *Thunberg's Travels*, trans. F. and C. Rivington, 4 vols (London, 1795)

Tsuji Nobuo *et al.*, eds, *Ukiyo-e hizō meihin-shū: Utamaro*, Gakken (1991)

Tsuji Tatsuya, 'Politics in the Eighteenth Century', *Cambridge History of Japan*, ed. John W. Hall (Cambridge, 1991), vol. IV, pp. 425–77

Uchida Kinzō, 'Kuwagata Keisai kenkyū: okaka eshi jidai no katsudo o megutte, pts 1 and 2', *Kokka*, 1158–9 (1992), pp. 11–30, 9–24

Ueda Akinari, *Ugetsu monogatari*, in *Ueda Akinara-shū*, ed. Nakamura Yukihiko, Nihon koten bungaku taikei, Iwanami Shoten (1959), vol. LVI, pp. 5–141

Ujiie Mikito, *Bushidō to erosu*, Kodansha Gendai Shinsho (1995)

Vaporis, Constantine, *Breaking Barriers: Travel and the State in Early Modern Japan* (Cambridge, MA, 1994)

Wagner, Peter, *Eros Revived: Erotica and the Enlightenment in England and America* (London, 1988)

Yamaji Kanko, ed., *Suetsumuhana yawa*, Hiseki: Edo bungaku sen, Nichirin-kaku (1975)

Yamamoto Tsunetomo, *Hagakure* in *Edo shiryō sōsho: Hagakure*, 2 vols, Jinbun Ōrai-sha (1968)

Yanagisawa Kien, *Hitorine*, in *Kinsei zuisō-shū*, Nihon koten bungaku taikei, Iwanami (1963), vol. XLVI, pp. 25–208

Yuasa Akeyoshi, *Tenmei taisei-roku*, in Seiichi Takimoto, ed., *Nihon keizai daiten*, vol. XXII, Hōbun Shoten (1927), pp. 145–364

Yuasa Genzō, *Kokui-ron*, in *Nihon keizai daiten*, ed. Takimoto Seiichi, Hōbun Shokan (1928), vol. XXII, pp. 3–28

List of Illustrations

1 Anon., *The Minister Relocated to the Northern Provinces*, monochrome woodblock illustration for Ihara Saikaku, *Shoen ōkagami (Kōshoku nidai otoko)* (1684).

2 Anon., *Monk Worshipping a Painting*, monochrome woodblock illustration for *Kōshoku tabi nikki* (1687).

3 Anon., *Produce*, monochrome woodblock illustration for Teikin, *Teikin warai-e shō* (*c.* 1830).

4 Anon., *Man using a Portrait and an 'Edo shape'*, monochrome woodblock illustration separated from an unknown *shunga* book (*c.* 1760).

5 Kitao Shigemasa, *Geisha from the Nishigashi* and *Inscription*, 1781, diptych, colour on silk. Original lost. Photo: Jack Hillier.

6 Suzuki Harunobu, *Shared Umbrella*, late 1760s, multi-coloured woodblock print.

7 Attrib. Isoda Koryūsai, *Lovers under a Willow in the Snow*, late 1760s, multi-coloured woodblock print.

8 Utagawa Kunifusa, *Playing Sugoroku at a Heated Table*, multi-coloured wood-block page with pull-up, from a *shunga* album, *Tsukushi matsufuji no shirakami* (1830).

9 Utagawa Kunifusa's *Playing Sugoroku . . .* with the pull-up raised.

10 Katsukawa Shunshō, *Wet Dream After Reading a Pillow Book*, monochrome woodblock illustration for Jintaku Sanjin, *Ukiyo no itoguchi* (1780).

11 Terasawa Masatsugu, *Song*, monochrome woodblock page from his *Aya no odamaki* (1770s).

12 Utagawa Kunisada, *Lovers Viewing a* Shunga *Scroll*, multi-coloured woodblock page from the anonymous *Shiki no nagame* (*c.* 1827).

13 Hishikawa Moronobu, *Lovers Indoors*, monochrome woodblock page from *Hana no katari* (modern title) (1679[?]).

14 Kitagawa Utamaro, *Lovers*, multi-coloured woodblock page from a *shunga* album, *Utamakura* (1788). The British Museum, London.

15 Chōbunsai Eishi, *Life on the River Sumida*, 1828, pair of eight-fold screens, ink and colour on paper. Formerly in the Azabu Museum of Arts and Crafts, Tokyo, present whereabouts unknown.

16 Isoda Koryūsai, *Public Bathhouse*, multi-coloured woodblock page from the *shunga* album, *Shikidō torikumi jūni awase* (*c.* 1775).

17 Ishikawa Toyonobu, *Wooden Bathtub*, *c.* 1760, three-tone woodblock print.

18 Utagawa Kunimaro, *Nun using a Portrait of Matsumoto Kōshirō*(?), multi-coloured woodblock page from a *shunga* album, *Ikurasemu* (*c.* 1830s).

19 Torii Kiyomitsu I, *Segawa Kikunojō II in the Role of Minor Captain Keshōzaka*, 1763, colour woodblock print.

20 Suzuki Harunobu, *Woman Bringing in Washing During a Shower*, 1765, calendar, multi-coloured woodblock print.

21 Tamagawa Senshū, *Woman Washing*, *c.* 1795, multi-coloured woodblock print.

22 Chōbunsai Eishi, *Three of the Seven Lucky Gods at a Yoshiwara Brothel*, late 18th century, section of a handscroll, *Lucky Gods Travel to the*

Yoshiwara, colour on silk. Formerly in the Azabu Museum of Arts and Crafts, Tokyo, present whereabouts unknown.

23 Utagawa Toyokuni I, *At the Women's Bath*, triptych, three-tone woodblock page from Karasutei Enba II, *Ōyo kari no koe* (1822).

24 Anon., *Mediaeval Lovers*, *c.* 1600, section of an untitled *shunga* handscroll, colour on paper.

25 Attrib. Okumura Masanobu, *Sexual Threesome*, *c.* 1740s, section of three-tone woodblock printed handscroll, *Neya no hinagata*.

26 Kitagawa Utamaro, *Needlework*, *c.* 1797–8, multi-coloured woodblock.

27 Yanagawa Shigenobu, *Foreign Couple, Rendered in Imitation of Copperplate*, multi-coloured woodblock page from a *shunga* album, *Yanagi no arashi* (1822).

28 Sakai Tadanao (Toryō, or Sakai Hōitsu), *Courtesan with Attendants*, late 1780s, colour on silk. Tokyo National Museum.

29 Kitao Masayoshi (Kuwagata Keisai), *Two Women with a Man*, 1780s, multi-coloured woodblock print. The British Museum, London.

30 Kuwagata Keisai (Kitao Masayoshi), *A Brothel in the Yoshiwara*, 1822, detail from a collaborative handscroll *Edo shokunin-zukushi*, colour on paper. Tokyo National Museum.

31 Katsushika Hokusai, detail from *Boys' Festival*, 1810s, multi-coloured woodblock print.

32 *Criminal, Spy*, Nanshoku, monochome woodblock page from Terashima Ryōan, *Wakan sansai zue* (1713).

33 Odano Naotake, *Diaphragm*, monochrome woodblock illustration for Sugita Genpaku *et al.* (trans.), *Kaitai shinsho* (1774 [copy after German original of 1725]).

34 Odano Naotake, *The Body, Front and Back*, from Sugita Genpaku *et al.*, *Kaitai shinsho*.

35 *The Female Body*, monochrome woodblock illustration for Morishima Chūryō, *Kōmō zatsuwa* (1787).

36 Eglon van der Neer, *Portrait of a Man and A Woman in an Interior*, *c.* 1675, oil on panel. Museum of Fine Arts, Boston (Seth K. Sweetser Fund). Photo: Courtesy of the Museum of Fine Arts, Boston.

37 Edouard Manet, *Olympia*, 1863, oil on canvas. Musée d'Orsay, Paris. Photo: Agence Photographique de la Réunion des Musées Nationaux.

38 Kuroda Seiki, *Morning Toilette*, 1893, oil on canvas. Original destroyed during WWII. Photo:Tokyo National Research Institute of Cultural Properties.

39 Kikuchi Yōsai, *En'ya Takasada's Wife Leaving her Bath*, 1842, colour on silk. Private collection.

40 Suzuki Harushige (Shiba Kōkan), *Foreign Woman and Child*, *c.* 1790, colour on paper.

41 Cover illustration to *Le Japon artistique*, no. 33 (January, 1891).

42 Marcantonio Raimondi, *First Position*, copperplate illustration for Pietro Aretino, *Sonnetti lussuriosi* (1524).

43 Koikawa Harumachi, *The Road to the Yoshiwara*, monochrome woodblock page from his *Muda iki* (1781 or 1783). National Diet Library, Tokyo.

44 Kitagawa Utamaro, *Three Beauties of the Present Day*, *c.* 1793, multi-coloured woodblock print.

45 Shimokōbe Shūsui, *Lovers*, monochrome woodblock page from an untitled *shunga* album (*c.* 1771).

46 Katsushika Hokusai, *Lovers*, multi-coloured woodblock page for *Fukuju sou* (1815).

47 Kitagawa Utamaro, *Lovers*, multi-coloured woodblock page from *Tama kushige* (1801).

48 Utagawa Hiroshige, *Lovers under the Moon*, multi-coloured woodblock page from a *shunga* album, *Haru no yahan* (*c.* 1851).

49 Utagawa Kunisada, *Lovers and Sleeping Husband*, multi-coloured woodblock page from *Shiki no sugatami* (1842).

50 Ishikawa Toyonobu, *Lovers and Servant Passing*, monochrome woodblock page from a *shunga* album, *Iro sunago* (*c.* 1750).

51 Kitagawa Utamaro, *Lovers*, monochrome woodblock page from a *shunga* album, *Ehon hitachi obi* (1795).

52 Follower of Keisai Eisen, *O-tsuru and Umejirō*, multi-coloured woodblock page from Shikitei Sanba ('Kōtei Shūjin'), *Nishikigi sōshi* (*c.* 1825).

53 Suzuki Harushige (Shiba Kōkan), *Nihon Embankment*, *c.* 1770, multi-coloured woodblock print from the series *Fūryū nana-komachi*. The British Museum, London.

54 Anon., *Whose Sleeves?*, late 18th century, left-hand of a pair of six-fold screens (right screen lost). Private collection.

55 Rekisen-tei Eiri, *Lovers behind a Sliding Door*, multi-coloured woodblock page from an untitled *shunga* album (*c.* 1785).

56 Suzuki Harunobu, *Autumn Moon of the Mirror Stand*, multi-coloured page from a *shunga* album, *Fūryū zashiki hakkei* (*c.* 1768).

57 Kitagawa Utamaro, *Lovers in Summer*, multi-coloured woodblock page from Intō-tei no Aruji (Shikitei Sanba?), *Negai no itoguchi* (1799).

58 Ogata Kōrin, *Rock Azalea*, *c.* 1700, hanging scroll, colour and ink on paper. Hatakeyama Memorial Museum, Tokyo.

59 Suzuki Harunobu, *Lovers with Rutting Cats*, multi-coloured woodblock page from Komatsu-ya Hyakki, *Fūryū kōshoku maneemon* (1765).

60 Inagaki Tsurujo, *Women Manipulating a Glove Puppet*, *c.* 1770, hanging scroll, colour on paper. Tokyo National Museum.

61 Kitagawa Utamaro, *Lovers with Clam Shell*, multi-coloured woodblock page from a *shunga* album, *Utamakura* (1788). The British Museum, London.

62 Kitagawa Utamaro, *Man Seducing a Young Woman*, 1801–4, hanging scroll, colour on silk. Tokushū Paper Company, Ltd., Historical Archives, Tokyo.

63 Isoda Koryūsai, *Boy Plucking Plum-blossom with Girl*, 1770s, multi-coloured woodblock print.

64 Yamazaki Joryū, *Kabuki Actor Holding Irises*, *c.* 1725, hanging scroll, colour on paper. Idemitsu Museum of Arts, Tokyo.

65 Suzuki Harunobu, '*Analogue' of Ju Citong*, *c.* 1765, multi-coloured woodblock print.

66 Kitagawa Utamaro, *Picture of the Middle Class*, multi-coloured woodblock print from the series *Fūzoku sandan musume*, *c.* 1795.

67 Kitagawa Utamaro, *Suited to Bold Designs Stocked by the Kame-ya*, multi-coloured woodblock print from the series *Natsu ishō tōsei bijin* (*c.* 1804-6).

68 Kitagawa Utamaro, *Goldfish*, multi-coloured woodblock print from the series *Fūryū ko-dakara awase*, *c.* 1802.

69 Maruyama Oshin, *Camels*, 1824, hanging scroll, colour and ink on silk. Joe and Etsuko Price, Shinenkan Collection, USA.

70 Utagawa Toyomaru, *Whale at Shinagawa* (modern censoring), monochrome woodblock illustration for the anonymous *Ehon fubikō tori* (1798).

71 Suzuki Harunobu, *Woman Playing the Shakuhachi*, 1765–70, multi-coloured woodblock print.

72 Torii Kiyomitsu, *Nakamura Tomijūrō in the role of Shirotae*, mid-18th century, three-tone woodblock print.

73 Suzuki Harunobu, *Komusō with Prostitute and her Trainee*, *c.* 1766–7, multi-coloured woodblock print.

74 Kitagawa Utamaro, *Umegawa and Chūbei*, multi-coloured woodblock print from the series *Ongyoku koi no ayatsuri*, c. 1800.

75 Suzuki Harushige (Shiba Kōkan), *Women Blowing Bubbles with Child*, c. 1780, hanging scroll, colour on silk. Kimiko and John Powers Collection, USA.

76 Suzuki Harunobu, *Blow-pipe Alley*, diptych, multi-coloured woodblock prints, 1765–70. The British Museum, London.

77 Kitao Shigemasa, *Blow-pipe Alley*, monochrome woodblock page for Santō Kyōden, *Ningen banji fukiya no mato* (1803). National Diet Library, Tokyo.

78 Nishikawa Sukenobu, *Kabuki Actor with Gun*, monochrome woodblock page for Nankai Sanjin (Sukenobu?), *Nanshoku yamaji no tsuyu* (1730s).

79 Kitagawa Utamaro, *Woman Blowing a Popin*, multi-coloured woodblock print from the series *Fujo jinsō juppin*, c. 1800.

80 Aubrey Beardsley, *Adoramus*, an unpublished drawing for *Lysistrata*, c. 1896.

81 Isoda Koryūsai, *Lovers in Fukagawa District*, multi-coloured woodblock page from *Haikai meoto maneenon* (c. 1770).

82 Katsushika Hokusai, *Lovers with Mirror*, c. 1810, multi-coloured woodblock page detached from an unknown *shunga* album.

83 Okamura Masanobu, *Lovers beside Paintings of* The Tales of Ise, hand-coloured woodblock page from a *shunga* album, *Neya no hinagata* (c. 1738).

84 Suzuki Harunobu(?), *Customer with Osen – Shunga Version*, 1765–70, multi-coloured woodblock print. Photo: Sumishō, Tokyo.

85 Keisai Eisen, Copied from Kaitai shinsho, multi-coloured woodblock page from his *Makura bunko* (1832). Photo: Fukuda Kazuhiko.

86 Utagawa Kunisada, *Vaginal Inspection*, multi-coloured woodblock page from a *shunga* album, *Azuma genji* (c. 1837).

87 Suzuki Harunobu, *The Jewel River on Mt Kōya*, multi-coloured woodblock print from the series *Mu-tamagawa*, 1765–70. Kobe City Museum.

88 Torii Kiyomitsu, *Lovers Using a Mirror*, multi-coloured woodblock illustration from an untitled *shunga* album (c. 1765).

89 Isoda Koryūsai, *Evening Glow at the Teashop*, multi-coloured woodblock page from the series *Imayō jinrin hakkei*, 1770s.

90 Anon., *Lovers at Asukayama* (modern censoring), monochrome woodblock page from Furukawa Koshōken ('Kibi Sanjin'), *Edo meisho zue* (1794).

91 Suzuki Harunobu, *Ibaraki-ya*, c.1767/8, multi-coloured woodblock print.

92 Nishikawa Sukenobu, *The Maid*, monochrome woodblock page from *Makurabon taikei-ki* (c. 1720).

93 Hishikawa Moronobu, *Through the Screens*, monochrome woodblock page from *Koi no mutsugoto shijū-hatte* (1679). Chiba Prefectural Museum of Art.

94 Detail from Hokusai, *Lovers with Mirror* (illus. 82).

95 Sugimura Jihei, *Erect Man Approaching Sleeping Woman*, monochrome woodblock page from an untitled *shunga* album (c. 1684).

96 Chōbunsai Eishi, *Woman Dreaming over* The Tales of Ise, c. 1800, hanging scroll, colour and gold on silk. The British Museum, London.

97 Hishikawa Moronobu, *Shunga Version of* Masashi Plain *from* The Tales of Ise, monochrome woodblock page from *Ise genji shikishi* (modern title) (c. 1684).

98 Sugimura Jihei, *Woman of Water with Man of Wood*, monochrome woodblock page from the anonymous *Sansei aishō makura* (1687).

99 Suzuki Harunobu, *Putai Exiting a Painting*, 1765–70, multi-coloured woodblock print.

100 Suzuki Harunobu, *Ukiyonosuke's Visitation at the Kasamori Shrine*, multi-coloured woodblock page from Komatsu-ya Hyakki, *Fūryū kōshoku maneemon* (1765).

101 Suzuki Harunobu, *Samurai Customer with Osen*, 1765–70, multi-coloured woodblock print. Photo: The British Museum.

102 Ihara Saikaku(?), *Yonosuke Watches the Maid through a Telescope*, mono-chrome woodblock illustration for his *Kōshoku ichidai otoko* (1682).

103 Okumura Toshinobu, *Sodesaki Kikutarō in the Role of the Maid, and Ichikawa Masugorō in the Role of Yonosuke*, 1730s, hand-coloured mono-chrome woodblock print. Keiō University Library, Tokyo.

104 Kitagawa Utamaro, *Kinjūrō's Letter is Inspected*, monochrome wood-block page from Namake no Bakahito, *Uso shikkari gantori chō* (1783). Tokyo Metropolitan Central Library.

105 Utagawa Kunisada, *Penises of Ichikawa Danjūrō and Iwai Hanshirō*, multi-coloured woodblock page from a *shunga* album, *Takara awasei* (1826).

106 Kitagawa Utamaro and Katsukawa Shunchō, *Three Women in an Upstairs Room*, monochrome woodblock page from Shōden-ga-Shirushi, *Ehon hime-hajime* (1790).

107 Kitagawa Utamaro and Katsukawa Shunchō, page following illus. 106, from Shirushi, *Ehon hime-hajime*.

108 Utagawa Kunisada, *Yoshizane Uses a Telescope*, multi-coloured wood-block page from Kyokushū Shūjin (Hanakasa Bunkyō), *Koi no yatsub-uchi* (1837).

109 Utagawa Kunisada, page following illus. 108 from Shûjin, *Koi no yatsubuchi*.

110 Utagawa Kunisada, *At a Summer House*, multi-coloured woodblock page from the anonymous *Shunjō gidan mizuage-chō* (1836).

111 Kunisada, page following illus. 110 from the anonymous *Shunjō gidan mizuage-chō*.

112 Suzuki Harunobu, *Motoura of the Yamazaki-ya*, multi-coloured wood-block print from the series *Ukiyo bijin hana no kotobuki*, 1765–70.

113 Kitao Masanobu (Santō Kyōden), *Boyish God Offers Tsūsaburō a Magical Telescope*, monochrome woodblock page from Sharakusai Manri, *Shimadai me no shōgatsu* (1787).

114 Kitao Masanobu (Santō Kyōden), *Peeping-Karakuri*, monochrome woodblock page from his *Gozonji no shōbaimono* (1782).

115 Anon., *Lovers Before a Screen*, monochrome woodblock page from *Hua ying jin zhen*, Chinese, Ming dynasty, 17th century.

116 Nishimura Sukenobu, *Lovers in a Ricefield*, monochrome woodblock page from the anonymous *Makurabon taikai-ki* (c. 1720).

117 Hayamizu Shungyōsai, *The Safflower*, monochrome woodblock page from the anonymous *Onna kōshoku kyōkun kagami* (1790s).

118 Suzuki Harunobu, *'Analogue' of 'Evening Faces'*, 1776, diptych, multi-coloured woodblock print. Tokyo National Museum. Photo: Kyoryokukai.

119 Kitagawa Utamaro, *Group of Women around Screen of* The Tales of Ise, 1800, multi-coloured woodblock print.

120 Suzuki Harunobu, *Lovers in a Ricefield*, multi-coloured woodblock page from Komatsu-ya Hyakki, *Fūryū kōshoku maneemon* (1765).

121 Utagawa Kunisada, *Beanman and Beanwoman Prepare to Attack the Vagina*, multi-coloured woodblock illustration for Naniyori Sanega Sukinari, *Sentō shinwa* (1827).

122 Maruyama Ōkyo, *Yang Guifei*, 1782, hanging scroll, colour on silk.

123 Katsushika Hokusai, *Maruyama*, multi-coloured woodblock print from the series *Nana yūjo*, 1801–4.

124 Chōbunsai Eishō, *A European and a Maruyama Prostitute*, c. 1790s, multi-coloured woodblock print.

125 Kitagawa Utamaro, *European Lovers*, multi-coloured woodblock page from *Utamakura* (1788). The British Museum, London.

126 Kawahara Keiga, *The Blomhoff Family*, 1817, standing screen, colour on paper. Kobe City Museum.

127 Kawahara Keiga(?), *Captain Blomhoff with a Japanese Woman*, after 1817, section of handscroll, colour on paper. Photo: Fukuda Kazuhiko.

128 Kitagawa Utamaro, *Emperor Xuanzong and Yang Guifei*, multi-coloured woodblock print from the series *Jitsu kurabe iro no minakami*, 1799. Private collection.

129 Anon., *The Forest of Meats and Lake of Sake*, monochrome woodblock illustration for Zhang Juzhen, *Teikan-zusetsu*, 1606 (copy after a Ming original of 1573).

130 Kano Mitsunobu (d. 1608), *The Geomantic Cave and The Four Greybeards of Mt Shang*, before 1608, pair of six-fold screens, colour and gold on paper. Metropolitan Museum of Art, New York (The Harry G. C. Packard Collection of Asian Art. Gift of Harry G. C. Packard and Purchase, Fletcher, Rogers, Harris Brisbane Dick and Louis V. Bell Funds, Joseph Pulitzer Bequest and The Annenberg Fund, Inc. Gift).

131 Kitagawa Utamaro, *Hideyoshi and his Five Wives Viewing Cherry-blossom at Higashiyama*, c. 1803–4, triptych, multi-coloured woodblock prints. The British Museum, London.

132 Kiyagawa Utamaro, *Machiba Hisayoshi*, c. 1803–4, multi-coloured woodblock print from a series based on the anonymous *Ehon taikō-ki*. The British Museum, London.

133 Yanagawa Shigenobu, *Gods on the Floating Bridge of Heaven Watch a Wagtail*, multi-coloured woodblock page from Detara-bō, *Ama no ukihashi* (c. 1825).

134 Keisei Eisen, *Gods on the Floating Bridge of Heaven Watch a Wagtail*, multi-coloured woodblock page from his *Makura bunko* (1822–32). Photo: Fukuda Kazuhiko.

135 Ichiraku-tei Eisui, *Portait of Jippensha Ikku*, monochrome woodblock page for Jippensha Ikku, *Tōkaidōchū hizakurige* (1802).

136 Katsushika Hokusai, *Akasaka*, multi-coloured woodblock print from the series *Tōkaidō gojūsan tsugi*, c. 1810.

137 Kitagawa Utamaro II, *Kagegawa*, multi-coloured woodblock page from a *shunga* album, *Hizasuri nikki* (1820s).

138 Utagawa Kunisada, *Odawara*, multi-coloured woodblock page from Tamenaga Shunsui, *Irokurabe hana no miyakoji* (late 1838).

139 Utagawa Kunisada, multi-coloured woodblock wrapper for a *shunga* album, *Shunga gojūsan tsuji* (c. 1820).

140 Utagawa Kunisada, *Oiso*, multi-coloured woodblock page from a *shunga* album, *Shunga gojūsan tsuji* (c. 1820).

141 Anon., *Portrait of the Author*, monochrome woodblock illustration for Azumaotoko Itchō, *Keichū hizasurige* (1812).

142 Utagawa Kunisada, *Lovers*, multi-coloured woodblock page from a *shunga* album, *Azuma genji* (c. 1837).

143 Utagawa Kunimaru, *Woman Resisting Intercourse*, multi-coloured woodblock page from Koikawa Shōzan, *Keichū ō-karakuri* (c. 1835).

144 Keisai Eisen, *Rape*, multi-coloured woodblock page from *Waka murasaki* (1830s).

145 Tsukioka Settei, *Maruyama*, monochrome woodblock illustration for his *Onna tairaku takarabako: shokoku irosato chokufū* (c. 1780s).

146 Nagahide, *Europeans Collecting Vaginal Juices*, monochrome woodblock page from the anonymous *Rakutō fūryū sugatakurabe* (c. 1810).

147 Yanagawa Shigenobu, *A Continental Couple Collecting Vaginal Juices*, multi-coloured page from Kōtei Shūjin (Shikitei Sanba?), *Yanagi no arashi* (1822).

148 Katsushika Hokusai, *A Couple Collecting Vaginal Juices*, multi-coloured page from *Enmusubi izumo no sugi* (1830s).
149 Kawahara Keiga(?), *Captain and Mrs Blomhoff – Shunga Version*, after 1817, section of handscroll, colour on paper. Photo: Fukuda Kazuhiko.